THE UNIVERSITY

Theatres of Learning Disability

Theatres of Learning Disability

Good, Bad, or Plain Ugly?

Matt Hargrave
Senior Lecturer in Drama and Applied Theatre, University of Northumbria, UK

First published 2015 by
PALGRAVE MACMILLAN

Palgrave Macmillan in the UK is an imprint of Macmillan Publishers Limited, registered in England, company number 785998, of Houndmills, Basingstoke, Hampshire RG21 6XS.

Palgrave Macmillan in the US is a division of St Martin's Press LLC, 175 Fifth Avenue, New York, NY 10010.

Palgrave Macmillan is the global academic imprint of the above companies and has companies and representatives throughout the world.

Palgrave® and Macmillan® are registered trademarks in the United States, the United Kingdom, Europe, and other countries.

ISBN 978–1–137–50438–8

Library of Congress Cataloging-in-Publication Data
Hargrave, Matt, 1971–
Theatres of learning disability : good, bad, or plain ugly? / Matt Hargrave.
 pages cm
Summary: "This is the first scholarly book to focus exclusively on theatre and learning disability as theatre – rather than advocacy or therapy. Matt Hargrave provocatively realigns many of the (hitherto unvoiced) assumptions that underpin such practices, and opens up a new set of critical questions. Stemming from a close engagement with the work of several very different theatre companies – including Mind the Gap (UK); Back to Back (Australia) – and unique solo artists such as Jez Colborne, this book shifts the emphasis from questions of social benefit towards a genuine engagement with aesthetic judgement. Hargrave examines the rich variety of contemporary theatrical practices in this field and spans a wide range of forms such as site specific, naturalistic and autobiographical performance. The book examines ways in which the learning disabled performer might be read on stage, and the ways in which s/he might disturb assumptions, not least about what acting or artistic authorship is. This is an important and timely study for all upper-level theatre and performance students and scholars alike, as well as a provocative contribution to debates within disability studies"—Provided by publisher.
 Includes bibliographical references and index.
 ISBN 978–1–137–50438–8 (hardback)
 1. People with disabilities and the performing arts. I. Title.
 PN1590.H36H37 2015
 791.087—dc23 2015002377

Typeset by MPS Limited, Chennai, India.

For Carolynn, Alex, and Dylan

Contents

vii

Envoi: The Bartleby Parallax **231**

Foreword

This is a book about exceptions, of exclusions and the excluded, the outsider, of gaps in thinking, of exceptions to the rule. It is also about exceptional acts and exceptional encounters, and most importantly it's about exceptional people: people who defy the norms, who don't fit neatly, and who challenge fixed-state thinking. It's also a book about theatre.

Like many, my first encounter with learning disability was within the pages of a book. I studied John Steinbeck's *Of Mice and Men* at school. I was drawn to the tragedy, the relationship between George and Lennie: two people who acted as one, each making up for a deficit in the other. My teacher set us the task of writing a final chapter. What would happen if we went beyond the events of that tragic night? In my chapter George returns three months later to the bar he was in that night and attempts to tell his story to anyone who will listen. I was intrigued by the idea of taking a story that already existed, retelling it from a different point of view. I was frustrated by the fact that there was nothing I could do to change the outcome for Lennie. In a curious way I identified with him the most. His fate was sealed.

Later when I was studying theatre at college, I began working in a local long-stay hospital. It was closing down and people were being 'decanted' into the community. What linked the artist and the patient was that they were outsiders, but with one important distinction: the artist was in the hospital by choice, the patient by force. At the time the only way that learning disabled people could engage with theatre was as a therapy. This felt inadequate. I became fascinated with how to use theatre as a means of raising the voice of learning disabled people. I needed a form of theatre-making that would work in this way.

For Augusto Boal the objective of Theatre of the Oppressed is for the non-actor to become the protagonist in his or her own life, not just to be a subject in someone else's story. What if we were able to enter the narrative earlier, before the crisis point? What would happen then? Suddenly I had a form that allowed me to break into the story, to change the outcome. This was a revelation. For many years we practised Forum Theatre at Mind the Gap, based on the direct experience of participants, and Boal became a friend and ally to our work.

What became clear very quickly at Mind the Gap was that we were working with talented and skilful theatre-makers, who had their own stories to tell but who also had a passion for making great theatre and a thirst to learn more.

In 2000 the Steinbeck estate granted us rare permission to make an adaptation of the story, which was done by Mike Kenny. They understood that we wanted to cast a learning disabled man in the role of Lennie and that we would need to reshape the story to be told by just three actors, as dictated by the economics of touring. They agreed but of course they would not let us change the story. As part of the development of the piece we improvised the campfire scene where George tells Lennie about the farm: their American Dream. We asked the actors what their dreams were. One of the actors, Jez Colborne, said that he had always wanted to ride across America on a Harley Davidson. This was the birth of the idea for *On the Verge* (2005).

Matt Hargrave is right in his assertion that the work of learning disabled artists is under-theorised. What has been written has tended to focus on the therapeutic benefits or on the instrumental use of theatre applied to social outcomes. Or it has proposed that the work is so different as to constitute a separate cultural form – as in Outsider Art. In fact, the critique of this work has mainly been what Boal used to call 'the critique of silence'. There are important voices that are missing in the debates and discussions that surround the work. When people write about the work, they use terminology that is therapeutically based or based on social activism, and there's a great deal of nuance that is missed out from this experience. It is written in language that excludes. We get to talk about authenticity or ownership, never about the forms and content of the work or about beauty and aesthetics. This has prompted companies like Back to Back to include such discussions in the shows they create.

As Matt points out, there is no one aesthetic at work here, no one culture of learning disability. Instead, there is a multiplicity of ways of telling and multiple theatres of learning disability.

Some readers may never have encountered this kind of work before. Some might be old friends. Almost all will be non-learning disabled. This is a problem. This is why there is an Easy Read version in the appendix. I needed a way to help take this analysis and make it available to learning disabled artists. Since its creation we have piloted the Easy Read version for those learning disabled artists who have good literacy skills – it has opened up the subject for them. We have also run seminars

that involved MA students and members of Mind the Gap's acting company. These have been fascinating encounters. Matt presented the key ideas, and the conversation that ensued was as rich, and the opinions as diverse, as any you would encounter in an academic setting. The artists at Mind the Gap are now talking differently about their work and the work they go to see. They have a wider vocabulary and a clearer sense of the possibilities of theatre.

I hope that this book is a positive encounter with the ideas of theatres and learning disability, and that it persuades you that there is more here than just a kind or worthwhile thing to do; rather, that the practice presents a rich set of aesthetic challenges. I've spent 26 years developing the work. There are now many companies developing their own practice across the country and across the world. Today there is a strong and coherent theoretical framework that can be used to understand, challenge, and develop that work for future generations.

Like all important works, this one is incomplete. What about the next chapter or chapters of this book? What's next for Mind the Gap, or Back to Back, or for artists like Jez Colborne? What ideas will it provoke in the reader? This is not the last word but hopefully the beginning of a stream of thought and theorising that will enrich, problematise, and ultimately propel the work forward.

For the past four years I've been working with Jez to write his own version of Homer's Odyssey. Matt's work has acted on this process like the wise counsel of Athena and the drafts of this book have acted like an atlas of maps to aid Jez on his own journey of twists and turns.

This year Jez received his first mainstream commission. He was funded by the PRS for Music Foundation to create a piece of music, entitled 'Gift for the New Music Biennial 2014', using a shipping container as a musical instrument. The container, like the Trojan horse, hides its secrets and asks audiences to choose to be either insiders or outsiders. They can listen to the piece from inside or outside the container, or they can do both.

Today, when a learning disabled child attends mainstream school, the school can request that the child be excluded from mandatory examinations. The process is called 'dis-application'. My hope for the future is that we are able to make the case for a dis-applied theatre. Not as a replacement for the excellent work done within the applied theatre framework but as an option that can, if appropriate, remove the obligation to make theatre with learning disabled people an attempt to cure or console, or otherwise make overt political statements. Dis-applied theatre would be about telling and re-telling great stories in exceptional

ways. Come to think of it, why not just call it 'theatre'? Good practice, like good theorising, should not become another way of excluding people. A good director, like a good academic, needs to know when to get out of the way and let the work speak for itself.

Tim Wheeler
Artistic Director
Mind the Gap
1988–2014

Acknowledgements

Many minds have influenced this work. Thank you to all the artists and associates of Back to Back, Shysters, Full Body & The Voice, Mind the Gap, and Dark Horse for making this research so stimulating and surprising. I hope that the book stands as a mark of a deep appreciation. Whilst many artists are quoted, I want to acknowledge the often intangible influence of those with whom I have spent time, whether travelling, eating, dancing, or – in Jez Colborne's case – hanging out with on Ipanema beach. With this in mind, I want to give special thanks to the team at Mind the Gap for opening the door on the research so widely. I owe a particular debt of gratitude to Frances Babbage and Tim Wheeler: they were the best kind of readers – patient, meticulous, enthused, challenging – and the most kind and careful of listeners. Their combined wisdom was constant; the errors are my own, but the insights are shared. Thank you also to the Arts and Humanities Research Council, to colleagues at Sheffield and Northumbria universities for generosity of time and spirit, and to Ruth Townsley for taking on the challenge of the Easy Read translation. Also, Jo Verrent, Jonathan Pitches, Cormac Power, Simon Murray, Colette Conroy, Joe Winston, Dave Calvert, Alice Nash, Bill McDonnell, Helen Nicholson, David Linton, Emma Gee, Alan Clay, Toby Brandon, Alan Roulstone, Julia Skelton, James Thompson, Mike Kenny, Bruce Gladwin, Richard Hayhow, and Jon Palmer.

Writing this book has been a journey, and anything but a linear one. I would like to thank the editors of *Theatre, Dance and Performance Training* and *Research in Drama Education, the Journal of Applied and Social Theatre* for opportunities to share ideas publicly at early stages. It is important also to acknowledge the role that The Theatre and Performance Research Association has played in offering such convivial intellectual company over the past years, in particular, colleagues across two working groups (Applied and Social Theatre; Performance, Culture and Identity).

My family supported me in all the invisible and unsung ways that are too many to name. Thank you Mum and Dad for creating a quiet space; thank you Carolynn for reminding me that I was missed; and thank you Alex and Dylan for asking, quite reasonably, 'Are you *still* writing that book?'

Prologue: Of Moths and Methods

The Moth Ball (2008)

It is a party to which you all come: the friends, supporters and alumni of the company. Rain and winter outside. Glass bubbles across the rooftops, the future penthouses of Bradford's new social elite. And in one enclave of this reconditioned slab of Bradford's industrial history, Manningham Mill – an old silk factory – a theatre company opens its doors to throw a masked ball. Tim Wheeler, Artistic Director of Mind the Gap, has provided you with a costume. You wear a tan safari waistcoat and a large bush hat. To this strange mix is added a butterfly net. You are to be a 'moth catcher', a netter of ideas. You have a voice recorder and notebook, but you will not use them.

Downstairs, an actor is dressed in a fine black suit. Alan Clay is a man of few words. He finds speech difficult and only seems to come alive on stage. In the foyer, as the first guests arrive you smile at each other, you and Clay. You have the costumes but your roles are not quite defined. 'It's weird', you say to Clay. 'It gets weirder', he says.

A string quartet begins to play. Your 'net' causes a commotion. JoAnne Haines, an actress soon to make her professional debut in a play called *Boo*, wants you to chase her. You say, 'It's pointless: If you run, I catch you too quick. If you chase me, you can't catch me. Ever.' This is a line from *Boo*. You spend several minutes trying to get the line right. The game goes on all night, way beyond the time that you put down your net and left it somewhere. She keeps asking you where it is. Then she finds it and wants you to play. You don't want to play. You drink champagne, then some wine. You feel yourself slipping into limbo: working but not working, something more like 'deep hanging out'.[1] Your 'role' is not quite working as you expected. You were supposed to

1

ask people what they thought the new building could be used for. You wonder if this was the right question.

Staged areas seem to appear as you move through the building. Many of the people in this building 'have' what in the UK is currently known as a 'learning disability' or 'difficulty'. It has gone by other names, some of them not pleasant. Haines has said, of the forthcoming *Boo*, 'people will know what to expect … it's Mind the Gap: theatre for spackers!'

A gong is heard. Within the gathering a chain of performers emerges. They are wearing masks that wrap around the upper face and eyes: moth masks. The doors open and gradually the audience moves into a smaller studio. A neon sign reads 'The Old Flame'. The room has been transformed into a bar where more alcohol can be purchased. In addition, you are invited to choose your own moth mask. You line up, waiting to be transformed: the masking creates a different atmosphere, each person now possessed of a secret identity, a moth self.

The atmosphere in the room has changed: no longer the gentle formality of the champagne reception but rather a hint of the transgressive. Almost immediately, on a steel walkway above you, more moth performers awake from a slumber, form a line, and recite lines of love poetry and images of desire. The line 'you set my heart a flutter' is repeated many times. You cannot hear everything that is said, as some of the lines run over one another. Also, some of the performers' diction is not quite clear. You cannot make out all the words. The intent is clear though: desire, secrecy, love lost or unrequited, old flames rekindled. The steel walkway suggests a cage. These masked creatures imprisoned in their desire gaze down upon you. You: guests, mortals, familiars who grow increasingly unfamiliar to others and to yourselves; how little masking is required for your identity to be placed in doubt. The mask renders the wearer camouflaged.

The next stage of the evening is an invitation to another space where you are encouraged to learn several dances, the 'Chrysalis' among them. Until now the evening has steered between the social and the aesthetic: moments of 'contrived' or 'prepared' performance have intervened in and around you as part of a social ritual. The invitation to dance is different. At some point, to your peril, you become aware that an understanding of the dance will be necessary later for the Ball. This puts you, and all the guests, on a different footing. You will need to intervene, to demonstrate something. You are all, momentarily, 'disabled', your competencies called into question.

You are watching learning disabled persons in strange masks trying to perform folk dance. Why are you anxious? Maybe it has to do with the precision that dance asks for, how unforgiving it is. The participants'

movements are not very precise and you worry if they are supposed to be doing it 'better'. Your tension dissolves as soon as you begin to participate in the dance. You are too concerned about making sure you get it right to worry about others. Self-interest outbids anxiety; competencies merge. Later, much later, you will see a picture of yourself dancing with Mrs Abbas, the mother of one of the performers. Your tongue is just visible pursed between your lips and you are looking down, trying very hard not to make a mistake. Applauding at the end, Mrs Abbas looks very satisfied, her hands clasped.

Well into the evening now, it must be 10.30, the Moth Ball begins. A young woman asks you to dance. You have not been asked to dance by a learning disabled woman wearing a mask before. For a moment, you are uncomfortable. You dance. Maybe, it is the alcohol and the range of sudden, desperate choreographies your body is negotiating, but the weirdness has to do with a strange shift in perception, a slippage between frames. You are dancing with a young woman. If the same activity were taking place in a well-lit workshop in the middle of the day, a very different mood would be established. But here and now, you are a masked couple at a ball. You hold hands, smile, and cavort. The only obvious impairment you can see are your own feet, woefully out of time, struggling to keep themselves from crushing your partner's toes. You consider that for much of your working life you have been engaged in performance work with people with learning disabilities, but rarely have you been at a party.

The Moth Ball itself lasts for about 40 minutes. The performative and social start to blur. You re-enter the lobby area. The doors are open now, allowing the cold December in. Outside is a huge industrial courtyard, partly re-developed, partly in ruins. Jonathan Lewis, a performer, possesses the quality of appearing both young and old. Now he is in a sleeping bag, sprawled out on one of the sofas. You think he looks unwell. His flushed face makes you wonder about his heart. You are worried about him. Is he ill now? Is he cold? He looks vulnerable. Then you notice that there are other people in sleeping bags. It is part of the event. Silver sleeping bags, with orange insides like pupae, start to appear all over the building, as if the life cycle is starting once more. The doors slide back on the kitchen serving tea and bacon sandwiches. Suddenly it feels like the middle of the night or maybe early morning.

You are aware of a photographer moving stealthily through the space. You wonder how this event will be captured. Some of the pictures are sneakily taken without the subject's knowledge. But mostly the photographer is an intrinsic part of people's experience; they are seeking out

the gaze of the lens in order to place themselves. Here. At the Moth Ball. On this December night. On the photographer's part, there seems no desire to attain an ironic or 'objective' distance. He is close up, collaborating with the guests, helping them evidence their own presence. Later, when the photos are developed, you feel sure you will see: Two young men, brothers. Ginger hair, one worn long, the other spike-gelled. Both men staring into the camera, completely open. Both masked. The non-disabled brother's arm around his sibling. A great emotional warmth emanating from this photograph. An image of 'strong family'. Or else: A young Asian man sitting with an older woman, maybe his mother. He will stare deadpan into the camera, the mask fixed to his face. She will hold her mask in her hand, a short distance from her face, creating a shadow. You will hardly see her eyes, a fact that will haunt the frame: it will be as if her eyes have been hollowed out.

You are called back into the main studio to see performers who now have wings as well as masks. Moths in formation, fluttering towards bare lightbulbs that throw out beams above them. There are maybe 15 performers. You have not thought, until now, how beautiful this is. The costumes and the lights, but other things too, vying for the attention of the senses: the 'secret' places within the building, surprise entrances and exits, gangways, balconies, stairwells, all created out of the husk of previous incarnations. Silk and money made this possible, and now the building is alive with new cultures. The people are beautiful. Kinship and more informal networks are celebrated in this moment: families, work colleagues, actors, artists, photographers, dressed up, intoxicated. You cannot separate the architecture from the social or from the aesthetic. They intertwine with one another, so that the site is imbued with everything performative. The real star of the show *is* the building, the host you all feed off. The form of this show – this ritual, this ceremony of becoming, this rite of passage – is *a striptease*: a gradual, seductive revealing of the new place in which we are now all implicated. The building is being burlesqued.

From somewhere you hear voices in song. They coincide with the dance now, real voices, live, in the moment. You recognise one of the voices as Jez Colborne, singer, songwriter, and actor, who has performed a one-man show titled *On the Verge*. You have travelled with Colborne and watched him, written about his performance. Another voice sings with him:

Birds flying high, you know how I feel
Sun in the sky, you know how I feel
Breeze driftin' on by, you know how I feel

It is a beautiful voice, strong, feminine. The voices take turns to sing a verse:

It's a new dawn
It's a new day
It's a new life
For me
And I'm feeling good

The moths dance to this song, edging nearer to the black curtain on the far side of Studio One. Slowly it opens to reveal a stage. Colborne and a young woman who works for the company can be seen: he in a 1930s pinstripe suit, fedora, trainers, and large moth wings; she, pregnant in a green dress. Behind the keyboard, stooped and ungainly, his knees touching, his feet turned inwards: Colborne.

Something snaps you out of your reverie. The first song is over. Inevitably perhaps, the rest of the evening's entertainment cannot maintain this level. It was too perfect. You lose track of what happens next. You are encouraged to participate in a version of Van Morrison's *Moondance*. The moth dancers are maintaining their choreography, or at least sticking together, but it feels as though the rehearsed moment has run out of steam. You overhear someone say, 'I'm not sure who it is for'. You are watching, vaguely participating, nodding your head, moving from side to side, caught halfway between involvement and watchfulness. The critic side of you – the professional side – is starting to take over, annoyed by the repetition of the song and music. And now, something else: the music stops and there's a voice, a poem is recited:

Between
light and dark
warmth and cold
new and old
drawn to dance, create
and explore ...
like moths to a flame

It is as though you are being 'shown' the meaning of the event, as opposed to simply experiencing it. The moth metaphor, which up to this point had felt light and teasing, is now heavy, defined, and finished. The eventual ending is a fade to black. Someone behind you says 'Ahhrr'. Someone else echoes it immediately, a response similar to

that of parents at a school play: an immediate response that expresses tenderness, a personal attachment to the performer. This jars suddenly. 'Ahhrr', you think, is the barrier to critical engagement. The image of fluttering moths – delicate, vulnerable – might not have been so pertinent in a company of performers defined by a quality other than disability. Other variables – individual psychology, mood, alcohol, or its side effects – might have coalesced into this 'Ahhrr moment', the nuances of which you will never know. Fade to black.

Overview of the book

This book is a poetics of the theatres of learning disability. It seeks to open a new critical space in which the work of learning disabled artists and their collaborators can be evaluated and appreciated as art, rather than advocacy or therapy. It extends the critical vocabulary available so that works funded and experienced as professional theatre can benefit from the kind of theoretical attention afforded to other artworks presented for public view.

The Moth Ball encapsulates important elements that emerge out of this critical work. Just as an early definition of the word 'person' was 'mask', both performance and disability complicate the relationship between mask and reality. As I later explore, psychoanalyst Joan Riviere suggested that the distinction between 'genuine womanliness' and the 'masquerade' be dissolved, that they be understood, rather, as 'the same thing' (Riviere 1929: 133); and just as philosopher Licia Carlson (2010) has sought to 'unmask' the faces of intellectual impairment, I examine the complex processes at play when learning disability is represented – its public face constructed – for the stage. The Moth Ball is suggestive of how things – disabilities, selves, beliefs – are always in the process of being both hidden and revealed. Camouflage complicates human adherence to visual order: symmetry, balance, and binaries. As Hillel Schwartz notes, 'Camouflage is not to prevent an object being seen but to prevent it being recognised as what it is, and preferably to make it seem to be nothing out of the ordinary' (1996: 200). It is precisely through such a process of defamiliarisation that the performances analysed in this book enrich the study of theatre and complicate both the terms 'performance' and 'disability'. Actors discussed in the following pages are at once defamiliar and 'nothing out of the ordinary'. Many of the critical insights I offer have arisen from momentary shifts in attention, which also describes the affects of camouflage. Several performances studied here provide 'fitful flashes of novel thoughts' (Schwartz

1996: 186) because they shift attention away from the 'play proper', dissolve conventional boundaries, and seemingly lead the spectator to mistake one thing for another.

The Moth Ball is indicative, then, of the defamiliarisation defined by Freud, and others since, as the 'uncanny'. The uncanny relates to instances in which primitive or repressed notions re-emerge to upset the 'proper' order of the habitual. Such sensations as *déjà vu*, intimations of spectral presence, or the piercing *Verfremdungseffekt* of certain artworks – evidence human existence as a continual negotiation between what is familiar (*heimlich*) and defamiliar (*unheimlich*). The narrator of the Moth Ball is both known (I) and unknown (you); or perhaps familiar (you) and strange (I). The narrator uses a rhetorical device – second person singular – that places identity in doubt. Just as the theme of this short extract is the experience of estrangement, so too the form that the writing takes enhances a pervasive sense of dislocation. This is in keeping with Michael Davidson's characterisation of disability as 'a both personal and social form of estrangement' (2008: 222). I argue in the forthcoming analysis that the interplay between story and theatrical structure is of crucial and surprising importance: where disability is concerned, content estranges form and form defamiliarises content. Throughout what follows, 'disability' and 'nondisability' – as well as other binaries such as amateur/professional or normal/divergent – seem to exist in perpetual quotes, dissolving into an ever more ambiguous mutual relationship.

Part I, 'The Surrogate', sets out some of the historical discourses and contentions that have shaped the field of performance and learning disability, as well as clarifying forms of contemporary practice that make the field so complex and exciting. It borrows its title, 'The Surrogate', from Joseph Roach's notion of performance as an act of surrogation; that is, the way in which performance sublimates constructed truths that subsequently become traditions. In a similar way, performance can 'stand in' for other cultural functions, in this case, advocacy or therapy. Chapter 1 is an overview of the terminology surrounding learning disability and the theoretical and political legacy of two closely linked social phenomena: the disability arts movement and disability studies. I summarise the effects that these twin agencies have had on the making and appreciation of art by disabled persons. I argue that theatre's relationship to these grounding bodies of thought has always been ambiguous and is increasingly untenable. This is because theatre, like other art forms, resists the kind of displacement that occurs when it is applied to achieving tangible social outcomes. Whilst I do not position the book

in the field of applied theatre, I do see it as allied to a growing body of seminal work that has developed in recent years from within socially committed performance practice, which has made a 'return to affect': for example, refocusing the importance of beauty in an educational context (Winston 2010) or in theatres of war (Thompson 2009). The book provides a complementary, often defamiliarising perspective on what James Thompson has called the 'end of effects' (*ibid.*), from connected but different theoretical starting points. By reconfiguring aesthetics at the centre of theatre and learning disability – a longstanding practice struggling to attain status on the basis of its affects – the book can usefully contribute to debates in both applied theatre and disability studies. It is precisely by dwelling on that which *resists* straightforward signification – the uncanny, for example – that theatre scholarship, whether 'pure' or 'applied', may deliver startling insights into discourses about social justice. It is not my intention in this chapter, or in the book as a whole, to denigrate the huge political advances made by advocates of the social model of disability and the disability arts movement (which in many ways has been its cultural vanguard); rather my purpose is to closely examine the effects of these theories on theatre practice. These effects have been as follows: the prevalence of a standpoint of binary opposition between 'disabled' and 'nondisabled' identities; a suspicion regarding the role of nondisabled artists; and a tendency to view theatre as a representation of either 'good' (democratic) or 'bad' (hierarchical) working relationships, rather than a complex aesthetic practice.

Indeed, as a first step in articulating a poetics of theatre and learning disability I depart from the standpoint that one must be disabled in order to voice an opinion about disability; or indeed that the principle function of a nondisabled person is to advocate on another's behalf. I argue that it is possible to speak as a nondisabled person so long as the act of criticism makes transparent the grounds for judgement as well as the interest in making those evaluations. My critique is rooted in a commitment to the collaboration between different intelligences and modes of virtuosity, in the interests of valuing increased human complexity; I reflect, therefore, on the generative, rather than the oppressive, potential of performance practice. Several authors have considered the problem of standpoint in relation to intellectual impairment (Carlson: 2010: 2) and, specifically, autism (Murray 2008: 18). Carlson notes how often she is asked by fellow philosophers if she has a family member with a disability, as if that were the sole reason she chooses to work in this 'anomalous' field. Murray, a parent of two autistic boys, admits that the majority of critical work on autism is done by those with a

personal connection to it. My own position is rather different in that I have had a professional connection to artists with disabilities for 15 years and, prior to this, worked in a residential special needs school as a care assistant. Part way through the research process, however, my stepson was diagnosed with ADHD inattentive sub-type, a hidden cognitive impairment on the autistic spectrum that does not manifest in the manner of the more visible 'hyperactive' type. For a lengthy period, my research was interrupted by a process of school refusal, diagnostic testing, and educational statementing. More recently, the diagnosis has shifted to encompass the possibility of Asperger's syndrome, as though the diagnosis grows to accommodate his disaffection. If anything, the process has complicated my view of cognitive difference; in an uncanny way, my son (and his disability) is/are both familiar and strange: a shift of perspective has occurred that puts our relationship on a different footing. My position, necessarily, is one that recognises disability as interconnectedness. I feel my son's vulnerability. I am implicated in his care and advocacy. My experience has also accentuated the disruptive quality of cognitive difference: disability upsets the linearity of everyday dramaturgy.

Chapter 2 advances this notion of interconnectedness. In a detailed study of two performances by very different companies (Australia's Back to Back and the UK-based Dark Horse) I articulate two findings of equal importance. First, performance can play a vital role in dismantling absolute distinctions between disabled and nondisabled persons, allowing new, less tightly prescribed identities to emerge. Second, disability is an aesthetic value in itself; one that, at the level of form as much as content, encourages insight into, and appreciation of, human variation. As the title of this chapter suggests, performance makes the 'pure product' of disability 'go crazy'. Here I am applying a 'critical disability studies' (Shildrick 2009) or 'complex embodiment' (Seibers 2008) approach to acts of performance. By this I mean that the categories of disabled and nondisabled, far from being absolute and fixed, are fluid and mutually interconnected. Disability, rather than designating illness or oppression, is 'a form of human variation' (Seibers 2008: 25) that must be recognised as integral – rather than exceptional – to the wider human experience. I am concerned with the power of art *forms* – and the *making* of such forms – to transform human identities. Just as the masks significantly changed how the Moth Ball was experienced, so theatre enables performers and spectators to explore those masks known as 'disability' or 'able-bodiedness'. The book interrogates society's – and theatre's – overwhelming preference for whole, independently functioning,

rational-minded persons. The theatres of learning disability challenge both the form theatre takes and the normative concepts that underpin its enduring structures.

Chapter 3 interrogates questions of quality and aesthetic value. The chapter is one way of responding to the 'Ahhrr moment' during the finale of the Moth Ball, where the writer experiences doubt about the meaning of affect in this context. On one level, 'Ahhrr' is immediate affective impact, which engages the spectator on levels beyond the instrumental; on another it suggests that such performers are, in the ironic words of Mind the Gap's Administrative Director, Julia Skelton, 'fluffy bunnies': child-like and somehow beyond criticism. This lack of critical response, I argue, is detrimental to the work of artists with learning disabilities. The notion that the work of such artists is 'good considering' does not allow for critical appraisal of the work *as art*; rather it becomes an extension of an 'aura' of social benevolence in which the aesthetic affects are secondary. Equally, the chapter explores the difficulty in making judgements about work created by those who have not been able to access professional training or may require increased levels of support to inhabit mainstream stages. Utilising a single case study – York Theatre Royal's adaptation of *Pinocchio* (2008), made in collaboration with the Shysters and Full Body & The Voice (a previous incarnation of Dark Horse) – I argue that it is both possible and necessary to make value judgements about such artworks. Such appraisal, in privileging the art works *as art*, fulfils three main functions: first, it upsets the stability of 'universal' standpoints in art criticism; second, it raises the aspiration of artists and is a concrete way of tackling the stereotype of disabled persons as less than fully competent; and third, it demystifies some of the pervasive cultural notions about learning disability. This chapter introduces the idea of theatre as a craft, a material thing made possible by processes of specialised labour. The chapter analyses the working collaboration between a mainstream venue and two companies that promote the 'authentic' qualities of learning disability. Research into the *making of* the aesthetic reveals, rather, a dynamic of *competing authenticities* that belie any attempt to portray performances by learning disabled performers as representative of a singular aesthetic quality. In this chapter I argue for art's irreducibility to the social; paradoxically, it is precisely by such separation that the critical value of art *to the political* is revealed. Broadly, I concur with art critic Janet Woolf, who has persuasively argued for an 'aesthetics of uncertainty': that while there cannot be a return to a universal canon, radical relativism that suspends aesthetic criteria should be viewed with equal caution (see Woolf 2008).

Applied to the artworks contained in the book, this involves recognition that 'difference' or even historical subjugation does not preclude the making of value judgements.

In Chapter 4 I explore the cultural forms that represented learning disability in the past. These forms are 'faces' reflected in the mirror held up by a society trying to construct a version of normality (order, homogeneity, regularity), a projection that informs 'us' what 'they' mean. These are the face of the feral, the face of the outsider, the face of the freak, and the face of the fool. I consider each face in turn to establish what function they serve. Whilst acknowledging the complex and violent history that is bound up with the creation of each face, I try to establish, not how 'good' or 'bad' each face is, but rather to work out how each face might serve as generative potential for contemporary artists. The chapter hinges on three broad principles. The first is that the faces invoke an intense and complex debate about artistic intention and authorship, with some suggesting that learning disabled persons *cannot*, on principle, be the authors of the works that they create, whether by singular or collaborative means. The second is that the cultural faces of learning disability operate as markers of a radical ambiguity: between what has value and what has none, between who is a person and who is a non-person – or non-actor, or non-artist. The third principle is that the faces can operate as masks for contemporary learning disabled artists to wear. A theoretical possibility exists that such masks (performative roles) might imbue the performer with a freedom and spontaneity that sits, if not outside, then alongside the label of disability. Rather in the way that terms such as 'crip' or 'queer' can be re-appropriated from their initial origins, some performers might continue to experiment with trying on the mantle of these different faces – to look into these 'mirrors' from history. Indeed, as James Thompson has noted, the political impact of affect may be strongest in moments of disturbance, which 'fundamentally challenge who speaks [or] where they dance' in order to redistribute the aesthetic realm 'in favour of those whose faces are excluded or made invisible' (2009: 176). In a sense, from this point, each chapter becomes a reflective surface – accruing depth in relation to what has, historically, preceded it.

Part II, 'A Proper Actor', represents a close engagement with Mind the Gap's work – in particular, two national touring productions, *On the Verge* (2005) and *Boo* (2009). Since this company has afforded me the closest possible vantage point on its performance work, I have sought to convey the intimate, almost ethnographic, quality of my research in this context. The major themes contained in Part I – authorship,

intentionality, binary vs. fluid identities, levels of 'aesthetic support', selective value judgements – re-emerge in different and ever more nuanced ways here. Chapters 5 and 6 are a demonstration of the kind of poetics I am arguing for: an act of labour that seeks to describe the precise aesthetic qualities contained in artworks. Both works emerge out of the singular aesthetic qualities possessed by two performers in particular – Jez Colborne in *On the Verge* and Jonathan Ide in *Boo* – and evidence further the propensity for form to arise out of human variation.

Chapter 5 follows on directly from a question raised in regard to the production of *Pinocchio:* that is, the level of support learning disabled actors require to fully occupy the stage. It also relates closely to the question of performative masks raised in Chapter 4. *On the Verge*, a solo performance by Colborne, gives an opportunity to analyse what, if any, particularities emerge from the presence of Colborne alone on stage, seemingly unmediated. The answer, I argue, is always double. Colborne is 'himself' but also 'Colborne': the collaborative aesthetic product of a creative process involving performer, writer, filmmaker, and director. The presence of 'Colborne' destablises not just the notion of pure or unmediated rhetoric but also the criterion of 'ownership': he makes work, out of his own experience, that demands to be judged aestheti-cally; and he can only do so with the close support of various authors. If the Moth Ball was an actual masquerade, I argue that *On the Verge* masquerades the idea of Colborne as someone with a learning disability. The show 'outs' Colborne as a man with a syndrome but in so doing leads the audience into new and unchartered territories of inter-subjective identity, created for and by performance, which undermine fixed notions of what learning disability is. Colborne's dissembling of the modes of the one-person show leads criticism into the territory of 'crip' or 'queer' theory, a body of thought that further undermines the con-cept of binary identity formation. I also owe Colborne the title of this book. At one stage in the show, he transforms himself into an imaginary cowboy and performs a stand-off at gunpoint. The cowboy asks, in slow Southern drawl, 'Well partner, are you good, bad, or plain ugly?' It has been my intention ever since to treat this as a serious aesthetic question.

In the longest section, Chapter 6, I analyse the dramaturgical proper-ties of Mind the Gap's re-telling of Harper Lee's *To Kill a Mockingbird*. By refocusing the story in present day Yorkshire, and from the perspective of a latter day 'Boo Radley', the work, *Boo*, inverts a canonical work and creates what I refer to as an 'uncanny' second. Freud's notion of the uncanny pervades this work in almost every respect: the eerie pres-ence of the lead actor, Jonathan Ide, who was both at the centre of this

'domestic' drama (*heimlich*) and outside it (*unheimlich*); the close, almost telepathic relationship between Ide and author, Mike Kenny, which troubled the notion of autonomous or independent artistic creation; the uncanny tendency of spectators to be drawn to events off stage; and the director's dramaturgical machine with its doubles, spectres, screened disappearances, disembodied voices, and palpable melancholy. Freud's uncanny is closely linked, as I will argue, with the sublime, an aesthetics concerned with dread, anxiety, and foreboding. The uncanny is an intriguing and productive way of framing aesthetics and disability. For Freud, the uncanny is not an either/or distinction between aesthetics and psychology but a means by which oppositions of all kinds are suspended: the uncanny is likely to be felt in instances where the imaginary and the real blur, where 'proper' distinctions of all kinds can no longer be definitively made. This proposal, as I have indicated, lies at the heart of the book: that binaries of both normative theatre and normative society are put in doubt by actors who speak and act 'differently'. 'Uncanny' is a precise description of the poetic affects of *Boo* and is, albeit unintentionally, an aesthetic realisation of Margrit Shildrick's 'critical' disability studies approach.

Shildrick's argument, in sum, is as follows: disability can no longer be reduced to a binary difference; rather its appearance highlights the profound interconnectedness of all identity; all persons should be validated as desiring subjects; nondisabled persons have as much right – and responsibility – to speak about these issues as disabled persons; and that all these issues are more complex than material exclusion (and thus cannot be 'solved' purely through redistribution of resources). Rather, as Shildrick argues, it is within the realm of the often unconscious cultural imaginary that foundational prejudices must be encountered, their affects examined (see Shildrick 2009 and 2012). Theatre, I argue, is the best place to see such affects, as it were, up close and personal: the 'side affects' of *Boo* – what the spectators saw and felt – are the uncanny double of Ide's affect. As with the terms 'disabled'/'nondisabled', Ide's affect/side affects *contain each other*, not in binary demarcation but in close proximity, in the shared mutual space of theatre.

In the conclusion, 'Conclusion: A Proper Actor', I dwell one last time on the mutuality of perceived opposites, in this case, the interdependence of the terms 'amateur' and 'professional'. As I argue, along with many other binaries discussed, the amateur/professional divide is a cover story for a more complex dynamic of power and disavowal. This final chapter 'outs' further the tension that remains prevalent throughout the book: namely, the gap between a view of the learning disabled

performer as innately 'authentic' and a view that posits her as special-ised agent (professional) in the creation of an aesthetic. I conclude by arguing that recognition as a theatre labourer provides a necessary corrective to a socially harmful perception of learning disabled citizens as economically or culturally unproductive. Philosophically, it corrects a view of the intellectually impaired as 'less than' full human beings. It also circumvents the imperative for learning disabled performers to produce a particular or 'proper' kind of theatre.

If the book has an urgent purpose, it is to refute unreservedly the notion that there is '*a theatre* of learning disability'. Rather, theatre is an art form, both supple and robust enough to admit all forms of human variation. I propose, therefore, a poetics of the theatres of learning dis-ability, not as a retreat from social realities – oppression, indifference, plain cruelty – but as a way of bringing focused attention to the *craft* of theatre: that which materialises through a complex intersection of techniques, sensitivities and affects. The subject here is theatre practice, yet the subject of theatre – and the subject of rituals like the Moth Ball – is always *transformation*: that is, the 'ability of human beings to create themselves, to change, to become – for worse and better – what they ordinarily are not' (Schechner 1993:1). This is the story of transforma-tions: from clients to collaborators; and from participants to artists.

Cognitive dissonances: a note on the appendix

One way of translating the aesthetic term *verfremdungseffekt,* and the psychoanalytic term *unheimlich,* is to define both as experiences of cognitive dissonance. By attaching an appendix – an Easy Read ver-sion intended for those unable to access the 'proper' version – I am, purposefully, opening up another kind of dissonance. The book – long, annotated, and professional – contrasts with the other work, which is shorter, simpler, and unreferenced: in other words, amateur. With regard to the Easy Read version, artists, not to mention the translator herself, might take exception and suggest that it is not 'mine' but 'their' version which is the most professional, since the act of distillation has involved yet more specialised labour. 'Criticism, is, I take it, the formal discourse of an amateur', said R.P. Blackmur in 1935, in an essay titled, ironically, 'The critic's job of work' (Blackmur: 885). My book is the work of an amateur if that means it is an act of appreciation, an act of love; it is professional, if by that is meant a job of work, a poetics. The terms entwine since my overarching theme is to suggest that the time has come to stop being professional (medics, advocates, therapists) and

start being amateurish (taking delight, finding inspiration). Yet the relationship is one of perpetual ambiguity; an artist is someone who takes delight and seeks renumeration for it: a 'professional amateur'. Most of the actors quoted here wish to be recognised as professional, as, on one level, do I: the research undertaken in this book spans several years, a period in which I bridged the worlds of amateur (student) and professional (titled academic).

At times I have had to confront the limits of final or doctrinaire knowledge, as with the later performances of Colborne in *On the Verge*. Throughout, I make continual aesthetic judgements: for example, '[t]he moth metaphor, which up to this point had felt light and teasing, is now heavy, defined, and finished'. Yet some members of the audience *liked* the ending because it delivered a definitive culmination. Just as Marx pointed out that the bourgeoisie mistake *their* world for *the* world, so academic criticism can often feel like the 'last word'. In the analysis that follows I offer careful judgements on the basis of what I have seen, in full awareness that not everyone sees the same thing. Where possible, I offer competing viewpoints; where not, I trust that the opening up of this field of study may bring about an increased critical interest, offering alternative analysis. The book does not attempt to embody the voice of learning disabled artists or spectators; such a thing would be impossible in any case. It is, rather, a critical framework that can be utilised or amended by future artists and scholars. The poetics of learning disability are alive to the interstitial moments of criticism, where the writer has to admit to doubt (doubt being a founding principle of the uncanny).

The Easy Read version does not reveal its sources, upholding the myth of its own self-sufficiency; the uncanny double of the book proper, it sits in uneasy alliance: it makes the learning – or at least the foundations of the learning – *disappear*. Like an actor on stage, the document *seems* unsupported. This emphasis on autonomy relates to a fundamental aspect of the research, to a set of societal labours that feminist philosopher Eva Kittay defines as 'dependency work': the type of labour often called 'care' or even 'women's' work, traditionally poorly paid and considered low status.[2] Theatre involving learning disabled actors evokes such issues; it places representatives of a societal group *defined by* diminished agency (dependents) on stage as seemingly autonomous agents (actors). In so doing, it upsets both the carer/cared for binary and the casting of nondisabled practitioners involved as 'dependency artists'. In recognition of the fundamental *interconnectedness* of disabled/nondisabled relationships, I argue for a greater awareness of the foundational

interdependency that defines virtually all artistic product and certainly most academic labour. This book, for example, may possess a single author but it is also the product of an intensively collaborative process (not to mention a beneficiary of the kinds of invisible support offered by family and colleagues), without which it would have been a different – and vastly diminished – piece of work.

There is no getting away from the fact that the existence of this book, in full academic form, is contentious because it cannot be read by the majority of its subjects. In some ways, therefore, it contains its own (continual) cognitive dissonance; and is – productively I hope – a contribution to a growing body of theatre historiography (Babbage 2005; McDonnell 2005), and ethnography more widely, that makes explicit the inconsistencies and ethical dilemmas central to its practice (Brettell (Ed.) 1996; Coffey 1999; Lassiter 2005; McLean and Leibing (Eds) 2007). The voice overheard at the Moth Ball – 'I'm not sure who it's for' – might echo in the minds of some readers. I invite the reader to draw their own conclusion but offer my own standpoint: I do not regard disability as a purely disabled person's 'issue', but one that affects all subjects. Whilst research has been undertaken in both theatre and disability studies, a tendency has been for it to be, where those with intellectual disabilities are concerned, resolutely anti-theoretical, on the basis that theory is too complex for learning disabled persons to understand and cannot fully involve them as participants.[3] I do not regard this as a tenable position in light of the complex collaborative practice evidenced by artworks studied here and, in any case, regard my project as an opening up, rather than a closing down, of debate. Nor do I regard an Easy Read version as *the* answer to the problem of access. As Licia Carlson argues, 'the question of authority is not solved' by the inclusion of learning disabled voices (2010: 129). The summarising of my argument into an easier and much shorter written format has been a surprising and rewarding process; not least because it offers a critique of the book itself, a way of commenting on it and beginning another discourse. The 'I' of the author becomes the more informal 'Matt': a source to be quoted or paraphrased. The author, therefore, becomes a subject, embedded in a further 'proliferation of meaning' that holds him to account (Foucault 1984: 110).

Of the many uncanny moments experienced at the Moth Ball, one stands out: where the author acknowledges his lack of previous *social* contact with persons with learning disabilities. The following lines from philosopher J.S. Reinders provide a valuable counterpoint to discussions of professionalism, standpoint, or artistic endeavour:

We cannot seriously maintain that we seek the inclusion of people with ID [intellectual disabilities] in their capacity as fellow citizens without considering whether we want to include them in our own lives as our friends. Or can we? The goal of inclusion ultimately raises not only a question for our agencies and organizations, but also for ourselves as human beings: namely the question of what we think of the good life for ourselves as human beings, and whether there is a place for people with ID in that life. I propose that this is the real challenge that people with ID pose for us, i.e., not so much what we can do for them, but whether or not we want to be with them. Ultimately, it is not citizenship, but friendship that matters. (Reinders 2002: 5)

Notwithstanding the uncomfortable (and dissonant) address to 'we', Reinders offers a profound and infrequently articulated insight: that social legislation alone, and even fairer redistribution of resources, cannot deal with the most fundamental questions of human companionship. Theatre, however, creates a space in which human proximities can be negotiated and redefined. Ultimately, the production of mimetic artefacts, displaying and critiquing the human condition in all its complexity, is *part of* the good life. Not only do learning disabled artists deserve a place in the human laboratory known as theatre, they have earned the right to critical review: in other words, to a poetics.

Part I
The Surrogate

1
The End of Disability Arts: Theatre, Disability, and the Social Model

The companies reviewed in this book are all, to varying degrees, subject to the discourse of disability rights, which has been prevalent in the UK and other parts of the world since the late 70s. This has been an emancipatory process seeking to uncover and dismantle the mechanisms by which all industrial societies operate an 'ableist' ideology: that is, the structures of thought and social organisation that validate able-bodiedness and high cognitive functioning as the validating ideal of humanity. In the first part of what follows, I introduce the reader to the changing definitions of learning disability. I then place contemporary performance in the context of identity politics, in particular the type advocated by adherents of the social model of disability and its cultural vanguard, disability arts. The role that theatre has played in the formation of a 'disability culture' is analysed, with underlying tensions between theatre as a mechanism for social emancipation and theatre as an art form considered. I conclude this chapter by considering such frameworks in the light of the burgeoning professionalism of theatre involving learning disabled artists and argue that the theories of art and culture based on the social model of disability are inadequate as a means to analyse work of increasing aesthetic complexity. I argue that a paradigm shift has already occurred in practice that is not yet reflected in its analysis. Whilst, as I demonstrate throughout the book, such theory has been available for some time, it has not been significantly applied to the rich seam of aesthetic collaboration between disabled and nondisabled theatre artists.

What is learning disability?

Mind the Gap's website announces 'powerful, bold, award winning theatre … Learning disabled and non-disabled artists working in

21

partnership' (mind-the-gap.org.uk). Australia-based Back to Back sug-
gests a more detached political vantage point:

> Back to Back's ensemble is made up of actors perceived to have intel-
> lectual disabilities, a group of people who, in a culture obsessed with
> perfection and surgically enhanced 'beauty', are the real outsiders.
> (backtobacktheatre.com)

A statement by Vanessa Brooks, Artistic Director of Dark Horse (formerly
Full Body & The Voice), implies the wish to transcend all categories:

> We actively discourage any dissection of disability beyond what is
> strictly necessary, focusing on the art, the performance and, most
> importantly, the audience. We aim to deliver productions which
> **engage, provoke** and **entertain** [their emphases]. We prefer not to
> define ourselves as a 'learning disabled theatre company' but as an
> exceptional producing theatre company at the cutting edge of con-
> temporary theatre. (www.fullbody.org.uk)

How does a learning disabled actor differ from an actor 'perceived to
have intellectual disabilities'? Linguistically this implies that one actor
possesses a disability whilst another is only *labelled* as having it, the
distinction being between learning (something one does) and intellect
(something one has). More radically, Brooke's overt rejection of learning
disability implies that the term is outmoded; her active discouragement
of 'any dissection of disability beyond what is strictly necessary' begs
the question: what is necessary and what is not? The definition of learn-
ing disability is clearly very important to these companies, but not in
the same way. For The Shysters, a UK company active between 1990 and
2008, it was both core *and* marginal to their practice. They said:

> [We were] happy to talk about a 'learning disability culture' and also
> feel we have made a contribution to it. However, learning disability
> is a label and as such something the company's actors frequently
> and understandably reject. Learning disability is central to our work,
> but we also want it to be invisible within it. (Quoted in Karafistan
> 2004: 276)

There is, then, an ambivalence about learning disability, suggestive of a
club to which few of its members wish to belong – or at least, of a club
in a perpetual tension about how to refer to its membership.

A similar inconsistency is prevalent in academic analysis. American philosopher Licia Carlson prefers to 'use the phrase "persons with intellectual disabilities" as opposed to "the intellectually disabled", foregoing the use of quotation marks 'for clarity's sake' but recognising that they are far from 'self-evident [...] or unproblematic terms' (Carlson 2010: pre-contents). British disability theorist Dan Goodley reverses the link between impairment and classification, noting that 'social structures, practices and relationships, continue to naturalise the subjectivities of people with "learning difficulties", conceptualising them in terms of some *a priori* notion of "mentally impaired"' (Goodley and Moore 2002: 211). This view is in keeping with the UK social model that argues that there is no such thing as mental impairment; rather, there are social practices, which create the *idea* of impairment.[1]

'Learning disability' entered classificatory vocabulary, in the UK, in the 1990s with the introduction of the Community Care Act. Prior to this, since the formation of the NHS in 1948, 'mental handicap' was the designated term, which, until 1959, was indistinguishable from 'mental health'. The World Health Organization defines learning disability as 'a state of arrested or incomplete development of the mind' and cites three diagnostic criteria as integral to it: IQ; social/adaptive dysfunction; and early onset (www.bild.org.uk). The British Institute of Learning Disability (BILD) estimates that 985,000 people in England have a learning disability (2% of the general population) though they believe this to be a conservative figure. Similarly, the Department of Children and Family Services in 2006 reported 2.6 per cent of the school population as having Special Educational Needs (SEN) (ibid.). So too, there is much debate about the use of the differing terms 'learning disability' and 'learning difficulty', the latter a term preferred by the international advocacy group, People First. BILD suggests that the distinction can be made on the basis of quantity or severity. For example, someone with dyslexia might have a specific difficulty but not qualify – or wish to identify – as having a general impairment in intelligence. This 'quantity' approach is reflected in the SEN statementing system that rates learning difficulty on a sliding scale: moderate, severe, and profound.

Foucault uncovered the mechanisms by which institutional practices defined 'disciplinary subjects' such as the mad and the deviant, so that 'penitentiary technique and the delinquent [became] in a sense twin brothers' (1979: 255). Licia Carlson, who applies Foucault's methodology to what was once called 'feeblemindedness', notes that 'within the complex institutional world, intellectual disability was both found and made, knowledge was remade and reported, patterns were recognized,

invented, imposed' (2010: 22). By the late nineteenth century, language had become underpinned by the science of eugenics, which sought to objectively quantify degrees of deviation from the human norm, and operated via two core methods: IQ testing and incarceration. The history of what we now refer to as learning disability has reflected the parallel story of the rise and fall of the 'total' institution, a story that only concluded in the 1970s and 1980s with the closure of Britain's long-stay hospitals. Carlson distinguishes between four sets or 'conceptual pairs' that have helped to define what is now called learning disability: qualitative/quantitative; organic/non-organic; static/dynamic; visible/invisible. I will summarise each of these briefly.

From the mid-nineteenth century onwards, mental retardation was classified in different ways, with phrases like 'idiocy or imbecility or fatuity [...] [referring to] grades and shades of mental states below the normal standard of human intelligence' (Carlson 2010: 30). The belief that learning disabilities can be reduced to a particular *quantity* – 'less or more' of human capacity – is 'in part, what has allowed for the infantilisation of this condition' (ibid.: 29). By forming a subject as one inherently *lacking* in developmental stages, that subject becomes a perpetual child; or rather, childhood becomes the only reference point for describing the intellectual status of the subject. This allowed for the anomalous creation of a status problematically positioned between adulthood and childhood. Yet to regard the classification as purely quantitative would belie the qualitative distinctions often made. The strong racial element to such distinction is obvious in Down's own classification of the syndrome he founded: 'Mongolian Idiocy'. So too, the qualitative difference was often betrayed in language that referenced idiocy as animalistic or subhuman: not part of a human continuum but wholly outside it.

Carlson's second organic/non-organic binary reformulates the nature/nurture debate. In classifying learning disabilities in the nineteenth century, there were two simultaneous drives: the need to create medical objects and the need to create conditions for dealing with them. The dominance of the therapeutic or pedagogic models, where individuals could be trained in tasks, gradually gave way to a concern for how environment *caused impairment*. As soon as genetic causal links became dominant, the fault was to be found in families. Eugenics and environment began to inform each other, feeblemindedness becoming linked to social deviance, thus encouraging 'cure' and sterilisation rather than improvement or therapy. Carlson's third binary is the tension between degrees to which intellectual impairments were improvable/curable

(non-static) or fixed and incurable (static). Here, there is no obvious correlation between the *quantity* of impairment and the perception of improvability. Rather, the fear of social depravity informed the ways in which treatment was organised. For example, at one time, the classification from 'severe' to 'mild' was thought to progress from 'idiot' to 'imbecile' to 'feebleminded', with those at the highest grade of ability the most amenable to improvement. By the turn of the twentieth century, however, the medical/reformist establishment began to propagate the view that those most able – the 'merely' feebleminded – actually presented the greatest social risk: because they were able to move about in society, relatively undetected, such 'types' could spread 'bad' genes and contribute to crime and deviance. The ground shifted and such subjects were thought to be beyond cure; thus segregation and sterilisation became more prominent than education or training.

The final conceptual pair Carlson cites is that of the visible/invisible. On the one hand, the growing number of residential institutions sought to render the class of peoples defined as mentally retarded, invisible from society. Within the walls of the institution, however, a kind of hyper-visibility operated, the professional's 'normalising gaze' boring into every aspect of a person's life, defining them in new ways as new types of human or sub-human subject. The IQ test moved the goalposts. As soon as testing became prevalent at the start of the twentieth century, a new form of feeblemindedness was created: that of the moron. The moron was able to act outside the walls of the institution, camouflaged by his/her outward normality, to an even greater extent. The growing obsession with intellectual impairment *as criminality* upped the stakes of testing. Binet's IQ tests shifted the diagnostic framework from visible defects to the invisible quantity of intelligence: in other words, to a capacity that could be recorded and scored. A person's physiognomy, will, and intelligence were thus narrowed down to just one: intelligence; and the IQ test was put to work in rooting out the moron. In a very real sense, then, learning disability became defined by the tension between that part of it which could be seen and that which remained hidden.

The binaries interrogated by Carlson are, I argue, directly relevant to the field of theatre and learning disability. This is because theatre, as a corporeal art form, renders such tensions visible; and where many of the 'harmful' definitions have been officially rejected, tensions remain. The relative visibility of people with learning disabilities in the social realm today can be set against their relative invisibility in culture. And when they *are* visible in culture, it is useful to think of the painful

history that is revealed or concealed in that process. Progress from test-ing to incarceration, to humanitarian reform, to de-incarceration and thus to community inclusion is not unproblematic, as was evidenced by the results of the 1971 Government White Paper, 'Better Services for the Mentally Handicapped'. This directive overhauled the long-stay system, yet 'Care in the Community' – as the UK process of deinstitu-tionalisation became known – failed to advance the living standards of the vast majority of ex-hospital inmates; and the 'Longcare' scandal of the mid-90s – involving the systematic rape and torture of residents – demonstrated the lack of accountability in new residential establish-ments. The 2001 Government White Paper, 'Valuing People', was an attempt to re-think the entire system of care and representation. To a large extent the practice now referred to as theatre and learning disabil-ity was only made possible by the move from large hospitals to smaller and semi-independent accommodation. Thus, Goodley and Moore can note that 'increasingly opportunities for participation in performing arts are seen as an exciting alternative to traditional care provision' (2002: 4), with art practice another way of being actively engaged in the good life.

In sum, therefore, learning disability is a heterogeneous and unstable category. It has never been a unified classification and has never been resident in any one field of knowledge. Unsurprisingly, it sits at the axis of medical, educational, moral, and political discourses. Indeed, the concept of competing discourse is axiomatic to my analysis of learning disability and theatre arts. I argue that, until quite recently, the domi-nant discourses within theatre and learning disability have been those of psychology (therapy), pedagogy (social learning), and politics (thea-tre with a rights agenda). Whilst questions of aesthetics have always been present, it is only relatively recently, in the past 10–15 years, that they have risen to establish themselves as uncontainable within other categories. As a consequence, I argue, the theatres of learning disability are ideally placed to interrogate the meaning not just of disability but of classification itself. As Tobin Seibers notes, 'the presence of disability creates [...] the opportunity to re-think how human identity works. I know as a white man that I will not wake up as a black woman, but I could wake up as a quadriplegic'. For this reason 'ablebodiedness is a temporary identity at best' (Siebers 2008: 5).[2] Whilst I do not sug-gest that one can 'wake up' with Down's Syndrome, I do argue that such a 'condition' is not neutral or stable; similarly, one can, whether gradually or suddenly, experience changes in cognition that deconstruct 'normality'. I allow the term 'learning disability' to act as a multi-layered signifier: one that alludes to actual impairments that are both

physiologically real, and alive with aesthetic potential; and active as a metaphor for meanings that may be at once disavowing and powerfully transgressive. I recognise that for many theorists and learning disabled persons, some of the ideas will be difficult, perhaps even offensive. This, I think, is a necessary risk in the attempt to make sense of an important, diverse, yet to date insufficiently considered aesthetic practice.

What is disability arts?

Disability arts is: an art practice that addresses the oppression of the disabled person; a mechanism for self-advocacy and self-governance; the cultural vanguard of the social model of disability; a cultural weapon to be wielded against the twin oppressions of mainstream culture and therapeutically aligned art; and a component in the struggle towards emancipation for disabled people. Disability arts grew out of the British disability rights movement of the 70s, and built itself through the 80s from a position of extreme marginality. It consolidated itself through the 90s in publicly funded regional forums, reached its apotheosis in 2003 in an Arts Council report, 'Celebrating Disability Arts', and promptly fragmented into contested pockets of practice, which may constitute a final demise. Whilst it has ceased to be a 'movement', it nevertheless remains a touchstone for a substantial body of ideas about what constitutes art, disability, and society, and an understanding of the relationships between the three.

A highly prescriptive, even Leninist, strand of thinking has always been part of the movement, summed up in 1991 by Sian Vasey, a founder of Disability Arts Forum (DAF):

> I think we should be adopting some sort of policy with artists who initially don't address the subject [disability] at all. We should be running some sort of education programme and then watching to see how they develop and if they don't perhaps we should be dropping them from the employment circuit. As a political organisation can DAF really mess about with arts for art's sake, or do we have to [embrace] as many disabled people as possible? (Vasey 1991)

For the artist to qualify for disability arts support, in 1991 at least, she had to be educated up to a proficient standard in political awareness. As Alan Sutherland noted, 'Disability Arts would not have been possible without disability politics coming along first. It's what makes a disability artist different from an artist with a disability' (1997: 159).

The distinguishing of artists *with* a disability is linked, in theorist Colin Barnes's view, to the 'tragic' perception of 'great' art, in which the individual overcomes their 'burden' to create something of lasting universal significance. Since impairment is linked to the dominant Western idea of artistic genius – tortured, disfigured or impaired (Beethoven, Kahlo, Van Gogh) – an artist *with* a disability can never be someone who fully identifies with an emancipatory social movement. Or put another way, there can be no Kantian disinterest in disability arts since it is primarily a form of advocacy (see Barnes 2008).

The disability arts movement was a challenge to negative representations of disability and judged efficacy on art's capacity to 'mobilise disabled people into action' (Hevey 1991). For Vic Finkelstein and Elspeth Morrison, the movement allowed an elite vanguard of activists and theorists to evidence that they were not 'out of touch' with the mass 'who were still prevented from controlling their own lives' (Morrison and Finkelstein 1991). Disability arts fulfilled the purpose of swelling the ranks, vindicating the actions of the elite, and of creating a more dynamic sense of *communitas*. The impact of disability arts was primarily one of social cohesion: attendance at events and festivals, often following the cabaret structure, that allowed disabled people to 'come together of their own accord, rather than being herded to a day care centre, hospital or the yearly panto' (ibid.). Finkelstein and Morrison maintained that grants by nondisabled organisations had 'for too long [emphasised] educating nondisabled people how to understand us' and 'helping them to become better and more understanding human beings [...] rather than communicating with each other' (ibid.). By contrast, the disability arts movement maintained that the only permissible art was that evidentially owned, controlled or performed by the disabled artist. 'What is happening', said David Hevey at the same conference in 1991, 'is that nondisabled people are getting rid of their fear about the loss of labour power and other elements in narcissism [...] the point I am making is that disabled people are the dustbin for that disavowal' (ibid.). In answering the question of what to *do* about this disavowal, the movement formed, and was informed by, a number of influential theoretical ideas. I want to summarise some of these core underpinning theories and to suggest that, whilst vital in their time, they have become inadequate as a means of critiquing theatre collaborations between disabled and nondisabled artists.

The social model of disability

It is not possible to fully grasp the philosophy of disability arts without first understanding the social model of disability, which has been the

dominant discourse in disability politics since the 1970s. The social model is defined most clearly by what it is not: it stands in binary opposition to the 'medical model of disability', which is sometimes referred to as the 'personal tragedy' or 'individual' model of disability. This model places the burden on the individual and presupposes that disability is a 'problem'. The 'medical model' thus became a unifying symbol of ableist society, a 'normative' construct that does things *to* disabled subjects rather than *with*: a society dominated by professionals who unquestionably regarded disability as a deficit. By contrast, the social model, as practised in the UK, roots all critique in the hands of disabled people themselves, working from a disability rights agenda: disability is not medical impairment but social oppression. The social model distinguishes between impairment (individual) and disability (social), and places emphasis on the overcoming of environmental and social barriers. To give a concrete example of how the social/medical binary operates in practice, imagine a candidate 'X' who is applying for a place at drama school. She is diagnosed as autistic, which, from a medical perspective, is an innate cognitive condition that cannot be 'cured' or altered. As a consequence of the condition, she finds it difficult to engage in big group activities and to memorise large sections of text. From a medical standpoint, she would have to adapt to meet the expectations of the curriculum, and overcome her challenges. Medical or therapeutic processes might help her but only on the understanding that she has 'a problem'. Conversely, the social model would argue that the barriers 'X' faces are environmental and social: it is not 'X' who has the problem but the drama school. 'X' is disabled not by her autism but by the disabling attitudes and restrictions placed on her by society. Utilising the social model would lead to the demand for the school to radically alter their curriculum, their class sizes, and the expectations placed on students to memorise text. To follow this to its logical conclusion, it might then be insisted that the aesthetic ideologies underpinning the training be analysed so that the curriculum be fully representative of disabled themes, content, and forms. In short, it is not for 'X' to fit in, but for the school to fit around her.

In recent years, whilst acknowledging the material and legislative gains made by the social model (Disability Discrimination Acts 1996/2003), some theorists both within and outside the UK disability movement have unsettled its foundations. These critiques have ranged from broadening the scope of the model to encompass more complexity (Thomas; Reeve); to 'former believers' leaving the faith (Shakespeare); to philosophers who cite the social model as a modernist discourse that must be supplemented by post-identity politics exploring the 'fluidity

of all forms of categorisation' (Shildrick 2009: 170). It is important to acknowledge that these debates are highly contentious and give rise to passionate defence and counter-claim (see Sheldon et al. 2007). What is at stake here is the very future of disability politics. In what follows I consider two significant issues arising from this debate.

The first problem with the social model, in its strongest social constructionist form, is that it identifies disability *purely* as a form of oppression. For Tom Shakespeare this means that the model does not allow analysis on the basis of impairment; indeed, attempts to address or mitigate the consequences of impairment will be met with suspicion (2006: 32). The only thing that matters to advocates of the model is the oppressive social process known as 'disability'. Impairment is often not recognised in the social model, the assumption being that eradication of oppression will make impairment irrelevant. Returning to our hypothetical case study, the 'designated impairment, autism, of 'X' need not be a factor in a discussion of her disability. Yet, this does not necessarily help 'X', who may be confused about how to establish the support she needs. The problem is that if disability is oppression then *anyone* can be disabled, regardless of impairment, because anyone can be oppressed by society's attitudes. If the predicament of 'X' is reduced to one of attitudinal barriers, then autism too is reduced: effectively, once the barriers (curriculum, class size, and so on) have been removed, it *disappears*. The social model does not address this: it is assumed that the erasure of oppression will render her impairment unproblematic. As Shakespeare has argued, this sidelining of impairment reduces the complexity of biological realities. Arguably, the situation of 'X' is made more complex by the relative invisibility of her autism. The removal of barriers is clear in the case of a wheelchair user, but less so with someone who is not visually marked. 'X', due to her impairment, might fail to pick up on social cues from casting directors who are not aware of her condition. In short, barrier removals do not successfully contest 'the underlying attitudes, values and subconscious prejudices and misconceptions that figure an enduring, albeit often unspoken intolerance' (Shildrick 2009: 5).

A second problem with the social model is the way it constitutes itself *against* an opposing model. The overarching binary distinction leads to other binaries that have become increasingly problematic. As Carol Thomas and Donna Reeve have demonstrated, there cannot be a polar dichotomy between impairment and disability because of the 'psycho social aspects of disablism' (Thomas 2007: 2). This refers to the process whereby social interaction affects the perception and meaning of impairment. People are not disabled purely by societal structures but

by infinite mutations of social relations, which influence impairment and vice versa. The autism of 'X' may change the way she is perceived. Some of her fellow students may have limited knowledge of the condition and assume that it renders her incapable of engaging in social interaction. This may affect her in complex ways, none of which can be anticipated by the removal of formal barriers. The binary problem is most notable, however, in the interplay between disabled and nondisabled persons. For the social model, nondisabled persons will *always* be an *a priori* oppressive entity, because they embody the normative values of an oppressive society. But it is much more complex than this. 'X' may well receive appropriate support from some tutors and less from others: 'to define disability entirely in terms of oppression risks obscuring the positive dimension of social relations which enable people with impairment' (Shakespeare 2006: 57). Another way of framing such a relationship is through the process of advocacy, which has positive and negative potential:

> Allies, advocates, assistants and interpreters seem to lose their status as non-disabled people, enjoying the temporary privilege of membership of the disabled world. (2006:194)

This highlights the blurring of formal categorisation that occurs when people work together to try to achieve common goals. Yet Kathy Boxall suggests that all such relationships belie the power dynamics at play. She points to the fact that people with learning disabilities frequently lack 'recourse to "higher authority"' when they disagree with those who support them' (Sheldon et al. 2007: 228). Boxall does not propose a solution, however; rather she reinforces the idea that all relationships between disabled and nondisabled people will always exist under the shadow of exploitation.

Fundamentally, therefore, the philosophy of disability arts is based on a conception of identity politics in which disabled people identify collectively as a unique social group bound by oppression. Swain and French's 'affirmation model' (2000), which aims to extend the social model further into the cultural realm, focuses on the need for a disabled person to feel a sense of pride; to reclaim identity as something validating, not stigmatising. The affirmation model shapes the identity of the disabled person according to the following criteria: adherence to the social model; being part of a campaigning group; the expression of 'frustration and anger' through collective means; challenging negative imagery through art; challenging exclusion; and a commitment to a

revolutionary as opposed to a revisionist vision of society. Whilst rooted in a passionate commitment to social justice, this model is lacking in the means to theorise collaborative theatre of increasing aesthetic complexity. Once again, I cite two issues of utmost relevance to theatre and learning disability.

First, the affirmation model assumes that there is a singular definition of disability identity that can be judged objectively. It presupposes that that all disabled people will want to subscribe to this. Take 'X', again: on completing her drama degree, and entering the job market, she may face continual challenges to her identity. She may wish to identify herself alternatively as a 'disabled actor', as 'an actor with autism', or as an 'actor with a learning disability'. She may, on the other hand, wish to identify herself as simply an 'actor'. Were she to make this last choice, she would effectively be barred from 'membership' of the disability rights movement. The affirmation model does not allow for the construction of individual or 'hybrid' identity or, indeed, complex identity shifts: the model does not allow a person to identify as disabled at some times and not at others. Equally, the notion that 'X' might engage in different kinds of acting work, sometimes being employed in a mainstream soap – in which her impairment is not signified – and at other times in disability cabaret – in which her impairment is the focus of the work – cannot be addressed in this model. It assumes that a disabled person is someone who will always identify as oppressed, proud, or angry and who will view disability as integral to their art. Their disability is a very literal sense, *who they are*.[3]

Second, the affirmation model perpetuates opposition to nondisabled intervention. As one scholar has suggested, this opposition

> [in] terms of identity [...] leaves no scope to deal adequately with those who cross over between disabled and non-disabled worlds, or those who inhabit a liminal space. In terms of politics, it lends itself to a separatism, which closes off many doors to coalition and transformation. (Humphrey 2000: 81)

The affirmation model affirms not openness to new enquiry and collaboration but rather a discreet, separatist agenda, which perpetuates exclusion. It renders the disabled person a victim of nondisabled oppression and makes coalition if not impossible, then clearly highly problematic. In fact, 'mainstream' coalition becomes the precise problem. Tom Shakespeare's most controversial attack is on the kind of

'victim mentality' such theories perpetuate, and includes not only non-disabled oppressors but those disabled people who succeed:

> If some disabled people have achieved their goals [...] then this undermines the victimhood analysis. For this reason, it becomes important to disown or condemn the 'tall poppies' who have succeeded. (Shakespeare 2006: 80)

If 'X' were to go on to become a professional actor with a career in mainstream film and television, even perhaps acquiring celebrity status due to her self-avowed impairment, advocates of the affirmation model might view this development with suspicion. Her embracing of a position in the mainstream would be seen as a disavowal of her disabled identity and even as an example of false consciousness.

What both social and affirmation models risk, therefore, is the systematic closing down of identity options for disabled artists. As one commentator said of disabled performer Mat Fraser (AKA 'Sealboy'): 'the disability community should completely excommunicate him for participating in the mainstream to the degree that he does' (Darke 2004). That which features the collaboration of nondisabled artists must, *de facto*, be unworthy of the name disability arts. The tension is summed up by artist Ju Gosling:

> [S]ome communities of disabled people, particularly people with learning difficulties, benefit from having their work facilitated by non-disabled people/disabled people from different impairment groups. Whether or not this is defined as being Disability Art depends on whether disabled people are enabled to have the greatest possible control over all aspects of the activity (though this is more often NOT the case). (Gosling 2006)

It is not simply that for disability arts 'ownership' of the work is the ultimate criterion, but that for much of the time this criterion is 'NOT' met. It is almost as if failure is built into the collaboration between disabled and nondisabled artists from the outset. In the early days of the disability arts movement, David Hevey promised that attempts to 'affect the taste of nondisabled audiences' would end in stagnation and failure, since only an alliance to the cause of 'political creativity within the disabled struggle' could bring about aesthetic 'change and growth' (1991). What is striking is how strongly this view has persisted, as

evidenced in attacks on artists like Matt Fraser. It is a position that still underpins much criticism of the work of learning disabled artists and their collaborators today.

Applied theatre: all the marginalised of the world

Most of the companies whose work I consider make theatre that spans a concern for social justice and promotes healthy recreation, participation, *and* aesthetic innovation. The work, therefore, has exceeded most of the narrower definitions of disability arts. Heart 'n' Soul, however, registered disappointment in 1997 that they did not meet Arts Council criteria for 'new art': their work was regarded primarily as an extension of the social care system.[4] Yet the theories of disability arts or the social model would not have provided a critical framework for arguing their case. The precise point of disability arts is to remain *outside* the mainstream, to remain pure, 'angry and strong'. Heart 'n' Soul's forays into 'mainstream' performance were condemned by disability activist Paul Darke as: '"heroic works" that assert the potential normality of disabled people to fit in [...] Non-disabled people love this "overcoming their disabilities" kind of performance' (2003 online version).

To date, there have been two broad approaches to thinking about theatre and learning disability: either the work has been seen as the therapeutic application of drama (Cattanach 1996; Chesner 1995); or it has been viewed through the lens of varying types of 'social' or 'emancipatory' theatre (often known as 'community', 'participatory', or 'applied' theatre). This second perspective seeks to empower the group more than the individual through a process of *communitas*: the process by which a group coheres around a specific political or social issue, to develop a greater sense of empowerment and confidence in social change. This position often stands in opposition to the therapeutic perspective, which is criticised by applied theatre practitioners as perpetuating a 'pathology of need' (Bayliss and Dodwell 2002: 46) and creating a dependence of client on therapist. These opposing perspectives within the applied arts field mirror to some extent the binaries of social and medical. However, a third kind of practice – the production of professional mid-scale touring work – has developed over the last 10–15 years. Often defined as 'arts and disability' rather than disability arts, it has gradually outgrown the above theoretical models, leaving the work of these artists in a strange critical limbo. To be exact, companies like Back to Back, Dark Horse, Mind the Gap, and the Shysters have, in very different ways, sought to create theatre that aspires to be

funded, judged, and critiqued in and of itself, rather than as a form of social benevolence. Furthermore, the similarities between therapeutic and participatory approaches have become apparent, so that the 'enormous [...] benefits of participation' are highlighted far more than the resulting aesthetic product (Goodley and Moore 2002: 5). I regard the relationship between art and therapy as highly contentious, since it has, in the case of learning disabled people, conflated the creative drive with sickness and reinforced a view of such persons as inherently in need of rehabilitation. Another book would, however, be required to do justice to this subject.[5] Rather, in what follows, I concentrate on a different but equally problematic perception, evidenced by disability arts' critical framework, that *all* interventions by nondisabled practitioners must be inherently exploitative. This has translated into a concern within applied theatre for an ethics of practice that, I suggest, often runs counter to the interests of both learning disabled artists and their nondisabled collaborators.

'Applied theatre' is a contested term used increasingly to describe work 'orientated towards aspects of social change, personal development and community building through various forms of participation in drama [...]'.[6] Such practice currently evidences a deep-rooted anxiety: that the presence of nondisabled professionals is an innately oppressive force; and that the work of theory is to foreground and monitor it. At a symposium at Central School of Speech and Drama organised by *Research in Drama Education* (*RiDE*) (2007) comprising academics and practitioners, I was struck by three recurring themes: that nondisabled artists felt a sense of perpetual anxiety about their role, largely due to the power imbalance between them and the participants they worked with; that all the ideas within and about the work created must evidentially be those of the participants (or else the work became invalid); and that the work must not be a copy or an imitation of a 'nondisabled form'.

Perhaps for reasons related to the therapeutic or medical gaze, disability arts has been resistant to the idea that its work should fit 'participatory' models of practice (see Conroy 2009). The discourse around theatre as a means of relaying disabled identity has, however, increasingly come under the growing umbrella of applied theatre, and in a review of *RiDE*'s themed edition, disability theorist Alan Roulstone (2010) made two astute observations regarding the conjunction of disability politics and applied theatre. First, early orthodoxies of the social model (Morrison et al.) have not been appropriately challenged, leading applied theatre theorists into a cul-de-sac: that of an outmoded binary between disabled and nondisabled identities. Second, he proposed that

theatre itself could be a 'protagonist' in a journey towards a more ena-
bling society, rather than a practice, required to meet the strict political
orthodoxies of a grounding theory. Roulstone's meaning, as I interpret
it, is clear: theatre theory needs to be supple and reflexive to meet the
new challenges of a developing aesthetic practice and a shifting under-
standing of disabled identity.

Certain strands of applied theatre express both a critical inattention
to and a denial of performance itself: that is, 'the run, the production
"open for critical review"' (Schechner, quoted in Schinina (2004: 28).
For Guglielmo Schinina, an Italian practitioner and scholar, the per-
formance must always be a singular, unrepeatable event, 'reflecting
the growth of the group', rather than the 'socioeconomic structure of
theatre' (ibid.). Schinina argues that enmeshment in the structures
of theatre – as evidenced when 'handicapped persons [...], people with
psychiatric disorders [...], prostitutes and "freaks" participate together
with professional actors in commercial theatre shows' (ibid.) – must be
avoided. Here, the possibility of collaboration between disabled and
nondisabled artists towards repeatable performances is rejected on two
counts; it is inherently exploitative and privileges the chosen few:

> Only the best (of the nonprofessional marginalized actors) go onstage.
> The others are left home. The success and the progress of the ones
> who were so lucky and so good to become real artists are exalted while
> all the others who live in similar conditions are forgotten. But they
> are as able as or even more able than the others who reached the stage
> to do what they do and to be what they are. Why should the joys, the
> emotions, the successes touch only some of the marginalized of the
> world? (Bernardi 2001, quoted in Schinina 2004: 28)

Schinina's concern is that by validating the participation of socially
marginal performers in professional systems, the system itself perpetu-
ates the 'creation of a new professional who the audiences pay to see
and who receives prestigious awards for being the "different" one who
can act "normal" or "better than normal"' (ibid.). My concern with
such an argument is that it invokes a dogma that excludes a person
who, legitimately, wishes to extend their talents. In parallel with the
affirmation model, Schinina's 'handicapped person' is defined wholly
by their marginalisation and by their affiliation to the set known as
'disabled'. They have no individual identity and must forgo their own
ambitions. When Bernardi speaks of others 'who are as able as or even
more able than [she] who reached the stage', he is invoking a utopia in

which everyone has, not just equal rights, but identical talents as well. It is only the 'marginalized of the world' who are equally talented in this utopia. For the argument to be valid, the entire population would have the right to win *The X Factor*. When Schinina pleads, 'Do not exploit them for *our* own aesthetic purpose' (ibid., my emphasis), he is eradicating the possibility that 'they' have an aesthetic purpose or that such a purpose can be arrived at by collaborative means. In one linguistic stroke he has denied 'them' aesthetic agency.

Another kind of tension in applied theatre is expressed by Fran Leighton in a reflection upon her own role as director of a research project that culminated in a devised performance project named *BluYesBlu*. She reports struggling 'with being receptive to the contributions of all the devisors and resisting the strong desire to develop and structure the "random" material into a recognisable performance which would meet the expectations of the audience and examiners' (2009: 103). What is at stake is the role of the nondisabled person as director. Leighton worries not only about shaping the performers' own material but about insisting that everyone attends rehearsal:

> I was caught between a strong desire to encourage a 'recognisable' theatre practice and a suspicion that trying to organise the devising around concepts of 'responsibility', 'commitment' and 'respect' for the work would be an imposition of normative behaviour. I was aware of the expectations of theatre practitioners and audience and for the consequences of disappointing these expectations. In [Judith] Butler's terms, I had maybe reached the limit of a 'scheme of intelligibility' and I questioned whether I was mediating the performers' work into a normative framework [...] Eventually as I 'allowed' a relaxation of the concepts of responsibility and commitment a more fluid, flexible, spontaneous way of working emerged. (Leighton 2009: 106)

I am struck by the use of quote marks that wrap around terms like commitment and respect. It is as if the presence of learning disabled performers has caused the author to view all her accepted values as contingent and negotiable, to worry that by insisting even on rehearsal attendance she is enforcing something harmful. Leighton's self-analysis is lacerating, caught between twin fears of normative convention and 'othering': that is, by invoking what another author has called 'counter-cultural fascination with "intuitive anti-performance"' (Perring 2005: 181). Leighton settles on a 'postmodern' form, ranging from physical

theatre to film fragments, to realistic autobiography, maintaining a commitment to allowing the participants to express themselves in their own way, rather than 'in "normal" ways (possibly failing)' (Leighton 2009: 105). A counter-argument to this is that learning disabled persons have as much right as anyone to have their work criticised. Without acknowledging this, disabled performers are *denied* the right to fail, and to learn through this failure. The inherent tension is the degree to which placing unrehearsed, spontaneous, and partly improvised performance on a public stage reinforces societal misconceptions about learning disability: for example, about ineptitude or the absence of individual agency. One member of the audience stated that the performers 'revealed their own good fortune to themselves' (ibid.: 109) – meaning that they felt lucky to be nondisabled – and some 'associate[d] it with therapy and therefore not audience worthy' (ibid.). Rather than claim, as Leighton does, that 'success of the performance can be viewed as an immediate improvement in the situation of learning-disabled people' (ibid.: 111), one might equally argue that the work reinforced stereotypes of incompetence, absolute otherness, and allowed spectators to feel relieved at their own 'ability'.

Both these examples amplify theatre as an inherently ableist institution, presupposing that learning disabled performers must be kept outside, for their own good, or else that it must be radically overhauled. If theatre *is* practised, where possible the form it assumes should be counter-cultural: that is, a non-copy of a normative original, non-realistic, and disavowing of any form that makes it difficult for a learning disabled person to express themselves 'naturally'. Goodley and Moore underscore this, linguistically, in the title of their book: *Disability Arts against Exclusion: People with Learning Difficulties and their Performing Arts* (2002, my emphasis). This presupposes that theatre, or performing arts more generally, can belong to a single identity group. Theatre, on the contrary, is a multi-form aesthetic that 'belongs' to anyone able to use it. To be clear, on the evidence of the diverse practice analyzed in this book, there is no learning disabled theatre – only theatre. The learning disabled actors who collaborate with nondisabled artists are part of that theatre.

Is disability arts worth paying for?

In 2007, disabled comedian Liz Carr guest-edited *Art Disability Culture* (Issue 198), a magazine she had, she admitted, given up reading due to new subscription charges: 'It was good', she acknowledged, 'but was it really worth paying for?' (Carr and Watson 2007: 4) Echoing this,

she asked in her editorial, 'What is good Disability Art?' These questions were mirrored in an article, titled 'Disability Arse', by performer Matt Fraser (ibid.: 5–6). Whilst acknowledging the safe and supportive environment that the disability arts circuit provided for many burgeoning artists, Fraser felt that 'some of what passed as disability art should never have been allowed on stage' (ibid.: 5). The general public were increasingly invited to such events and, for Fraser, this open access and increased visibility changed things:

> Please let me be clear what I mean: I really love any disabled person having a go at performance, I love material that will only be interesting to the DA insiders' crew and I will always support people's attempt to have a go, as long as it IS only for the aforementioned DA insiders. However I know of no other group that so allow untalented people onto a public stage to entertain and indulge their inability to perform. And I don't think it's healthy, sorry. Why am I so harsh? Because dammit, 'they' – the normal people, the mainstream, the misunderstanders of what we do – all think we're crap. 'They' think that what we do isn't art at all but is in fact angelic therapy to calm our traumatised bodies and minds from the torture of impairment, etc, etc, etc. Watching crap people be shit on stage is only going to reinforce that view! (ibid.: 5–6)

Fraser's polemic is rooted in his experience as someone who self-confessedly moved from 'political ranting dressed up as performance' (ibid.: 6) to professional employment. Ironically, the tensions about quality were flagged up by the uncompromising Sian Vasey as early as 1991, who felt that the movement risked putting itself 'in a limiting corner by spending so much time and energy on providing performance opportunities [...] to acts which are never likely to be any good' (Vasey 1991). This proves that, at the inception of disability arts, quality could be part of the agenda as much as political efficacy.

The tension between 'having a go' and 'doing it for real' is another echo of the amateur/professional binary that shadows this theatrical field. Fraser's carefully structured polemic is part of a wider discourse about the move of disability artists towards engagement with nondisabled audiences. For Richard Tomlinson, co-founder of Graeae theatre company, the act of performing in front of a 'passive, captive crowd' gives disabled performers an ability to clear away the negative stereotypes, particularly those of submission and acquiescence (Tomlinson 1982: 11–12). But tensions arise in the pursuit of 'quality'. As Conroy

notes of her time as Associate Director with Graeae, the 'injunction, "look at our work" turned into an injunction to look at us as *professional*. That got us jumping through hoops and participating in all sorts of exclusionary practices' (Conroy 2009: 7). She notes for example that Graeae's 'professional programme specifically excluded artists with learning disabilities' (ibid.) and that in a bid to stand against the mainstream, the company was forced to pursue conservative aesthetics for the sake of 'quality'. Nowhere is this tension more keenly felt than in the realm of theatre involving learning disabled artists. The complexity of what constitutes 'conservative' or 'oppositional' is thrown into sharp relief here as actors have embarked on long-term training programmes to become professional at the risk, in some eyes, of destroying their essential 'authenticity'. There has always been the question within disability arts as to who the audience should be. For disabled author Alan Sutherland, in 2005 it was clear-cut: 'The primary audience of disability arts is other disabled people. We don't feel that our work has to be ratified by the approval of a mainstream, able-bodied audience' (2005 online). For others, it is a 'popular misconception that Disability Arts is aimed primarily at a disabled audience [...] Initially, only disabled people were interested in the work. And the only opportunities disabled artists had to present their work was [sic] in segregated settings' (Gosling 2006). Clearly, the identity of the audience has been, and continues to be, a highly contentious issue.

In December 2007, six panellists from the world of arts and disability met at Tate Modern to debate the question of whether disability arts, as a category, should be discontinued due to the tendency for such art practices to be increasingly rooted in the mainstream. The vote to maintain the category was carried by 99 per cent. A dissenting voice, Alan Holdsworth (aka 'Johnny Crescendo'), founder of the People's Direct Action Network, felt that the move towards the mainstream had 'diluted the content of the work [...] [and allowed] venues not to take disability arts that seriously' (Carr and Watson 2007: 10). Earlier in 2003, however, Paul Darke had sounded the death knell, arguing that the disability arts movement had 'sold out' to the mainstream; that the last vestiges of the form were being atomised by increasing numbers of disabled people taking administrative jobs. He also noted those 'artists with hidden impairments who succeed through the suppression of their own identities or merely offer themselves as [...] modern day freaks' (Carr and Watson 2007: 14). This is evidence of the prevalence within disability arts for a perception of identity based wholly on the experience of disability as oppression.

The end of disability arts and the sharing
of a hidden secret

Such conflicts of mainstream and margin came to the fore once more in discussions concerning a series of events under the umbrella of *Unlimited*, a cultural Olympiad project that commissioned 29 pieces of work by disabled artists (July–September 2012). One project offered as part of *Unlimited* was *Creating the Spectacle!*, a series of performances by artist Sue Austin in her self-propelled underwater wheelchair. In the film that accompanied the project, Austin can be seen preparing for and executing her dive into the Red Sea, harnessed to her wheelchair. As she explains:

> The focus of the project has shifted from being about transforming preconceptions about the wheelchair to a more global perspective – that we all have issues to transcend to give people a sense that 'if you can do that I can do anything'. I'm hoping for other people it'll push them outside the box because the whole project is completely outside of the box [...] I'm arguing that the wheelchair is a portal that pushes me through into a new level of awareness [...] conceptually, physically, emotionally. (www.thespace.org/items)

This statement is in direct antithesis to disability arts' founding agenda: Austin embraces rather than rejects the notion that the disabled person has something to 'teach' normative society. She validates an 'over-coming' narrative in which the disabled artist pushes the viewer into considering their own limits and capabilities. The goal of the work is clearly to transform the spectators' perception of what it is possible to achieve, physically and aesthetically. We see Austin 'scuba wheeling' through sunlit coral seas, wearing a summer dress: a deeply defamiliaris-ing image. *Creating the Spectacle!* in some ways alludes to the 'spectacle of deformity' that was the freak show, a well-established mode of pre-senting the anomalous body for amusement and profit (see Chapter 4). In Austin's case, contemporary performance art collides with freakery; the film invites the viewer to experience amazement, incredulity. The moment in which Austin dangles her feet over the side of the boat and wiggles her toes invites the question as to whether Austin needs the chair in 'real life': if she could move her feet, did this mean the chair was a cultural *choice*, not a necessity born of impairment? Had she not simply 'acquired' her impairment as a lifestyle accessory? The work, and Austin's commentary, invites the viewer to immerse themselves, to

let their minds wander, as if the open water is the unconscious allow-
ing unbidden, uncanny thoughts to rise to the surface. On her website,
Austin frames her own practice in the third person:

> Rather than being didactic [...] a primary aim will be to create portals or
> multiple entrances into the resulting artwork (e.g. through live art, asso-
> ciated online and multi-platform presentation, etc) so that it can find a
> way to ask questions but at the same time leave space for the audience
> to generate their own meanings. She aims to find dramatic and powerful
> ways to re-position disability and Disability Arts as the 'Hidden Secret'.
> She argues that this 'secret', if explored, valued and then shared, can act
> to heal the divisions created in the social psyche by cultural dichotomies
> that define the 'disabled' as 'other'. (www.susanaustin.co.uk)

In a sense, Austin's approach stands for the reconfiguration of art and
disability over the last decade: towards reconciliation, the healing of
divisions, and the recognition of multivalent readings. These aspira-
tions are a long way from the didacticism of the early 1990s. Art is rec-
ognised here as indirect, something evocative and enticing: a 'Hidden
Secret'. Nonetheless, it would be a mistake to say that it is somehow 'not
political'. As Austin says:

> Through the performative presentation of a diverse embodiment,
> the main focus for this work is about reconfiguring preconceptions
> through the use of dramatic and unexpected juxtapositions that act
> to surprise, open up thinking and then, through that reordering of
> associations, to create empowered and empowering narratives. This
> manifests in an artistic practice that makes use of 'surreal juxtaposi-
> tions and quirky re-presentations of disability equipment to facilitate
> new ways of seeing, being and knowing'. (www.susanaustin.co.uk)

Austin is arguing for complexity and art as a corporeal validation of
that complexity. By placing her wheelchair, a symbol of boundaried
existence, in open water – which has no boundaries – Austin is, in
a very direct and arresting way, performing alienation. New ways of
'seeing, being and knowing' are the gift that the aesthetic realm offers
the social: it allows one to envisage a world that does not yet exist but
can – though art – momentarily be seen. Austin, I argue, is performing
a very subtle reversal of the social model of disability: she is taking the
metaphor of disability – boundedness, dependency – and performing an

act of defamiliarisation, re-shaping the metaphor into something that is both unknown and uncannily familiar.

Something similar, but in some ways more complex, happens with Jez Colborne and Mind the Gap's *Unlimited* commission *Irresistible*, a site-specific work that builds a song cycle around the Odyssean myth of the Sirens (2012). From a disability arts perspective, there is something 'incorrect' about the publicity description of Colborne as a 'composer, musician and performer with Williams syndrome', because it states his medical impairment as part of his identity (thespace.org). It is presented as fact, a bit like saying, 'He lives in Nottingham'. The publicity film has Colborne, partly on site but mainly in the studio, working on songs and discussing his fascination with sirens (as material rather than mythical objects). It is his work as a musician that defines him rather than the 'meaning' of the sirens, or indeed his disability. Colborne's obsession – his wish to work with sirens and to make music with them – has grown out of both a childhood fear of sirens and his 'condition', which can often manifest as gifted musicality.

Some early responses to the *Unlimited* commissions by members of the disability arts movement were negative. *Disability Arts Online* editorials and blogs revealed a mood of pessimism that centred on two issues: legacy and political efficacy. There were fears that it would be a 'one-off celebration of "crip art"' and that a legacy will be 'spun' that substituted tokenism for real change (see www.disabilityartsonline, Aug 2012). Equally, there was a feeling that life for the vast majority of disabled people would continue as before: 'It's good we have dancing under water and such. But is this the age of the uber-crips who glitter in the spotlight as so they should and the best of luck to them, while so many others go to the wall?' (ibid.). This is precisely the argument used by Schinina: that the few are exalted and the many left behind. A reoccurring theme here is the inadequacy of art to effect material change for disabled people, exacerbated in a time of economic austerity. Seen from this perspective, slick production values and expensive promos are a luxury 'we' can't afford. What often characterised the critique, however, was unsubstantiated generalisation and an unwillingness to deal with the specific artworks themselves. Arron Williamson was, thus, able to say:

A glance at the publicity material released after the first round of Unlimited in 2009, gives an idea of what has come to be officially identified with disability art in the UK. Large awards were bestowed

on groups making circus, street art, storytelling, mime, juggling, line dancing and 'aerial performance'. The tone is one of celebration – of various buzzword-ideas like diversity, empowerment, inclusion – with the overall aim being to show disabled people to be a thriving social group who are happy to sing and dance and give a good account of their sense of belonging, to show mainstream audiences that they are positive and upbeat. If their chosen art forms – circus and so on – appear infantile in character then that can only serve to draw a mainstream, family-oriented audience who might take 'inspiration' from disabled people's triumphant victories over adversity. (www.parallellinesjournal.com)

This is not factually correct. Two notable works that did use 'popular' forms – Caroline Bowditch's *Leaving Limbo Landing* (aerial) and Mish Weaver's *Box of Frogs* (circus) – did so in ways that 'mark' the form as in some way representative of disabled corporeality and/or cognition. In *Leaving Limbo Landing*, for example, Bowditch choreographed her movement onto five nondisabled dancers who were, for the duration of the performance, impaired by various aerial restrictions. For Weaver, circus is the form that best expresses the manic side of her bi-polar condition. There was nothing intrinsically 'positive' or 'upbeat' or indeed 'infantile' about these works, or any indication that they were made for a 'family audience'. Colborne's work also used popular forms. The tone of the piece – in keeping with Colborne's own optimistic disposition – was upbeat, not in the sense of making others take inspiration from him, but because the music he created was mostly affirmative: his burden, if he has one, tends, in an inversion of the Sisyphus myth, to rock 'n' roll. Since the festival, the Arts Council has announced a £1.5 million investment in the Unlimited project up to 2016.

Conclusion

In this chapter I have identified learning disability as an unstable category that stands for a range of complex social processes. As this is the most economical and accessible term in the UK context, I continue to deploy it but hope the reader will place their own quotation marks around it when necessary. When this is relevant to the study of aesthetics, or when a performer herself openly speaks of it, I will refer to impairment, which I view as *both* real and culturally constructed. Often, I seek to clarify the aesthetic potential of impairment as a quality of human complexity. The subject of the book is most accurately described

as 'theatre involving the collaboration of learning disabled artists', which articulates a process rather than a fixed point. I have argued that the learning disabled artist who collaborates with a nondisabled person, or aims work towards a 'general' audience, is poorly served by current theory. I have, for the moment, concentrated my analysis on the disability arts movement, whose theoretical basis is the social model, arguing that both models are increasingly flawed as frameworks for discussing works of aesthetic complexity. The primary problem is that artists, in these models, cannot escape the master–slave dynamic: the nondisabled artist will always be viewed as a potential oppressor. I have also detailed the way in which the field of applied theatre has oversimplified and underestimated the complexity of theatre and learning disability.[7] For Schinina, 'the aesthetic must always be a means to an end, not the aim of our work' (Schinina 2004: 29). I scramble this sentence: rather, the aim of the aesthetic is to make work that disturbs the idea of what an 'end' is. Equally, the tensions can extend Licia Carlson's list of conceptual binaries, to include professional/amateur and normal/other. While binary oppositions are useful as a way to tease out tensions, they rarely settle comfortably back in place, once they are upset. To say 'double bind' is sometimes more accurate than binary. Binaries close things – people, identities, creativity – down; by contrast, double binds, like sticky situations in a plot, tend to reveal things like character complexity and may even bring about creative solutions. They are also rooted in a complex mutuality.

Over the course of the book, I investigate a range of examples of theatre created out of the double bind that is disabled/nondisabled collaboration. I develop modes of theoretical analysis that can intercede with subtlety and precision. Such collaborating artists sometimes invoke the criticism of those who believe art's primary function is as a tool for changing material conditions. I argue that this is an unrealistic demand to place either on an artist or on an artwork. This does not mean, however, that the aesthetic has no place in the political realm; far from it. I shall argue in the next chapter for a close examination of aesthetic form and for the role that form can play in reshaping the discourse on content and, therefore, social relations. I will argue that only by embracing more subtle theories of embodiment and cognition can theatre and learning disability escape the current theoretical straightjacket. This straightjacket affects some discourses within applied theatre as much as disability arts or disability studies. Too narrow a focus on (a particular) ethics is disabling in itself, and risks 'dis-applying' theatre from disability. In a strange way, learning disabled artists risk becoming

the subject of disavowal, not simply at the hands of a normative society, but precisely by the actions of those who claim to speak on their behalf. The theoretical framework that can support emerging theatrical forms, in all their complexity, does not yet exist, and the book seeks to redress this imbalance. Theatre is a cultural site of ambiguity and transgression. In order to address the twin goals of advocacy and aesthetic innovation it must be conceded that they should be at times allowed to separate and that neither should be required to act as surrogate for the other.

2
Pure Products Go Crazy: The Aesthetic Value of Learning Disability

> An important step or element in appreciating anomalous art is the insight that it is indeed art. Anita Silvers (2002: 240)
>
> I love the feeling of being on the edge.
> Actress, Sonia Teuben (interview 2007)

Defamiliar dramaturgies

In this chapter I address learning disability as an aesthetic value and analyse the dramaturgical properties of two works created in collaboration with disabled artists: *Small Metal Objects* (2005) by Australian company Back to Back and *Hypothermia* (2010) by UK-based Dark Horse theatre. These works provide contrasting dramaturgical responses to the following questions: how does theatre produce or reflect dynamic identities of learning disability beyond binaries, and how are these identities demonstrated in and even shaped by the form and content of the work? Disability has a knack of shattering the distinction between form and content: disability *changes* aesthetics. If the first principles of this book are that art and disability is no longer a territory solely occupied by disabled persons and that disability designates more than social oppression, then this chapter evidences a further important principle: that disability is to be valued as 'a form of human variation' (Siebers 2008: 25).

Tobin Siebers argues that virtually *all* art summons issues of disability. This is because concepts of 'harmony, integrity and beauty' eventually reveal their own contingency (2010: 3). 'Disability aesthetics' describes, then, not just new works that choose disability as their *subject* but any art that utilises the fractured body or mind as an *interruptive value*. Thus,

47

trauma, injury, wounding, vandalism, the misshapen, and incomplete are all materials that can be refigured through the lens of disability. As Siebers notes:

> Disability does not express defect, degeneration, or deviancy in modern art. Rather disability enlarges our vision of human variation and difference, and puts forward perspectives that test presuppositions dear to the history of aesthetics. (2010: 3)

Such an approach, when translated into the theatre practice of learning disabled artists, challenges dominant concepts of virtuosity, competence, and control (intention). In common with post-dramatic art and performance art, disability ruptures the ideology of success: of progress as normative culture ideal.[1] Acts that upset the notion of mastery are to be considered with curiosity, as potential for emergent human complexity. Both Siebers and Michael Davidson have opened up an understanding of disability as an aesthetic 'frame for engaging disability at levels beyond the mimetic' (Davidson 2008: 2). To a large extent this has been directed towards the aesthetics of *physical* impairment. I argue that disability as diverse embodiment *and* cognition can be viewed as form. To acknowledge this is to concede the formal innovation that learning disability offers theatre *per se*.

To be clear, these are not 'only' formal questions: an investigation of form highlights the intrinsic politics of the stage, how it privileges particular virtuosities at the expense of others. In a discussion of the 'Ugly Laws' of the late nineteenth century, for example, Davidson shows how closely the languages of aesthetics and eugenics intertwined, and how the 'aesthetic was used to validate and reinforce the so-called objective science of heredity' (2008: 7). A focus on aesthetics, therefore, does not erase social questions; on the contrary, it tends to raise their profile. By integrating theories of complex embodiment (Siebers 2008), postmodern disability studies (Corker and Shakespeare 2002), and critical disability theory (Shildrick 2009), I acknowledge that performance of cognitive impairment is an important contribution to an understanding of human diversity. Such theory tends to frame 'the body and its representations as mutually transformative' (Siebers 2008: 25); and since theatre is, arguably, the art form best suited to the act of transformation, it follows that by observing actors on stage, such transformations are *made* and *shown*.

The poetics of the theatres of learning disability is, I argue, descriptive rather than prescriptive, as much an attitude – a sensibility – as a model. A model implies something fixed and correct. An attitude, on

the other hand, like camp or the unique way a jazz musician approaches a theme, is less about what is said than how it is said. As Anita Silver reminds us at the beginning of this chapter, this *is* art we are talking about. Silver's belief that 'aestheticizing disability elevates otherness to originality' (2002: 241) should not, however, preclude an awareness of how disability can be fetishised and manipulated. I am cautious, too, about subscribing uncritically to the generalisation that disability is somehow the fragmentary contemporary identity writ large. Such is the view of Lennard Davis:

> I want to make it clear that disability is itself an unstable category [...] [It is] a subset of the instability of identity in a postmodern era [...] Rather than ignore the unstable nature of disability, rather than try to fix it, we should amplify that quality [...] it can create a dismodernist approach to disability as a neoidentity. (Davis 2002: 23, 25–26)

The contention that *all* are either disabled or 'temporarily able-bodied' is potentially liberatory but it ignores the possibility that instability is best enjoyed by those with the freedom (and money) to change face. As Turner and Behrndt summarise the post-colonial dilemma:

> [T]he potential for valorizing 'hybridity', 'displacement', 'migration' as essential aspects of the 'postmodern condition' can lead to a dismissal of those who do not and cannot migrate. (2008: 89)

The vast majority of postmodern theory also tends to focus on questions of embodiment, and not on cognition. How does intellectual disability further complicate and refine theories of complex embodiment? And how does theatre represent or further nuance such ideas? I argue that the theatres of learning disability *do* enrich and benefit from such theory but that theory should be grounded in material practices. As Carlson argues, moral philosophy has, until recently, de-humanised learning disabled persons by equating their status with that of non-human animals. It has conflated suffering and learning disability and represented the learning disabled person as 'both victim and cause (to those around her) of profound suffering' (Carlson 2010: 17). Postmodern positions are desirable if they remain rooted in recognition of fundamental inequalities.

In this chapter I utilise Mitchell and Snyder's work on the historical construction of deviance (2006) to argue that ableism – the ideological preference for homogeneity – is a logical outcome rather than an

aberrant side effect of modernity, and that modernity has shaped thea-
tre in a similarly ideological fashion. Modernity – industrial growth,
techno-rationality, centralisation of power in the city – did not create
anxiety about difference but it responded to it as never before: in the
form of eugenics. From the latter part of the nineteenth century,
the centralised, bureaucratic state was able to use 'scientific rhetoric in
the legitimisation of social-engineering ambitions' (Bauman 1989: xiii).
This classificatory zeal evidenced modernity's intense preference for
whole, productive, rational, and psychologically stable bodies. In thea-
tre, naturalism was the aesthetic outcome; and, since the beginning of
the twentieth century, naturalism established itself as normative. This
is the theatre that Nicholas Ridout refers to as 'the theatre of modernity,
the theatre of the darkened auditorium that knows its own history,
reflects and theorises on its own origins, while participating eagerly in
the worlds of commerce, leisure and entertainment that define its social
place within modern capitalism' (2006: 40). The bureaucratic drive of
modernity that incarcerated some people in a closed institution on the
edge of the city, placed others at its heart, in a different kind of institu-
tion, the modern theatre. Run on the two core principles of professional
specialisation and precise scheduling, this theatre was developed to run
exactly on time by people paid to know exactly what they were doing.
In common with Brechtian and post-Brechtian (feminist, inter-cultural,
post-dramatic) dramaturgies, the theatres of learning disability disrupt
the normative theatre. Learning disability demands not just an interro-
gation of different forms of virtuosity but an analysis of how difference
was and is excluded from the normative theatre.

Naturalism is modernity's version of the 'well-made play'. To the
latter's entirely visible chain of linked events, naturalism added depth,
psychology, and symbolism.[2] Psychoanalysis and naturalism were, in a
sense, twin brothers. Just as penitentiary technique and the delinquent
were entwined in the formation of learning disability, the stage became
the modern institution where a palatable version of the new private
self could be publicly displayed. As Richard Sennett has argued, the
modern self was created by the city, and the actor was its most emblem-
atic creature: someone who gave material form to necessary role play
(see Sennett 1992: 20–40). Naturalism was formed by the observance
of three basic tenets: the pre-arranged verbal text as main structural
event; linear coherence of storytelling; and the preference not to inter-
rupt or negate its telling. Brecht's alternative is well known: to expose
the unities of action, time, and character to 'a never ending series of
clashes, of contradictions between opposing forces' (Willett 1984: 193).

Verfremdungseffekt can be understood as 'non-empathetic distancing', in which the audience is interrupted in the process of identifying with the characters. The term has also been referred to as 'making strange' and is one that opens up the possibility of intellectual impairment as both a formal device and an aesthetic quality. Reconfiguring *Verfremdungseffekt* as learning disability leads directly into a conflation of art and politics. What if Jez Colborne, for example, described briefly in the prologue, could be redefined not by his syndrome alone but by his aesthetic distance? This is *ostranenie,* which the Russian formalists saw as the primary function of art: 'laying bare the device' or de-familiarising normative assumptions. What if learning disability – in its complication of intention, timing, virtuosity – could be *ostranenie*? Might it 'recover the sensation of life [...] to make one feel things, to make the stone *stony'* (Shklovsky 1965: 12)? I argue, in what follows, that learning disability is both content and form in contemporary dramaturgy.

As Turner and Behrndt define it, feminine writing, or *écriture féminine,* positioned itself

> [b]etween the semiotic and the symbolic [...] through a range of strategies including gaps, erasures, stutters, repetition and word-play. In performance, language may be further destabilized by the ways in which other 'texts' or 'textures' are deployed – the body, the voice, the instability of performed identity. (2008: 83)

Intellectual disability further complicates such issues: what if gaps and erasures, verbal inconsistencies, and semi-decipherable registers of speech are not 'authored' but 'naturally' embedded in the aesthetic? What if they were not performative games but real presentational states? Such defamiliarisation is the primary focus of the following analysis. To repeat, this is not 'only' a formal question. My intention is to investigate the ways theatre can bridge gaps and increase opportunities to transcend fixed binary identities.

One: *Small Metal Objects* (2005)

Back to Back was founded in 1987 in Geelong, Australia. Made up of an ensemble of six actors, the company frames the learning disabled person as cultural outsider:

> This position of marginality provides them with a unique and at times subversive view of the world. The stories they create explore

'the cold, dark side' of our times, be it sexuality of people with disa-
bilities, the uses of artificial intelligence and genetic screening, unful-
filled desire, the inevitability of death, and what the fixation with
economic rationality and utilitarianism means for people excluded
from the 'norm'. (backtobacktheatre.com)

Such thematic concerns are allied to a strong preference for the loosen-
ing of boundaries between visual art and theatre. As Bruce Gladwin,
Artistic Director since 1999, says in his manifesto: 'Our vehicle is all
known and unknown mediums. We endeavour to allow form to define
itself, to deliver dynamic and enhanced performance that exists in end-
less suspension and oscillation' (ibid.). *Small Metal Objects* (2005) is a
response to a formal question: how to create work in a large site with
actors who have few or no projection skills? *Small Metal Objects* follows
Soft (2002*)*, which was performed in a large inflatable structure acting
as an auditorium. *Small Metal Objects* grew out of the attempt to create
a parallel sense of structure in a busy urban area with no recourse to the
inflatable. As Gladwin puts it,

> We had a choice either to invest in a great fuck off sound system or
> mic the actors and get headphones for the audience. It was all theory,
> but it was about saying, this gives us a structure, we can go out in to
> the chaos and forge a space. (Gladwin 2007)

The company invested in the headphones and created *Small Metal
Objects* for the Melbourne Festival. Since then it has toured train sta-
tions, shopping centres, parks, and other urban spaces throughout the
world. The discussion of the work that follows is a response to seeing
the piece in November 2007 on Stratford East railway station, London.
 The work positions the audience above the action on raked seating
and provides them with headphones. They eavesdrop on the dialogue
between the actors below, who are equipped with microphones. The
'real' actors are visible but at times they intersect with the 'wrong'
actors: commuters moving down escalators and across concourses, una-
ware that they are extras in an unfolding fiction. The piece is porous,
with the commuters, at times, mistaking the audience for a show. They
take pictures of spectators on mobile phones; they point, laugh, stare.
The story itself is simple. Gary (Sonia Teuben playing a man) and Steve
(Simon Laherty) are two small-time drug dealers. They are contacted on
a mobile phone by Alan (James Russell) and arrange to do a deal with
him. Midway through the play, Steve changes his mind; he stands on

the concourse and makes a mysterious decision not to move. Because Gary won't leave his friend, the deal is called off. In desperation, Alan is forced to call Carolyn (Genevieve Picot), a business – and sometime sexual – partner, for help. A therapist by trade, Carolyn locks horns with Steve in a battle of wills. Despite beginning discussions calmly, she finally resorts to intimidation and then to offering to arrange sex for him. Again to no avail – Steve stays put. The yuppie pair are forced to look elsewhere for their fix, leaving Gary and Steve to ruminate on events. The narrative of the piece is almost too simple to sustain an hour's theatre, yet this simplicity is offset by the complexity of form.

The distance between audience and performers means that the actors are camouflaged in and amongst the commuters. The text itself is camouflaged. At the start, five minutes of dialogue are overheard before the identities of the characters in the crowd are revealed. There are times when the dialogue seems improvised, contingent. (It is not.) Surrounded by commuters, themselves unaware of what is being staged, the spectators are semiotically overloaded, alive to the possibility of the aesthetic in everything. Because 90 per cent of visual 'intake' *is* improvised – it is real – this bleeds into the unfolding drama (which is scripted but at times *seems* real). The style (or quantity) of the acting also diverts the audience's attention away from theatricality: the style is 'filmic', as if the actors are playing to close cameras, not far away audiences. The actors never 'project' their speech, because they are wearing microphones, and only rarely are there 'gestic' moments where their bodies hint at anything other than pedestrian movement.

Between work and audience

Ostranenie is thus inherent in the form of *Small Metal Objects*. The form defamiliarises Carlson's conceptual pair of visible/invisible. The artwork plays a game with the visibility both performance and disability. Looking is just as much the subject of the piece as the story. Equally, because the spectators are so distant, disability seems to disappear, or at times become irrelevant or imperceptible. In this show, disability as unstable category is no longer a theory but material reality. *Small Metal Objects* makes theatre – and learning disability – blurry around the edges.

According to Petra Kuppers, disabled performers have to negotiate a double identity:

[The] physically impaired performer has to negotiate two areas of cultural meaning: invisibility as an active member in the public sphere, and hyper-visibility and instant categorisation. (2001: 26)

The situation is compounded for artists who are intellectually as well as physically impaired, their performative 'competence' called into greater question. Rosemarie Garland-Thomson is mindful of the way that staring casts disability in the way that the 'male gaze' casts women, as objects to be desired and controlled:

> If [...] gazing is the dominant controlling and defining visual relation in patriarchy between male spectators and female objects of their gazes, staring is the visual practice that materializes the disabled in social relations. The male gaze produces female subjects; the normative stare constructs the disabled. (2005: 32)

One sexual, the other medical, both these visual practices suggest a narrative: 'Gazing says, "You are mine". Staring says, "What is wrong with you?"' (Thomson 2005: 32). Furthermore, looking is at the very heart of identity formation: as Thomson argues, 'Gazers become men by looking at women, and starers become doctors by visually probing people with disabilities' (ibid.). *Small Metal Objects* is an examination of the choreography of looking. It inverts most of the negative implications of staring – a 'furtive and compelling' way of seeing that tends to provoke 'discomfort and [...] anxiety' (ibid.: 30) – and recasts them as generative and reciprocal.

Towards the end of the play, Steve stands on the concourse, refusing to go to the lockers and continue with the drug deal. Carolyn, the psychologist, has started to lose her cool with him, despairing that she will ever negotiate the transaction. The following conversation takes place:

Steve: I'm not going.
Carolyn: You're always going to be unhappy, Steve, because you won't take that first step.
Steve: I don't want to go.
Carolyn: I'll seriously make it worth your while. What, are you lonely? You're lonely aren't you? You don't have a sex life? I'll organise someone to suck your dick, if that's what you want? You want that?

Carolyn has delivered these lines bending down, looking at Steve directly in the face. The audience hears the lines intimately through the headphones. Occasionally, one of the commuters hears also.

Carolyn: The clock is ticking. You're standing here dying and you could be living. Come to the locker and I'll suck your fucking dick.

There is a pause. It is not clear what Steve will do. Eventually he says:

Steve: I'm staying here.

There is something shocking about Carolyn's line. It is as if content (or representation) has pierced form, for the first time making the spectator 'think about' learning disability. Within the piece itself, the dialogue makes perfect sense. Carolyn has been brought in to negotiate, the clock is ticking. Steve has already been offered huge amounts of money. He cannot be bought with this so she tries sex. The way she says it – direct, aggressive – combined with the intimacy of the headphones, make it almost too real: a middle-class, middle-aged woman is offering to fellate a younger autistic man in a semi-public space. And the way the technology allows one to listen in: it is eavesdropping as opposed to viewing, closer to being a voyeur than a spectator. Perhaps at some level this is why it turns to sex in the end. There is an inevitability about the form: a furtiveness of surveillance. It is subversive, because it allows for the possibility that Steve is a full sexual being, a man as opposed to a child. The work draws on the tradition of surveillance, categorisation, and differentiation that characterises the history of learning disability. The stare, that question it asks – 'What's wrong with you?' – are put to work here. The artwork subverts the act of watching. The drama becomes 'What am I looking at?' Or 'What choice should I make to look at someone (an actor) above others (an incidental member of the public)?' Or even, 'What does this watching say about me?'

In complicating the visual and spatial dynamic between the audience and performers, *Small Metal Objects* creates 'a relational space where the social codes and regulations dissolve' (Thomson 2005: 38). Due to the distance between 'stage' and seating, it is not clear, until late on in the show, that Gary is played by a woman (Teuben): a disabled woman masquerading as a nondisabled man. It adds another layer to the identity shifting, and one that is made possible by physical distance. In fact 'watching' or 'staring' cannot do justice to the sheer varieties of looking, glancing, scanning, surveying, checking, double-taking, and squinting that go on here. This is one way in which performance can change perceptions: by giving up, for the duration of the performance, a world of tight social prescription in favour of *Small Metal Object*'s world of fluid, playful identities, spectators are encouraged towards developing a raised consciousness.

The awareness of fictionality is, according to Joanna Kot, 'the first moment in the process of aesthetic reception'. Such a process is intrinsic to the theatre transaction and allows the audience to feel 'emotionally

cushioned and safe' (1999: 9). Disability scholar Harlan Hahn distin-
guishes between two kinds of discomfort that the presence of disabled
people often causes some nondisabled people: existential anxiety (how
will disability threaten my idea of a healthy, functional life?); and
aesthetic anxiety (how will this person threaten my idea of what con-
stitutes the perfect body or cognition) (1998: 42–43). Aesthetics and
distance, then, are complicated by disability. I argue that in reframing
the act of looking *at disability, Small Metal Objects* opens up a radical
space for conceiving new identities.

Between work and artist

This discussion has illustrated how difficult it is to separate out form
from content. This may be the case in all art but, with disability, this
issue is compounded by the fact that 'representations of disability have
greater material existence than other representations', that the disabil-
ity overpowers other types of mimetic presentation (Siebers 2010: 2).
Bruce Gladwin raises the issue that *Small Metal Objects* in some ways
'uses the disability':

> I find Simon [Laherty] utterly fascinating to look at. He's got an
> amazing face. I always found myself as a director thinking, you don't
> have to do much, Simon. In a way his function in the show of 'I'm
> just gonna' stand here' comes out of my desire to just sit and watch
> him. It's like when you cast any actor in a role, it is because of some-
> thing, a feeling, an aesthetic quality you are drawn to. So the narra-
> tive in the show of Steve [Laherty's character] having some kind of
> 'metaphysical meltdown' came out of this. (Gladwin 2007)

Gladwin does more than 'enable' Laherty: he aestheticises him. Actor
and director are co-creators in a vision that outstrips straightforward
advocacy. Laherty's pared-down performance is integral to Galdwin's
conception of minimalism:

> I've got a strong interest in how to distill things down to their sim-
> plest form, how to reduce things [...] The piece is all about creating
> theatre without a theatre, therefore there is a simplicity about it.
> (Gladwin 2007)

The narrative of *Small Metal Objects*, then, and the character of Steve
in particular, is an exercise in paring down: a comedy of concision.
Laherty's character hardly moves. For most of the 60 minutes he is still,

a seemingly weightless touchstone in a moving world. There is something about his stillness that transcends the 'stubborn' and becomes eloquent, as if the character is making an aesthetic judgement as much as a psychological or moral one. He will not move. He will not go through with the deal. Why? There is no answer. *We don't know why Steve says put.* This is at once the problem of the play and its comedy. He will not move, not for money, not for sex. This is his choice – but one born out of a conflagration of narrative and aesthetic strategies.

There is another way of defining Laherty's aesthetic contribution. Just as learning disability has been medically and socially framed as 'quantity', so it is with acting. In his seminal essay 'On Acting and Non-Acting', originally published in 1972, Michael Kirby describes a continuum of acting 'amounts'. A 'non matrixed' (or non-acting) performer is someone who is present on stage but does not do anything; he may be performing certain tasks but is not feigning anything. 'Non matrixed *representation*' is where a performer behaves 'as himself' but carries out certain actions that may be interpreted as having a meaning in the wider 'matrix' of the play. In 'received acting', which moves another step towards acting 'proper', an actor can be read as part of the wider narrative, attaining the status of character, however minor. The fourth stage is that of 'simple acting'. If 'acting can be said to exist in the smallest and simplest action that involves pretense' (Kirby 2002: 44), then 'simple' refers not to a 'lesser' form of acting but rather to a different 'amount' of acting. Kirby defines 'simple acting' as 'that in which only one element or dimension of acting is used', for example a physical task or a speech delivered at a single emotional register (ibid.). 'Complex acting' involves multiple tasks, physical, or emotional registers. The amount of acting depends on how much effort an actor takes to do something. Complex acting is not 'better' than simple acting; rather it describes the holding of potentially contradictory elements in a single moment. From this perspective, most film acting might be perceived as simple, though certain examples ('method acting') might be *perceived* as complex.

The performances in *Small Metal Objects* are an object lesson in simple acting, in Kirby's terms. Perhaps this relates to what Gladwin has said, that the stillness is *both* aesthetic (director) and character (actor) driven. Steve/Laherty will not move – not for money, not for sex, but also because he is good to watch. By stripping back, by doing less – by not doing anything – Laherty does more. He is still for such a large percentage of the play that he comes close to an even more pared-down point of 'received acting'. He rarely appears to be *actively* feigning or

representing anything. There are two ways in which Laherty's central performance is important.

First, the formal minimalism he inspires imbues the entire cast of *Small Metal Objects* with simplicity. This means that form and corporeal mechanism (actors) convey an aesthetic value that is rooted in learning disability. This can only be shown through the form, making performance a unique site to generate new forms of human understanding. It is evident that the value of the work cannot be understood as something purely 'learning disabled' or indeed owned by disability. Rather, it must be understood as a hybrid, a collaboration of very different intelligences, which manifest in a particular way. The challenge generated by Laherty's acting – and by Gladwin's commitment to its simplicity – is highlighted by fellow cast member James Russell:

> Until we actually did the show, I thought, this is theatre of *nothing*. Bruce was like, do less. Less, less, less. It is very close to film acting in that sense. At one point Bruce said, 'no don't turn around, we don't need to see your face. It's enough that we can hear what you are saying'. But now I've done this play a lot and I'm still not sick of it. As an actor you get to experience a full vocal range that you don't get in a theatre, it is so intimate. (Russell 2007)

It is clear how much the nondisabled actor has been challenged and developed by the process. This is not to imply that Russell has somehow been 'improved' by the experience, but rather to acknowledge that his breadth of aesthetic possibilities has been extended. This reaches back into the creation of the work from the point of improvisation:

> Simon would give me nothing to work with in improvisation, you know the unwritten rule of accept and build, that comes with actor training, but Steve gave me nothing. I was finding that difficult, like it was going nowhere – but it became a big scene in the show and it works very well. (Russell 2007)

This, again, highlights the way in which form is rooted in a particular sensibility, a strange kind of anti-acting, in which all the accepted Stanislavskian notions of character and intention have been dismantled, not aggressively or perhaps even intentionally, but in a rather gentle style of resistance – something that I will refer to as 'Bartlebyan'.

This is the second way in which Laherty's performance is of particular aesthetic value. His character, Steve, is carrying on an anti-climactic

tradition of modernism, which began with Pessoa and Kafka – that of the 'broken line of weak, troubled clerks and office workers' and their 'perceived inability, willful or otherwise, to achieve an outcome or fulfill a set of agreed principles' (Bailes 2011: 3). In some ways, this tradition of failed modern labourers reaches into the millennium in the form of anti-heroic figure David Brent in the BBC comedy, *The Office*. The most emblematic antecedent, however, is the eponymous protagonist of Herman Melville's *Bartleby*. As a literary figure he first appeared in 1853, became a 'classic' of American literature, and has been the subject of analysis and debate ever since. The story has recently been 'reclaimed' as a 'radical narrative of autistic presence', a way of describing a particular set of behaviours that would only become a medical category 90 years later (Murray 2008: 51). I want to flag up the implications of such a reading.

Bartleby the Scrivener, A Tale of Wall Street, tells the tale of the eponymous copyist who, having no known past, begins to work in a law firm. The tale describes his gradual withdrawal, first refusing to do certain tasks, then refusing to work altogether, and eventually refusing to leave the office. Rather than face the task of removing him, the law firm moves offices, leaving Bartleby behind. He remains there until he is forcibly removed, arrested, and taken to the Halls of Justice. He refuses to eat and eventually dies. The phrase he uses to define his refusal is 'I would prefer not to'. Murray's close reading of the text reveals that he uses this phrase, with slight alterations, 22 times. Bartleby has no discernible character or past. He is always a literal version of himself and is not referred to by metaphor: that is, beyond his corporeal presence. He 'was always there', possessed of 'great stillness', and 'unalterableness of demeanour under all circumstances' (Murray 2008: 52). In this reading of the text, therefore, Bartleby, like Laherty's Steve, is defined by *preference*, as opposed to intention. There is no 'meaning' in the Bartlebyan character because there is no discernible desire. He is defined not by what he wants but by what he *prefers not to* do. This resistance is passive, a disengagement rather than a protest.

Laherty also complicates the idea of intention in his delivery of the text. Unlike Teuben, Russell, and Picot, who appear to have rounded characters – the sense of family, interests, a past – Laherty delivers his lines functionally, as if they were devoid of emotional meaning: when Steve tells Alan, 'I'm deep in thought', the comedy of the line derives from the distance between the words and the tone. The way he says the line – in a monotone, dispassionately, literally – conveys the opposite of someone deep in thought: more absent than thoughtful. The closest

we come to an 'explanation' for Steve's preference for stillness is in the following text:

Steve: I've started being aware of myself.
Gary: Is that good?
Steve: I'm missing something, a feeling.
Gary: A good feeling?
Steve: A feeling that I've felt and sensed and that I've always known.
Gary: Hmm.
Steve: It's my task to be a total man.
Gary: Ok.
Steve: I want people to see me. I want to be a full human being.
Gary: Yes.
Steve: I just want to wait here and think about it.

Yet, again, the meaning of these words – the sense that they mean *anything at all* – is left hanging in the balance. Laherty's delivery is so deadpan that it almost registers as a rupture in the aesthetic distance modulated by the rest of the cast. *Small Metal Objects* is a play that faces two powerful anti-intentional forces: the presence of pedestrians and the presence of Laherty. The above text, as read in a script, could be construed as an indictment of ableist society and how it de-humanises and emasculates those who fall outside the normative ideal. Yet in live performance, the words are devoid of passion, and operate as a kind of throwaway, failed political speech. In the show, they are *very* funny, the irony stemming from the distance between text and intention.

A further parallel between Bartleby and Steve is the effect both of them have on the nondisabled characters. The narrator of *Bartleby* – a lawyer – is 'thrown into a state of nervous resentment', an apt description for both Carolynn and Alan – another lawyer – and Russell's experience as an actor during improvisation. More importantly though, both works leave, as Murray puts it, 'the space of autistic presence undisclosed and open, and [invite] interpretations that might make sense of it' (2008: 55). By foregrounding autistic presence as an aesthetic quality in *Small Metal Objects* I am also suggesting that the work moves beyond both Marxist material and universal humanist readings. Steve is not a metaphor for the withdrawal of labour from capitalist exploitation. Neither is he a metaphor for the essential dislocation of human beings from one another. Both these readings 'sacrifice Bartleby's [and Steve's] strangeness by making him into a representative' (Naomi C. Reed 2004: 265). *Steve is strange*: in acknowledging this we move beyond representations

of disability and concentrate on the pleasure, the *jouissance* of disabled presence. Each actor brings a certain aesthetic substance to *Small Metal Objects*, and none more so than Simon Laherty. In the words of both Steve and Gary: 'Everything has a value. Everything has a fucking value'. That value is as much aesthetic as it is moral.

Between art and reality

Postmodernism's insistence that identity is 'interdependent, fluid and endlessly in process' (Shildrick 2009: 10) is exemplified by *Small Metal Object*'s aesthetic form. It is a piece that endlessly and effortlessly challenges the notion of the fixed artefact. The structure or score of the piece is repeated as exactly as possible in each performance, yet it can never be read the same way twice. The frame is upset by pedestrians, not simply passing, but interacting, both with performers and audience. The boundary between audience and performers is always complicated by the fact that both are being watched at various times by real people who do not know it is a performance. The aesthetic distance between art and reality is never stable, it is always in process. Sometimes pedestrians recognise the actors and speak to them. The normative boundaries that regulate disabled from nondisabled people – dependency, money, power, access to sex – are all inverted here: the professionals want what the others have, and even offer sex to get it. Actors pass for real people, and real people pass for actors. Thomas Couser's belief that disability is threatening to the nondisabled precisely due to the 'indistinctness and permeability of its boundaries' is accurate but *not* in this aesthetic space, because it is one permeable among many (1997: 178).

Small Metal Objects demonstrates one way, then, in which theatre does not just represent or create learning disabled identities but fundamentally upsets our notion of what an identity – or a role, or a mask – is. Theatre in this case does what theory and, to some extent, other art forms cannot do, which is to catch the fluidity of identity, and to make it visible in real time. Passing as both male and nondisabled, Sonia Teuben personifies Tobin Sieber's belief that 'disabled people who pass for able-bodied are neither cowards, cheats, nor con artists but skillful interpreters of the world from which we might all learn' (2008: 24). Passing is heightened again in a formal sense, in that people pass by continually. Passing is aestheticised, a contingent choreography that informs the play. Indeed, Gladwin notes that some audience members found this 'distracting' and wanted to 'concentrate on the play' (2007). The decision to play a man was taken by Teuben after Gladwin had asked what would challenge her most. Since in her own words 'I usually

play a girl or a dyke', the character was based on a male friend of hers, a drug dealer, around whom much of the background story revolves (2007). So, as Gladwin puts it, 'Gary is a mixture of Sonia [Teuben] and her friend'. It is ironic, given her contribution, that an audience member could express surprise that the company was able to employ Teuben as an actress. As Russell told me:

> 'I mean', she said, 'how do you work with these people? How do you do it? How do they remember their lines? It must be extraordinary. Are you just bouncing all over the shop with the lines they give you?' I'm like, well, it's tightly scripted, actually. If I've forgotten a line, I can always rely on Simon [Laherty]. He knows every line in the show, not just his own. (Russell 2007)

These comments are a mark of how deeply learning disability defamiliarises perceptions of intention and competence. The aesthetic of the piece tends to reinforce the idea of unscriptedness. Rooted in a devising process of very quotidian, un-theatrical language, this is the ultimate con-trick, the ultimate act of 'passing', if you will: a play smuggled into reality. It is unsettling to learn that an audience member left the play thinking that Teuben and Laherty were making the job harder for Picot and Russell. Did the lack of 'virtuosity' actually reinforce the notion of 'the learning disabled actors' as incompetent or in need of care? In highlighting the positive virtues of identity shifting, perhaps it is prudent to bear in mind that such ideas are *always* dependent on the existing preconceptions of audiences, and that these will sometimes, in the manner of a self-fulfilling prophecy, be reinforced rather than challenged.

Small Metal Objects has been performed in different places connected by their interstitial quality. Parks, railway stations, shopping concourses all correspond with what Homi Bhabha referred to through the metaphor of the staircase:

> The hither and thither of the stairwell, the temporal movement and passage that it allows, prevents identities at either end of it from settling in primordial polarities. This interstitial passage between fixed identifications opens up the possibility of a cultural hybridity that entertains difference without assumed or imposed hierarchy. (1994: 4)

Whilst the metaphor of the stairwell might prompt questions of disability access, the meaning still holds true. *Small Metal Objects* raises questions, not just of moral rights and the value of human bonds, but of *aesthetic*

structures: the formal mechanisms that examine the gaps between fixed identities. It offers generative opportunities to see and to act out conceptions of difference that are not constrained by absolute polarities.

In sum, *Small Metal Objects,* is a site-specific practice that forgoes the dominant markers of theatrical form (proscenium arch, strict parameters between stage and audience, mimetic sealing of dramatic fiction) and liberates actors from fixed identity. The liberation opens outwards too. It 'softens' the spectator and gives her permission to look at the actors and to accept that the boundaries between life and theatre, as between self and other, are permeable, liable to change. *Small Metal Objects* demonstrates the theory of disability/nondisabilty as interconnectedness in real time. Ultimately, intellectual divisions between form, content, fiction, site, and reality peel away, and diversity, in and of itself, is revealed as a value. Learning disability exists deep in the dramaturgy, enriching the interstice of form and content. Since the mid-nineteenth century, learning disability has been an object of classifying practices (medicine, education, incarceration, rehabilitation) and subject to liberating forms of political consciousness (social construction models of disability). In performance, on the evidence of *Small Metal Objects*, it can be aestheticised but not classified. This is the creative possibility of theatre and learning disability. It is, to borrow a line from Carlos Williams, a pure product gone crazy.[3]

Two: *Hypothermia* (2010)

Hypothermia, a play set in 1940 in Nazi Germany and concerning the forced euthanasia of learning disabled patients in hospitals, was written and directed by Vanessa Brooks, Artistic Director of the Huddersfield-based theatre company Dark Horse. The company produced the piece in 2010, under their previous name, Full Body & The Voice, a name that was used from 1999 when it was set up under the directorship of Jon Palmer. The name change is significant, as the website points out:

> In April 2012 Dark Horse officially became the new name and identity for Full Body & The Voice theatre company, a change made to reflect the company's full movement onto the national stage via recent evolutions in ambition, reach and artistic output. (www.dark-horsetheatre.co.uk)

The company's preferred form is 'rooted in the naturalistic representation of real people in the imagined past, present and future' (www.fullbody.org.uk). Furthermore, their 'actors commit themselves to a

super-objective; the play, and what it has to say' (ibid.). There is a clear sense that the play is paramount, and that the actors are, in true modernist fashion, specialised agents of the aesthetic. The company has a regular ensemble of eight actors but the national touring productions tend to feature – as with Back to Back – fewer ensemble members, and include collaborations with nondisabled performers.

Where *Small Metal Objects* purposefully sidesteps most formal conventions, *Hypothermia* resides firmly inside them. It is the only production of those examined in this book in which the nondisabled performers outnumber the disabled actors, in this case by a ratio of 4:1. Oskar (Ben Langford) is a young man with a learning disability who is resident as a long-stay patient in a hospital for 'hereditary and incurable diseases'. Dr Erich (Bradley Cole), director of the hospital – '[b]arely in control; a shaky grip; an atrophied heart' (Brooks: 1) – is an alcoholic overseeing a dwindling number of patients (who are all gradually leaving to go to the mysterious Hadamar Institute), supported by a young administrator, Lisa (Fay Billing). The main action takes place over two days and centres on the visit by Erich's old friend from medical school, Dr Katscher (Johnny Vivash), now a member of the SS and a member of the 'Committee for the Scientific Registration of Severe Hereditary Diseases'. He tries to persuade Erich to relinquish his post and join him at Dachau to carry out medical experiments. The 'hypothermia project' of the title refers to experiments in human resistance to extreme temperatures. Dr Katscher soon sets up an antagonistic relationship with Oskar, insulting him, teasing him, and challenging Erich to punish him; he is also sexually aggressive towards Lisa. By the end of Act One several things have become apparent: the patients at Hadamar are being systematically murdered as a test case for extermination procedures in the concentration camps. Erich is made aware of what is happening but becomes emotionally paralysed and fails to act. He does, however, refuse to join Katscher in Dachau, but only on the basis of his alcoholism, not his moral beliefs. Act One culminates in a challenge that Katscher makes to Oskar to beat his time of seven seconds in a race between two air holes in the hospital's frozen lake. Understanding that Oskar cannot swim, Erich takes his place; he survives.

Act Two begins with the appearance of Frau Poppendik (Margaret Fraser). She confronts Erich with the death of her disabled son at Hadamar, a death for which she now holds him responsible. Thwarted in his attempt to persuade Erich to join him in Dachau, Katscher demands that seven more patients be transferred from the hospital to Hadamar. He breaks open the drawer containing all the staff and

patient records and calls an official meeting to decide who will be moved. In this penultimate scene it is revealed that Lisa entered the Institute as a patient following a 'psychotic breakdown'. Katscher gives Erich the choice of deciding whether it is Oskar ('the idiot') or Lisa ('the whore') who will be sent to their death. The scene contains the play's main dramatic irony: of Oskar electing *himself*, even though he is defined (by Katscher at least) by his inability to make an informed choice. The play ends ambiguously. Katscher challenges Erich, who has become increasingly paralysed with alcohol and remorse, to one more ice water swim. Katscher dives in but does not return; his contorted dead body is represented for the audience. A series of tableaux show images of the cast, contorted, frozen, dead, on the ice, which imply the coming Holocaust.

Eugenics as subject

By rooting the story in Nazi Germany, the play places an immediate distance between the material and the actors. Brooks, in her foreword to the published text, describes the impact of watching a documentary about the T4 project, the 'Nazi's macabre "dress rehearsal" for the genocide on the Jewish people', and her desire to write 'a drama about the [...] value of human life and the human capacity for cruelty' (2010: pre contents). By framing the theme in this context, the play runs several risks. It depicts Nazism as an aberrant force, safely consigned to history, and risks aestheticising the learning disabled character as 'victim', in this case at the hands of the 'uber-nondisabled' Katscher. It could be read as offering the audience a safe vantage point from which to view human cruelty, which does not implicate them. In a very positive press review, which praises the 'hard hitting premiere' and sense of 'mutual trust and respect' emanating from the ensemble, Val Javin asks: 'Who today could stand by and see one person so arbitrarily weigh the value of another? Who could condone such ruthless disregard for human life?' (Javin 2010). The safety of this fiction is unsettled, however, if the eugenics movement is reconfigured, more accurately, as a transatlantic phenomenon. As Mitchell and Snyder have argued, in the years leading up to World War Two 'European and North American eugenics engaged in a shared campaign of biological targeting that addressed deviance as a scourge to be banished from the transatlantic hereditary gene pool' (2006: 103). The intellectual and practical apparatus of the Holocaust was made possible only by the 'legislative tactics, sterilization policies and co-option of institutions' practised in France, Britain, the United States, Canada and elsewhere' (ibid.: 106). In fact, German scientists

came relatively late to the eugenics movement. The Holocaust was thus constitutive of modernity, rather than aberrant to it. Drawing on Zygmunt Bauman's work, Mitchell and Snyder recognise

> modernity as a type of bureaucratic nightmare from which we cannot awake. [Bauman] contends that treating the Holocaust as a uniquely pathological, extraordinarily brutal event runs the risk of asking nothing of modernity itself or its residents. If we fail to recognize the Holocaust as a byproduct of modern Utopian fantasies, then we avoid the task of making urgent critiques of our own fetishization of normativity as the outcome of a narrow homogenous social vision. (Mitchell and Snyder 2006: 32)

What does *Hypothermia* ask spectators of themselves? How are they implicated in these events? The eradication of deviance was a goal expressed, in one of its most violent forms, in Nazi Germany, but it exists as an underlying trope in all ableist societies. As I will show, the facts, too, are more complex than the play has room for. The Nuremberg trials reinforced the unspoken belief that the death of disabled people was either less important to, or at least unconnected to, loss of other persecuted groups: the courts did not pursue those involved in euthanasia projects. Many scientists remained in post until well after the war, ensuring continuity rather than disruption of health service structures (see Mitchell and Snyder 2006: 102). Crucially, by skirting over such complexities, by situating the story in history untroubled by them, the play 'others' the perpetrators. It places the problem in the past and absolves the actors and the audience of responsibility to think through the issue as current: in Bauman's words, focusing on the *German-ness* of the crime pulls 'the sting out of the Holocaust memory' (Bauman 1989: xii).

Eugenics has been utilised as material in other productions featuring learning disabled actors, such as Back to Back's *Ganesh and the Third Reich* (2012); the Holocaust is not somehow beyond representation. In the case of *Hypothermia*, however, the work invites doubt as to whether it implicates the viewer in events or not. In her introduction to the play, Brooks describes the difficult process of researching and writing it. Two points she raises are of particular note. It is intimated that the subject is almost too contentious to be dealt with by herself as a nondisabled writer; and that learning disabled actors, it was suggested to her, 'lacked a cogent awareness of the implications of the Nazi genocide and should therefore not be prime movers (actors) in dramas about it' (2010: pre

contents). She admits to finding that these 'political machinations and sensitivities' were 'more arduous than the writing', and the play was put on hold for some time (ibid.). What remains untold in Brooks's introduction is how these issues were broached in the final play and production; yet these questions are *precisely* the ones that are immediate and necessary. Aesthetically, I argue, the tensions *are* present in the work, and account for the uncanny sense experienced during spectatorship that the characters might somehow burst out of character, that the tension they were holding could only be released through revealing themselves as real people, with real dilemmas in contemporary time.

Form as eugenics

Eugenics – the erasure of the anomalous body from a constructed normality – is raised in the form, in this case a highly charged naturalism that could be described as 'hyper-realism'. I contend that naturalism, in this case, works metaphorically as a mode of eugenics: it separates out trained and untrained actors, spotlights them as polarities, and in so doing both accentuates and, paradoxically, erases difference. While *Small Metal Objects* deepens a sense of human and aesthetic complexity, *Hypothermia* risks sealing off complexity and reinforcing binary positions. Langford exists alongside the others and remains an 'other' throughout the play: he is other to professional, other to actor, other to nondisabled, other to scripted dialogue. In *Hypothermia*, a nondisabled actor might thus be perceived as follows: speaking many lines; walking independently on and off stage; learning script and enunciating words clearly; being the protagonist or antagonist of the story; conveying 'real' emotions; understanding the mechanism of the play; showing verbal and physical prowess; fulfilling physical embodiment of pre-existing ideas; playing someone other than 'self'; and performing 'complex acting'. A learning disabled actor, on the evidence of this play, might be perceived as follows: speaking very few lines; needing help to move between on and off stage; seeming to exist 'outside' the other characters; playing a character who troubles the notion of the informed choice; playing 'himself'; expressing himself in abstract movement; being the centre of attention during the curtain call, with other actors encouraging the audience to applaud him especially.

Ridout argues that modernity resulted in a pervasive demarcation between work and leisure, and that theatre plays out this division in the shape of actor (labourer/producer) and audience (consumer). Theatre's 'embeddedness in capitalist leisure, its status as a bourgeois pastime' (2006: 4), means that it cannot be neutral. This it has in common with

modernity's overwhelming 'preference for able-bodiedness' (Siebers 2008: 6). Similarly, the box office, the dark auditorium, the hushed spectators, the 'proper' acting, can often feel unquestionable or natural. Yet the normative theatre, like the normative society, is not neutral:

> The prostitute who is both seller and commodity is emblematic of modern capitalism for [Walter] Benjamin, because she makes visible the nature of the underlying economy. The moment you recognise the actor in similar terms, a certain awkwardness or embarrassment comes into the relationship. (Ridout 2006: 27)

One might argue therefore, that the *primary subversion* in *Hypothermia* is not the presence of the learning disabled performer, or even the revelation of new or unfamiliar aesthetic forms. Rather, it is the act of paying for it.

Theatre lays bare the devices that signpost inequalities inherent in society. The relationship of learning disabled people to work is doubly complex in theatre because the 'Whore's Profession' itself has a conflicted relationship with labour. As Ridout has pointed out, the normative theatre has its employees engaged in repetitive nightly activity in anti-social hours; maintains low wage levels by keeping a huge pool of surplus labour (with occasional opportunities for massive differentials to be earned by 'stars'); subjects its workers to financial insecurity and intense critical scrutiny. It does so by keeping the 'means of production' hidden: work masquerades as 'play' and success is attributed to spontaneous creativity by bohemian artists who are either lazy or obsessive or both (see Ridout: 100). I argue that learning disabled actors radically invigorate such critique. Their presence complicates the notion of theatre as employment: what does it mean for a learning disabled person to act before a paying audience if she is not allowed to earn money due to benefit payments, if she cannot take responsibility for her own safety or financial future? It is not simply that the disabled performer may be discriminated against – aesthetically, economically, socially – but that her presence reveals modern theatre as inherently and consistently discriminatory.

Actress Margaret Fraser described her trepidation in taking on the role of Frau Poppendick:

> I knew it would be handled sensitively though. I felt this was important work for which we carried great responsibility. I knew we were going to work together to create someone [her character] that was real and truthful [...] these issues are never black and white, these are real people. (www.darkhorsetheatre.co.uk)

The play, however, *does* risk presenting a 'black and white world', if what is meant by that is the operation of thematic and formal binaries. Langford remains on the point of Kirby's continuum, called 'simple' acting, where one element of performance – in this case, the gestural – predominates. The other actors work at a more 'complex' level, increasing the quantity of their acting by means of a constant negotiation between text, movement, and scene change, and by varying emotional registers. They are 'a kind of group apart, more beautiful perhaps, more agile, more powerful and subtle of voice. Creatures who have been chosen on the basis of some initially desirable attributes, which they have subsequently honed and refined by means of professional training' (Ridout: 97). Issues of training are advertised and documented on the company website:

> The silent approach, a groundbreaking rehearsal room method, is used cross company. Whole days can pass in the rehearsal room without the need for words at all. The silent approach is accessible, physical, emotional and honest, with the objective of representing real human beings, live and in the moment, on stage, TV and film. (http://www.darkhorsetheatre.co.uk/method)

The description is accompanied on the website by a short film that documents the 'silent' training and the 'competency based system for actor training', a 'unique and revolutionary' system used 'to develop and evaluate key skills in Stanislavsky based method' (ibid.). The 'actors', we are informed (in a voiceover by Fraser), 'are so trained, so highly disciplined, that there is no speaking at all, unless it is strictly necessary'. The 'silent approach' is a method that was utilised in *Hypothermia* rehearsals. Faye Billing (Lisa) describes the process as 'naturalism' but with 'no verbal discussion, no dissecting, no analysis. [We just had to] get up and do it, no need to justify what you were doing' but at the same time it was 'incredibly physical' (ibid.).

In *Hypothermia*, all the actors in a sense 'over-enunciated' their physicality. One reviewer welcomed this, noting two different kinds of movement quality: '[b]oth characters [Katscher and Erich] are played with deliberate physicality offering a stark contrast to the serene and seemingly fragile figure of the play's central character [Oskar]' (Javin 2010). Perhaps this was the aesthetic outcome of the unusual process of undertaking psychological realism without recourse to verbal analysis. In that sense, all the nondisabled actors were impaired. The heightening of the physicality hinted at a neurotic tension in the characters on stage. This

does beg the question: why not produce a silent play? Is there not something contradictory about making a piece of speaking drama with no course to verbal preparation, a tension between the play and the process? When Billing describes the play as mainly 'naturalism with some stylized movement in certain scenes' she is only partly right. There are moments that allow Langford to contribute through stylised movement, but the whole piece is aestheticised by the extended physicality of all the actors.

A parallel exists between the acting style and an argument made by a *New York Times* reviewer concerning an exhibition of Rico Lebrun's Holocaust paintings:

> Visions from which we should avert our eyes are pumped up to Michelangelesque scale; a clamorous painterly virtuosity all but overwhelms images that should be greeted by visual silence [...] [Lebrun's] impassioned modernist vocabulary might have been effective in the cause of a different political art, an art of activism and advocacy, say, like the revolution-inspiring murals of Diego Rivera. But applied to the Holocaust, stylistic passion becomes theatricality and theatricality is an affront. (Quoted in Wolff 2008: 54)

This describes almost exactly the theatricality of *Hypothermia*, which continually, and unconsciously, drew attention to itself.

Oskar commits himself to death rather than see his friend, Lisa, suffer. His choice also reveals something else: that he has spent the whole play *pretending* that he cannot make a choice. Lisa thinks that 'Oskar will always make the last of two choices' (Brooks 2010: 5) regardless of which one appears rational. Erich thinks rather that Oskar is joking, that in fact, 'he's playing with us [...] smarter than we know' (ibid.: 6). The latter view is vindicated at the finale. Oskar makes the ultimate choice, to give his life for another, revealing a clear moral intelligence and certainly a 'pure' goodness lacking in any other character, especially the conflicted Erich. This feels like a direct answer to the question posed by Brook's research, that learning disabled persons would lack a 'cogent awareness' of the issues. Here, within the play itself, perhaps Oskar is answering such critics, implying that that while he may *appear* not to comprehend the greatest moral questions, this is in fact a ruse or camouflage. He is, instead, *playing the role* of someone who cannot give informed consent.

Yet the formal conventions once more complicate the issue. Is Oskar's rationality simply authored by Brooks? Does Langford understand the dilemma his character faces? Because the form seals off such questions, it is never open to debate. The danger, beyond these immediate

questions of authorship, is that of simplistic moralising. Art critic Janet Wolff notes the problem of 'pre-empting' the Holocaust by 'rendering it paradigmatic [...] in order to point out moral lessons or retrieve moments of redemption' (2008: 61). Such pre-empting is written into the form of *Hypothermia* since, as the author notes, it is a 'story about the most potent of topics, the value of human life and the human capacity for cruelty' (2010: pre-contents). Oskar does a saintly act and becomes a giver of life. In so doing, he *becomes* that 'moment of redemption'.

Another issue is the degree to which Oskar is the subject of talk rather than the maker of active meaning. Much of this is metaphorical:

Erich: It's not pity, it's value.
Katscher: Open this drawer. There is no value in ...
Erich: I've saved frostbitten plants that have cross-fertilised and generated fields of colour.
Katscher: Those fields of colour would bloom anyway without the need for a gardener. Nature does it.
Erich: Blonde beautiful bodies will all die of something.
Katscher: They'll look pretty and sing wonderful songs before they do.
Erich (*indicating Oskar*) He can sing.
 (*Oskar sings – a single, pure note. A silence.*)

The problem is that, despite what Erich says, pity, in this context, *is* the value. The moral question that the Holocaust asks is: 'What would I have done?' Yet, the play never invites this. It asks nothing of the spectator and therefore all one *can* do is feel sorry for Oskar.

The play also sets Oskar in binary opposition against other characters. He stands in absolute opposition to Katscher, the one who takes life. In simple narrative terms he is the 'good' to the SS officer's 'evil'. It is hard to say who is the protagonist of this play. Erich is the one who changes the most in terms of status, moving increasingly towards despair, unable to act or to stamp authority on the situation: he represents the confused liberal, failing to comprehend the challenge of fascism. Yet Oskar is the one whose decision changes things most for Lisa. His sacrifice makes redemption possible, not just for Lisa, but for us. Oskar's choice represents hope for humanity. In the character sketches at the start of the play Brooks notes: 'Oskar; an observer. Sensitive. Warm'. This in contrast with Erich – 'A shaky grip. An atrophied heart' – who is grilled by Katscher:

Jesus, what's wrong with you? Who in their right mind would want to work with such creatures? Um? A sadist I can understand ... a sexual pervert, yes ... but a normal man ... who enjoys working with morons? What is it? Guilt? Or does it make you feel superior? Think you're better than me, Erich? ... Some of us, Erich, have the guts and sinews to be active in this life. The rest of you stew and fester in your sickly sweet passivity. The idea that we are somehow elevated by our capacity to pity is tedious and naïve. The imbecile becomes sacred. Ancient superstitious nonsense. (Brooks 2010: 54–55)

The fascist, here, is asking the liberal whether supporting a vulnerable person makes you better than everyone else. And if so, is this because you are guilty of something? Psychologically, Erich explains his guilt by reference to the death of a disabled boy in childhood. He did not help, because, 'it wasn't what everyone was doing – do you see? My instinct was right. But I couldn't be different'. Perhaps this is too neat an explanation; it gets short shrift from Lisa, who counters: 'And look where that's taken us. Get off me you coward' (ibid.: 58). Liberalism – defined here as care for the vulnerable in society – is thus held up as a *cause* of fascism; Erich's 'type' failing to act results in totalitarianism.

I argue that Oskar's redemptive act renders him less, not more, human. The play suggests that his character range is so small as to be almost cartoon-like. Yet without his presence *Hypothermia* would have no dramatic irony. His choice is what gives the play a moral point. But the inverse effect of this is to render him devoid of the more complex psychology afforded his nondisabled mentor, Dr Erich. Denied an emotional range, he risks becoming a cipher rather than being a character. Furthermore, his sacrifice is good for 'us', but not good for him. He puts the needs of others before himself: he denies himself. As disability activist Paul Darke has argued, one aspect of 'normality drama' is the tendency for disabled characters to act not as protagonists in their own right but as narrative vehicles that allow others, more 'normal' than them, to grow and to change (Darke 2000). Read in this way, the theme of the play becomes more that of liberal guilt than the experience of a vulnerability. In the collaboration between artists, liberal guilt may be a valid subject; in the case of *Hypothermia*, however, the risk is that good and evil appear as a split in a binary opposition between two characters. Katscher, like Oskar, becomes one half of a moral divide. This takes responsibility away from the liberal – and arguably the dramatist – and places it in the hands of either an avenging devil or a sacrificial angel.[4] In psychoanalytic terms, such splitting of people into wholly good or

wholly bad categories is a neurotic defence mechanism. It places the 'problem' as existing outside the self and inside an 'other': a kind of scapegoating. Perhaps it is the projection of guilt that drives Oskar to effectively commit suicide.

Anomalies

Langford begins and crucially *remains* an anomaly outside the normative standard set by naturalism. His aesthetic separation creates a fissure in the theatrical form, yet the opportunity to examine it is not made available within the dramaturgy. His difference is not played as a value, but is set – or in theatre terms, *blocked* – by the conventions: it remains static. Langford reveals the workings of the machine from which he is excluded but neither he nor the play critique the exclusion. Theatrical anomalies (children, animals, machines, or, in this case, learning disabled actors) tend to reveal anxieties about exploitation, the figure on stage perceived as being there because they are 'owned' in some way. The 'knowingness' or otherwise of the figure on stage might also raise anxieties about their ability to give informed consent. It is in the affront to 'proper actors' that 'non-normative' actors reveal the unfairness of theatre itself.

I want to extend Ridout's argument here about the fundamental rupture that modernity makes with theatres of antiquity. Ridout (2006) argues that the presence of the non-human animal is a 'set' that stands outside humanity: they are viewed as standing outside history, as being 'pure', 'authentic', untainted by the unwritten laws that govern economic production; and are often viewed as economically or socially non-productive. Ridout argues that pre-historical theatre included every living being. Only with the onset of cities and with the distinction between intellectual and manual labour did theatre (tragedy) become the preserve of *only* humans, and a particular type of human at that. Seen as a myth of origins, the modern theatre is rooted in a violent expulsion:

> The pre-tragic theatre, material, feminine, infant and populated by the animal gives way to the tragic theatre that is ideal, male, political and only human. (Ridout 2006: 117)

Also: literate and vertical. The idea follows that an actor is one who stands tall (not on all fours, or stooped, or crooked) and enunciates words (rather than sounds) that have been written in advance via the intellectual labour of someone else, namely, the dramatist. Langford's presence is radical in this context: he makes the spectator notice *how hard the other actors are working*. This becomes comic; their effort 'sent

up' by his ease. Langford is almost effortless in the carrying out of stage duties. All he has to do is respond to the others, to echo them, to *be there*. His dexterity is physical not verbal, his mode responsive and rarely proactive. He is playing while they are working. Unintentionally therefore, there is a comedy in the following exchange:

Erich: I am convinced that the utmost care was taken at
 the Hadamar Institute. We are all professional.
Frau Poppendick: Professional what?

She is referring of course to the psychiatric profession but the exchange reveals another potential meaning, which is the extent to which those on stage and surrounding the production are professional. Who exactly are they? Are they professional theatre makers? Or are they partly carers? Are their roles as performers heightened or devalued in the act of holding Langford's hand as he enters the stage? Is their role and their art in any way compromised by the task of collaborating with Langford, less advantaged by education and training than themselves? Is he less of a professional 'actor' to their actor? As phenomenologist critic Bert States recognises, there are moments where anomalies stand out:

> In the image, a defamiliarized and desymbolized object is 'uplifted to the view' where we see it as being phenomenally heavy with itself. A transitional moment of shock signals the onset of the image: one feels the shudder of its refusal to settle into illusion. (1985: 37)

Langford's presence is the anomaly that refuses to stay within the constraints of illusion. As Ridout says, the material presence of anomalies on stage 'penetrates the membrane between its own realness and its signification' (2006: 125). Langford's presence does more than just complicate the aesthetic: it reveals theatre as an inherently economic arena. In positioning himself amongst those who are formally trained, he reveals training for what it is: a highly formalised mechanism for conveying a complex system of representation, embedded in a particular economic system.

Naturalism is not 'out of bounds' as a mode of representation for learning disabled performers; naturalism is simply not neutral. As a manifestation of modernist drives, it operates as a kind of aesthetic eugenics. It can be worked with, but not trifled with. The theatres of learning disability require a self-reflexive critique that remains alive to questions of form, whose borders can be permeable enough to generate

multiple interpretations. To this end, throughout the performance of *Hypothermia* as a spectator I wanted the cast to break out from behind the fourth wall. I craved for the artifice to break down, for the actors to reveal themselves *as actors*, to complicate the story they were telling in some way, to acknowledge that there were *problems* with representation. *Hypothermia* presents a world in which the binaries of disabled and nondisabled remain static, where the nondisabled person is a victim, where the theatrical forms keep audience and performer separated, and where, in the words of Katscher, the former is 'somehow elevated by [...] capacity to pity' (Brooks: 55). *Hypothermia* maintains the hierarchy of conventional form, without subverting or altering it. On this occasion the consequences are as much social as aesthetic.

Conclusion

I have analysed two contrasting works, considering each carefully in relation to the formulation of new, creative identities. I have argued that *Small Metal Objects* creates a space in which the audience becomes hyper-alert to their own complicity in forming identity judgements, and that by contrast, *Hypothermia* closes down the dialogue between audience and dramaturgy, largely because the work is done for them. In both these works, form plays a crucial role in mediating learning disability as a dynamic identity. In *Hypothermia*, form, like normality, appears neutral, but close analysis reveals its partiality. Naturalism's preference is for highly specialised, rational, corporeally precise performing agents who convey meaning through vocalisation. The meaning of the play is conveyed adequately as long as the audience is able to understand the words spoken. I am not arguing that any form is *a priori* 'out of bounds'; I am suggesting that form has to be understood critically, first. This highlights a primary issue in the formulation of appropriate critical frameworks: because learning disability is such a contested and unstable category, theatre has a role to play, not just in exploring identity but in *ensuring that audiences are implicated in the telling*. This is vital because disability is not a 'disabled person's problem'; it is, ideally, a shared societal contemplation about human difference. Disability implicates everyone and this is a formal question as much as an ethical one.

Wider theoretical implications may be drawn from these two case studies. Tobin Siebers recounts a number of beneficial outcomes in considering disability as 'complex embodiment' as opposed to an either/or of social/medical models. I list them below in order to highlight the parallels between theatre and disability theory:

- Complex embodiment theorises the ~~body~~ actor and its her represen-
 tations as mutually transformative. (Siebers 2008: 25)
- [T]he ~~body~~ actor possesses the ability to determine ~~its~~ her social
 representation (ibid.: 26)
- In almost every [...] case ~~people~~ actors with disabilities have a better
 chance of future happiness and health if they accept their disability
 as a positive identity and benefit from the knowledge embodied in
 it' (ibid.: 27)
- Disabled ~~people~~ actors who pass for able-bodied are neither cowards,
 cheats, nor con artists but skillful interpreters of the world from
 which we might all learn (ibid.: 24).

<div align="right">(All substitutions are my own.)</div>

From the theatrical point of view, then, the theory of complex *aesthetic*
embodiment challenges many ways of making and thinking about thea-
tre. The disabled actor, as a representative of human diversity, is an asset
to the stage. His actions may transform not just the representation of his
own disability but the theatrical form that he embodies or works within.
His body, framed by the ideology of the stage, has, *prima face*, an aesthetic
dimension. The way he looks, moves, interacts, behaves, delivers dia-
logue, dances, responds, enters and leaves the stage *is* complex embodi-
ment. By acting, literally representing himself and others, the actor may
influence social change. Whether he passes for able-bodied or whether he
chooses to play 'himself', he becomes 'a skillful interpreter of the world'.

Two other general principles may be drawn from these case studies.
First, the poetics of theatre and learning disability inverts normative
modes of success and invites contemplation about failure. Alan Read
comments that

> [w]hen something goes wrong in the theatrical fiction, a corpse here,
> a collapse there, it rarely forces cancellation but an increased level of
> attention and participation from the audience. (Read 1995: 53–54)

This fact is something that corresponds with the site-specific form
utilised by *Small Metal Objects*, where, if not failure exactly, accidents
and contradictions certainly contributed to the work's complexity. By
contrast, *Hypothermia*, in its formal adherence to technique, narrative
closure, audience distance, and a preference for giving Langford tasks
rather than text, was a work 'heavily insured against the risks of going
wrong' (Ridout: 32). A poetics of learning disability might recognise,
but not privilege, mastery of technique or perfection. If ineptitude,

forgetfulness, or lack of finesse are aesthetic qualities that increase audience attention, then these should be examined, developed, even celebrated.

Second, these artworks invite a contemplation of the entwining of moral and aesthetic complexities. For George Steiner, the poet who truly wants to extend the reader's moral universe must be prepared to extend the poetic language available. The reader, for her part, must be able to accept that the poet is purposefully making her work harder, in order that she can attain a higher level of understanding. This is what Steiner calls 'tactical difficulty', and works as a pact between an author prepared to risk obfuscation and a reader tasked with deciphering. The question of tactical difficulty is recast by learning disability; in the case of *Small Metal Objects*, the form operated, I argue, not as difficulty, but as tactical *complexity*. Gladwin's strategy was to allow the simple – the 'theatre of nothing', as Russell put it – to be radically re-contextualised. This complexity did not make the work difficult or inaccessible. Rather, it injected an ever-increasing degree of complexity into a work that was as simple or as complex as each spectator chose to make it. UK reviewer Howard Loxton made the point:

> I can't decide whether its novelty makes it appear more weighty or whether that novelty may be obscuring something deeper. Why *Small Metal Objects*? Maybe it is something Australian that I am too naïve or too innocent to know – but I wouldn't be surprised if somebody is already at work on a thesis about the mythical role of gender in transportational metatheatre or something rather like it! (Loxton 2007)

In fact, the title refers to the objects – 'Thirteen stubby holders, a collection of gemstones and a black key ring in the shape of a shoe' – that Steve collects; there is a passing reference to them at the start of the play when he explains, 'If I lost one of my things, I just couldn't go on living. That's what my life is about, keeping things that are valuable for as long as I can'. Loxton's ironic remark hints at the uncanny way in which the play *alludes* to such complexity without ever seeming to be anything but simple. Tactical difficulty/complexity also relates to the 'problem' of idiosyncratic speech patterns. To what extent is an audience prepared to 'tune in' to difficult speech patterns? In what sense is there a limit to variations on the actor's vocal 'norm'? For Steiner,

> [t]he authentic poet cannot make do with the infinitely shop-worn inventory of speech, with the necessarily devalued or counterfeit

currency of the everyday. He must literally create new worlds and syntactic modes [...] If the reader would follow the poet into the *terra incognita* of revelation, he must learn the language. The underlying manoeuvre is one of *rallentando* [meaning a reduction in speed]. We are not meant to understand easily and quickly. Immediate purchase is denied us. (Steiner 1978: 35)

Complexities arising from different speech patterns ask not just what can be communicated but what steps audiences and performers might make to reach one another.

At the end of *Hypothermia*, during the applause, the four nondisabled cast members made a formal gesture towards Langford, indicating that the audience should, briefly, acknowledge him over themselves. It was a small moment but a loaded one. The acknowledgement simultaneously signified their own generosity and his difference. This moment captures the operation of Foucault's 'capillary power': that is, the tendency for power to permeate the smallest units of interaction. The four actors had revealed in this moment, a little tear in the fabric of performance, an inequality in operation. If, as Brooks argues, Langford has taken 'his long overdue place centre stage in a text-based play' (2010: pre-contents), he does so as someone afforded a quite different status to the other performers. By way of contrast, in *Small Metal Objects*, a brief exchange between Gary, the drug dealer, and Alan, the lawyer, reveals a quite different power relationship:

Alan If I give you the money, how do I know ...
Gary Alan, did you use to play footy for the Broadmeadows Special School?
Alan No

In the live production, it is so small as to be almost unnoticeable but on the filmed documentation, close up, the confusion on Alan's face is palpable. It is not the fact that he did not (it is implied) attend special school, it is the idea that he might pass for someone who did. This subtle, subversive moment is a reversal of binary power dynamics. It is one of a series of moments in *Small Metal Objects* that turn the pure product of learning disability crazy.

3
On Quality: Disability and Aesthetic Judgements

The parallax gap

August 2004: Poet and arts consultant Dennis Casling writes, in a disability strategy paper for the Arts Council England:

> [T]he unavoidable fact [is] that the majority of disabled people who receive funding are people with learning difficulties or rather groups working with people with learning difficulties. Such people must, of course, be funded, but not at the expense of other artists and impairment groups who are most likely to represent quality art to the mainstream. (Casling 2004: 3)

September 2005: An undergraduate writes a letter of complaint to the Artistic Director of the West Yorkshire Playhouse concerning her visit to see Mind the Gap's *Of Mice and Men*. Knowing the 'very high standard of performance' at the theatre, she is 'disappointed and embarrassed' by what she sees. She thinks it is 'very admirable to support theatre groups with disabled members' but feels 'strongly that this should be made clear in the advertising of the play'. She also feels that many people, like her, found that the show they had bought tickets for was not what they expected (Brown 2005).

July 2007: At the *Act Different* symposium in Huddersfield, Lloyd Newson, Artistic Director of DV8, is invited to make a speech about diversity in performance. The most important thing, he says, is that the work (of differently able performers) has 'got to be good'. Newson speaks about the eminence of technical facility in dance, arguing that a failure to fully master technique risks 'demeaning the art form'. The question raises a great deal of debate. At what point might a certain

'lack of precision' cause a director or an audience to question the accept-ability of a performer? Might a dancer with intellectual impairment not fulfil the criteria for precision or have the ability to 'learn steps'? Could an actor with cerebral palsy or Down's syndrome ever be physically eloquent?[2]

July 2009: I tell a delegate at the Boal Summit in Rio de Janeiro that I am researching the aesthetics of theatre and learning disability. She asks what I mean. I say I am raising other kinds of questions than the ones usually asked, such as 'How does this group benefit?' or 'How effective is it as a means of raising political awareness?' I am asking things like 'How good is this work?' and 'By what criteria can we judge?' She stops me, open mouthed, and says, 'Why would I be interested in how *good* it is?'

September 2012: Jo Verrent, a disability arts consultant, who has worked within disability arts for many years, is troubled by the lack of critique available to disabled artists. Rather than pretend that work is good because it is produced by a disabled person, she calls for more robust criteria. She posts on her website a provocation: 'This is a plea to all promoters, producers, programmers and others who take on these functions. Please stop programming shit'.[1]

These moments evidence what Slavoj Zizek refers to as a parallax gap: a 'confrontation of two closely linked perspectives between which no neutral common ground is possible' (2006: 4); in this case, quality versus inclusion, social value versus value for money, aesthetic uniform-ity versus heteronomy. A parallax, *Webster's* says, is 'the apparent dis-placement of an observed object due to a change in the position of the observer'.[2] The parallax is that which cannot be mediated or reconciled through the dialectic: it is a parallax gap because 'the shift from one to the other is purely a shift of perspective' (Zizek 2006: 5). Only by mov-ing from one perspective to the other is it possible to see what the other sees: a consultant whose slip reveals a tension about the ability of learn-ing disabled performers to deliver on quality; a disgruntled audience member who feels she is not receiving value for money by having learn-ing disabled actors tell the story; a renowned theatre director who wants 'better' performers; a community artist with no interest in aesthetic debate, believing it serves only to exclude; a cultural activist convinced the time has come to change the perception of diversity as 'lesser' qual-ity. This chapter examines the parallax gap, as Frederic Jameson puts it, 'to perpetuate the tension and incommensurability rather than palliat-ing it or concealing it' (Jameson 2006). It is my contention that there cannot be an agreed set of aesthetic principles that mediate between

competing agendas; rather, there can be what Judith Squires terms 'principled positions', which lay bare the mechanism of judgement and open up a debate between competing viewpoints (see Wolff 2008: 11). The critical project of this chapter is to establish the underlying structures or interests that different perspectives serve, to perceive them more clearly and thus strip them of assumed neutrality or unquestioned superiority. My contention, also, is that no matter what perspective is utilised, a further operating principle of theatre and learning disability is that it must be valued – and critiqued and compared – as art. This is because theatre, not social care, is the institutional field that endorses and funds the works I discuss; and, politically, because the aesthetic and the social cannot be collapsed or synthesised. Paradoxically, it is only through separating out the fields of politics and art that art can be politically useful. Further to this, I argue that it is precisely by tackling questions of 'quality' and 'aesthetic value' that the underlying reality of the political is revealed. The first section in this chapter provides a discursive essay on the meaning of 'quality' in the context of current UK Arts funding structures, which takes a critical view of its relationship to diversity and aesthetics. I argue that value debates are crucial as a means of defence against reactionary 'universality' and to generate aspiration amongst learning disabled artists. The second section is a detailed case study of *Pinocchio*, a collaboration between two companies of learning disabled performers and a major mainstream theatre venue. This case study enables an in-depth analysis of how aesthetic values were embedded in a specific and revealing way, unmasking many underlying assumptions about quality, disability, and aesthetics.

Quality: why be interested?

The dialectic between instrumental and intrinsic value has been a feature of UK Arts policy debates since 1945. On a broader level, the debate perpetuates a dynamic of art's relationship to the social, which has featured throughout the twentieth century. The binary presupposes that there is a 'pure' something (called aesthetics), free from constraints, and an 'impure' opposing substance (the social), which complicates everything with relationships, power, and money. Any serious discussion of these issues must acknowledge the fundamental ambiguity of such a relationship. As Clifford Geertz notes, 'the means of art and the feeling for life that animates it are inseparable and one can no more understand objects as concatenations of pure form than one can understand speech as a parade of syntactic variations' (Geertz 1983: 98). He argues

that the notion of an aesthetic system, with universally agreed criteria, is a uniquely Western idea dating from the Enlightenment. Within the twentieth century, art theorist Claire Bishop cites three key dates – 1917, 1968, and 1989 – that have acted as catalyst for a utopian re-imagining of art's potential to create a 'better world'. 1989 is the most ambiguous, since the collapse of European communism ushered in a new era of neoliberalism. This post-ideological politics heralded the 'end of history', a claim that the old dialectic between competing ideologies was now defunct. This is the wider context in which debates about art and disability have taken place.

If 1982, the year Strathcona formed, is the inception of theatre and learning disability as an aesthetic practice, the New Labour years between 1997 and 2010, in the UK at least, represented its maturation period. There are two key reasons for this: first, the government made the Arts Council distributors of new National Lottery resources, which were explicitly underpinned by social agendas; second, they published 'Valuing People' (2001), a strategic plan to embed inclusive policies and practice at all levels of public life. Allied to the Disability Discrimination Acts (1995, 2003, 2005), these policies had several notable effects. Increased resources were made available during this period, accompanied by a growing recognition that investment needed to be allocated in line with individual requirements: 'Grants for the Arts' application forms contained questions about the access requirements of both artist and audience; 'extra' support costs incurred were viewed as legitimate and chargeable; and routes to paid employment were positively encouraged, even for those on long-term benefits. Thus, New Labour's cultural policy made explicit the social job that art should do: to become a weapon against social exclusion; theatre and learning disability benefitted as art became both a cultural symbol of, and a practical tool with which to tackle, social inequality.

Despite the positive spirit of 'Valuing People' and the inclusive intent behind the resource distribution, however, there remain substantial problems. There are still obstacles, for example, with regard to paying learning disabled actors. Until recently, individuals on long-term disability benefits were able to take a 'benefits holiday' of an agreed period of up to eight weeks, enabling them to do a professional tour and 'hop' back on benefits at the end. This has been replaced by Disability Tax Credits and Permitted Work arrangements; in practice, the detail of an individual's case is often at the discretion of the local officer and is dependent on a number of personal factors, making each case unique. Suffice to say, the 'benefits trap' means that the supportive

infrastructure underpinning the artworks analysed in this book are subject to bureaucratic layers of risk and ambiguity. The equality-driven agenda has also created a vacuum in the critical vocabulary available to marginalised artists. In the different, but allied, context of participatory visual arts practice, Claire Bishop makes this fundamental point:

> [T]he urgency of the social task has led to a situation in which socially collaborative practices are all perceived to be equally important artistic gestures of resistance: there can be no failed, unsuccessful, unresolved, or boring works of participatory art, because all are equally essential to the task of repairing the social bond. (Bishop 2012:13)

Bishop's point raises not just the question of government policy but of artists' own perception of their work. Her argument is that value judgements are *needed*, not to support elite hierarchy or to delineate between 'art' and 'non art' but rather 'as a way to understand and clarify your values at a given historical moment' (2012: 8).

The Arts Council's 'The Creative Case' (2012) indicates a policy shift from diversity as social deficit to diversity as human value, integral to all culture. The document indicates, rightly, that exclusionary practice is a complex process that cannot be addressed by simple mechanisms of non-oppressive practice, quota redistribution, or ring-fenced funding. It also calls for an end to the 'lack of profile and critical debate on work produced by diverse artists', accepting also that issues of 'historical distortion', 'exoticism', and 'lesser value' need to be analysed (2012: 17). This document, and the attendant case studies, *on the surface* represents a shift that mirrors the move from art as an advocacy tool to art as a complex system of identity representation, as discussed in Chapter Two; its argument, however, must be critically examined in full awareness of how it might be appropriated by public policy. This shift away was articulated, in part, by the then Head of the Arts Council, Peter Hewitt, in 2005:

> I believe the Arts Council no longer has any justification for a professional/non-professional distinction. Maybe that needs saying, loudly and clearly. But in order to cope with the scale and range of demand that might then be made on the Arts Council, we must do two things. Firstly, we must make clear that in a world without such distinctions, quality has to be the absolute determinant of our support. Secondly, we need to reaffirm that we will judge quality on terms that include quality of process, quality of execution, quality

of engagement, quality of distribution as well as quality of final product, and we also need to show new confidence in our judgment of quality. We might be helped in this by encouraging people, when making proposals, to define quality themselves, and by changing our language to draw out excitement, enthusiasm, and passion ('what's truly great about your idea?') as something the Arts Council is ready to respond to. (Hewitt 2005)

The report does what many policy statements do when addressing quality: it turns circular. The first part says there is no justification for delineating between professional and amateur, yet proceeds to claim that the Arts Council must be more concerned with quality judgements. Such discerning judgements, however, are a mark of the professional, the person who engages in long years of specialist training in order to make them. The paragraph ends by saying that 'new confidence' in judgements will come from asking people – presumably both amateur and professional – to define quality for themselves. But the *criteria* he offers are 'excitement, enthusiasm and passion', which are, *reductio ad absurdum*, the definition of amateur, one who plays for love, not money. Collapsing the professional/amateur distinction is suggestive of the neoliberal process of building an individualised, entrepreneurial workforce prepared to work for little (or nothing) and to accept that risk as their own responsibility. In this world, everyone is an artist, if by artist we mean marginal, poor, at the whim of contingent sponsorship. The focus on quality as a facet of process diminishes the true question of quality, and the primary concern of aesthetics, which is: how good is this work and by what criteria shall we decide?

In another highly influential report, Lord McMaster identified diversity as integral to quality but also argued that criteria must be objective:

Within these concepts of excellence, innovation and risk-taking, and running through everything that follows below, must be a commitment to diversity. The diverse nature of 21st century Britain is the perfect catalyst for ever greater innovation in culture and I would like to see diversity put at the heart of everything cultural. We live in one of the most diverse societies the world has ever seen, yet this is not reflected in the culture we produce, or in who is producing it. Out of this society, the greatest culture could grow [...] it is my belief that culture can only be excellent when it is relevant, and thus nothing can be excellent without reflecting the society which produces and experiences it. (McMaster 2008)

The report enfolds diversity and quality to the point where they both vanish. Excellence (the new quality) is only apparent if relevant; and relevance is (currently) diversity; so to be excellent one must be diverse; and everyone is diverse; and so on, until the criteria collapse on themselves. Perhaps this should come as no surprise; for Terry Eagleton, the aesthetic is 'always a contradictory, self undoing project' whose theoretical language offers always to undermine the object of its appreciation (1990: 2–3). In speaking of the aesthetic and in intervening in a discussion of value, I am also, inevitably, entering into a dialogue about 'dominant ideological forms of modern class society' (ibid.: 3). Yet this truism, in itself, offers to subvert the aesthetic: if art is always the product of class, and can only be rescued by competing ideological counter-systems (feminism, disability studies, post-colonialism, and so on), should this mean that it is no longer possible to defend *any* transcendent or even partly objective value; that quality is *always relative*? I will return to this question shortly. For now, I will suggest three reasons why it is *vital* to defend aesthetic value from within the field of theatre and learning disability.

First, without critical engagement, the agenda will be subverted by reactionary positions that call for a return to 'traditional values' and 'universally accepted' notions of 'good' art. Andrew Brighton, formally a senior curator at Tate Modern, argues that the 'propagating of serious art amongst those who are relatively uneducated is an act of cultural aggression' (2006: 5). Art by 'priority groups' – for example, working-class or pensioner – or in those '"underrepresented" amongst the educated' – for example, black and ethnic minorities or disabled – is bad, not simply because it is non-universal but because it is unnatural (ibid.: 7). He delineates also between art that is made by educated people and 'art which has no significance except for those who make it' (ibid.: 5). Crucial to this argument is the notion that such art takes place outside 'any elaborated culture of reception or production' (ibid.), which is 'still the elitist enemy' (ibid.: 10). Brighton's position is indefensible. The claim for art's universality is incommensurate with a critical assessment of the aesthetic. He shares with Edmund Burke the notion that aesthetic judgement must be stable and universal (see Eagleton 1990: 52). There are, however, no empirical grounds for this assertion. Rather, the universal works as ideological cohesion, helping a diverse industrialised society to achieve shared values. The claim for universals typically avoids the question of criteria:

'Moral sense' is equivalent to confessing that there is no longer any rationally demonstrable basis for value, even if we nevertheless

continue to experience it. Morality like aesthetic taste becomes the *je ne sais quoi*: we just know what is right and wrong, as we know that Homer is superb or that someone is standing on our foot. Such a viewpoint combines the dogmatism of all appeals to intuition or 'felt experience' with a serenely pre-Freudian trust in the subject's immediate presence to itself. (Eagleton 1990: 64)

Brighton's claims are rooted, not in a system of aesthetic evaluation, but in a simple, highly ideological and, I argue, groundless assertion that educated people should be able to 'do art' and others – the uneducated – not. In common with most conservative critiques of 'diversity', the writer assumes a position of neutrality against the 'ideological state', which is handing out money to 'diverse' people. In point of fact, his is a competing ideology that 'just knows' what is good art and what is not.

Second, the aspiration toward aesthetic quality from 'minority artists' is a way of combatting social prejudice. Brighton is right to attest that questions of quality are undeveloped in some fields (notably theatre and learning disability) but this is precisely why they are needed. Their absence is a challenge, not a *fait accompli*. Disability consultant and cultural activist Jo Verrent defines what she means by saying some work by disabled artists 'is still a bit shit':

What do I mean …? Well, this is a very personal list, please feel free to create your own. It's subjective of course. What hits the mark for one person, won't do the same for all others. For me, the list is as follows:

- work that's shown before it's ready
- work that pulls back, and doesn't let itself push where it should
- work that doesn't have a clear intention
- work that's really a workshop on stage
- work that's placed in the wrong place at the wrong time because it ticks a box on someone's list, not because the context is right for the work
- work that's more for the benefit of the people performing it than the audience who comes to see it

(www.joverrent.com September 2012)

Verrent's provocation deals directly with often unvoiced assumptions, and is allied to her practical intervention: the co-production of a series of 12 promotional films, all designed to underline quality work by

disabled artists. Under the collective title *Push Me*, they accentuated the diverse aesthetics of the works, which had all been commissioned as part of the disability focused Unlimited Festival (2012).[3] The films, two of which were discussed at the end of Chapter One, are all just 90 seconds long, accompanied by a brief interview with the artist, and seek to capture some of the stunning visual images that grow from the works. The works range from aerial dance (Caroline Bowditch), to intimate 'private dancing' involving one audience member (Janice Parker); to large-scale site-specific (Jez Colborne); to the conflation between manic depression and circus (Stumbledance); to stand-up comedy (Laurence Clarke); and – as discussed previously – wheelchair scuba-diving (Sue Austin). Verrent's wider goal was to challenge the negative perception of disability arts as lacking in ambition and quality. Here, we are encouraged to see art *by disabled artists*, not frightened to take risks, wishing to be regarded as the equal of any other artist. Verrent has spoken of the theory known as 'drench hypothesis', which refers to the impact that an unusually positive portrayal of a cultural minority can have in challenging stereotypes, for example the *Cosby Show* in the US, which sought to challenge the idea of a 'typical' Black family. More disturbing, Verrent argues, is the tendency for digital images of disabled people on line to become 'troll magnets', meaning that they become targets of hate-filled posts and derisive abuse. For her, *Push Me* was a way of combatting such prejudice: the quality of the images was a way to strategically avoid being the source of mockery or humiliation (Verrent 2012).

A third argument for the reintegration of quality into the field of theatre and disability is that, properly utilised, it has a demystifying purpose. As Peter Schjeldahl notes:

Quality [...] has been abused by those who invest it with transcendent import, rendering it less a practical-minded rule of thumb than an incantation. Quality is a concept of humble and limited, but distinct usefulness. It is the measure of something's soundness, its aptness for purpose [...] Much resistance to the reality of quality, as a measure of fulfilled purpose, bespeaks the condition of people who either lack a sense of purpose or whose purposes must, by their nature, be dissembled. (1998: 59)

Schjeldahl's pragmatism renders quality relative to purpose. Rather than see quality as a pre-existing mythical substance, quality remains the evaluative tool of the craftsperson. Quality is not beholden to one form over another, or to a singular definition of the 'right' aesthetic,

but is pliable and contextually supple. The criteria for judging the quality of *Small Metal Objects* must be different from those for judging *Hypothermia*. Quality judgements are thus allied to, but separate from, aesthetic preferences. A piece of naturalism can be well executed but emotionally unengaging; post-dramatic theatre can be conceptually rigorous, original even, yet boring. One can dislike a performance but acknowledge the quality of its execution, whether conceptual, technical, or for its propensity to change perception. Where the current debate about aesthetics, theatre, and disability tends to collapse is in the assertion of artistic preference for certain modes on behalf of the entire sector. This need not be the case. Invariably, theatres of learning disability are just that: a plurality of forms and modes of representation, which cannot be rationalised to a single model.

What is at stake, on a theoretical level, is the question of value after post-critical aesthetics. Feminisms, colonialisms, and structuralisms have attended to the problem of how the 'universal' is ideologically constructed. Yet, even when instability of value is acknowledged, artists still deserve a mechanism with which to address the primary question of aesthetics, which is: how good is this work? A framework is required that neither abandons principles of aesthetic judgement nor surrenders to pre-critical universals. Janet Wolff's 'aesthetics of uncertainty' is such a framework: rooted at the intersection of relativism and universality, this system, Woolf argues, makes it possible to negotiate an agreed set of standards *within* communities of interest and *between* competing canons that does not descend into uncritical defence of Enlightenment hierarchies (see Wolff 2008). Aesthetic judgements need to take account of the social inequalities that have led to marginalisation and the institutional and political facts that perpetuate it. The distance travelled by a learning disabled actor over the course of a single show (in terms of technical reach and delivery) may be far greater for them than for an actor who has benefitted from a regime of formal training. The formal 'problem' set by an actor with little or no vocal projection, and the solving of it through innovative staging systems, can lead to new aesthetic insights, their power deriving precisely *through* the technical restriction. Despite these inequalities, it is still absolutely necessary to engage in a debate about the formal qualities of the work: to accept tokenistic or 'good enough' critique is to fail the work; the absence of debate signals indifference, or at least lack of aspiration. Whatever else the work of the companies analysed in this book may be, it is aspirational and deserving of close critical attention. It is not a question of arriving at the 'right' aesthetic judgement nor at the 'purest', since, as I have argued, there

are no disinterested positions. Aesthetic preferences can be negotiated not just in relation to qualities inherent in a work but as the mode of thought by which the work is appreciated. As Peter Abbs notes:

> Aesthetic denotes a mode of sensuous knowing essential for the life and development of consciousness; aesthetic response is inevitably, through its sensory and physical operations, cognitive in nature. (1987: 53)

Diverse cognition highlights the instability of reception. It concedes a self-evident fact: not everyone sees the same thing. Furthermore, not everyone commands a precise and formal language with which to express their appreciation. It is therefore doubly necessary to allow for 'uncertain' and partially formed, perhaps even seemingly 'nonsensical', notions of what constitutes quality in certain works.

Recent debates within participatory art (Bishop 2012; Jackson 2011; Kester 2004) centre on the interplay of autonomy and heteronomy: the dichotomy that arises between single and collective authorship; and between the *ergon* of the work (the aesthetic artefact that can be seen) and the *paraergon* of its supportive framework (that which exists around and beside it, which is very often invisible to the spectator). Many of the *Push Me* films, for example, invoke the complex interplay of supporting frames that underpin the artworks. Sue Austin is supported not by her chair but by a crew of invisible divers. The chair, which has a particular utility on land, is rendered wholly aesthetic in water. The interdependency of the aesthetic is revealed as she leaps into the sea: there is no way she could survive without the support of others. This is a recurring motif: the supporting sticks in Jenny Sealy's *The Garden*, which allow the actors to hover and dip in the air; the ropes and pulleys in both Ramesh Meyappan's *Skewered Snails* and Caroline Bowditch's *Leaving Limbo Landing*; Claire Cunningham's conflicted love for her crutches; Laurence Clarke's Powerpoint (which aids interpretation of his 'difficult' speech). It is not just that the artwork reveals the mechanism of support; it is that such support is *integral to* the aesthetic. The complex network of support that enabled Jez Colborne to become an author of his own musical *Irresistible* (songwriting and production support, for example) is not immediately apparent from the film, however. This evidences the way in which learning disability sometimes complicates the *paraergon*: the support is not always visible in the way that it is with physically disabled artists.

Aesthetic autonomy implies that the work stands alone, that it does not require a contextual frame or to be placed 'in quotes'. Many of the

underlying issues in theatre and disability stem from the inversion of this convention. The *Push Me* films, in their high definition, belie the rough mechanics underneath: messy things like relationships, economics, power, control, dependency, loathing, care, and value judgements. Yet the quality of the actual film stock points in itself to the degree of support offered to these projects. Almost uniformly, the artists who had been awarded these commissions had undergone a rigorous selection procedure and attained higher levels of financial and practical support than they had enjoyed previously. The *Unlimited* commissions were designed to increase the material resources available to disabled artists. In music theory, quality means the number of harmonics of a particular frequency that contribute to the richness of the sound: the higher the quality, the better the sound. Quality in digital film relates to the number of pixels contained in the frame, the clarity and sharpness of the picture; it relates to the vividness with which the object can be seen. *Push Me* highlights the material reality of quality: far from mysterious or ineffable, it is dependent on investment. Money and resources sharpen quality.

Pinocchio (2007), the tale of a puppet

Pinocchio (2007) was a first-time collaboration between York Theatre Royal (Vicki Hackett, Laura Sanchez, Robin Simpson with Director Damien Cruden) and four learning disabled actors from two companies, the Shysters (Jon Tipton, Lisa Carney with Director Richard Hayhow) and Full Body & The Voice (Ben Langford, Peter Wandtke with Director Jon Palmer, prior to the name change of Dark Horse). Also involved were dramaturg Bridget Foreman and composer Christopher Madin. Formally, it is a piece of movement-based theatre that uses montage, musical score, and mime to convey meaning. Set in a shantytown on the edge of the sea and surrounded by huge urban high rises, the adaptation centres on a marginalised fishing community. The narrative is supported by a voiceover spoken by Azura (Vicki Hackett), a poetic text that delivers a whimsical philosophical take on the story in a broad sea dog Yorkshire accent. The adaptation centres on eight scenes from the original story and is the only piece discussed in this book that was specifically designed for a 'family' audience. The adaptation assumes that the audience is familiar with the material and very often implies the story through image as opposed to leading us completely through the narrative. Pinocchio's rite of passage from puppet to boy is based on two scenes featuring the travelling marionette show: one at the centre of the

play and one at the end. These are dramatically defined by allowing the actors speaking parts as puppets. They do not speak text elsewhere; the entire piece is engulfed by a huge, rich musical score. The puppet scenes mark Pinocchio's journey: he meets first with puppets and a second time with puppeteers. They define his passage from one world into another. The piece's most intimate moments occur in these two spoken scenes and also in a moment before the show has begun when the actors just appear on stage 'as themselves', exploring the stage before the show 'proper' begins.[4] The 'play proper' is anarchic in the sense that it breaks several conventions: the idea of Pinocchio's nose is created by a broom handle and then immediately discarded; stylistically it hovers energetically at the boundaries of several forms – theatre, mime, dance – never quite settling for one; and some scenes have little narrative momentum, tending to 'fill' the musical score rather than develop character or plot.

For the remainder of this chapter, I concentrate on the rehearsal and production process of the show, focusing on the evaluative reflections of key players. I suggest that *Pinocchio* is a bold experiment in 'integrated' theatre, but that it represented, in Foreman's words, 'a watered down version of what we hoped to achieve' (Foreman 2007). The gap between intention and outcome leads to generative insights and to a concrete consideration of the values that underpin abstract terms like diversity, quality, and representation. I offer three main avenues of theoretical enquiry that have evolved in response to the work and that are of direct relevance to the wider field of theatre and disability: the interplay between autonomy and heteronomy in the authorship and form of the work; theories of support that consider the aesthetic scaffolding – both visible and invisible – required to respond to the needs of actors from different training traditions; and a critical response to 'authenticity' as an operating value.

Artistic visions

Pinocchio was a self-consciously elegiac work, a call for community values in an age of technocratic individuality – it is no accident that the set design was informed by images of Old Shanghai, demolished to make way for high-rise Beijing. That sense of elegy was compounded by the artists' desire to capture the 'authenticity' of the learning disabled performer and also the fact that Palmer and Hayhow left their jobs, as Artistic Directors, shortly after *Pinocchio* was completed: it was at once a journey towards integrating dominant and marginal voices and a final bow, which raised serious questions about that possibility. The project was conceived in 2004 and underwent a lengthy gestation period,

including development weeks and symposia that addressed learning disability and aesthetics in national forums. *Jumping the Shark* (Symposium 2006) took its name from the media term denoting an unexpected or spectacular plot twist in a long-running television show, at a point when the show has begun to lose its way and needs a fresh impetus. Since the episode of *Happy Days* in which Fonzie literally jumped over a shark, the term has defined a creative effort that has moved 'beyond the essential qualities that initially defined its success, beyond relevance or recovery'.[5] Hayhow's provocation was similar: 'How do we keep the creative spark alive? How do we connect with and influence other theatre and dance practice?' (Symposium 2006). From the outset, then, *Pinocchio* was rooted in a self-reflexive process. *Learning Disability and Contemporary Theatre: Devised Theatre, Physical Theatre, Radical Theatre,* which Palmer and Hayhow self-published in 2008, further articulates this reflection and makes a case for an 'authentic' theatre. The authors refer to the learning disabled person as inhabiting a 'different' place culturally and translate this notion into performance: they advocate work that 'arises from the needs and abilities of the individual performer on the grounds that an authentic performance will never come from imposing alien theatrical models on the actor' (2008: 59). The term floats over the book offering insight into an 'aim [...] shared by many [...] who perceive authenticity as a fundamental premise for profound theatre' (39). Palmer and Hayhow devote an entire chapter to 'authenticity' but do not narrow it down to a unit of critical currency. In what follows, I extract the determining criteria of 'authentic' from the text in order to draw out the version of 'authenticity' that their book explicitly promotes.

First, the authors base their theory of authenticity in a particular approach to disability. For Palmer and Hayhow, learning disability is 'ordinarily taken to refer to' a breakdown in normative socialisation; this results in an inability to acquire the full range of communicative tools, such as reading and writing, and often in an inability to '"censor" certain "inappropriate" behaviours' (2008: 41). Authenticity, in this case, is that which is natural or innate within the individual before the social moulding takes place. They argue that the learning disabled person, due to their lack of sophistication in social terms, is more 'naturally authentic' and that they bring this quality into the rehearsal room. Second, they regard the learning disabled actor as primarily nonverbal. Authentic performance is an escape from the 'tyranny of words', a phrase that they borrow from Artaud (37). Rather than rely on spoken text, such theatre depends on an intense physicality, 'intimately tied

into the actors' own natural bodily manners' (50). Third, this does not mean that the final performance needs to be utterly spontaneous. The authors refer to the control required to repeat a performance: the act of nightly repetition, fully informed by the awareness of an audience, is crucial to performance, but it must be maintained 'authentically', that is, 'without losing the connection with themselves or the audience' (47). The fourth marker of authenticity, implicit in the text, is the authors' desire to glimpse the 'real person' in performance, a belief that manifests in the distinction between character and actor. Palmer and Hayhow cite their own practice in the body of late twentieth-century devised theatre that borrows from performance art, site-specific 'happenings', physical and visual theatre. Broadly speaking, as Heddon and Milling define it:

> The liveness of performance led often to a focus on action rather than acting, and performing equated with doing rather than pretending. Perhaps paradoxically live performance offered the potential for authentic activity and within this frame, representation might be considered as presentation. (Heddon and Milling: 63)

Just as in the Happenings of the 1960s, 'performers purport to present only themselves' (quoted in Palmer and Hayhow 2008: 45); so, too, the actors from the authors' respective companies have tended to blur the distinction between themselves and the role they are playing. Fifth, authenticity is marked in the ownership of work by the performers. Paradoxically, this boundary is best facilitated and monitored, it is suggested, by the nondisabled director whose role it is 'not only to aid the actor in reaching into themselves [...] but also to enable them to become increasingly aware of themselves' (49). Failure to ensure ownership of the work by the disabled actor will result in 'false authenticity' (49) that 'shirks from the rather scarier aspects of true authenticity' (ibid.). The concept of 'false authenticity' is bound up in what I identify as the sixth and final component of the term: that which relates to the theatrical form. Authenticity drives the authors to resist 'conventional theatre' in all its forms and stems from their view that certain forms of theatre risk

> reinforcing the perception of good theatre as rote-learning or 're-presentation' of a role, whilst effectively forcing actors with learning disabilities to produce theatre that is quite alien to them and is even misrepresentative of their world view and perceptions – their 'ways of being' and 'ways of seeing'. (2008: 54)

Fundamentally, Palmer and Hayhow argue that there are certain forms of theatre that are bad for those actors defined by intellectual impairment and some that are good: self-exploratory/devised/visual/gestural, good; spoken text/role interpretative/pre-existing narrative, bad. By extension, authenticity must refer to the *essential nature* of learning disability, something that exists *a priori* to the theatre and that can be judged as present – or absent – both in the person and in the work.

Creative tensions

The principles of authenticity, as defined above in Palmer and Hayhow's terms, were 'contaminated' during *Pinocchio's* rehearsal process by the exigencies of show deadlines, funding restrictions, and competing definitions of quality. Palmer acknowledged that his original goal with Full Body & The Voice – to create an ensemble that questioned the foundations of theatre as a form – floundered because the 'audiences were not getting any bigger [...] it was very specific work for a very specific audience', and that it 'became difficult for the company to justify its own existence'. Palmer, therefore, sought a 'new strategy' to 'see if our performers could influence the mainstream' (Symposium 2006). Out of this process came the collaboration with York Theatre Royal.

Two main creative tensions arose in various symposia prior to rehearsals in October 2007.[6] There was a major debate around the amount of time that might be needed to realise the production. One (nondisabled) actress felt that, to do justice to the project, the cast would need eight weeks (Symposium 2005). Palmer was opposed to this, arguing for the regular four week Arts Council-funded process, on the basis that anything else would marginalise the work further. For him, the point was to get the work on the main stage, delivered on time, at a reasonable cost, avoiding a 'special case' argument (ibid.). Cruden spoke of the mainstream 'ecology' of rehearsal (three weeks rehearsal and one week tech) that might not fit with the more exploratory process of the two companies of learning disabled performers. The Shysters' working process could usefully be compared with that of a number of experimental companies, such as (the now disbanded) Goat Island. For example, Nick Fryer (2010) defines the latter's devising process in the following terms: first, it was based on a very long, deliberately 'inefficient', gestation period encouraging the company members to create a devising practice of their own, rather than reproduce the model of economic efficiency that usually frames the creation of performance work. Second, the work tended to 'create itself', following its own logic, and performers were encouraged to 'give up' the idea of owning their work. Third, the form

was clearly post-dramatic, making use of formal and thematic juxtapositions that create unusual and disparate links between ideas, rather than reproducing existing forms (see Fryer 2010). The same could be said of the Shysters; as Hayhow articulated it, *Falling Angels* (2002) took two years to create, via a process of 'deep voodoo, not shallow magic' (Symposium 2006). Ironically, Hayhow, borrowed the 'voodoo' reference from Michael Boyd, then Artistic Director of the Royal Shakespeare Company (RSC), in his defence of ensemble funding. For both companies, operating in very different performance ecologies, the primary currency was time. Indeed, Hayhow evinced that 'the process becomes the aesthetic: the fullest expression of the people in the ensemble is the form that the work takes' (ibid.). Despite this, the eventual rehearsal process followed a mainstream ecology, lasting four weeks in total, and Palmer's wish to see the work on the main stage of York Theatre Royal was realised.

Another major and continual tension in the process of making *Pinocchio* was the working relationship between disabled and nondisabled performers. For Hayhow, 'the problem with integrating disabled and nondisabled people is that the work becomes weighted in favour of the nondisabled world' (ibid.). He had experienced past collaborations and felt that each time the work had lost something in the translation. For him, the primary objective was to 'go to the new world of the learning disabled performer first', but he found that this often caused problems as the nondisabled actors were more concerned with structure and the memorising of text in advance. Palmer described his own working method as 'chaos', and said he was 'quite happy with that' (Symposium 2005). The tension between freedom and structure was thus inherent and played out in complex ways throughout rehearsals. The 'binary' dynamic between nondisabled 'efficiency' and disabled 'creativity' in many ways defined the working process.

Heteronomy/autonomy

Cruden observed, in early discussions, that the learning disabled actors tended to slow the pace down and to repeat material from earlier improvisations in an unstructured way. For Cruden, the challenge was 'how to work something to a point where the piece is *meant* and *clear*' (Symposium 2006, my emphasis). Intention was thus a marker of quality for Cruden. To put this in context, I witnessed one improvisation during the development week where, during a scene in which Pinocchio faced death by fire, one of the disabled performers casually asked, 'Where are we going to get a gas fire at this time of night?';

and as the improvisers circled around the problem – both literally and metaphorically – the same actor stated, 'We're going round in circles'. These moments cut across the intentionality of the other performers: they hijacked the formal 'rule' of improvisation to 'accept and build'. There was a palpable sense of confusion from the nondisabled performers, which perhaps invoked Cruden's concern. There are several ways of viewing such moments, for example as Brechtian distancing or as ironic post-dramatic failure.' They suggest the underlying heteronomy within artworks: the tension that derives from shared authorship, and, in this case, a confusion that ensued in the creative team about how to harness it.

The critical terms 'heteronomy' and autonomy' have marked debates within visual arts, particularly in the field referred to as 'socially engaged' art practice, which seeks to remove the barrier between artist and participant or between maker and spectator (see Bourriaud, Kester, Bishop, Jackson). Such terms tend to shift meaning depending on context. Autonomy denotes self-governance, as opposed to heteronomy, which is governed by rules from an external source. In art terms, the distinction can be made between the *ergon* of the autonomous aesthetic artefact and the *paraergon* of the heteronomous social context. The notion of the autonomous artwork is a vexed one. The Kantian notion that art must be removed from a means/end relationship and remain a thing in itself has been, as I noted earlier, comprehensively challenged by Marxist accounts in which the aesthetic reveals underlying class ideology. Later neo-Marxist readings complicate matters further: for Bourriaud (1998), the distinction between text and context is spurious because he is concerned to promote works that deliberately blur the distinctions between artist and participant, or between the 'process' and the 'event'. For Rancière (2002), the situation is more complex still: the very tension between heteronomy and autonomy is precisely that which must be *accentuated* in the interests of political emancipation. Radical 'undecidabilty' – that ineffable quality that cannot be reduced either to 'art' or 'life' – gives the aesthetic its particular power. Rancière moves beyond the social/art binary to suggest that all aesthetic experiences are political because they cannot be reduced to simple social formulae: it is art's ability to make us 'think contradiction' that is its ultimate political offer.

In recent years, art theorists Grant Kester (2004) and Claire Bishop (2004, 2006) have engaged in vigorous debates as to what constitutes quality in participatory art practice. For Kester, the ethics of the process are a primary marker of aesthetic quality: the depth of the relationships,

the de-hierarchisation of roles, and the shared ownership of the creative event *are* the aesthetic. The 'artist' is to be judged, not on the artefact itself but on the extent to which she applies 'good' or 'bad' models of collaboration. 'Good', here, means consensual dialogue and sensitivity towards difference, and 'bad' means 'using' or 'exhibiting' participants in pursuit of an autonomous – and singular – artistic goal. Claire Bishop, on the other hand, argues that these humanist ideals mask more complex political mechanisms and become a new kind of 'repressive norm' (2012: 25). Bishop is critical of pervasive neoliberal government agendas, and sceptical about the capacity of art to 'represent' difference and the likelihood that change will come about through such representation. Her foundational principle is that art is best served by acknowledging authorial presence and cannot be collapsed into a model of democratic social relations. Bishop, in turn, has been criticised by performance theorist Shannon Jackson (2011), for 'over-valuing' artist-led works simply because they follow a more antagonistic and disruptive path. These debates, while not always directly analogous, are important as means of theorising *Pinocchio*. The autonomy/heteronomy tension became apparent through rehearsal in two ways: in the competition between the primacy of process and product; and in the shifting territory of artistic directorship.

Despite the role he played in choosing and planning the source material, Cruden – officially the director – exempted himself from rehearsals. At key moments, however, he intervened to make decisions that were acted upon by Palmer, Hayhow, and Foreman. Cruden watched a run-through at an embryonic stage of the piece's development. His critique revealed three important issues: the work did not show *all* the actors to their full potential; the use of verbal text was inconsistent; and that to make the narrative clearer, there needed to be added some kind of storyteller. His point was that the *nondisabled* actors needed a kind of liberation, to be free to use language. Up to this point the play had progressed on the understanding that since not all the actors were verbally expressive, the whole company should seek more non-verbal means of expression. Hayhow felt from the beginning that there was a risk that as soon as the nondisabled performer spoke, the audience would read them as the 'better performer', that somehow the disabled performers' 'lack' of verbal expression would be exposed.

By way of compromise, two scenes in the play broke with the predominantly non-verbal approach: the midpoint scene where the actors portray puppets, all of whom spoke freely, and the final scene in which the puppets are revealed as actors, human beings who portray

the puppet world, again speaking, even more freely this time, closer to a stage persona of 'themselves as actors'. The energy of the performances was magnified during these scenes, and the distance between performers and spectators, in the large auditorium, seemed to reduce. It reflected well on all the performers, not simply the most verbally eloquent. Hayhow reflected later:

> The scenes with words were a deliberate attempt to explore that territory in a way that would allow all the actors to speak without creating the situation in which the audience could potentially read anyone as a 'better' performer. Whether those scenes succeeded in doing so is a different question. Playing to the actors' strengths as Damian [Cruden] was saying is important but it must be counterpointed by the way in which these strengths could be interpreted. (Hayhow 2008b)

The decision to use direct speech at fixed points highlighted the lack of speech at others. The piece became a dialectic between intimate aesthetic – spoken, direct – and a distant one that positioned the actors as 'movers' behind a musical fourth wall. The spoken text had the quality of anarchy in upsetting formal convention, testing audience perception of who these actors were. It is clear that value judgements became more charged as the first night got closer. The exigencies of an audience forced artists out of discussion and into concrete choices about what would be most likely to ensure quality.

Foreman's role as dramaturg developed into that of scriptwriter. Her voiceover text stemmed from Cruden's recommendation that a form of verbal storytelling was required to compensate for the gaps left by the predominantly visual form. It is tempting to view Foreman as a surrogate for Cruden, or indeed for the conventions of mainstream theatre in general. She worried that the pace was being set by the disabled performers and that there was 'no unifying style'. Of the work, just after opening night, she said, 'We lurch around a lot [...] is it unfinished, a lack of coherence?' It was precisely this *lack* of coherence that Palmer wanted to accentuate more. He felt that aesthetic disparity was a value present in Kneehigh's *Cymbeline* (2006), which he loved: 'It was like they had continually asked, what works for this scene? Fuck the aesthetic unity of the play.' Palmer felt that the compromises made to narrative coherence were disappointing, and asked, '[I]s that all we are doing, trying to make it clearer to the nondisabled audience? If so, what was the point?' (Palmer 2007). Foreman's role was clearly a difficult one, an act

of mediation between a large-scale theatre and a competing aesthetic system. Perhaps this contributed to her feeling that the main strength of the piece was not in formal structure or elements of the work but in the 'relationships between the actors on stage' (Foreman 2007).

Where are the voices of the actors in all this? The antinomies of autonomy/heteronomy were evidenced in the work of the 'creative executive', not debated amongst the cast. As Hayhow acknowledged at *Jumping the Shark* (to which no learning disabled persons were invited), 'their role is not to be directors, that is not their skill' (Symposium 2006). A most illuminating comment about process came from one of the disabled actors: 'I enjoyed the performance of the directors most' (Symposium 2005), suggesting that the 'main' show was off stage, an interplay of competing aesthetic systems that remained occluded from the eventual spectators. I recall an image from early rehearsal, the three directors in matching dress (jeans, loafers, V-Neck sweaters): Hayhow in the ensemble, Palmer at one remove, and Cruden on the outside, taking notes. This captures something of the scrutinising pressures summed up by Hayhow ('We wanted Damian to be happy with it, there was so much riding on it') and Palmer ('I was very aware of Damian's status [...] within the profession and the region, so maybe you censor yourself, maybe that is why it became so safe'). In this context, autonomy, whether political or artistic, had no real currency. It is easy to suggest, with hindsight, what might have been different: an embracing of the antagonism between the free and the structured; aesthetic incoherence as a value; a relinquishing of control by the main house. Clearly, *Pinocchio* was a teeming, complex interplay of relations. Its failure was in not recognising the opportunities that this heteronomy afforded, and paradoxically in the lack of a wilful authorial presence. Foreman's belief that the primary strength of the piece lay in the relationships between the cast members might have been utilised and embedded more creatively *within* the aesthetic. One initial concept had been the notion of the actors on stage 'as themselves'. This idea was not realised, *because* authorship had been spread so thinly and its force diluted. The debate is reflected in the views of an Arts Council audience member who told Palmer that *Pinocchio* had made her reflect critically on the suitability of integrated casting: that integration, in itself (relational value), was not a *reason* for doing the work (Palmer 2007).

The aesthetics of support

One way of reframing the heteronomy/autonomy pair is to perceive it as the support that the artwork needs to be realised. Shannon Jackson

identifies the etymology of 'support' as having both structural and temporal elements: structurally, it means to prop or hold up; and temporally, it means to bear or to endure without opposition or resistance, to tolerate. Support requires resources and labour above and beyond the mechanical (see Jackson 2011: 30). The offer of unconditional support is perhaps the highest human offer, but aesthetically represents a low order of merit. In idealist nineteenth-century aesthetics, art was recognised primarily for its ability to transcend the 'material substrate' and to 'exist autonomously of its making' (ibid.: 31). This idealism has been continually challenged since Brecht, and as recent theorists (Read 2008; Ridout 2006) claim, theatre almost always fails – or refuses – to conceal the labour of its making. In modern art, critics of the Greenberg school attempted to reduce art to purely formal elements, stressing that the two-dimensional 'fact' of the canvas made it the unquestionable medium of art, and claimed it as 'the ineluctable flatness of support'. Yet such attempts to reduce art to pure form flounder when considered against the 'invisible' support of transportation, gallery walls, and institutions. In the field of performance and learning disability, I argue that supporting foundations are especially complex and require correspondingly subtle theorising. To begin with, the disabled citizen upsets the capitalist ideal of autonomous personhood. This is a two-fold action: the disabled person is constructed as contingent and dependent; this in turn enables the rest of society to imagine itself as stable and self-governing. A physically disabled performer may reveal the supportive infrastructure of prostheses, chairs, or crutches; a learning disabled actor, however, may depend on *invisible* support structures such as the extended time required to memorise script. What *Pinocchio* offers is a glimpse of the aesthetic components of music and recorded narrative voiceover that contributed to 'supporting' actors who might have struggled to tell the story without them. These structural devices reveal support as a conflicted territory: art responds to the frustration of its attachment to the *paraergon* by either disavowing it or embracing it to a point where the distinction between art and support, as in Bourriaud's relational model, disappears. In *Pinocchio*, however, the 'support' was imposed from above as part of an aesthetic system that sought to erase the possibility of unintelligibility.

Foreman admits, 'I was anxious, how are we going to make sure we don't simply *support* the disabled actors?' But at the same time, she felt responsible, as part of the ensemble, for 'how the learning disabled actors are perceived'. She noted:

> They are not just themselves, we are asking them to do something on which they will be judged on a certain level, that's our responsibility.

We're asking them to trust us not to make them look foolish. It's a bit out of their control. We have to be careful of this. (Foreman 2007)

Mediating between the authentic world of Palmer and Hayhow and the Rep theatre world of Cruden, Foreman tasked herself with 'not simply supporting' the disabled actors and ensuring they did not look 'foolish'. This concern hides her assumption that the 'other' actors could work unsupported. In theatrical terms, it begs the question as to whether one could delineate between main and supporting actors in *Pinocchio*. As Jackson notes, if we are to take seriously the language of support, then it is important to acknowledge the 'structural location of certain roles in holding up the entire performance event' (2011: 37). Clearly, Jon Tipton, a wiry and kinetic main character, was 'the lead' and did not require any visible means of support. Historically, actors were often judged on their ability to 'support' the character they played (see Jackson 2011: 37–38). The presence of learning disabled performers complicates this designation. As Foreman pointed out, 'I was told very early on that these actors would only ever play themselves' (2007). Notionally then, Tipton, Wandtke, Langford, or Carney could not 'support' a character. This is ironic, given Tipton's enthusiastic description of his character to me:

JT: What do you think of my finished character?
MH: It's good. How do you know it's finished?
JT: I feel happy inside. It took me ages.
MH: How did you do it?
JT: I started with the walk. I put cardboard in my sleeves to keep my arm stiff. It was very difficult. I used to have another character called Percy. I'm going to be honest with you, I think it's very distinctive. Bold, would that be the right word? I should think so. I've been doing it for 15 years.

(Rehearsal conversation.)

A comparison of Tipton's confidence with Foreman's anxiety leads to the conclusion that 'supporting' the disabled actors was a sublimated way of acknowledging that Foreman had no means of defining artistic quality; in other words, concern for the disabled actor offset her latent fear that he would ruin the show. Another way of conceiving 'support' was in the interplay between Tipton and the nondisabled Simpson. Playing the supportive role of Candlewick, Simpson often performed 'goofy' by turning his baseball cap back to front, sticking his tongue

to the side of his mouth, and frowning, a kind of 'stupid shtick'. He *passed* for 'disabled' at certain moments by the repetition of an act. Simpson's pass – an inversion of Teuben's in *Small Metal Objects* – made his performance arguably the most complex. Simpson acted for some of the play 'as if' he had an intellectual impairment: finding simple tasks difficult, deploying a 'goofy' face, getting the sequence of things wrong. Alongside several disabled actors, he often seemed the 'most impaired'. In some subtle way perhaps, whether conscious or otherwise, it was a sensitive counterpoint. Hayhow was aware of it: 'I wouldn't have described it as taking on a learning disability identity as such – more maybe that he was absorbing an aesthetic from the work rather than character traits' (2008b). This hints once more at the possibility that disability is arbitrary, performative. The actor may have been finding some point of reference, some means of collaboration: an unconscious, ambiguous support.

Support was manifest in the aesthetic mainly through the use of a complex sound score, composed by Chris Madin. Alongside the huge set and voiceover narration, the music defined the piece that *Pinocchio* would become, a dominating force that 'propped up' the show. Suffering from a back injury, based in London, Madin could not attend York rehearsals and watched a DVD of a run-through midpoint in the process. He created the orchestral score exactly to that model and delivered it to the directors. Foreman explains how 'the show got made to the music. The music pretty much defined it. The music was the form' (2007). As Hayhow affirms, the Shysters' work had been defined as sitting 'on the borderline of theatre, dance and mime' but *Pinocchio* pushed things in a more balletic direction. The music was used, less expressionistically and more as a holding form. As Hayhow put it, 'Like *Peter and the Wolf*, the music had to work with a degree of precision that we were not prepared for' (2008a). Action and music had to cohere to a degree where 'the audience felt that the actors were making the music' and this became 'a technical job, not a creative job. There was no room for spontaneity' (ibid.). This was at odds with Hayhow's previous working process and in many ways countermanded the initial process of improvisation and relationship-building.

The music became a kind of competing essence, a constant presence that had to be tamed. It changed the aesthetic from a drifting picaresque into a frenetic choreography. It is ironic that the directors saw ballet as the closest description of the form, since ballet precisely defines 'the idealization of grace and corporeal verticality, and the subsequent establishment of the dance academy in which this idealization

was codified in technical form' (Smith 2005: 81) – in short, everything that the learning disabled performer is excluded from. Compared to the 'ineluctable flatness of support' that, for Greenberg, characterised the two-dimensional canvas of modern art, ballet offers what Joseph Roach defines as *inscription*: the process whereby meanings are applied to the body to promote 'objective' judgements. Ballet, as form, is supported by a network of ideological systems, not least of these being the 'fact' that a female dancer, if leaving the ground, must *always* be supported by a male. In the case of *Pinocchio*, the balletic score was *imposed* on the work, not in order to demonstrate the technical prowess of the performers, but to fill the gaps left by narrative incoherence. Palmer explained:

> We were running to catch up. The difficulty was that the music was written *for* the movement but it then *changed* the movement. We did not have enough time to respond. It was daunting because it was like that, but it was also a safety net, to put it bluntly, to cover moments that might not stand up in their own right. (Palmer 2007)

The form of *Pinocchio* arose out of the myriad possibilities to achieve that most conservative and enduring of forms: the fairy story, set to music. Ironically, the work demonstrated the disabled performer's ability to deliver precisely choreographed movement to a tight and dominant score, as competently as any other performer on stage. This is quite apart from questions of preferred aesthetic style or political sensibility. The performers brought the show in on time, to the main stage, for paying audiences, after a four-week rehearsal period. This is one definition of quality.

Outsourcing authenticity

These discussions have not dealt with the principle question: how 'good' a work was *Pinocchio*? The directors found several ways to answer this question. Palmer identified two polarities in audience responses: one side felt that the work was 'too safe'; the other that the integrated cast was, in itself, a virtue: 'that you couldn't tell who was disabled and who wasn't, which was a bit naff on one level but that was partly our reason for doing it, for people to feel it was genuinely equal' (Palmer 2007). Palmer himself felt that the work was bland, and that there were too few moments where performers were 'particularly exposed', or where 'I really felt for or empathized with a character' (ibid.). Foreman was 'very undecided' between wanting the audience to be impressed and surprised but feeling that they would 'come with not

quite the same critical faculties turned on' (Foreman 2007). The media reviews were supportive but reflected Foreman's uncertainty. Jessica Price focused on the difficulty of deciding who the play was for, noting that it was not sophisticated enough for adults but perhaps a little too disturbing for children. In line with Palmer's first polarity, she noted: '*Pinocchio* was not as self-consciously "different" or "edgy" as a lot of other plays I've seen' but felt this 'was to its benefit, meaning that its message was communicated effectively' (Price 2007). Clearly, the moral message was more important than aesthetic complexity, but Price did not say what the message was. She felt that the continual underscoring and narration 'worked' but did not ask why, or how, or to what end it was required. Cecily Boys remarked on the 'playfulness of the production' and the 'affecting' nature of the collaboration, urging teachers to 'take youngsters to it' to teach 'responsibility, generosity and humanity' (Boys 2007). Only Alfred Hickling of *The Guardian* sounded a critical note:

> It is all done with an irrepressible gusto that proves that performers with learning difficulties have an uninhibited creative energy that able-bodied actors spend years trying to tap into. As with any improvised show, it has its stilted moments, though you can forgive Pinocchio for seeming a little wooden. And Christopher Madin's delightful music – effectively a full-length ballet score – brings great coherence to an evening that is an altogether different kettle of fish. (Hickling 2007)

Hickling hints that the acting was *not* very good and that the music held the show together. That he gets it 'wrong' about the level of improvisation in the piece suggests that the acting was not precise enough and/or that the show was structurally weak. Hickling reveals an underlying belief that was perpetuated by Palmer and Hayhow, and adhered to by Foreman: that learning disabled actors possess a transcendent creative capacity that nondisabled actors can only acquire after years of searching.

Reflecting on his collaboration with the mainstream, Palmer said:

> A small part of me wonders about this. Maybe the point of all this is that the nondisabled people should be transformed. Ultimately it is not about the end product, it's how they [the disabled performers] open our eyes to different ways of doing things. (Palmer 2007)

Palmer could not decide if the work of learning disabled actors really could stand up, 'unsupported' alongside 'other' actors. Hayhow echoed this uncertainty in his enthusiasm for Cruden's commendation that the presence of disabled actors had 'changed the culture of the theatre' (Hayhow 2007). There are parallels here with Joseph Roach's 'surrogate': that mechanism whereby the staged performance of a disavowed minority reinforces hegemony. Puppets, of course, are surrogate objects. Pinocchio, a puppet who passes for a boy, eventually *becomes* a boy. Does this make him a metaphor for the journey of the learning disabled actor? In the York adaptation he attains his passing, his 'coming of age' by moving from the world of the puppets to the world of the travelling players. There may be a dark side to this story: Pinocchio has gained but also lost something, some fine-grained, anomalous essence: no longer one of the puppets, but among the puppet masters. Perhaps others, watching from the sidelines, might condemn his passing, seeing in it some unwished-for fate.

The meaning of *Pinocchio* and its relationship to both authenticity and quality is accentuated if read in conjunction with Heinrich von Kleist's essay, 'On the Marionette Theatre' (1810). This short, enigmatic work takes the form of a story: a meeting between the author and 'an old friend' who is a 'principal dancer in the local theatre [...] enjoying immense popularity' yet fascinated by the more commercial puppet shows in the market place (Kleist: 1). The friend claims that he is in awe of the 'mute gestures of these puppets' and that 'any dancer who wished to perfect his art could learn a lot from them' (ibid.). This sly essay turns accepted notions of virtuosity on its head: puppets have the 'proportion, flexibility, lightness [...] all to a higher degree' (3); they are 'never guilty of affectation'; and 'grace appears most purely in that human form which has no consciousness or an infinite consciousness. That is, in a puppet or a God' (5). In an uncanny premonition of Palmer and Hayhow's authentic theatre, Kleist's 'friend' argues: 'We see that in the organic world, as thought grows dimmer and weaker, grace emerges more brilliantly and decisively' (6). Kleist's hidden theme is precisely that of *Pinocchio* in the York version: innocence lost through self-consciousness. What puppets offer – that human actors cannot – is performance free from the strictures of the self. The puppet, incapable of affectation, is arguably a mirror image of the *idea* of the learning disabled actor, from whom, in Foreman's words, 'there is no affected performance'. In an inversion of Kleist's erased consciousness, Foreman feels that 'they will only ever be themselves on stage' (2007). Thus, if

not without self, these actors have a qualitatively different kind of self – one that overrides the ability to feign or to lie.

This is exactly the point made by Ridout, in his reading of Kleist: that 'the self-consciousness that follows "the fall", involves [...] representation' (2006: 17). The puppet shares with the learning disabled performer an unrepresented or unmediated presence: in other words, he is the blank slate on which to project. What Kleist's argument overlooks is that 'puppets only achieve their transcendence of human gracelessness by means of human labour' (Ridout 2006: 26). Kleist makes much of the prosthetic limbs that enable those who have lost a leg to move with 'certainty and ease and grace' (Kleist: 2). Equally, Palmer and Hayhow's authentic system requires unique specialists – nondisabled artistic facilitators – to best operate it. The mechanics of puppetry belie the smooth surface of autonomous creativity. It is not that the puppet is so radically different. What is so shocking is that the puppet and the human actor share the same fate: continual nightly repetition, supported via a network of levers that remain hidden due to the willing suspension, not of belief, but of economic reality.

Pinocchio allowed York Theatre Royal to demonstrate its inclusivity. The authenticity of the learning disabled performers, here, was *co-opted* by the producing theatre. York effectively 'outsourced' authenticity, delegating the job to external providers, in return for a guarantee of its presence. I do not mean to suggest that the act was mercenary, more that, in an unconscious transaction, a complex network of drives and desires were negotiated. The concept of 'delegated performance' is useful here. Borrowed from conceptual art, it defines a practice in which the artist hires non-professionals – or professionals from a different field – to carry out instructions given to them by the artist. This is different from the normative Western theatre transaction where a director delegates the job of storytelling to a hired agent of representation (an actor). Rather, as Claire Bishop says, 'artists tend to hire people to perform their own socio-economic category, be this on the basis of gender, class, ethnicity, age, disability, or (more rarely) a profession' (2012: 219). Press responses to *Pinocchio* blurred, yet affirmed, the lines between actor and 'socio-economic category'. Shysters/Full Body & The Voice also gained in this transaction. In exchange for 'authenticity' they received the validating mark of 'quality' – that is, they became 'good enough' for the main stage. The music score (an expensive and labour-intensive item) was the sonic equivalent of the safety net, in case the artwork did not make sense or was not 'good enough'. The devising process enabled York Theatre Royal to claim that it had achieved equality between

disabled and nondisabled cast members, that it had bridged the gap and rendered disability invisible, and that the presence of learning disabled persons had 'changed the culture of the theatre'.

Conclusion

Pinocchio highlights the difficulties of judging work on the basis of singular aesthetic values, such as 'authenticity'. The production process, involving substantial sums of public money, put pressure on the makers to produce a 'good show' and cancelled out any notion of aesthetic purity. The spontaneity of early rehearsal gave way to the exigencies of the first night: making sure that the piece adhered to the score and that the audience could understand the narrative. In this particular case, asking 'how good is this work?' has revealed particular assumptions. Palmer's first polarity – 'too safe' – implies that the expectations of the 'Rep theatre' have been met only too well and that the machinery of mainstream representation got what it wanted: a family entertainment with little formal innovation or disruption. The second – equality on stage – asserts social cohesion but masks more complex subliminal relations: a tendency for disabled and nondisabled cast members to sit apart in break times (noted by Palmer) or the underlying aesthetic tension that resulted in Cruden's insistence on verbal framing. This gap between performed cohesion and social disparity is a small but important finding. It highlights the obfuscating effect of art judged 'as a model of social organization' (Bishop: 238), when, in fact, it has been arrived at through a more complex, exigent set of artistic mechanisms. Social democracy, in other words, cannot be inferred from theatre ensemble and neither can staged antagonism be identified as a breakdown in social cohesion. As Bishop states:

> This tension – along with that between equality and quality, participation and spectatorship – indicates that social and artistic judgements do not easily merge; indeed they seem to demand different criteria [...] For one sector [...] a good project appeases a superegoic injunction to ameliorate society; if social agencies have failed, then art is obliged to step in [...] For another sector [...] judgements are based on a sensible response to the artist's work, both in and beyond its original context. In this schema, ethics are nugatory, because art is understood continually to throw established systems of value into question, including questions of morality; devising new languages with which to question and represent social contradiction is more important. (Bishop 2012: 275–276)

Such polarities cannot easily be merged, nor should they. I suggest that artists and spectators have a choice about the kinds of aesthetic judgements they want to make, but they are best served by recognising when they are using different, and incompatible, criteria.

From a 'relational' position, ethical questions are foregrounded: the 'intersubjectivities' between the work and the persons involved become primary. From this place, a deliberate fluidity is perceived between the work and the process, and quality judgements are not reserved for the formal attributes of the work, but rather open out or back into the field of its making. Here, the question is less 'Is this work good?' and more 'What is a work?' and 'Where are its borders and how do we extend or remove them?' For relational aesthetics, the point of judgement is precisely in the 'relationships' formed by the work. From a Rancièreian position, the criteria for judgement depend more on recognising the 'absolute singularity of art' (2002: 23). The value of art, here, lies precisely in valuing it as something apart that cannot be reduced to social outcome or subsumed into the existing order. In this case, by asking 'how good is this work?', one is entering into a dialogue about what makes art unique, inviting oneself to question underlying assumptions, rather than making a direct correlation between the theme of the work and its social efficacy.

Consider the difference between metaphor and metonym: the first stands in for something else; the latter adds to it, renames it, or refocuses it. As Peggy Phelan points out:

> Metaphor works to secure a vertical hierarchy of value and is reproductive; it works by erasing dissimilarity and negating difference; it turns two into one. Metonymy is addititive and associative; it works to secure a horizontal axis of contiguity and displacement. (1993: 150)

This is precisely relevant to the field of theatre and learning disability, which exists against the cultural hierarchy of disability as metaphor. For Rancière, 'good' art has the potential to move into new and as yet unmapped worlds, for example the possibility of disability as metonym: of disability *'and'*, rather than disability *'for'*. Rather than stand in for 'social inclusion', or use *Pinocchio*, the puppet, as a metaphor for the learning disabled performer, the work might add to or undermine preconceived perceptions. From such a perspective, there are dangers in embracing the Arts Council's 'new diversity' or 'Creative Case' uncritically. Used unwisely, the term creates a perception that the state of

creative antagonism has ended. It is yet another version of the 'end of ideology', which really means the victory of the ideology of the market.

Zizek's critique of multiculturalism (1997) is clearly relevant here. First, the neoliberal consensus – of which the Arts Council is a functionary – builds on the inherent contradiction of liberal multiculturalism in that it condones and celebrates the 'folklorist Other', much like an array of ethnic cuisines. At the same time, however, it disavows the 'Real Other' as fundamentalist, patriarchal, and violent (or in the case of learning disability, as transcendent, pure, and non-verbal). Second, the operating mechanism of this 'repressive tolerance' is a surface respect for the 'authenticity' of the Other, who remains closed off in their own community. Such tolerance masks the myth of multicultural neutrality. The power to position the Other as 'authentic' is only made possible by assuming a 'privileged *empty point of universality*' (ibid.: 44). Third, the surface acceptance of diversity (hybridity, inclusivity) deflates criticality. The 'Creative Case for Diversity' (2012) might appear to give the 'diverse artist' (a ridiculous term) what they want: escape from the silo of the social agenda; recognition that 'they' are integral to mainstream; even a promise that the work will be the recipient of increased critical reflection. The ultimate result is a new diversity, which is a more sophisticated version of the old diversity: a surface difference, which belies the reality of crushing homogeneity.

Hayhow's own preference for theatre he can 'believe in' is reflected in his comments about *Small Metal Objects*, where, although he was '"entranced" by the way the mics were used', found it 'very difficult to believe in the actors' situation [...] because of [their] relatively "poor" acting ability' (2008b). It is significant then that the 'authenticity' of Teuben and Laherty in *Small Metal Objects* was, for Hayhow, hindered by the *quality* of their acting. Hayhow continues:

> It's possible that the use of mics in *Small Metal Objects* came about as a way of overcoming the actors' untrained voices and it was then converted into an aesthetic during the process. The danger is the aesthetic becomes the focus for the piece, and what we talk about, and also a mask for the inherent 'limitation'. (Ibid.)

Hayhow perceives the aesthetic as the 'cover up' for the real thing: in this case, the lack of vocal projection. Rancière observes that the aesthetic regime of art is always 'shuttling' between 'two vanishing points': that is, between 'becoming mere life or becoming mere art' (2002: 150). His point is that art's power lies precisely in its undecidability, in the

ambiguous position of delivering neither 'political accomplishment' (ibid.) nor untainted, disinterested art for its own sake. Hayhow's own critique is poised between the aesthetic and the point at which the 'true' person is revealed. This Artaudian position is at odds with *Pinocchio* as a production. This rather neatly sums up the aesthetic quality of *Pinocchio*: shuttling between two vanishing points, the essence of the authentic and the call of the main stage.

I invite the reader to undertake a hypothetical task. Imagine you have been asked to curate a festival and could exhibit two of the three works discussed thus far (*Pinocchio, Small Metal Objects, Hypothermia*): which two would you take and which one would you leave behind? This question raises the uncomfortable spectre of exclusion but is no different from the questions that are asked of works on a regular basis by national funding bodies: namely, what is this work's quality and on what basis should it continue to be financed? Is there an answer that does not, at some level, refer to non-sociological criteria: formal structures, technique, conceptual intention, innovation, attention to detail, and so on? I argue that there is not. Equally, if the work itself persuades you that there is a better (more complex, nuanced, ambiguous, sensuous, more amusing, surprising, heart-stopping) way of seeing the world, then it is likely that *part* of the reason it does so will have nothing to do with 'purely' formal questions. What *Pinocchio* proves is that aesthetic judgements are both *inter*- and *intra*-cultural. That is to say, they are a mix of deliberations about 'universal' or 'canonical' aesthetic values (how good is this work in its own right?) and sector-specific deliberation (what does this work say or value about disability?).

My conclusion is that while there cannot be a return to a universal canon, radical relativism that suspends aesthetic criteria should be viewed with equal caution. Located between these two poles, not as an ameliorative synthesis, but rather as the site of passionate debate, is Wolff's 'principled' or 'uncertain' aesthetics. This is an aesthetics of reflexive deliberation that accepts art works as socially situated but simultaneously capable of withstanding robust critique. What is crucial is that the criteria for judgement are made clear, whether these be formal, extrinsic (thematic), relational or subjective questions about beauty or pleasure. The dialogue with the social is also a dialogue with the canon – or perhaps the ecology – of 'normative theatre'. *Pinocchio* was an attempt to bring a marginal aesthetic to engage with the dominant ecology. Its relative failure – its 'blandness' or 'safeness' – is not a reason to retreat from dialogue; quite the opposite: the critical task is to venture further into such realms of uncertainty, to pry open the gaps

outside and inside the dominant ecology. Wolff notes, in the context of her essay, that the task is not to 'add' women to the canon or to reject the canon outright: rather the point is to engage *with* the canon, to examine its operating 'mythic structure' (Pollack, quoted in Wolff: 26). Furthermore, in concrete political terms, the exposure of value judgements is a necessary process of disentangling the aesthetic from the need to represent social democracy. To do so is to acknowledge what makes art unique: its non-reducibility to the social. It is precisely through the 'constitutively undefinitive reflections on quality that characterize the humanities' (Bishop 2012: 7) that the reductive demands of social policy and the crushing weight of instrumentalism can be resisted. Theatre and learning disability, I argue, is an aesthetic practice, which should refuse to act as a surrogate for social amelioration. As this chapter has demonstrated, it is by tackling questions of quality that the underlying reality of the political is revealed.

This book refutes the notion that there is a 'singular' aesthetics of learning disability; rather, there are competing aesthetic responses to the opportunity offered by learning disabilities. It is vital that Palmer and Hayhow's views on authenticity are clearly stated. It is equally vital that the assumptions underlying their philosophy are properly understood, so as to relieve them of 'absolute' authority. In the next chapter, I analyse some of the historical contingencies that have *created the idea* of the learning disabled performer as 'authentic'.

4
Genealogies: The Cultural Faces of Learning Disability

> in my opinion recourse to history [...] is meaningful to the extent that history serves to show how that which has not always been; that is, the things which seem most evident to us are always formed in the confluence of encounters and chances, during the course of a precarious and fragile history. (Foucault 1978: 450)

> My characters have no shadows, they come out of the darkness and such people have no shadows, the light hurts them. They are and then are gone to their obscurity. (Werner Herzog *The Enigma of Kaspar Hauser* DVD, director's commentary)

Introduction

Back to Back's *Ganesh versus the Third Reich* (2012) grew out of an experience the company had touring the previous work, *Food Court* (2009), when Artistic Director Bruce Gladwin was asked by staff in one of the receiving venues to clarify if the ensemble knew whether or not they were acting. In *Ganesh* this 'problem' of intentionality is addressed in a sly and disquieting exchange between the actors on stage, who purport, for large sections of the piece, to portray 'themselves' rehearsing the play. Actor Scott Price claims that his colleague Mark Deans cannot tell the difference between fiction and reality, that 'Mark's mind is probably working like a goldfish'. An uncomfortable moment of audience interaction ensues in which the figure of the director (played by the only nondisabled actor, David Woods) looks out onto the 'empty' auditorium and makes the following declaration to his 'imaginary' spectators: 'You people [...]. You have come here because you want

to see an aquarium, a zoo. You have come here because you want to see a freakshow, haven't you?' The conceit of course is that the seats are full and that far from addressing an empty row of seats, he is pointing at real people: 'For example, this person sitting here, you are a pervert. You have come to see a bit of "freak porn", haven't you?' *Ganesh* deconstructs not just theatre form and spectatorship but the very notion of who possesses – or is perceived to possess – authorial presence.

Foucault argued that 'a certain rational being that we call an "author"' (1984: 110) was in fact 'only a projection'; that the '"deep" motive or creative "design"' attributed to this figure is rather 'a certain functional principle by which, in our culture, one limits, excludes, and chooses; in short by which one impedes the free circulation, the free manipulation, the free composition, decomposition, and recomposition of fiction' (ibid.: 119). The author, then – as well as the contemporary actor-deviser – is a culturally contingent mechanism for placing a boundary around creative acts, one that reinforces the notions of private property and individual agency. This authoring process – which Foucault argues, stems from a 'fear [of] the proliferation of meaning' (ibid.) – can be read as closely aligned with his analysis of unreason in another context:

> Madness is the absolute break with the work of art; it forms the constitutive moment of abolition, which dissolves in time the truth of the work of art; it draws the exterior edge, the line of dissolution, the contour against the void [...] Such a work of art opens up a void, a moment of silence, a question without an answer, provokes a breach without reconciliation where the world is forced to question itself. (Foucault 1971: 287–288)

Cognitive impairment, like 'madness', it would seem from Back to Back's experience, impedes someone's ability to be *perceived* as the maker of meaning.

My contention is that choices available to learning disabled artists and their collaborators are shaped by historical precedents: by ideas about intellectual disability that play an 'extra-cultural' function. If properly understood, these ideas can help us to grasp the points where change in perception is possible. The purpose of this chapter, then, is to demonstrate that contemporary performance involving learning disabled artists *has* a genealogy. I use this term in the Foucaultian sense:

> Genealogy is, then, a sort of attempt to desubjugate historical knowledges, to set them free, or in other words, to enable them to oppose

and struggle against the coercion of a unitary, formal and scientific discourse. The project of these disorderly and tattered genealogies is to activate local knowledges. (Foucault unreferenced, quoted in Carlson: 105)

This chapter is not a search for the essence or origins of learning disability in performance, but rather starts from the supposition that the very idea of origins is a fabrication. Theatre historian Joseph Roach argues that all performance offers a substitute for something that pre-exists it. He identifies three complementary meanings of the word: performance carries out a purpose thoroughly (Turner); it actualises something that was, up to the point of delivery, only a potential (Baumann); and it restores or repeats a given behaviour (Schechner) (see Roach 1996: 3). Substitution or *surrogacy*, for Roach, is the process which allows 'normative' society to create the fiction of stability and therefore 'essential' or 'timeless values'; for example 'authentic' nationhood or 'whiteness' as a value. The surrogate is a figure who fills – whether theatrically, or in real life – 'the vacancy created by the absence of an original' (Roach 1996: 36). Roach argues that the need for surrogates became intense in the circum-Atlantic world when the slave trade violently reconfigured normality. The eugenics movement was a similar normalising discourse born of a society obsessed with the setting of normal standards. Thus, both blackface minstrel and freak shows are surrogates: performances that stand in for an original that never existed. Such performances reveal the strange pull between centre and margin; successful surrogation involves the precise symbolic centring of that which is socially excluded.

In identifying the *cultural* faces of learning disability, I draw on Licia Carlson's unmasking of *theoretical* faces (2010). Specifically, these are: the face of authority (the way philosophers have claimed moral expertise in defining learning disability); the face of the beast (association between learning disabled persons and non-human animals); the face of suffering (making learning disability synonymous with pain or sadness); and the face of the mirror (the way in which disabled persons function as a mirror for the nondisabled). The mirror is evoked each time a philosopher uses a learning disabled person as a marginal case (them) to articulate something about the majority (us). The mirror is 'existential': it projects the self onto the other, so that the self can be better understood – another way of saying 'there but for the grace of God go I'. As Adam Smith defined his relationship to the non-rational other:

The compassion of the spectator must arise altogether from the consideration of what he himself would feel if he was reduced to the same unhappy situation, and what, perhaps is impossible, was at the same time able to regard it with his present reason and judgement. (Quoted by Hauerwas 1986: 174)

In saying 'this could have been me', Smith is projecting himself onto the 'poor wretch' – the reflective surface becomes a 'funhouse mirror' where the 'I' is seen in a distorted form (Carlson 2010: 190). Both observer and subject, therefore, are distorted in an endless hall of mirrors. As Uma Narayan points out, in serving as a mirror, the subject 'is put out of countenance' and 'loses face' (1997: 141). I argue that the four cultural faces of learning disability identified in this chapter are, similarly, mirrors that bring about distortion. These are: the face of the outsider; the face of the feral; the face of the freak; and the face of the fool.

Untamed minds: the face of the outsider

The term 'outsider art' refers to a field of art practice in which some, or all, of the following formal characteristics are present: a preference for recycling of real or 'found' objects; the repetition of the same ornamental motifs that tend to dominate or overpower the figurative; a lack of concern for 'correct' drawing or composition; a sense of compulsive repetition that tends to reoccur over the course of an entire body of work, not simply in a single piece. The formal elements, however, are to some extent secondary to the contextual framing of the artist. The outsider artist, in order to qualify as such, must, whether by solitary choice or institutional intervention, be removed from mainstream society. Such a person is withdrawn from social engagement, and inhabits a place on 'the edge of intelligibility' (MacLagan 2009: 11). The social marginalisation of such an artist is therefore inherent in the aesthetic appreciation of her work: her value lies precisely in her awkward relationship both to society and to established art tradition. The work of the outsider artist must be non-derivative, peculiar in its intensity, and eschew the primacy of an audience or intended other. The outsider artist is a being of extreme solitude.

'Outsider art' was named in 1972 by Roger Cardinal and can be understood as an anglicisation of its precursor, *art brut*, a term coined in the late 1940s by Jean Dubuffet, meaning art that was crude or raw, literally 'unsweetened'. Dubuffet spent much of his career in perpetual conflict with the art establishment and sought to discover and exhibit the works

of untutored artists, many of whom were inmates of prisons or asylums. The value of *art brut*, for Dubuffet and others, lay in its lack of adherence to the rules of established art. The works had to be made by

> [p]eople free from all artistic culture, in whom imitation contrary to what happens with intellectuals, plays little or no part, so that their makers draw everything (subjects, choice of materials, means of transposition, rhythms, ways of writing, etc.) from their own accounts and don't borrow from the schemas of either classical or fashionable art. Here we witness the artistic process quite raw, reinvented by its author in the entirety of its stages, starting off with only his own impulses. (Dubuffet, translated and quoted in MacLagan 2009: 10)

There is a startling symmetry here with Rousseau's noble savage, a precultural being, perfect in himself, untainted by the constraints of culture: someone who has only his innate (good) impulses to work from. Yet Dubuffet, in his validation of the 'anti-aesthetic' of *art brut*, went much further:

> Careless outlines, dirty colours, repetitions, and omissions, or even, to shift things from the level of technique to that of the moods inspiring the work, the resort in some cases to positions as ill-advised as, for example, confusion of mind, poverty of thought, imbecilic stupor: these don't seem to me necessarily negative values. (Ibid.: 49)

Intellectual impairment thus becomes an aesthetic value. Such a vehement rupture with established convention is an extension of a vigorous modernism, hungry for new modes and psychological affects. When André Breton remarked that only madness guaranteed 'total authenticity', he was articulating modernism's deep-seated drive to save everything that industrial society was in the process of destroying.[1] The avant-garde response was a pervasive primitivism. The society that Breton, Artaud, Klee, Satie, Gauguin and Picasso responded to has been described by anthropologist Dean McCannell as a 'totalizing idea, a modern mentality [...] in opposition both to its own past and to those societies of the present that are premodern or un(der)developed' (MacCannell 1989: 8). For moderns, attachment to naturalness, innocence, and authenticity was a necessary psychic debt, a way of vicariously obtaining what had been lost. At the opposite pole stood *la pensée sauvage* ('savage mind') of those who inhabited a place beyond the

reaches of industry. In studying primitive myths – those 'master works of untamed minds'[2] – Levi-Strauss thought he had found the gateway to radical alterity. For Artaud, all creativity stemmed from 'a secret psychic impulse, speech prior to words' (Artaud 1997: 42). For Baudelaire, genius was a child's perspective re-captured at will, and for painter Franz Marc, artistic vision was savagery uncovered: 'the early people', he said, 'loved abstraction before they encountered sentimentality' (quoted in Conrad 1999: 346). Unlike romantic art, which had sought to appropriate nature figuratively, abstraction was made up of the raw stuff. The world was unknowable, and art's role was to recapture it from a past 'when mystery awoke in men's souls and with it the primordial elements of all art' (ibid.: 347).

This urge to recapture art's primordial state underpinned *art brut*. Unknown artists like Miguel Hernandez or Adolf Wolfli were drawing on the 'most profound inner workings of the artist', offering 'us a burning language' drawn from the 'underlying layers' of the personality (Dubuffet, translated and quoted in Peiry 2006: 92). Absence of technique was a validating ideal: 'little works of nothing at all, totally basic, half deformed, but which ring true' (ibid.). This need for the work to 'ring true' led Dubuffet to make an absolute distinction between 'true art' and 'false art': *art brut*, the 'true art', was free from and uncontaminated by culture. Gilbert Lascault, contemporary critic of a 1967 *art brut* exhibition, made the same distinction, arguing that the works had to be understood on their *own terms*, and could not be explained by reference to existing cultural works. They were born of 'a notion radically opposed to art: the skill is suspect; the mimetics, the deference toward myths, the modes, the techniques are fearsome' (quoted in Peiry: 168). In these artworks Lascault saw Levi-Strauss's 'savage mind' aestheticised: not 'incomplete or unpolished' but demonstrative of an '*other* logic' and '*other* technique', the subtlety of 'uncultivated, untamed thought' (ibid.).

Outsider artworks, then, like the theatres of learning disability, invoke debate about artistic intention. For 15 years between 1987 and her death in 2005, Judith Scott, an artist with Down's Syndrome, created an enormous body of fibre sculptures. The process of building these sculptures invariably involved the binding and weaving of textiles (paper towels, cardboard) around a solid core – a found object such as an electric fan or a piece of wood – that was eventually hidden within the structure. This secreting of an object is given added nuance by reports that Scott behaved as though she were stealing the objects even though she was given them freely. Scott had been incarcerated since

the age of seven in various remedial institutions and was then 'rescued' by her sister at the age of 42 and enrolled in a Creative Growth Centre. As her biographer John MacGregor asks: 'Does serious mental retardation invariably preclude the creation of true works of art? Can art, in the fullest sense of the word, emerge when intellectual and emotional maturation has failed to be attained?' (1999: 3). Because Scott was not able to verbalise, or to communicate, other than through her art, her intention was occluded.

In some senses, the responses to Scott's work are as mystifying as the work itself. Some have drawn attention to the fact that her relative furtiveness is partly a criminal sensibility born of years spent in an institution. Such a view, as Tobin Siebers points out, precludes Scott's proximity to art of the 'found object', a practice that would not, in other cases, be deemed criminal. The official website, maintained by her sister, describes Scott as having been 'mistakenly branded in childhood as profoundly retarded', as though to have created these works 'proves' the absence of retardation.[3] David MacLagan considers that there are two main 'problems' with establishing the credibility of artists like Scott *as artists*. The first problem is that the 'special' studio is an artificial environment involving direct input by helpers and facilitators. This means that the relationship of the artist to the work is not a direct one; rather it has been 'interfered with': in *art brut* terms, it has been contaminated; there is no way of knowing if those 'supporting' the artist have had an influence on her work. The second problem is that the work is not *intended* for an audience. As Alain Bouilet writes:

> [T]he work of art is only such – that is, both 'work', and 'of art' – and only has meaning for us because 'it is only present through a relation with the other', because it 'calls for the other', because it 'requires the other'. But the *art brut* work has no need of the other [...] The maker of *art brut* neither invites nor addresses us. The encounter with the other is conjured away and all we are left with is the projection of our own fantasies. (Translated and quoted in MacLagan 2009: 143)

The meaning of the work, then, cannot be said to lie in the motive of the artist, but *only* in the minds of its audience. Rather like the scribble of a child or the markings of an animal, the meaning is in the eye of the beholder. Conversely, the motives of *any* artist might be considered as secondary to the reception of the work: any work of art invites the spectator into an engagement with his own fantasies. Equally, the notion that Judith Scott does not meet the essential criteria as outsider

artist – let alone artist – because her work has been 'contaminated' by helpers, would be a harsh conclusion, an intensification of the exclusion she had faced through life.

The tension felt in the reception of Scott's work represents society's devotion to the idea of genius: the notion of the singular gifted artist who creates by force of will and stamps their authorship on the art. Yet learning disability forces one to reconsider such certainties. As Tobin Siebers believes:

> Genius is really at minimum only a name for an intelligence large enough to plan and execute works of art – an intelligence that usually goes by the name of 'intention'. Defective or impaired intelligence cannot make art according to this rule. Mental disability represents an absolute rupture with the work of art. It marks the constitutive moment of abolition, according to Michel Foucault, that dissolves the essence of what art is. (2010: 15)

Yet, in addition to the question of authorship, it is likely that a learning disabled artist will not have benefitted from the training and intellectual grounding of a tradition. They might remain outside tradition or be forced to continually invent one, or as Siebers suggests, art might have to be fundamentally reconceived in order to allow such artists a place in the tradition. Yet perhaps the most fundamental rupture that learning disability causes is the challenge to the idea of art as a wholly solitary pursuit. The questions posed by outsider art's challenge to intentionality are like the proverbial Russian doll. There is an essential paradox at its heart. By failing to find what Madeleine Lommel calls the 'answerable presence' of the artist (translated and quoted in MacLagan 2009: 147), or by being uncertain that the 'individual signature' of the artist has been arrived at through wilful means, the outsider art movement continually draws on its own inherent contradiction. Outsider artworks are trapped in a continual feedback loop, caught between vehement individualism and the root of its expression: that is, an instinctive and automatic process over which they apparently have no conscious individual control.

Radical dignity: the face of the feral

If the face of the outsider perpetuates the paradox of the learning disabled subject as both *super*-creative and void of individual agency, the face of the feral reinforces the persistent and allied notion that cognitive

impairment therefore has something to teach 'us' about who 'we' are. Werner Herzog's 1974 film *The Enigma of Kaspar Hauser* is a complex depiction of cognitive disability and features a remarkable performance by an untrained actor, credited as 'Bruno S'. Bruno plays the role of real-life Hauser, the wild or 'feral' man who mysteriously appeared in Nuremberg in 1828. A first-time actor, who had been beaten and locked up by his mother and institutionalised as a schizophrenic through adolescence, Bruno shared many of the characteristics of the real Hauser and also of outsider artists more generally. His early trauma caused him to lose language, which he only regained in later life. He imbues the role of Hauser with a perpetual amazement that occasionally spills beyond the confines of the frame, as if he is looking directly at the viewer. He is attributed as 'Bruno S' because he, of his own volition, did not want to become known as an actor. He did not seek fame or notoriety and persuaded Herzog to drop the surname. The story of Hauser is a point of departure from which to explore the face of the feral: a story of a person without a history, which is also a representation of the history of learning disability.

At the beginning of Herzog's film, Hauser's 'father' instructs him how to walk. It is at once comical and horrifying. Like Kleist's marionette, Hauser is manipulated, a being starved of social oxygen, with unpractised motor skills, without the ability to move independently. This is Pinocchio made flesh. Hauser was not an isolated case but rather a manifestation of a wider post-Enlightenment drive. The cultural function of the feral being was two-fold: to try out new scientific approaches on those classed as 'idiots', and to test out the 'Romantic notion of individuals as blank slates – a surface upon which culture inscribed itself in shaping a self' (Mitchell and Snyder 2006: 186). This drive to understand anomalous humanity paved the way for disciplinary training methods that changed the way learning disability would be 'treated'; it 'primitivised' such persons, rendering them objects that could instruct the general core of humanity 'about itself'. In a study of the 'wild boy' of Aveyron, Roger Shattuck (1980) describes the new training process enacted on 'Victor' as the 'forbidden experiment'. He details the exhaustive systems designed by a succession of doctors to bring the boy out of his pre-linguistic state. These included electric shocks to control unacceptable behaviour and hanging him out of a fifth floor window to 'teach' fear. The 'feralisation' of learning disability, as Mitchell and Snyder put it, had been established. The reduction of people to IQ level emptied them of individual qualities and feeling: it rendered them as mere biology. Feralisation extended outwards into institutional

practices. In the early stages of institutionalisation the emphasis was on rehabilitation; idiocy could be cured or at least moderated. This took the form of rote learning and constant supervision. If idiocy was 'insufficient mastery of the will' (Mitchell & Snyder 2006: 115), then the best way to deal with it was to repeat activities and routines until they became second nature. Thus, 'wildness' or 'idiocy' could be 'overcome by modern disciplinary techniques' (ibid.).

The sense that idiocy could be 'cured' or attenuated was rooted in a *quantitative* perception of the category: it *was* a form of humanity, but at a much lower stage of development, like that of a child. This process infantilised learning disability. Rousseau's thinking had a crucial impact on Edouard Seguin, one of the first medical practitioners to argue that cases like Hauser or Victor might be the route to discovering the lost authenticity of a primitive self. As Carlson observes, 'it is not incidental that his [Seguin's] definition of idiocy closely resembles the description of infancy in Emile' (2010: 29); and as Rousseau believed:

> We are born capable of learning but able to do nothing, knowing nothing. The soul, enchained in imperfect and half formed organs, does not even have the sentiment of its own existence. The movements and cries of a child who has just been born are purely mechanical effects, devoid of knowledge and will. (Rousseau, quoted and translated in Bloom 1979: 61)

What Kaspar embodied, therefore, was a real, breathing manifestation of Rousseau's human *tabula rasa*. Even more closely, he resembled Rousseau's 'man-child', an imaginary being born with the body of a man and the mind of a child: 'an automaton, an immobile and almost insensible statue' (ibid.). Such a figure is not 'neutral' but an object of philosophical speculation, primed with information about what a pre-cultured human being might be. The implications of this model are well articulated by Mitchell and Snyder:

> As an example of 'primitive promise', disability is situated as an opportunity to learn about ourselves as vulnerable organisms – the reestablishment of our own bodies to some 'rudimentary origin' where the mechanics of the organism were somehow more self-evident. Thus disability is recognized essentially as a *body-in-the-making*. As the bald, albino, female/protagonist narrator, Olympia, in Dunn's *Geek Love* explains, 'There's something about disability that's like wearing your vulnerability on your sleeve, as if all of my secrets are

exposed, and people trust in me enough to confess their own secrets of failure or dysfunction.' [...] Disability makes one's body fodder for any number of invasive approaches. (2006: 187)

At stake here is the extent to which formal enquiry embroils the subject in a field of knowledge that excludes her as a beneficiary. What Herzog's film does, in ironic fashion, is to embody this 'invasive' approach through several characters, particularly the notary. This character's almost child-like excitement in producing a 'report unlike any other' personifies not just the modernist drive towards obsessive bureaucracy but also the sense that Hauser's details can be embedded in that bureaucracy, put to work as a definition of what constitutes abnormality.[4]

The scrutinising of native differences by colonial forces is something Gayatri Spivak calls 'measuring silence' (1988: 286). This echoes the film's unattributed opening quotation – 'the screaming men call silence' – and the film aestheticises both silence and its twin, darkness: Hauser is a figure, in a sense, trapped between darkness and light; wanting to be part of that which surrounds him but always being, in Spivak's words, 'irreducibly different' (ibid.: 287). Some part of him always craves the isolation of the cave. 'Measuring silence' implies that persons like Hauser will always be defined by their deviation from the norm, rather than accepted on their own terms. Hauser's life, by the end of the film, has achieved meaning, not through something he has done for himself but because he has been subsumed into a knowledge system and enabled further definition of humanity writ large. He is the surrogate who allows the knowledge-producing society to confirm its own stability. Hauser's life was turned into any number of metaphors and plot possibilities. What Herzog's film glosses over is the way that his benefactor, Daumer, used Hauser as a vehicle to try out his theories of human perception. Daumer was a mesmerist: he believed that magnetic forces passed between people, that the perceived reality was a veil over another, deeper reality. Hauser, he felt, was in touch with extreme states: both of exaggerated self-awareness and self-ignorance (an 'inner darkness'). Due to the amount of formative life that had been lost to sleep and solitude, he was hyper-sensitive to the outside world yet lacking a secure sense of self. The border, for mesmerists, between the bestial and the angelic was a fine line and it is an ambivalence that recurs endlessly in popular fiction.[5]

The process of feralising humans is an example of Carlson's qualitative/quantitative pair in action. In this case, Hauser teeters on the brink of both: he is both a wholly different species and a radical version

of the human. The film heightens the formal divide between culture (proportioned, framed, symmetrical) and nature (wild, untamable, enigmatic). One of the most memorable shots in the film is of the interior of Daumer's house. Daumer and his servant, Kathe (Brigitte Mira), are foregrounded. Through two sets of open doors we can see Hauser, absolutely central but twice removed: his back to us, working at a desk, writing his journal. He is the interior of the interior: one who lives on the surface like a genteel man of leisure, yet whose internal world is alien and unknowable. Herzog comments that despite the trappings of civilisation, he 'cannot be deformed, he still retains his own way of thinking, he stepped too late into human existence to be completely deformed by those around him' (director's commentary). He describes Hauser/Bruno, as having 'something radical about him, a radical dignity' (ibid.).

This is the most profound question that the story asks of us: namely whether Hauser, like Bartleby discussed in Chapter 2, is a passive agent of choice, whether his passivity is a projection.[6] Kaspar Hauser is a story, a myth of the abandoned child, which has been told endlessly in many different forms. As Newton argues, it confers on Hauser the status of Christ, a being without original sin. It is that most enduring of tales, the 'romance plot', in which the abandoned child must find his parents. But, for Hauser, this reconciliation did not happen. He lost his childhood and, with it, a socially accepted sense of self: that conjoining of 'past and present that would draw him into the social domain as a person with a history simply never occurs' (Newton: 181). Hauser, as contemporary press reports defined him, was a 'child of Europe', a boy without a past, who belonged to an entire culture. He was and is a projection of that culture: a mirror held up that expresses a deep question about the way society is constructed.

Intolerable ambiguity: the face of the freak

As literary theorists Bennett and Royle argue, 'monare' (to show) and 'monere' (to warn) share the same Latin root (see Bennett and Royle: 259). This sense of showing or warning is deeply embedded in 'monster', which mutated from this origin, becoming 'something extraordinary or unnatural, a prodigy or a marvel [...] partly brute, partly human, or compounded of elements from two or more animals' (ibid.: 261). One thing that characterises learning disability is its relative *invisibility*, its subtlety in comparison with a more obvious or 'marked' physical difference. There is little direct evidence of learning disability figuring large in the Victorian era, that epoch defined by Rosemarie Garland-Thomson

as the 'consolidation' of freakery (1996: 2). Nevertheless, a considera-
tion of freakery offers valuable insights that enrich and complicate the
field of theatre and learning disability. There are three reasons for this.

First, freakery, a 'frame of mind and set of practices', is a perfoma-
tive act (Bogdan 1997: 24). Michael M. Chemers asserts that 'every
disabled body in performance (on stage or in everyday interaction)
enters into some kind of dialogue with the perceived history of the
freak show' (2008: 25). Evidence of freak shows can be traced back to
antiquity but the modern freak show, presenting extremes of human-
ity for amusement and profit, reached its apotheosis in both Victorian
England and antebellum America. They were enmeshed in a show
system, modulated by market forces, and dependent on a diverse
set of performance practices, which both enforced and undermined
definitions of normalcy. Unlike the face of the feral, the face of the
freak can make no claim to 'essential nature'. It is, by definition, an
act, involving a cash transaction. The meaning of the form can only
be understood by investigating the critical reception of the shows,
how they were staged, and the attitudes and exchanges between the
performers and their audience. Far from existing as straightforward
'spectacle' with performers maintaining a discreet distance, recent
evidence points to the more raucous dialogic relationship with spec-
tators in which 'things seldom go as planned: freaks talk back, the
experts lose their authority, the audience refuses to take their seats'
(Adams 2001: 13). By focusing on the artefact and its critical reception,
the complexities of this particular process of othering become more
vivid. As Rebecca Stern has argued, beyond a discourse of disavowal,
theory often has little to offer beyond 'pity and misguided worship'
(2008: 203). Stern, however, sees no difference between 'denigra-
tion, pity and reverence' because 'all use the body of the Other as an
occasion to construct some element of the self, and do so without
recognising the desire, will or subjectivity of the Other' (ibid.). The
structure of the self corresponded to the structure of the shows, which
often allowed the audience to shout out, to challenge the authenticity
of what they were seeing. Not only were the exhibits an occasion for
'ruptures in the anticipated order of things' (Adams 2001: 13) but the
form itself was a interrogatory practice that created a 'volatile interpre-
tive space' (Tromp 2008: 8). Advertising 'biggest' or 'smallest' or 'most
authentic' was not invoked in order to *prove* something but rather to
'provoke profitable conjecture' (ibid.: 8). The ontological question
'Is this real or fake?' was part, not just of the show dynamic, but of
knowledge production: the show producers would often exacerbate

disagreements between medical and lay opinion, the point being to *increase ambiguity* and profit from it.

Second, the study of freaks offers an analysis of the extent to which representation is controlled *by the subject themselves* and whether the mere presence of the anomalous person on stage is irreducibly exploitative. Many disability scholars have argued that the purpose of theory is to 'reflect critically on the utility of the freak show for understanding the contemporary predicament of disabled people' (Mitchell and Snyder 2005); yet more recent studies have sought to 'move beyond the binarism of victim and agent, arguing that this mode of analysis tends to close down any real discussion of the freak show's cultural work' (Durbach 2009: 14).[7] Levinas's philosophy, for example, entails a reconfiguring of the relationship between self and other. He sees the dynamic between self and other as not only reciprocal but as something both feel responsible for. This shifts the subject/object relationship to one of mutual responsibility.

Christopher R. Smit argues, in a study of photography and freak shows, that Levinas's ethical system is 'a call to accept the conditions of misunderstanding and imperfections that taint all interactions with and representations of otherness' (Smit 2008: 287). Levinas's ideal ethical position is that of cultural union or *Verbundenheit*, a process of dialogue. In his view, responsibility to the other pre-exists self-consciousness and is therefore just as innate as the process of disavowal. By challenging the notion that the freak show can *only* be viewed as an oppressive act, this theory opens up the possibility that the aesthetic is an act of attempted cohesion. Levinas thus opens up a space where, instead of being relegated to the role of perpetual victim, the freak attains agency. From this position, three core ideas serve as a basis for the appreciation of work. First, as a default position, the subjects are viewed as active agents in their own representation. Second, because the other is never isolated but always connected to other subjects, the work produced – a photograph, film, or play – is inherently collaborative. Third, since all knowledge is collaborative, the meaning of a work is never the 'dream and execution of just the person behind the camera' (ibid.: 295). From this perspective, Smit writes: 'Rather than assume an able bodied catalyst in the showing and viewing of freaks, I examine a dialogical relationship between the photographer [...] and the freak subjects who worked *with* him, not for him' (ibid.: 286). The baseline for analysis shifts from single ownership to collaboration. The painful history of exploitation and disavowal is mixed in with re-appropriation and resistance, in which there can never be a straightforward (binary) ethical response. The face

of the freak is the first visage to suggest that the reflection might be more than static or mute.[8]

The third and final insight offered by a study of freakery is that the 'plasticity' of the word, as Rachel Adams puts it, means that the term 'freak' 'cannot be aligned with any particular identity or ideological position' (Adams 2001: 10). The inherent instability of it as a category generated conjecture in the nineteenth and twentieth centuries in ways that challenged both freakery and normalcy. What began as surrogate – creating a freakish anomaly to satisfy modernity's attachment to normality – turned into a site of feverish speculation. What freak shows did, quite deliberately, was to challenge medical discourse as the primary arbitrator of knowledge or classification. Highlighting Judith Butler's notion of identity instituted through 'a stylised repetition of acts', Adams argues that it is not the theatrical artifice *per se* but rather the repetition of the role that is crucial. The underlying transaction of the traditional freak show is to embody the 'essence' of freak: the advertisement of absolute otherness, coupled with the separation between performer and audience, colluded to set up a clear if erroneous distinction between normal and abnormal. Conversely, as a performance, it was modified, controlled, and manipulated by the performer, giving agency back to the stigmatised person. Subtle shifts of emphasis in a single performance give the lie to the fiction that division between normal and deviant is quantifiable. The show can change.[9]

The term 'freak', whether embraced or repudiated by a performer, is positioned at one remove from the category of disability. Whilst many freaks were physically or cognitively impaired, many were not. Elizabeth Grosz examines medical definitions of impairment and notions of freakish, to conclude that distinction is in the eye of the beholder: the freak is not defined by what she is but what she does. Her role is one that invokes discord with established norms or categories. She represents an 'intolerable ambiguity':

> Freaks are those human beings who exist outside and in defiance of the structure of binary oppositions that govern our basic concepts and modes of self-definition. They occupy an impossible middle ground between oppositions dividing the human from the animal ([...] the 'wild man' [...]); one being from another (conjoined twins [...]); nature from culture (feral children [...]); one sex from another (hermaphrodites [...]); adults and children (dwarfs [...]); humans and gods (giants) and the living from the dead (human skeletons). Freaks cross the borders that divide the subject from all ambiguities,

interconnections and reciprocal classifications [...] they imperil the very definitions we rely on to classify humans, identities, and sexes – our most fundamental categories of self definition and boundaries dividing self from otherness. (Grosz 1996: 57)

A false analogy between freaks and contemporary disabled performers should not be inferred; a theoretical possibility exists, however, that performative roles or masks might imbue the performer with a freedom and spontaneity that sits, if not outside, then alongside the label of disability. The underlying agenda of Freakology is to imbue the subject with agency. Rather in the way that 'crip' or 'queer' can be re-appropriated from its own initial origins, some performers continue to experiment with trying on the mantle of the freak. As performer Hioni Karamanos explains, the history of the freak show 'gave me the opportunity to further explore the performative nature of my own disability [...] and the way my own sense of self may be expressed and created' (interview, quoted in Chemers 2008: 8). As Adams argues, loss of 'wholeness' might 'inspire a more capacious understanding of the human in which such [distinctions] are no longer foundational, but some among many options' (Adams: 7). Similarly, I argue that the genealogy of learning disability and performance can play a part in rediscovering the face of the freak and draw on its generative potential.

Punctum indifferens: the face of the fool

A final face, that of the fool, complicates and enriches the genealogy of learning disability still further. The fool exhibits psychic and social ambiguity, a straining of the boundary between on- and off stage, and often functions dramatically as a *punctum indifferens*: a still point of reflection amid chaos. The ambiguity of the fool's traditional dramatic function offers insight into powerful aesthetic drives that, if understood and utilised, can contribute to the formation of more dynamic social identities. Two main principles may be drawn from the discussion that follows, which directly impact on the critical appraisal of contemporary theatre and learning disability: first, that the fool is not just part of, but constitutive of theatre; and second, that the aesthetic value of the fool's role is rooted in, and draws power from, a radical ambiguity.

According to the literary critic William Empson, the fool is a person who is stupid, simple minded, and/or lacking common sense. In addition, this person is mocked, brash, innocent, childish, liable to be duped, or pitied as a dependent. The term also refers to the *knave*, which

carries Biblical connotations of un-Godliness and lack of religious belief (Empson 1951: 110). Indeed, a fool could be a knave or '*sub specie eternitatis* [...] a worthless character that lurked beneath the veneer of [...] respectability' (ibid.: 107) but also the court jester, liable to 'tell the truth with impunity', and thus venerated (ibid.: 107). 'Fool' can refer, then, to the job of *jester* or *clown*: someone who 'professionally counterfeits folly for the entertainment of others' (Oxford English Dictionary). A distinction can be made between 'natural' and 'artificial' fools of the English court – between those deemed to be real and those impersonating them. The former were said to be closest to God and of a very high status in relation to the monarch. The word itself is both ambiguous and reflexive. It carries multiple, even contradictory, meanings, as in Socrates' phrase, 'the Fool is he who does not know he is a fool' (quoted in Empson 1951: 108). The word 'idiot', from the Greek root *idios,* meaning 'private person', is thus bound up with the highly public jester; the Latin '*follies*' means a 'pair of bellows, a windbag' (Willeford 1969: 10). The doubleness of the word 'fool' – the way it acts both as synonym and opposite – is evidence of a powerful contradiction.

Lewis Hyde's work on the trickster reincorporates the fool as part of an ancient body of myth, and imbues the character with a wild imagination entwined with the origins of art. The trickster is a particular mythic character in folk tradition, cast in tales as a cunning animal, a coyote or fox. He lives at the margins of society, by his wits rather than by assumed social standing or spiritual power; he is amoral (but not necessarily immoral); he does not respect rigid social hierarchy; he is a boundary crosser, at once rejected and required by society; and he is a creative force whose role is to 'bring things to the surface [that have] previously been hidden from sight' (Hyde 2008: 7).[10] If he lies, 'it isn't so much to get away with something [...] as to disturb the established categories of truth and property' (ibid.: 13). The role is invariably one that upsets the normative ground rules – as Hyde puts it, 'when a trickster breaks the rules we see the rules more clearly, but we also get a glimpse of everything the rules exclude' (ibid.: 295).

Historian William Willeford regards the fool as an archetype – in Jungian terms, the role is deeply ingrained at a symbolic level and cannot necessarily be represented in concrete, rational terms (see Willeford 1969: xvii). The 'no-one', or 'idiot', or 'private person' who failed to enter into public life was perhaps one of the earliest symbolic fools. As such she gave 'symbolic expression to the problems of human individuality in its relation both to rational norms and to what exceeds them' (ibid.: 13). Outsiders – 'who violate the human image' – have

often made a compact with the wider society by 'making a show of that violation' and enter into a bond of complex mutuality (ibid.). As Enid Welsford says of the court fool, it is his very 'deficiencies' and 'deformities' that 'deprive him both of rights and responsibilities [but] put him in the paradoxical position of virtual outlawry combined with utter dependence on [...] the social group to which he belongs' (1935: 55). Paradoxically, then, the fool makes good use of his vulnerability to attack those of higher status; yet the underlying mechanism of the fool stems, in Welsford's view, from ancient Greco-Roman practices of scapegoating: here, the 'keeping' of a dwarf or fool in one's house was part of a process of warding off the Evil Eye, that is, the bad luck brought about by 'hubris' or presumption. What better way to avert the unwanted gaze than to be mocked on a regular basis by one's own fool, an economically unproductive person, who risked no loss of wealth and who could transfer all the hubris onto himself?

It is well known that Shakespeare's fools exist both inside and outside the play proper, allowing the author a chance to comment on the work. Less obvious is how complex this line between being in and out of the play was. As Empson argues, Shakespeare built up the role of the fool over time, embedding the character into comedies, almost instructing an audience what to think of him: 'this fellow's wise enough to play the fool, and to do that well requires a kind of wit' (1951: 114). By *King Lear*, the fool has attained the power to comment on tragedy in a way that no other character could. As George Orwell notes:

> The fool is integral to the play. He acts not only as a sort of chorus, making the central situation clearer by communicating it more intelligently than the other characters, but as a foil to Lear's frenzies. His jokes, riffles, scraps of rhyme, and his endless digs at Lear's high-minded folly [...] are like a trickle of sanity running through the play, a reminder that somewhere or other in spite of injustices, cruelties, intrigues, deceptions and misunderstandings that are being enacted here, life is going on much as usual. (Orwell 1951: 42)

Orwell argues that the fool is the author's mouthpiece for subversive social commentary and that 'if he had been forced to take sides in his own plays, his sympathies would probably have lain with the fool' (ibid.: 49). Within the structures of Elizabethan drama, however, clowns would have been a separate turn, often openly satirising the play and its author. To counteract this potential for confusion, Shakespeare had to build in a commentary about the clown into the plays. This

demonstrates two things: that the fool was fundamental to the work-ings of Shakespeare's art and that he was explicitly analysed in a way that other characters might not have been. The fool, thus, attains meta-critical significance.

Another facet of Shakespeare's fool is what he has to tell us about the paradox of 'the natural' and 'the wit'. Touchstone, in particular, is an example of a character who is introduced as one, 'this natural', and discovered to be another, 'not a natural, but a mordantly satirical wit' (Empson 1951: 117). Far from being a concrete, clear model, the distinction between opposites is deliberately confused. The relationship between witty and moronic or between eloquent and tongue-tied is porous and paradoxical. Within the boundaries of Elizabethan drama, there was never a clear-cut distinction between what would now be called intellectual impairment and its opposite. The 'audience is thus required [...] to enjoy the folly and the wit without any naturalistic sense of their incompatibility' (ibid.: 118). Shakespeare's fool is an oxymoron: literally, *oxus* (sharp) and *moron* (fool).

The fool is also a 'provisional form, of a new and more adequate iden-tity' (Willeford 1969: 208): the traditional balance between king and fool is fundamentally shaken because it is the king himself who eventually takes on the mantle of fool, leaving one self for another. The mechanism that makes this possible is that of nothingness: the Fool at the beginning reacts badly to the banishment of Cordelia, accusing the King, 'now thou art an O without a figure. I am better than thou art now: I am a fool, thou art nothing'. Here, Willeford draws the parallel between the 'nothingness' of fools and the 'zero' value of the fool card in games. Just as the fool himself may be 'not fully human and not even real in the way that nonfools are' (ibid.: 212), so the card that carries the fool's image is a wild card: it can stand for nothing and be removed from the pack; but it can stand for the highest value too. In Tarot, similarly, the fool card is characterised by ambiguity: it can be the first or the last, and it sometimes stands outside the sequence, forming a link between the two.

In *King Lear*, the link between the fool and the king is as if *one* 'sover-eign fool' has been created: a melding of the two characters so that the Fool King 'is *both* sovereign and nothing, and Kingship is totally assimi-lated by Folly' (Willeford 1969: 213). *Lear* plays out a very complex and suggestive psychology, one that upsets the traditional opposition of King and Jester. The *coincidentia oppositorum* ('coincidence of opposites') on which the relationship rests has been thrown into chaos. A measure of how fundamental the fool is to Shakespeare's dramatic engine can, paradoxically, be seen in *Hamlet*, where there is no fool, because Yorick,

Hamlet's father's Fool, is dead. Shakespeare therefore has to reinvent him: it is Hamlet himself who takes on the 'antic disposition'. And what is this disposition? In the words of literary critic Geoffrey Bush, 'Like the Fool, he is both within and without his situation; it is not only his misfortune, but his tragic privilege to stand at one remove from the world' (quoted in Willeford: 193). As Enid Welsford writes:

> [I]n his capacity as detached commentator upon the action the fool exploits an inner contradiction; the incongruity due to that strange two-fold consciousness which makes each one of us realise only too well that he is a mere bubble of temporary existence threatened every moment with extinction, and yet be quite unable to shake off the sensation of being a stable entity existing eternal and invulnerable at the very centre of the flux of history, a kind of living *punctum indifferens*, or point of rest. (Welsford 1935: 324–325)

That *punctum,* whether indifferent or active, is what keeps the fool alive as a perpetual value. The fool is both a threat to the 'stability of the ego' (Willeford 1969: 235) and a recurring trickster who generates survival energy: '[For] [f]ools and nonfools alike, life is largely action, a play upon a stage [...] the "wooden 'O'" of the theatre is in one sense the "nothing" of the fool's nature; in another it is more real than life as we live it' (ibid.: 235). This is evidence once more that the fool is integral to theatre: both blank space on which to project and real person.

The most vivid example of a *punctum indifferens* – a renunciation of action in favour of reflection – is that of the play within a play. In *Hamlet* and *King Lear*, there are moments when the 'fool show' takes over and the drama takes on a less formal, improvisatory quality. When Hamlet invites the company in to play out a story of his devising, it is

> [a]n improvisation – for here the role of Hamlet, as showman, as master of ceremonies, as clown [...] who lewdly jokes with the embarrassed patrons – Hamlet the ironist, in sharpest contact with the audience on stage and audience off stage, yet a bit outside the literal belief in the story; it is here that this aspect of Hamlet's role is clearest. (Fergusson, quoted in Willeford: 197)

This play within a play structure brings us back to *Ganesh and the Third Reich,* in which the story 'proper' and the actors' story (or 'fool show') merge in ambiguous fashion and implicate the audience as freak-seekers. Here, the fool show takes over to a point where the underlying conflicts

in the historical story spill over into a conflict between performers and 'director'. It is precisely in the deconstruction of 'literal belief in the story' that the performance evokes such comedy and such disquiet.

Conclusion: the trickster

Philosopher Ian Hacking has spoken of 'unmasking' rather than refuting ideas, proposing that one can undermine ideas not by demolishing them with 'better' ones, but by unmasking the 'extra-theoretical function' that they serve (Hacking 1999: 20). The process works by stripping an idea of its 'false appeal or authority' (ibid.). In this chapter I have exposed the extra-theoretical function of the question posed to Bruce Gladwin and quoted at the start of this chapter. I contend that the ultra-liberal concern to ensure that the company 'knew' reality from fiction – and were thus not being exploited – is in some senses a pseudo-problem that acts as a cover for the 'real' problem, which is resistance to aesthetic engagement with the work of learning disabled artists. This resistance is rooted in a very deep psychic process that casts persons with learning disabilities as symbolic outsiders.

The gap between reason and unreason, or between intentional and non-intentional art, asks not a single question but a proliferation of questions. Foucault imagines a world where different questions were asked:

> We would no longer hear those questions that have been rehashed for so long: Who really spoke? Is it really he and not someone else? With what authenticity or originality? And what part of his deepest self did he express in the discourse? Instead there would be other questions like these: What are the modes of existence of this discourse? Where has it been used, how can it circulate, and who can appropriate it for himself? What are the places in it where there is room for possible subjects? Who can assume these various subject functions? And behind all these questions we would hardly hear anything but the stirring of an indifference: What difference does it make who is speaking? (Foucault 1984: 119–120)

The unmasking of the cultural faces of learning disability has uncovered a hall of reflecting mirrors. In addition to powerful circumscribing social factors, there exist deep-seated forces within the cultural imaginary, which can, if unchecked, perpetuate pervasive binary distinctions between disabled and nondisabled persons. As long as the cultural face of the non-rational other is used as a mirror to 'explain' humanity to

itself (feral), or as foundational principle in certain kinds of art (outsider), or if the staged presentation of the anomalous body is inexorably perceived as exploitation (freak), then the cycle will continue. This is not to deny the power of many works of outsider art; it does, however, illuminate the extra-artistic function that is served by appraising them by a wholly *other* set of aesthetic criteria. Nor is it to deny the fetishism that forms part of the freak show; it is helpful to acknowledge, however, that not all performer/audience transactions – or those between collaborators – follow that same disavowing pattern. The genealogy of learning disability and performance offers multiple points of resistance to overarching binaries. As noted in the introduction to this chapter, the process of desubjugating local knowledge need not be straight refutation of projecting ideas, but rather a reconfiguring of their value. 'It is not', as Foucault believes, 'that everything is bad, but that everything is dangerous, which is not exactly the same' (quoted in Tremain 2005: pre-contents) – it is possible to wear different masks at different times, and to utilise their subversive power. The genealogy that emerges from this project may be 'disorderly and tattered' (Foucault, quoted in Carlson: 105), but this is in keeping not only with Foucault's sense of emergent knowledge but with Orwell's notion of the fool as a ragged, earthy pragmatist.

The ambiguity of the fool is a powerful value. Rather than refute or collapse such ambiguity, it is important to embrace and aestheticise it. To *accept* the fool as one who both knows and does not know, and who is both of and not of the stage, is potentially liberating because it frees fools (and non-fools) from having to accept static categories. The psychological projection that Willeford describes as the 'mechanism by which we see in him [and her] our own foolish tendencies' might also be allowed (1969: 33). It is important, I argue, to accept that some mirrors are unavoidable. In a sense, unmasking the cultural faces of learning disability invokes a double bind. To project onto the other, whilst often a root cause of disavowal, is also, in psychoanalytic terms, what makes us human. We cannot *stop* projecting. It would be straightforward, but extremely reductive, to conflate Herzog's projection onto Bruno S with exploitation. Rather than view projection as *innate* disavowal, it might be seen, in Levinas's terms, as a desire to know and to respect the other. The idea of projection is intimately bound up with theatre as a form. The psychological transaction that enables theatre to impact on the self is a version of projective identification: that is, the attributing of one's own thoughts and feelings to the other whilst continually trying to adapt the behaviour of the other to best fit the projection. By

projecting onto Bruno S, Herzog was honouring the actor *as an actor*. The psychological danger of projective identification is that it often becomes a self-fulfilling prophecy; the projection risks being validated by the other. There is a danger, too, in assuming that projection is a one-way process. Bruno projected onto Herzog too. Work would often stop for hours as Herzog listened to Bruno's diatribes against him: how he was swindling him out of money, for example. (Similarly, Judith Scott behaving as if she had to 'steal' the materials for her artwork can be read as a projection onto a normalising world.) Herzog, however, did listen. And he insisted that the entire crew listen. The important thing is that, as imperfect as the working relationship may have been, it *was* a relationship. In response to Bruno's wish to remain semi-anonymous, Herzog says, 'I refused, therefore to name him. He is the unknown soldier of cinema and I hope that Kaspar Hauser is his monument' (director's commentary). The value of *The Enigma of Kaspar Hauser* lies partly in a creative 'transference' between lead actor and writer. Far from contaminating the 'purity' of the former's disability, the process can be viewed as complicating and validating his beauty. The psychological process that took place was intrinsic to the work as it often is between collaborating artists (see Chapter 6).

I argue that the trickster is an aesthetic and cultural energy, a *jouissance* that transcends binary values of 'good' or 'bad'. Fools sensitise audiences to the fluidity of on-stage and off-stage relations; they mark identity as unstable and permeable; they perturb the distinction between the natural and the skilled; they complicate the notion of authorship or intention. They provide a *punctum*, a point of reflection, around which meta-theatrical questions ('Who am I?' and 'What is my role?') revolve. The power to defy categories is precisely the dynamic at work in outsider art, too. Each face has something of the trickster in it: 'the boundary crosser [...] the creative idiot, [the] wise fool, the grey haired baby, the cross dresser, the speaker of sacred profanities' (Hyde 2008: 7). I argue that to deny the social and performative legacy of the fool – and other faces – would be to miss a rich seam of potential understanding, both in the form that work might take and in its reception by audiences. Moreover, the trickster does not work in isolation. She 'needs a relationship to other powers, to people, institutions and traditions that can manage the odd double attitude of both insisting that their boundaries be respected and recognizing that in the long run their liveliness depends on having those boundaries regularly disturbed' (ibid.: 13).

The face of the trickster is also the face of the actor. The actor, as will become apparent in the next chapter, wears more than one mask.

Part II
A Proper Actor

5
Nobody's Perfect: Disability Identity as Masquerade

> Daphne/Jerry: But you don't understand, Osgood! [*Whips off his wig, exasperated, and changes to a manly voice.*] Uhhh, I'm a man!
> Osgood: [*Looks at him, then turns back, unperturbed*] Well, nobody's perfect!
>
> *Some Like it Hot (1959)*

Masquerade

In this chapter I interrogate performance identity through the lens of masquerade, with specific reference to the solo performance *On the Verge* by musician and actor Jez Colborne of Mind the Gap. Colborne's work offers a unique opportunity for analysis since it is, to my knowledge, the *only* one-person show ever to feature a learning disabled performer. As Michael Peterson argues, the 'performance art monologue' tends to privilege 'reality' over 'fictionality', and gains its affects by acknowledging that the 'author is present on stage in the body of the performer' (Peterson 1997: 12). This imbues solo performance with a kind of authenticity, making the individual, implicitly or explicitly, representative of the social group to which they belong and thus creates the sense of unmediated presence: the 'monologic apparatus', therefore, has a two-fold effect of speaking for the individual but also their social category. An element of heroism also attaches itself to the solo performer, because they inhabit a largely bare stage and may call on few, if any, resources. Colborne's performance is important both because it adheres to the conventions of the solo autobiography – direct audience address, self-reflective anecdote, adoption of multi-character personas,

juxtaposition, or collage as well as straight narrative and lack of visible human support – and because it dissembles these conventions in surprising ways.

Such dissembling is referred to by some disabled performers as 'cripping' and is often used in conjunction with 'queering'. It refers to the way that disability acts as a particular kind of queering agent: that is, as a mechanism that upsets known binaries and sureties of identity (McRuer 2006; McRuer and Mollow 2012). Queer does not define a specific identity but rather in Butler's terms is a 'site of collective contestation' to be 'redeployed, twisted and queered from prior usage' (1993: 223). The notion of 'collective contestation' is particularly important here as Colborne, in common with many other learning disabled persons, disrupts the script of artist as autonomous author or independent subject. What is at stake is the freedom from preordained socially scripted identities and the power to invent and reinvent other life scripts, those that proceed from inter-subjectivity and co-authorship. I argue that *On the Verge* does more than subvert the normative 'ideal', rather it collapses the binaries on which normative ideology is based: disabled/nondisabled; masculine/feminine; performer/author and so forth.

To underscore a discussion of Colborne's performance, I refer to early feminist psychoanalyst Joan Riviere's notion of the masquerade. In 1929, Riviere argued that women, in order to achieve success in male-dominated environments, often 'put on a mask of womanliness to avert anxiety and the retribution feared from men' (1929: 130). Rather than draw a line between 'genuine womanliness' and the 'masquerade', she suggested that they were in fact 'the same thing' (ibid.: 133). The implications of this idea have been taken up by a wide array of theorists, most notably Butler and Lacan. The notion reverberates through *On the Verge*. How is learning disabled identity – itself already a performance – further formed or framed by theatrical events? When a disabled actor upsets the performance script 'set' for him in everyday life, how does this alter perception, not just of him, but of performance itself?[1] When does an audience 'see' the disability of a performer and when is it concealed from them? Disability, like womanliness, might be a *symptom*, a way of surviving via continual performance. Riviere argues, from a psychoanalytic perspective, that 'woman' is defined by lack, the symbolic castration complex that renders existence a continual process of rivalry and bids for supremacy. Tobin Siebers makes a direct link between castration and disability, to argue that disability too is defined as a stigma or 'unwanted difference' that must be managed performatively (2008:

96–118). Perhaps more hopefully, Siebers argues that the mask, if understood, can be made to fit: exaggeration, role play and buffooning are methods to manage identity.

As a strategy, masquerade involves 'coming out' as disabled but twists the process by *overplaying* such tropes as passivity and weakness. 'Voluntary disclosure' thus goes hand in hand with 'exaggerated self presentation' (2008: 107). Siebers gives us the visceral example of three dozen protestors leaving their wheelchairs to crawl up the steps of the Capitol building in 1990 (ibid.: 106). Whilst acknowledging that there are pros and cons to the approach, Siebers argues:

> The challenge is to find a rhetorical form that satisfies theoretical, practical and political requirements. Narratives about disability identity are theoretical because they posit a different experience that clashes with how social existence is usually constructed and recorded [...] When a disabled body moves into a social space, the lack of fit exposes the shape of the normative body for which the space was originally designed. (2008:105)

What kind of rhetorical form did *On the Verge* take, and does the form expose a lack of fit? I argue throughout this chapter that a continual tension is felt between the 'reality' of who Colborne is off stage and the persona created on stage, a performance that presents disability through masquerade.

It would be misleading to suggest that this chapter is 'just' about Colborne. Ironically, the solo performance highlights just how many other intelligences are embedded in the work. In a practical sense, the 'author' is not on stage, if indeed any singular author can be found. My research involved repeated viewings of *On the Verge* and interviews held with members of Mind the Gap. Not having been present at the devising process, I pieced together a narrative from participants whose experience was already slipping into the past. Whilst there have clearly been disadvantages to this approach – unavoidable lapses in memory, for example, or the possibility of the myth-making that blurs the edges of factual accuracy – there are perhaps unforeseen advantages. As Mike Pearson has argued:

> Maybe we concentrate too much on the analysis of contemporary performance from positions of spectatorship, on the authoritative documentation of dramaturgy and its exposition, on constructing some kind of 'official version', causing us to be rational and

reasonable about work that was none of these things. And too little on histories written on and in the body, on oral testimonies that might discomfort the past: secret histories, stories of awkwardness, pain, trauma, scarring. (Unpublished conference paper, quoted in Heddon and Milling 2006: 234–235)

Pearson's words prove prescient. I have chosen to quote from the 'oral testimonies' of these interviewees at some length, to allow their accounts to be communicated in their own words rather than solely via my mediation. The presentation of work in this way and the inclusion of Wheeler's and Colborne's comments on an early draft of this chapter is an attempt to offer the reader first-hand evidence of such 'secret histories' and to problematise the concept of an 'official version'.

Analysis of the work from concept to artefact allows me to engage in depth with the idea of masquerade and the anxiety of ownership that ensued amongst the collective. My viewing of the live work took place on three separate occasions between October 2005 and June 2007. The majority of the discussion of Colborne's acting style focuses on his performance during this time. Later in the chapter, I discuss further performances viewed on three consecutive nights in Hong Kong, July 2007, which forced me to re-evaluate what I had previously seen. Rather than try to gloss over the contradictions in interpretation between these two periods of research, I welcome them. Is this not the precise function of both theory and masquerade? To render fixed knowledge redundant, a visage that reveals and conceals the expectations that lie behind the mask? In this chapter, the identity of the performer is continually on the verge of being known, as is the theory that might support him.

On the Verge (2005)

On the Verge was conceived as an adaptation of Kerouac's *On the Road*, but developed into a 60-minute one-man show, something Mind the Gap had never before attempted. The company was formed in 1988 by Tim Wheeler and Susan Brown. Their initial aim was to develop an organisational structure without the need for nondisabled direction. These ideals gave way to a more pragmatic awareness of the level of support and training required to aspire to professional standards in artistic and public life. Today, their current mission statement asserts their intent

to dismantle barriers to artistic excellence so that learning disabled artists and nondisabled artists can perform alongside each other as equals. (www.mind-the-gap.org.uk)

This shift in emphasis suggests that the nondisabled person is now in a role more nuanced and complex than simply that of 'facilitator' or 'enabler'. As Wheeler has expressed the company's goal elsewhere:

> I think that it is our aim to make it possible for non-disabled people to be considered artists in their own right and not as facilitators of learning disabled artists. That would mark the final transformation – when the liberation happens both ways! (Wheeler 2007c)

By placing their work in an artistic context, Mind the Gap has articulated an agenda distinct from therapy – in which the disabled client is the sole beneficiary – to one of mutual dependency and responsibility. Wheeler, who trained with the Brazilian director and activist Augusto Boal, was a pioneer in the use of Boal's Theatre of the Oppressed techniques in the UK and one of the first to apply them to a disability context. Broadly, the company has sought to marry a concern for social change with innovations in aesthetic form. Engaging in theatre development at many levels with the wider learning disabled community, they have consistently challenged the exclusion of learning disabled people from British cultural life, also creating increasingly assured national touring work that demonstrates high quality performance and sharp production values.

Prior to *On the Verge*, the national touring work had fallen into two distinct strands. The early and mid-period work, up to 1999, was usually devised, working strands of the performers' own experience into carefully plotted stories and fantasies, in shows such as *The Big Picture* (1998) and *Neville's Advocate* (1999). At the turn of the decade the company made a distinct shift from devised stimulus to the re-invention of classic texts with *Of Mice and Men* (2000), *Dr. Jekyll and Mr. Hyde* (2001), *Pygmalion* (2002), *Don Quixote* (2003) and *Cyrano* (2004). There was both an aesthetic and a pragmatic rationale for this. On the one hand, they felt that they had, for the time being, exhausted one artistic route, and that devising work from fragments of real, lived experience kept them locked in a particular mode. Wheeler defines this shift as 'moving out of the room called surreal'. Citing Keith Yon (a tutor at Dartington Hall) as an influence, he has said that early on in his

performing arts education he was encouraged to question the notion of surreality:

> We learn to seek narrative at a very early age [...] this sense of 'what's going to happen next' is the basis of our desire to connect ideas; a sense which is further developed through imaginative play, and through the stories we hear and tell each other. If we are excluded from understanding the world in this way then it is perhaps understandable that our ideas might appear to be set together in an incongruous way. Of course the Surrealists made great play of the incongruous juxtaposition of ideas and objects. But they did this consciously – a wilful art is very different from art by accident. (Wheeler 2007c)

Underpinning Wheeler's commentary here is a wish to see artists with learning disabilities not as exotic or eccentrically gifted 'naturals' but as potential students of theatrical form. Another governing factor in moving 'out of the room called surreal' was more prosaic: the company wanted to reach a wider audience. Adapting *Of Mice and Men*, John Steinbeck's 1945 tale of two itinerant farm workers, Lennie and George, gave the company an opportunity to cast Kevin Pringle, a learning disabled actor, in the role of Lennie. The character of Lennie, whose arrival at a remote farm precipitates a series of tragic events, though never stated as such by Steinbeck, can be read as someone living with a learning disability. As far as the company is aware, this was the first time the character had been played by a learning disabled actor. The piece also featured Jez Colborne as George and physically disabled actress Ysy Collyer playing a variety of female roles. The interpretation of the piece in this way created a powerful dynamic that charged the work with moral significance: the piece and accompanying educational outreach programme encouraged audiences to consider the prevalence of learning disabled 'clients' in the criminal justice system and real-life cases such as Derek Bentley. Over the past decade, the show has been redeveloped and has toured on three other occasions, each time with Colborne in the pivotal role. Reviewer Adam Robinson noted of the 2011 version that

> [a]t the centre of the piece is Jez Colborne, around whom all the other parts seem to orbit. His performance is sturdy and the apparent frustrations of the trouble-wracked George simmer throughout. This is an epic part and one which requires both intensity and

vulnerability; a feat which Colborne manages to an impressive
degree. (Robinson 2011)

Thus, Mind the Gap embarked on the series of adaptations that began
to interrogate the meaning of learning disability from a wider cultural
perspective: *Dr. Jekyll and Mr. Hyde* (learning disability perceived as a
symbolic negotiation between angelic and bestial forces), *Pygmalion* (the
theme of illiteracy and class), and *Don Quixote* (the fine line between
fantasy and reality) have followed. Many artists have been involved
in these productions since 1998, amongst them four key collaborators:
performer and musician Jez Colborne; Artistic Director Tim Wheeler;
writer Mike Kenny; and film-maker/designer Jonathan Bentley. These
four artists came together once again to create *On the Verge*.

Colborne's dream was to ride across America on a Harley Davidson.
Wheeler, a fellow Harley enthusiast, began a process of research that
was to lead to its successful realisation. This was underpinned by the
idea of the Outsider, offering a bleak post-9/11 commentary on the
American Dream. Wheeler had the idea of meeting up along the way
with a series of outsider artists to share their experiences before ending
up in rural California, the birthplace of Steinbeck's tale. *On the Verge* is
a one-man show in the tradition of 'an audience with ...', combining
travelogue with filmed diaries cutting in and across the live stage narra-
tive. These offer us bite-size chunks of footage that focus on the traveller
as much as the territory. The piece can be read through a pop culture
lens as akin to comedian Billy Connolly's tours or Michael Palin's globe-
trotting expeditions. In design terms, *On the Verge*'s bar stool, tall table,
and coat stand create a diner, a sense of Americana that places the
audience in an intimate setting. The introductory music, 'Like a Rolling
Stone', played as the audience members take their seats, hints at some-
thing Dylanesque about Colborne: Dylan circa '66, hair wild, a cigarette
dangling, the cover of *Blonde on Blonde*. Colborne likewise does seem
to share Dylan's otherworldliness, a certain disinterest in what others
think of his art.[2] The piece also utilises moments of disability cabaret, a
form popularised by the disability arts movement and performers such
as Matt Fraser and Johnny Crescendo, combining elements of popular
song, comedy, and polemic. Colborne regularly breaks up his spoken
narrative, turns to his keyboard, and sings songs related to the trip and
to his experiences as a disabled man.

The filmed elements that follow Colborne and members of the artistic
team on their journey are a gentle *cinéma vérité*. The spectator follows
them from East to West and back to New York again before the flight

home. Along the way, Colborne meets a cast of colourful 'outsider' types: the transvestite, the cowboy, the bottle collector outsider artist, the beggar, the actor dressed as Spiderman, to name but a few. The idea of Colborne as 'outsider' is a core element in the piece. It is tempting to see Colborne in this way, a self-taught virtuoso and performer operating outside the aesthetic norm like the psychiatric subjects of early *art brut*; but this temptation should perhaps be resisted:

> Not sure about this thing you say about 'psychiatric'. There may be a psychiatric patient who makes something without being taught. But *On the Verge* isn't like this. I'm living a dream. I'm not in an institution and I have to rehearse and practice. Although it may be about outsiders it's not psychiatric, not about the medical model of disability. I don't need to have calming down tablets. (Colborne 2007b)

As Colborne implies, the outsider art label carries the connotation of institutional client, someone incapable of or resistant to engagement with audiences. Outsider art also implies a deep solitariness, an obsessive attention to a singular project that can take years to culminate, if indeed 'culmination' occurs. Colborne seems too sociable, too enamoured of the audience to accept so lonely an occupation. Throughout the piece, however, the spectator is continually introduced to the 'underdog' and the strange. The conversations that Colborne strikes up are based on the question 'What does it mean to be an American?' It is the answers to this question that give shape to the journey and the artwork. The live performance, as Colborne introduces himself, talks about his dream to cross America on a Harley Davidson, and recounts his experiences, is carefully scripted. 'I'm not the first person to have this dream', he says, 'or the only one, but I might be the only person who got the Arts Council to pay for it.' This sets the humorous tone of the piece: 'If you look up Williams Syndrome on the website, you'll find out I have an overfriendliness to strangers. This came in very handy in America. It felt like home. I think the whole country must have Williams Syndrome too, because they were all very friendly to me.' *On the Verge* celebrates Colborne's medical 'condition' and avoids pathologising it.

There are moments in *On the Verge* that function as a highly public 'coming out' as a learning disabled person. Colborne's restatement of his disability is an act of reclamation: by saying what is 'wrong' with him, he deflates any sense of watching him to diagnose him. Along the

way, we find out more about Colborne and more about what it means for various people to be an American citizen. It is the odd juxtaposition of these two things, America, and Colborne's unique way of seeing it – off-key, wide-eyed, eccentric – that contributes to the aesthetic unity of the work. The raw, often clichéd materials of Americana are transformed into something unique, because we are seeing them through Colborne's eyes. The theme of *On the Verge* is 'freedom', an idea constantly referenced by interviewees in the film: the catch-all answer to the question of what it is to 'be an American'. In one section, the spectator is encouraged to make a link between Elmer, the bottle artist – '[In America] you're free, you're absolutely free' – and our narrator, a disabled artist: 'Elmer takes junk and he makes it into beautiful things. He's made a forest of bottle trees. In England, he'd get hassled by the planning department. I find him inspiring. He's an artist. Living on the verge, doing his thing, like me.'

'On the verge', the phrase itself, could be read as an attempt to define a learning disabled aesthetic. It is not deliberately edgy or overtly dangerous; it seems more passive, non-confrontational; something almost there, almost realised, but not quite – emergent, but slightly self-apologetic. As Wheeler notes: 'I like the fact that "on the verge" has both a poised and a passive connotation – on the verge of a nervous breakdown is very different than left on the verge. One is a point of becoming, the other, of ending' (2007c). The aesthetic of *On the Verge*, in its appropriation of a 'classic text' (*On the Road*) and 'mainstream' form – stand-up and travelogue – plays with our notion of centre and margin, self and other. This appropriation could be read as a conservative act of co-option. Alternatively, 'on the verge' is a metaphor for transformation of theatre and learning disability itself: a direct address, a step closer taken by the 'I' of the disabled performer to the 'you' of the nondisabled audience. Still, this begs a deeper question: which 'I' is being performed and what is the social context in which 'you' engage in that performance?

The end of the piece draws on the theme of freedom and subverts it by dealing with two distinct but related experiences in New York. In the first, Colborne is confronted by the manager of the hotel he is staying at and reprimanded for talking to strangers in the lobby. The exchange ends badly, with Colborne being asked to leave. 'You look strange. You put people off', says the manager. The second is a trip to Ellis Island. The account of this event eventually became the core of the piece, where Colborne comes to realise that, as an immigrant, he would have been marked with a cross for 'feeble minded' and almost certainly shipped

back to the port of embarkation. This story leaves us with the image of family separation: 'Imagine, an eleven year old girl, learning disabled from a village in Lithuania, sent alone to Liverpool and left there.' Colborne follows this with a kind of anti-tribute ballad to Ellis Island, called 'American Dream'. The chorus gives a flavour:

America, America
I'm waiting for my dream
I'm wondering if America
Is really what it seems
Come to find America
Like millions have before
America, America
Will you open up your door?

The performance ends with this song, the stage empty before an image of the Statue of Liberty on the screen. These lyrics could be variously interpreted as hopeful, ironic. or sentimental (or all three). This song, when performed, is cloying and over-emotional, as if the spectator is being manipulated to feel rather than gently provoked. It jars somewhat with the tone of the whole, which up to this point has been ironic and non-judgemental. This is the section of the show that comes closest to disability cabaret: a song that makes a statement. In narrative terms, however, the song helps to provide closure for the piece. As Colborne sings, the audience watches a filmed collage of him travelling through America. We revisit the territory we have seen throughout the last 70 minutes, but through a darkened lens. It is worth noting, too, that Kevin Berry, in his review for *The Stage* felt that 'the lament [Colborne composes] to voice his feelings' was 'deeply moving'; and also that the anthem has become a favourite within Mind the Gap's acting company (Berry 2005). Colborne returns after a bow to lift the mood with a version of *Born to Be Wild*. To do so was very important to him: 'I want people to be entertained. It's a happy piece. It's about my Dream. I had a good time. I don't want to make people sad' (2007a).

On the Verge contains most rhetorical devices present in solo 'crip' performances: a reclaiming of crip identity as positive; the act of 'coming out' in a highly public forum; the bodily display of difference; and the act of witnessing injustice, both in the past and present (Sandahl 2003: 28). Learning disability, in contemporary society at least, is no longer a secret, but the fact that Colborne can talk directly about his

own impairment in a comedic way is uncanny: it subverts the notion that a person with an intellectual disability cannot speak for himself. Colborne upsets the notion, discussed in Chapter 4, that a learning disabled person is a blank slate to be projected onto: rather, he projects himself and thus attains a highly public identity.

Creating Colborne

This identity – and the process of constructing it – is more complex than first appears. Mike Kenny comments:

> [I]n this case Jez set off to find a dream, and frankly there was little chance that he wouldn't discover it, so I suppose for me as writer the big question was the journey that the audience were taken on rather than the one Jez went on. It seemed important to leave Jez's dream more or less intact, while the audience raised the questions about it, and I emphasize that they were questioning the dream not Jez. It seemed to me that trashing the American Dream had been done so many times before that it was a comfortable cliché. So I thought it was less comfortable for an audience to see that dream as still having positive elements, i.e. through Jez's eyes. (Kenny 2006)

It is clear that the concern for the writer was the lack of drama: 'We didn't have a play until we went to Ellis Island. The sheer scale of the dreams there blew me away' (ibid.). Kenny's role in the devising process was discontinuous; he kept in touch with the journey but only spent the last week with Colborne and the others in San Francisco and New York. He says: 'I arrived at the end first, with Ellis Island and the hotel incident. In a sense, I wrote the play backwards' (ibid.). As Wheeler explains, 'It was difficult because we didn't have a real story between us. The story was what happened to us. It was raw, direct [...] I was implicated in the material' (2007b). Bentley commented that there was a creative tension between his own wish to shoot footage 'on the hoof' and the director's idea to stay focused on what they had planned before they went on the road. There is a sense from both artists, however, that the creative dilemmas actually assisted the process of making the work. These difficulties echo Mike Pearson's frustration with 'official' academic critique discussed at the start of the chapter. Bentley, like Wheeler, felt that *On the Verge* was his best work with the company up to that point but, equally, his most challenging. Bentley returned from the US with over 26 hours

of footage and quickly edited what he regarded as the most 'filmic sequences'. He comments:

> There was a possible structure. The combine harvester, the train sequence: these machine moments seemed to define Jez. Also the homeless guy, the balloons. I immediately edited these. The conclusion was always going to be Ellis Island but the problem was ... very little footage! We had to edit from bits of different boat trips. It was very fabricated. (Bentley 2006)

Bentley describes the work as 'part documentary, part oratory' and as a good example of 'film filling in the gaps that theatre can't' (ibid.). Richard Hayhow, of the Shysters, commented, '*On the Verge* is obviously an intimate piece, which uses film to make it "bigger"' (Hayhow 2008b). One way of interpreting both these perceptions is that Colborne as a live performer creates a gap in our 'performance consciousness', which requires film to fill in certain moments. As Peggy Phelan comments:

> [We might] speak of performance consciousness as that which alters and interrupts the seam between performance as in everyday life and performances that are larger than life [...] Similarly consciousness of disability awakens us from our untested beliefs in embodiment; disability transforms one's worldview because it reorders the invisible and the visible frames that illuminate our worlds. (Phelan 2005: 324)

On the Verge sets up a gap between Colborne's stage persona – carefully rehearsed and scripted – and his film persona, which is improvised. Ironically, whilst the size of the screen and the landscapes portrayed often create the sense of the piece enlarging, opening outwards, some of the most intimate moments happen on camera where there is little or no artifice between Colborne and his audience. Performance consciousness is a condition of acute perception. Consciousness of oneself *as a performer* or *as someone being watched* is an interchangeable condition between the stage and everyday life. Phelan's point is that the condition of performance consciousness *both for the watcher and the watched* is heightened in the context of disability. Extending Phelan's argument in relation to *On the Verge*, it is possible that the interruption of the seam between artifice and reality is writ large in the very structure of the work: the interplay between the media of live theatre and recorded film heightens our awareness of Colborne's disabled (doubled) identity.

Kenny's role as writer increasingly encompassed that of editor and/or therapist, constantly filtering and downloading the lived experience of others. Previously, his work for the company had been as a re-interpreter of classic narratives, such as *Don Quixote* or *Of Mice and Men*. In *On the Verge*, the writer became a different kind of interpreter, someone who must interpret real life, shape, and symbolise it. Kenny has termed both practices 'ghost-writing' – in each case the writer-interpreter must negotiate a prior text. The metaphor of the ghostwriter also has currency in performance since when we listen to Mind the Gap's actors on stage, we also hear Kenny: the gags, the politics. There is a tension here highlighted by the distinctive format of *On the Verge*: the one-man show. Kenny admits that the production is, 'me trying to frame Jez as a learning disabled Billy Connolly'. Alone on stage, Colborne is exposed and potentially vulnerable, certainly with no visible means of support. His situation heightened Kenny's anxiety that he was 'creating Jez, or at least a persona for Jez that isn't really Jez' (2006). Kenny's process of 'trying to frame Jez' resonates with Phelan's analysis of disability as a repositioning of framing devices (2005: 324). An audience viewing *On the Verge* has, consciously or otherwise, to negotiate the meaning of several frames: the frame of everyday life from which the material is devised; the frame of Kenny's script; the live performance frame of direct audience address choreographed by Wheeler; and the screen frame of Bentley's film. The devising and performance process is a continual filtering between these contrasting frames.

Wheeler's concern about the first draft was that it was not theatrical enough, that not enough was 'happening' on stage, and he asked Kenny to write some more characters based on the real-life people they had met. In the finished piece, Colborne briefly 'becomes' others on stage: a Wyoming cowboy, a cop, George from *Of Mice and Men*, an irate hotel manager. Moments of transformational acting, where the narrator enacts rather than recounts, are a key feature of the piece, complicating Colborne's persona. Colborne tells us about his fascination with cowboys and acts out an imaginary shoot-out, playing both characters:

Cowboy: You look like you can handle yourself.
Colborne: (*Whips out a pretend gun, picks off a few desperadoes, blows his finger, returns it to its holster*) Reckon I can.
Cowboy: That's pretty impressive feller. Are you good, bad or plain ugly?
Colborne: I guess I can be all three, if I need to be.

(Kenny 2006)

The text is performed by Colborne using a cowboy hat as signifier. He puts the hat on: *(Southern drawl)* Looks like you can handle yourself. He takes the hat off: *(Received pronunciation)* Reckon I can. There is a delay each time in the transfer, a slightly longer period than we might expect of a 'trained' actor, and a certain lack of precision. His gaze, for example, doesn't fall in the 'right' place every time, to indicate the position of the imaginary 'other'. These are little tear marks or *punctums* in the performance where the audience is able to see the joins created in rehearsal; the blocking that has been learned through repetition. As Marjorie Garber has noted, transformational moments of this kind invoke the 'third actor': the extra component that Sophocles added to classical Greek drama, the one who could mediate between the protagonist and the antagonist and take on multiple roles. The 'third actor' is thus not simply an addition to but a *complicating of* the stability of the one, or the balance of the symmetrical. The third position places identity, self-knowledge, and self-sufficiency in doubt. One of the clearest examples of this in theatrical practice was the role of the 'boy' on the Elizabethan stage, who was able to cross as woman; and in the same context, the fool, as I noted in Chapter 4, complicated the boundary between on and off stage. The 'third presence' places the spectator back in the realm of seeming – of parade – and offers a 'mode of articulation' rather than a discreet entity, 'a way of describing a space of possibility' (Garber 1992: 11). Or put another way, in the context of *On the Verge*, the third presence exposes the gap between the 'original' masculine (cowboy) and Colborne's derivative: his travesty.

Disability drag is the practice of nondisabled actors 'cripping up' to play disabled characters (Siebers 2008: 114). The position is reversed when Colborne 'norms up' to play nondisabled characters. Juliet Halberstam (1998) defines beautifully the 'problem' facing women who impersonate men, known as drag kings. Unlike their male counterparts, queens, kings rarely find anything directly *performative* in masculinity: no gesture to camp, no masculine signifier that lends itself to theatricality or parody. The reason she gives for this is simple: like the ableist norm, heterosexual masculinity is invisible. It survives by being natural and inevitable, something only men can 'have'. In other words, masculinity 'just is'; femininity – and by extension, disability – is artificial. Yet, as Halberstam rightly says, masculinity does not belong to men, it is just a question of *how* to imitate or embody it. Colborne is at his most subversive when impersonating men. This is not just because he parades in these moments as 'nondisabled' but rather that he tries on the mantle of being a man. As noted in Chapter 4, learning disabled persons are

often perceived to inhabit a liminal cultural space between child and adulthood. I suggest that Colborne represents a 'third' ability or gender. He does not 'have' hetero-normativity but rather at times seems to have it or appears 'with it'. In this way, *On the Verge* is not a critique of gender or disability but rather a critique of these things *as categories*.

Of the different types of drag kinging analysed by Judith Halberstam, the most relevant to Colborne is what she calls 'denaturalized masculinity', which comes very close to 'male mimicry' with some subtle differences. Colborne does not simply mimic masculinity by dropping a register, but parodies it. Rather than understating the supposedly invisible assumed essence of masculinity, Colborne exaggerates it. As Halberstam explains, masculinity is only visible at its most performative, in the 'gadgets of sexism' or misogyny (1998: 266). It is no accident that the cowboy picks a fight and murders him or that the cop plays with his gun, not to the mention the hotel manager who tries to throw him out for looking different. Because these moments are *presented* in a gentle and ironic tone, it is easy to miss just how subversive they actually are as markers of the often 'invisible' normative.

To complicate matters further, Kenny points out: 'I helped create a persona that Jez stepped into [...] He inhabits it very well, but it's not quite him'.[3] Whilst many of the details are about Colborne's obsessions, all the direct address material about his disability came from Kenny and his research into Williams Syndrome. Colborne's image is mediated through a film-maker, his words scripted by a writer and his every move choreographed through a director. Who then is the performer 'Jez'? Colborne is very clear about the persona that he himself wants to portray on stage. The biker jacket, the unkempt hair, the big boots, all add up to a kind of rogue outsider look. In real life he wears camouflage. Colborne is very deliberate about his choice of camouflage and has an encyclopedic knowledge of different shades. 'I'm a soldier of love', he says. He dresses like this not to blend in but to stand out. But as Wheeler notes, 'in New York, it had the opposite effect, where he just blended in' (Wheeler 2007c).[4] Colborne has said, of his general experience, that people are scared of disability, fearing that 'if they touch me, they'll be like me' (2007a). This is visceral evidence of 'aesthetic anxiety'; as noted in Chapter 2, disability can be 'used' in performance to exploit the notion of aesthetic distance, opening up a gap in spectator consciousness as to whether the performer is playing himself or not, or whether the events enacted are 'fictional' or 'real'. This has implications for a reading of *On the Verge*, a piece that plays with perceptions of Colborne's disability.

The show manages perception by portraying Colborne as a tourist, whose disability – or difference – tends to merge into the generalities of 'America'. The idea of the tourist works on both a literal and a metaphorical level. Colborne is, as are most people in the neoliberal West, a tourist. He does things that all tourists do: he visits sites; he samples local food; he records events on camera; he talks to 'the natives' in order to get a flavour of their lives; and he comes back to tell the story of his travels. The all-pervasiveness of tourism makes it a metaphor for a neoliberal economy, which turns lived experience into economic productions called 'leisure'. The Route 66 featured in *On the Verge* is now as much a theme park as a road, servicing the consumer who wants to 'experience Route 66'. So while Colborne's 'otherness' on stage may provoke anxiety, this is countered by his generic identity, on film, as an affable tourist. If, as Dean MacCannell has written, 'the tourist is one of the best models available for modern man in general' (1989: 1), then 'we' are 'Colborne'. He has become 'Everyman'.

The text, in contrast to his Everyman status, clearly 'marks' Colborne as disabled but it does so ironically. Disability, in medical terms, is most often represented as pathology, the genetic failure that has tragic consequences for the individual. As quoted earlier in his joke about Americans having Williams Syndrome, in *On the Verge* it is not Colborne but 'overfriendly' America itself that slides into pathology. The work plays with perception of disability: it refuses to define disability as a fixed point. Rather it is performative, defined by something someone does rather than what someone is. To extend the metaphor, disability is much like America itself, a territory struggling to define itself, a state of mind as much as a real entity, a configuration of dreams often at odds with official statements about its essence or level of influence in the world. America and Colborne are two characters on stage at all times: both real and symbolic. Perhaps a nondisabled audience manages the aesthetic distance by identifying so completely with his dream – the uber-male fantasy of riding across the desert on a Harley – that Colborne becomes the protagonist, the cipher. As Kenny says, 'We all like to hate the US. At the same time, we are all Americans now' (2007).

Another way of addressing the difference/commonality continuum is to ask if the work attempts to shock its audience. Does it attempt to give a radically altered view of the world by confronting viewers with disability or is it the role of the director to support a nondisabled audience through the anxiety aroused by seeing a learning disabled actor on stage? The piece is gentle, unassuming in its tone. For Wheeler,

[...] it's the duty of theatre to provoke, but there are different ways of provoking. You can be unkind to an audience but to a sophisticated audience you need to go quite far to shock them. O.K, people like to feel anxious. We love anxiety in films, stories [...] but you can get into the realm of sensationalism or exoticism. (Wheeler 2007a)

In the final editing process, where the piece was essentially torn up, at least one element was cut due to its potential to cause discomfort. Kenny had written a joke during the 9/11 section commenting on the fact that there were no disabled people left to die in the building, that at least 'access wasn't a problem' on 9/11. The test audience visibly tensed at this moment, as if 'it became conscious of itself', that it considered the jokes in bad taste (Wheeler 2007a). It revealed the parade, with Kenny, on this occasion, peeking through the surface of 'Jez' to become momentarily, and uncomfortably, visible. Whatever else the *final* version of the piece wants you to do, it wants the spectator to 'like' the performer. It wants her to relax in Colborne's company, sympathise and feel at ease with his journey and his occasional tribulations. It requires the viewer to see the innate affability in Colborne. It is the opposite of viewing someone like British comedian Ricky Gervais, whose work demands that the spectator negotiate a complex web of sympathy and revulsion on a minute-by-minute basis.[5] In an exact parallel of Riviere's masquerade, it could be argued that Colborne uses 'charm [...] ardor, deference, humour or entertainment to relieve nondisabled people of their discomfort' (Thomson 1997: 13), or more controversially that he has become 'supplicant and minstrel', striving to create a valued representation for the majority (ibid.). But this would be an unfair simplification. Colborne, I argue, is neither 'overcomer' nor 'charity case' (Sandhal: 41).

Colborne's 'film' persona is mediated powerfully through Bentley's editing; yet the film also captures Colborne at his most direct: unscripted and vulnerable. In one sequence, Colborne watches a freight train, 'a very large, very long, very big freight train'. The film cuts to a title, 'Seven Minutes Later', and the train re-emerges, still travelling the same length of track. 'Incredible', says Colborne. He continues: 'Four big V18 or probably V24 powered locomotives. With over 2000 Horse power each. That is a lot of horsepower.' Colborne's autistic persona is gently sent up, the comedy arising from the sheer size of those things – trains, machines – that he is obsessed by. It is a moment of extreme passion, as if Colborne has waited his whole life for this train. Or rather as if the train has waited until now for this man, this desert. Following the obsessive detail of the engine size, and the probable route it has taken,

Colborne confronts the vast emptiness of desert. The camera lingers on him. He might be lost. But he laughs, as if at least now he could die happy.

Camp Syndrome

There may be no precedent for Colborne's acting style, especially in the relationship between the actor and his body. When he puts on a character, for example when he tells the audience how he played George in *Of Mice And Men*, he is quite clearly being directed to make certain movements with the text: the wave of arm to denote 'river'; the hand to the nose and the funny 'oink' to demonstrate 'pigs'. The acting is emphatic, demonstrative, as if it needs a constant sub-play of mimetic gesture. In fact, these were a conscious attempt by the company to embed elements of Makaton sign language into the performance. These elements appear as a gestural aesthetic but are rooted in a desire to increase access for audiences who cannot easily understand verbal communication. How might such physicality compare with the work of DV8 Physical Theatre performers or, by extension, the solo work of the company's co-creators, Nigel Charnock and Wendy Houstoun? In these instances, the pace may be more rapid and the movements more abstract, but there is still a highly choreographed relationship between text and body. Previous observations of Wheeler directing Colborne in rehearsal suggest that the style of performance achieved is deeply linked to rehearsal protocols.

Once the script is in Wheeler's hands, he goes through it, piece by piece, with the actors. At the read-through, the piece is broken down, not just into scenes but into units of scenes, units of action. These are marked like mini-chapters on the page and given titles. These titles are used, in the manner of Boal's Image Theatre, to create a series of still pictures in the room, and physical gestures may be applied. Wheeler's 'intention in rehearsals is to make the process of direction visible so that the actors can learn how a show is directed' (2007c). The method is designed to give the performer a physical score for the piece, a series of images to move through. Thus, the actor establishes a physical journey through the text, each sentence delivered with a gesture, the blocking becoming a safety net in case of lapses in the memory sequence. Given that Wheeler likes 'to get away from the script as soon as possible' and that many of the actors are non-literate, it does beg the question: why bother with a written script at all? Wheeler's response to this is clear: 'The danger is that we end up putting a workshop on stage' (2007c).

The issue of 'intentionality' is submerged in this comment, and I suggest that Wheeler's concern to convey 'finished' performance is rooted in an anxiety that learning disabled performance may be re-read on stage as the opposite of 'finished', that is, as contingent, experiential, improvised, and, in traditional Western theatre terms, 'unprofessional'.

A strange thing happens sometimes when Colborne's body will not quite do what it is 'asked'. In culturally dominant modes of theatre the actor is expected to have complete control over his movements, but with Colborne there is always a delay. The acting style allows the spectator to see each element of the performance quite clearly. In the language of the trade, we can 'see the blocking'. He is stopping the George speech now and starting another section. He pulls out his harmonica and begins to play. Then he stops and puts it back. Now he is getting up and walking around the suitcase and standing there. None of this feels quite 'natural'. It is heavily choreographed, as if he has grafted the blocking onto his stage persona. The viewer is hyper-aware of the length of time it takes for him to zip up his jacket, the slowed-down effect of pouring the sugar into the coffee. The coffee, the sugar, the tall diner stool, these become a physical as well as a design motif. Colborne is walking back to the table again. Not walking exactly. How does Colborne walk? He galumphs, stoop-shouldered, heavy-footed – there's nothing delicate or artful about it. The 'diner' is suggestive of American actors – a Pacino, a De Niro sitting there, making it all seem so natural. The coffee in the Styrofoam cup or the tall mug is an aid to the text; you can taste the coffee in the text, but with Colborne the coffee, the sugar, the audible gasp after the tasting, all of this gets in the way of the flow of the text. There is no flow. The artifice can be seen. These props draw attention to themselves in his presence. Colborne is De Niro's nemesis.[6]

Whilst Colborne's acting is not subtle, this does not mean that it lacks complexity. To return to the notion of drag, Colborne's performance is most complex at moments where he crosses into other characters. What Halberstam refers to as 'layering' are those moments where dyke masculinity might 'peek through' into the hyperbole of performed masculinity. Arguably, this happens with Colborne, whose 'learning disability' (his ineptitude, for want of a better word) is always, in a sense 'peeking through' the parade. This goes to the heart of identity representation in which 'role playing reveals the permeable boundaries between acting and being' (1998: 261). To borrow Halberstam's point, Colborne in drag is performing his own disability and simultaneously exposing the artificiality of conventional roles. He is both a performing disabled person and disabled performer.

It is not easy to say some of these things. To my commentary on his performance, Colborne has responded:

I wasn't sure about the loafing thing. People have commented on my legs, the way I walk. People stigmatise. They focus on things I can't do more than things I can do. Time and time again. It gets tiring. Here I am, you can take it or leave it. It's important not just to criticise but to give me ideas what I can do better. Just like Tim does. He helps me make it a bit slicker. I want to do anything to make it good. (Colborne 2007b)

By critically appraising a disabled actor on stage the critic is negotiating a territory (disability) that is already a performance and one in which the performer is most often framed by his *lack* of competence or by the *adjustments* that the 'audience' (nondisabled society) has had to make for him. My conversations with Colborne about my criticism of the show have been some of the most difficult but ultimately beneficial aspects of this research. Colborne's definition of 'good' is 'slicker'. Does this mean that the definition of his 'success' will somehow be the attainment of a kind of invisibility, his ability to 'pass' as a nondisabled performer? Above all, what Colborne's performance does is to question the very notion of virtuosity. He is not 'slick'. We are aware of the mechanics of performance at all times; he does not somehow transcend the form.

Susan Sontag has written on Camp, not as a queer aesthetic but as a mode of appreciating performances that question 'high art' or display other forms of competency. As she argues, 'Greta Garbo's incompetence as an actress enhances her beauty [...] She is always herself [...] *a person being one very intense thing* [my italics]' (Sontag 1999: 62). One negative implication of viewing Colborne as Camp is that actors with intellectual impairments are perceived as 'less able' to transform themselves into 'characters' at one remove from themselves. Colborne is always Colborne, no matter what action he is performing. Yet, is this so very different from certain celebrities? Colborne, for example, is Camp in the way that Arnold Schwarzenegger is Camp, a man endlessly re-enacting a very special persona.[7] He is always being 'intensely Jez'. As Sontag indicates, this need not imply a negative value judgement:

Camp is a mode of enjoyment, of appreciation, not judgement. What it does is find success in certain passionate failures [...] Camp turns its back on the good–bad axis of ordinary aesthetic judgement [...] what it does is to offer for art (and life) a different – a supplementary set of standards. (Ibid.)

Colborne's performance begins to redefine the concept of what an actor is, who can be an actor, and how their work can be represented: is Colborne an actor or an 'actor'? Does the viewer make 'allowances' for him because of his disability or is something genuinely 'new' taking place? By putting the performance 'in quotes', by seeing the surface of everything, the blocking, the zip, the coffee, the sugar, by making these 'intentional', Colborne's performance becomes aesthetically rich and strange. As Mike Kenny has noted, Colborne has 'a tendency not to inhabit the character, but to rather gesture appearance of character' (2006). At no stage in the performance is the spectator asked to suspend disbelief as he tries on the mantle of a cowboy or a police officer. In *On the Verge*, the performer is seen getting in and out of character the way he might a costume.

Camp depends on the recycling of existing modes of behaviour in a self-conscious and parodic way. A learning disabled performer invites a re-examination of terms such as competence, eloquence, skill, and self-consciousness. He exists in a realm of continual parody of the accepted modes of behaviour for an actor. Pushing this further, an intellectually impaired actor may currently exist as 'fake' in relation to the dominant ideology's unimpaired 'authentic'. Parody is inherent in the idea of being 'a learning disabled Billy Connolly'. It is only through reference to the nondisabled 'original' that the impaired 'copy' can be identified. In this way, all learning disabled performers may be survivors of a secondary but no less intriguing condition: Camp Syndrome.[8]

As noted in Chapter 1, disability activists have challenged work that aspires to reach 'mainstream' audiences. Paul Darke worries that artists who strive for such recognition are guilty of 'normalising' and neutering the essential difference of disabled performers, forcing them into 'the ideal of the normal through parody and pastiche' (2003: 130). Might Darke's analysis mean that, consciously or otherwise, *On the Verge* is asking us to view Colborne as 'less disabled' than he is? Such analysis cuts to the heart of the issue for devisors. What is at stake here is the very identity of the disabled actor. *On the Verge* exists in a contested realm of identity politics where the work will always be viewed against the history of oppression of disabled people and their public representation. The idea of Camp can be read negatively as compounding that oppression; alternatively, it can be embraced as part of a new aesthetic that armours itself with parody:

What if you turn it on its head and say, yes [...] we are pretending, we are demeaning the art form? What we're doing is re-appropriating, re-focalising the original with a 'copy', a travesty perhaps. But why

should the original be deemed 'better'? Or the copy of less worth? Could we reclaim travesty as a theatrical form? (Wheeler 2007b)

Watching Colborne again during a short tour for an international audience in Hong Kong (July 2007) challenged many of the aesthetic judgements I made during the show's earlier incarnations. Over the course of three nights, initially suffering from intense jet lag, Colborne captivated his audience and dealt nonchalantly with technical glitches such as a non-functioning keyboard and various errant props. All these became part of the show. Even in the initial run-throughs I noted an organic quality to the piece, a flow and rhythm that contradicted what I had observed previously: awkwardness of pace, or fissures in the acting. In the delivery of the language, particularly, he had begun to find a new kind of poetry and a comic timing. He lingered over the words at times in the way that he lingers over chord changes. The show seemed to flow directly from him, possessing an improvisatory quality. It is worth noting that the re-rehearsal for the tour did not involve reference to the written text at all. What this transformation may tell us is that Colborne's art is simply one that takes longer to develop. The gaps, the tears in his performance, are part of him, but they are not necessarily a given. Without access to mainstream 'conservatoire' training, Colborne and his collaborators are 'in training' before a paying audience. The transformations that 'trained' actors make in the rehearsal room, Colborne is making throughout the life of the tour; his is a virtuosity in process. For Darke, this analysis may be guilty of 'normalising' Colborne, trying to make him fit into the constraints of a definition of virtuosity that privileges physical perfection, seamlessness of delivery, and rehearsed spontaneity. Ultimately, however, Colborne's art transcends attempts to pigeonhole it into singular definitions of correctness.

It is as though I am writing about two 'Colbornes'. One is stark, awkward, strange-making. He allows a reviewer the luxury of describing 'new' or 'authentic' performance qualities. I can *place* him. The other Colborne is more elusive. This second or 'double' Colborne brings me to account. His impairment is not so readily 'available'. Where the first takes hesitant, marked-out footsteps, the second improvises, ad-libs, and 'passes'.

Tear marks

Deidre Heddon and Jane Milling argue that contemporary devised – as opposed to extant text – work follows a typical pattern: first, devising

tends to deliver a fragmented dramaturgy; second, 'it is [not] any less or more democratic a form of creation than any other process' (2006: 223); and third, 'the performance product [is] a central validating element of a company's work' (ibid.: 224). Broadly, *On the Verge* supports this generality, but offers specificities that enrich or 'crip' the model.

Four days before the opening night, what should have been a 70-minute piece was running at over 1 hour and 40 minutes. Wheeler describes the process of making *On the Verge* as 'the most difficult thing I've ever done not just the financial investment for the company but my personal investment' (2007a). Unlike with a 'straight' adaptation, Wheeler was, as he says, 'implicated in the material' (ibid.). Initially, the plan had been for Colborne to appear on screen as sole traveller but this did not work out in practice, due to Bentley's filming style. Wheeler is seen on screen throughout much of the film, asking questions, 'looking after' Colborne on his travels, literally chauffeuring him around America – if not 'ghostwriter', then 'ghost-rider'. A few days before the opening, it was as if the process had defeated him. He knew that he had to edit, and fast, but what to take out? He was editing lived experience, which he and others had invested in, struggled to shape; and then there was the question of Kenny's script, which Colborne had struggled to learn.

In the run-up to the first night, Julia Skelton, Mind the Gap's Administrative Director, describes a piece in disarray: 'It was running way over the agreed duration for the venues [...] There was no choice but to do a brutal editing job.' One of the pressurising factors here is the extent to which the company needs to be prepared for changes in advance. When learning scripts it is not unusual for a support worker to be learning lines with a performer every night after rehearsal. One of the company's challenges is a tendency for performers to get lost in script 'loops'. This meant that any changes had to be swift and final, as Colborne needed time to re-acquaint himself with the new structure. Both Wheeler and Skelton report that stress on the performer – and for Wheeler himself – was beginning to threaten the viability of the piece. Wheeler asked his colleague to cast an editorial eye. Skelton felt strongly that Colborne's story was getting lost. Skelton's advice was to push the 'freedom' references to the forefront and to dispense with other elements. 'We literally tore pages out', says Wheeler. 'We had a contract to deliver a 70 minute show. It's left tear marks in the piece' (2007a). Skelton believes that this cutting and re-focusing on the holding question made the piece what it is. It seems that in order for the piece to be born, it took the director to literally, in his own words, 'get out of the way' (ibid.).

The question is still: why did it take so long to sift through, to arrive at this conception of what it was? Wheeler explains that part of the difficulty stemmed from trying not to upset Kenny's carefully wrought dramatic structure; that cutting could have irreparably damaged the play. On the other hand, 'maybe there was a reluctance to shape the material too much because everybody was so clear that this was, *had* to be Jez's story', says Skelton (2007). Ironically, perhaps, the reason for the delay in finalising the piece was an over-emphasis on Colborne – an over-cautiousness, a desire not to disturb some fine balance of ownership, a meta-concern for what Mind the Gap calls 'authenticity of voice' (Skelton 2007). The question still remains: who *owns* the piece? Colborne, in particular, is very clear:

> The show belongs to me. Yes, Tim helped me get the show on the road, but it's still my show, my dream. Yes they did all those things but [...] it's all down to me mate. I'm the one who's working my guts out. (Colborne 2007)

Kenny, though, worries about how the work is perceived. He has asked himself: 'Is it a one-man show? If we give Colborne complete ownership of the work aren't we selling it as something it is not?' (Kenny 2006). On one level Kenny's concern can be read as straightforward artistic ego, a wish to plant one's mark on the process, but perhaps it is more complex than this. As discussed in previous chapters, a suspicion of control enters into the debate when it comes to learning disability. Kenny is far more verbally eloquent than Colborne. Colborne, by his own admission, does not like conflict. He seems to draw into himself, close down. His confidence dwindles when faced with a direct challenge or a criticism. This might make him a willing cipher for someone else's vision, more coerced than collaborator. I suggest, following Skelton, that at least part of the difficulty of making the work was a projected anxiety *on behalf of* the disabled artist. The struggle to make the work, one could argue, demonstrated not a manipulation of Colborne but rather the opposite: a desire to demonstrate his relative autonomy. The exigencies of the first night caused even the director to relinquish 'control'.

Dramaturgically, the creative tension is between the journey that the play sets up in the audience's mind and the actual journey that took place. For example, Colborne did not travel the whole of Route 66 on a Harley. Wheeler rode the whole distance; Colborne rode pillion on long sections of the route. At times, when it was raining, or when they needed to get to a particular point, Colborne rode in the car so

Wheeler could ride fast. There is a sense in which, in common with many TV travelogues, the wool has been pulled over our eyes. What the company call 'real experience' is really a fiction. What seems like a set of chance happenings is a well-made play. Read like this, *On the Verge* becomes a series of fictions or subterfuges. From the viewpoint of privileged observer, I see the joins, the tears in the fabric of performance. The piece becomes an elaborately constructed artifice that overlays symbolic structure over messy reality. Yet, surely, that is a definition of art.

The tension that *On the Verge* sets up is in the degree to which this 'false structure' has been 'managed' by a nondisabled aesthetic viewpoint. Milling and Heddon's second point about the level of democracy inherent in a devising process is complicated by the context of learning disability. Whilst Colborne was at the centre of the creative process, he was, so to speak, *on the verge* of the decision-making process. This is inherent in Kenny's concern that Colborne's persona is 'not quite "Jez"'. Just because 'Jez' said that line, for example, does it make it true? Does it belong to him? Just because he tells us about Ellis Island, was he really interested? The ironic catharsis that is achieved by the trip to Ellis Island in the work is linked to 'Voyage and Return' narrative structures where the hero comes back changed, altered by his travels. The process throws up a doubt whether Colborne has been 'changed' by the experience; rather, his transformation has at least partly been predetermined by the imperative of narrative completion.[9] This process is either a negative reflection of a company's inability to maintain a wholly egalitarian ethos or simply a fact of the contemporary devising landscape. Clive James makes the point about performers such as Peter Sellers and Tony Hancock that their 'conspicuous individual talent [was] interpretive' rather than 'directly creative' and that they could not emulate artists such as Tati or Chaplin who conceived whole projects independently, a failure of recognition that led to their eventual decline (2006: 129). It would be untrue to argue that Colborne's input was interpretive as opposed to creative, but it is fair to say that his strengths lie as an artistic collaborator and a performer, not as a shaper or organiser of product. It is important to note that some of the material cut out was deeply embedded in Colborne's personality, but had struggled to find a place in the form of *On the Verge*. One 20-minute scene featured Colborne impersonating a range of warning sirens (something he had performed for the Police Chief in Oklahoma!). 'It was very funny at the time,' Wheeler explains, 'and became the origin of *Irresistible* [Colborne's 2012 song cycle]' (Wheeler 2012).

Milling and Heddon's final point is vindicated by the company's desire to be judged on product, not process. To be judged on anything other than the final product would undermine the company's stated objective of achieving artistic excellence (and, incidentally, fail to meet the Arts Council's criteria for national touring theatre). Mind the Gap represents a shift in ideology from a community theatre company concerned with participation by a marginalised sector of the population to a company concerned with the creation of art. This shift reconfigures the relationship between performance and the 'very idea of the political' (Jones 2004: 460). Mind the Gap is part of a wider re-animation of the political in performance, which has coalesced, not around class, direct action, or macro-politics:

> Instead, resistance formed around and between the twinned poles of an aesthetics and micro-politics of the flesh and subjectivity, energy and spectacle in performance: that which precedes argument and remains after it has done its worst – the body and the consciousness, specifically that of the performer (Jones 2005: 460).

Arguably, performance – as opposed to political advocacy – is the *primary place* where meaningful change can occur in one's perception. This is because performance, as David George notes, 'offers a rediscovery of the now [...] rediscovery that all knowledge exists on the threshold of and in the interaction between subject and object' (1996: 25). This is a crucial point that supports the case for a deep engagement with the aesthetic. Underlying Mind the Gap's work is the theoretical imperative that the work should be judged on its own terms. This inverts Palmer and Hayhow's sense of authenticity as that which exists *a priori* in the body of the performer, waiting to be discovered. In philosopher Bruce Baugh's terms, the authenticity is located precisely in the *artifice* of the work itself.

For Baugh, 'works of art have a "world" that they can make "their own" by revealing it in a singular manner and [...] it is in this that artistic authority consists' (Baugh 1988: 479). Art does more than simply represent: it transforms the spectator. It does so paradoxically, not by the intended transmission of a 'message' but conversely by suspending the need for such a definitive outcome. *On the Verge* is authentic because it is a 'made thing', something that is intentionally willed into existence. It is precisely this intention that allows it to be perceived as art. The show also *defined* its own world: it created an opportunity for a new space to emerge outside existing social constructions. Baugh argues

that artworks transform our experience when we 'adopt what we take to be the work's organizing principle, and allow it to order our experience' (480). This distinction between *our own ends* and the *ends of the work* is crucial. Only by relinquishing a wish for the work to be 'useable', Baugh argues, can spectators truly allow themselves to be transformed. The end of the work cannot be known by the makers or by the recipient, but only experienced in the moment of the work's reception.

Baugh's model of authenticity offers considerable theoretical insight. Colborne, however, twists expectations of both theory and theatre. Baugh argues that the audience must 'strive to meet' the 'demands of the work', allowing those demands to govern them during the course of the work:

> That means meeting certain demands seen as issuing from the work, or as having to be met in order that the work be perceived, such as attending to some aspects of a performance (whatever is prescribed by the score) and not others (the appearance of musicians, shuffling paper, etc.). (Baugh 1988: 481)

Colborne complicates spectatorship by virtue of his *over-attention* to certain details, such as the sugar and coffee, or even in walking from one part of the stage to the other. His presence also complicates the idea of authenticity as that which originates from willed, individual agency. In doing so he breaches a cherished ideal of Western liberal ideology: that of the individual rhetor producing speech acts, which in turn confirm the existence of a fixed core self. Colborne's presence punctures the notion of an autonomous self, operating from within, to produce clear and unmediated messages. His staged self is the product of a deeply inter-subjective collaborative process. The anxiety of the creative team, as I have shown, stemmed from this schism with normative ideology. To adopt Cynthia Lewiecki-Wilson's term, Colborne's performance is an example of 'mediated rhetoric' (2003). In common with many other learning disabled persons who, to a greater or lesser extent, depend on advocacy, Colborne was supported to achieve his rhetoric, one which operated across the boundaries of self and other, or able and disabled identities. This is a compelling example of where heightened states of performance drive out underlying political anxieties. Kenny's concern about creating a persona that Colborne stepped into is a version of the anxiety that is felt about facilitated speech with regard to those with more severe impairments: namely, whose subjectivity is being voiced, what is the risk of appropriation, and would this stand up in court?[10]

Colborne also queers premature definitions about 'finished product'. The 'virtuosity gap' between the UK and Hong Kong performances is a reminder of how inadvisable it can be to make 'final' judgements about live performance. Two points are particularly noteworthy. First, the Hong Kong shows followed not just incisive re-rehearsal but several informal discussions between myself, Colborne, and Wheeler about the performer's 'style'. Wheeler comments:

> It is interesting to note that since Jez read your criticism of this section he has cut the use of [some] gestures. This was prompted by the writing and not me. An interesting effect of the positive power of a thoughtful critique? A sign that Jez responds to critique as well as direction? (Wheeler 2007c)

Colborne had read what had been written about him and had changed aspects of the performance *without direction*. It is possible that this critique, together with a chance to run the piece consecutively, had a direct impact on the show, making it tighter, more focused. A second mitigating factor is the size and attitude of the audiences. Two of the UK shows, including the London performance viewed several times on video, were matinees playing to fewer than 15 people. In contrast, the Hong Kong audiences packed out the small Soho venue, their relative close proximity and willingness to engage in the 'cabaret' atmosphere encouraging the performer, supporting him to excel.

Theoretically, the problem of finalisation resonates with crip/queer theory. As Robert McRuer argues, the hetero-normative self is that which unquestioningly embodies a seamless univocal whole. This system can only operate in contra-distinction to the crip/queer/non normative self, which refers instead to

> the open mesh of possibilities, gaps, overlaps, dissonances and resonances, lapses and excesses of meaning when the constituent elements of anyone's gender, of anyone's sexuality aren't made (or can't be made) to signify monolithically. (Segwick 1993: 8)

Such resistance to totalising systems is relevant not just to Colborne's identity or to the fractured dramaturgy that ensues from him, but to the responding critique. Just as the inter-subjectivities of *On the Verge* undermine mastery as an autonomous operating ideal, so they queer *telling about* the work. This is another way of conveying the importance of a *poetics* of learning disability, as opposed to a model. A poetics of learning disability dislocates not just the work but the critique. As an

act of intellectual labour, such a poetics must state clearly what cannot be known or what remains ambiguous, uncertain, unfinished. Just as Colborne's self might remain, in Donna Haraway's words, a 'permanently partial identity' (1991: 154), so the poetics of this emergent field must be alert to what is not yet seen. The gaps, inconsistencies, and tear marks embedded in *On the Verge* do not undermine its authenticity – quite the contrary, they invoke what Baugh calls 'anxiety and psychic dissonance' (1988: 481). By force of its (mediated) singularity *On the Verge* is capable 'of commanding our assent' (ibid.: 482) and can be 'held back' only 'due to misunderstanding, ignorance, or a refusal to judge the work aesthetically' (ibid.). *On the Verge* is the start, perhaps, of what I would term a theatre *distoriography*: a process that names and captures the open mesh, lapses, and excesses of the work and all that avoids neat, final composition.

Nobody's perfect

The question still remains: who and where is 'Colborne'? Does he inhabit some undefined space in the gap between Kenny's text, Bentley's film, and Wheeler's stage directions? Or has he become the gap itself? Has he taken on the mantle of the learning disabled Billy Connolly and become his own persona, 'Jez'? Skelton likens Colborne's story to the kind of memories that one carries from childhood, a mixture of lived experience and projected images based on what other people *tell you* has happened. He has had his experience edited via the process of film and performance. So when it is told, it is still his story, just a filtered version of it. Performance has become lived experience. Returning to Dean MacCannell's reflection on the tourist:

> The act of sight seeing is a kind of involvement with social appearances that helps the person to construct totalities from disparate experiences. Thus, his life and his society can appear to him as an orderly series of formal representations, like snapshots in a family album. (MacCannell 1989: 15)

Subsequent to the making of *On the Verge*, a strange reversal occurred: Billy Connolly produced a six-part TV series documenting his journey along Route 66. The 'original' thus became the 'copy', an uncanny notion I return to in Chapter 6.

Were a similar study of the process of Connolly's travelogue to be conducted, would these issues of ownership emerge? Undoubtedly, Connolly is mediated through a director, a producer, a supervising

editor, in the same way that Colborne is. But were his show to be 'investigated', it is unlikely that his identity would be contested in this way, his contribution – his very being! – scrutinised as such. Asking 'Who owns the work?' in the final analysis is rather like asking a writer, 'Where do you get your ideas from?' or an actor, 'How do you learn all those lines?' It is ironic that a (predominantly nondisabled) 'concern' for ownership risks becoming a secondary disabling factor. Wheeler's point about the possibility of nondisabled people being considered artists in their own right, not simply as facilitators of learning disabled artists, is apt here. If learning disabled art is a 'hybrid' form, its rehearsal process always contingent on the interplay of disabled and nondisabled minds, then it will always, rightly, be contested. 'Ownership', however, should no longer remain a primary criterion of aesthetic judgement.

The presence of Jez Colborne destabilises the criterion of 'ownership' for two reasons: he makes work that demands to be judged aesthetically; and he can only do so with the support of other authors. The solo form tends to mask this fact, and the anxiety evoked is a symptom of this (open) secret. In attempting to delineate, however, between the real and the fake or between the proper and the mediated voice, the spectator closes down subjectivities. As Lewiecki-Wilson so clearly states, 'by insisting on a sharp demarcation line between individual rhetorical agency and its lack we don't solve these problems so much as silence them' (2003: 162). It is emphatically by means of live performance that such complexities can and should be debated. The choice is quite stark: to welcome the emergence of mediated and intersubjective identities or to silence them. It is in the gap between these two poles that *On the Verge* does its work.

The cowboy asks Colborne, 'Are you good, bad or just plain ugly?' It is my contention that this question should be asked of Colborne's work and that of others analysed in this book. For Peter Schjeldahl, beauty is related to a 'conversion' experience, an upheaval in perception that leads to a new belief. 'Sometimes', he says, 'the object of beauty is not just unexpected but bizarre, with an aspect I initially consider odd or even ugly. Such experiences are revolutions in taste, insights into new or alien aesthetic categories [...] as a rule what had seemed most odd or ugly became the exact trigger for my exaltation' (1998: 54). Watching Colborne's performance, my own perception underwent a revolution. His performance is punctuated by numerous stops and starts, as if each small segment of text must be accompanied by a certain gesture: a finger pointed or a zip fastened. Seeing the join, the continuous deconstruction of performer and text, felt alien – none of it quite 'natural'. At

first, this 'lessened' the impact – or the beauty – of the performance. But watching the piece again, I began to enjoy these punctuations, until in the later performances, they disappeared; and when they disappeared, I missed them. I relished the way these *punctums* offered a kind of performance I had never seen, the eloquence of *dis-precison*. Schjeldahl is not making any explicit reference to disability when he argues,

> Entirely idiosyncratic, perverse or otherwise flawed experiences of beauty may be frequent. There is nothing 'wrong' about them and the distinction between them and the 'real' experiences of beauty is murky (requiring quotation marks). Unusual experiences may constitute a pool of mutations, most of them inconsequential, but some fated to alter decisively a familiar form. (Ibid.: 58)

On the Verge, I argue, exists in 'murky', even mutant territory, 'requiring quotation marks', caught between the 'real' and the 'wrong'.[11] Nondisabled audiences may require quotation marks: seeing a performer as 'good' as opposed to simply *good* because they are working in spite of impairment. But are quotation marks not inevitable in the first stages of an aesthetic movement? At the start – perhaps even now – DV8 existed in quotation marks: not dance but 'dance'. Not theatre but 'physical theatre' – their work often purposefully deconstructs the technique of the performer, has them demonstrating some aspect of rehearsal in performance. Is this so far removed from Colborne? The question is whether the mutations in form will remain 'inconsequential' or, as Lloyd Newson's work has done, decisively alter a familiar form.

Sartre's 'authentic Jew' is someone who refuses to establish his identity – his 'Jewishness' – on the basis of historical or pre-existing labels. So, when Sartre says 'the authentic Jew escapes all description', he means that 'categories are publically defined' (Baugh 1998: 486 nn). Therefore, 'anyone who fits a category is to that extent defined by others' (ibid.). One might, by extension, be 'genuinely' disabled but not 'authentically' so, meaning: one meets all the medical or symbolic criteria but has not yet formed one's own definition of self. One's identity, in other words, is prescribed. In *Kalooki Nights* (2007), novelist Howard Jacobson quotes Wittgenstein: 'You get tragedy where the tree instead of bending breaks. Tragedy is something un-Jewish' (2007: 121). The book re-imagines the inconceivable events of the Holocaust and renders them ... well, *Jewish*. Is there a learning disabled 'Jewishness'? What would it mean to render something learning disabled? Foolish? Inept? Disruptive, obsessive, or inconsistent? Is there a particular aesthetic

form that seems to grow from such disability? Not form perhaps but *attitude?* For Jacobson's Mendel, a cartoonist imprisoned in a concentration camp, caricature has to 'evoke something previous to the work. Because it is only by recalling the original that the caricaturist can be seen to be exaggerating' (ibid.: 358). But Mendel goes further; rather than see the caricaturist as a 'second-hand artist', he views him as a satirist, and therefore the most God-like because 'in his act of creation, the satirist destroys' (359). Colborne is that most disturbing of figures, the satirist who wants to be liked, who is happy to be supported, authored, and reframed by his collaborators, into something ... 'authentic'.

As Garber argues, a cross-dressing figure in a text often indicates a 'category crisis' elsewhere (1992: 16). In *On the Verge*, the 'ownership crisis' masked the 'real' distinctional problem of disability. The presence of Colborne, who both passes as nondisabled and masquerades as learning disabled, imbued the entire process with category dilemmas. Blurring between disabled and nondisabled made other categories – author, director, film-maker, producer, actor, self, persona, fiction, reality – equally uncertain. These were symptomatic rather than foundational: they diverted attention from the permeable, undisclosable reality of learning disability. This is not to denigrate the process, far from it; the point is to realise the extent to which Colborne disrupts stable identity and in doing so renders artistic creation fraught. If, after Riviere, being a man or a woman is a persistent parade that passes for real, Jez Colborne could be regarded as the expert impersonator of his own disability.

Osgood's casual response to Daphne/Jerry's revelation that he is a man dressed as a woman in *Some Like It Hot* (1959), quoted at the head of this chapter, has become something of a cliché in the criticism of transvestite theatre (Garber 1992: 7). I recall this here, because it attains a different power in relation to *On the Verge*. The power lies in its ambiguity. On the one hand, it suggests that Osgood is happy with his 'man'; on the other, precisely the opposite. As long as Jerry wears the dress, he is still Daphne – the masquerade, in other words, is real. It is not just that nobody is perfect, more that nobody lives without some kind of masquerade. 'Nobody's perfect' also becalms the palpable anguish that ensued in the devising process. In the process of creating Colborne, everybody's contribution was flawed.

Colborne/'Colborne' might easily, for a moment, be substituted for Daphne/Jerry: 'But you don't understand (*whips off the cowboy hat, raises his voice half an octave*), I didn't write it myself!' The reply, unperturbed, is: 'Well, nobody's perfect'.

6
The Uncanny Return of Boo Radley: Disability, Dramaturgy, and Reception

> Something comes back because in some sense it was not properly there in the first place. (Royle 2003: 85)

Introduction: the uncanny

Boo (2009), Mike Kenny's play about scapegoating, features a cast of learning disabled actors with a range of impairments that are largely invisible. The play re-imagines *To Kill a Mockingbird* in a contemporary Northern English town, and follows two distinct but eventually interwoven narratives. The first concerns Boo, a young man who has Asperger's syndrome, a condition he shares with the actor playing him (Jonathan Ide). Boo lives a concealed house-bound life with his older brother, Benny (Alan Clay), who looks after him. Their relationship is a tense one, with most scenes beginning or ending in conflict and Benny invariably returning from work only to storm out again. Usually this is caused by Boo's intractable need to resist any kind of change or because he has engaged in his favourite hobby: cutting up Benny's newspaper. Boo's monologues – addressed directly to the audience – reveal a lot about his inner world: his thoughts arising from the death of his mother; his monotonous routine; his obsessive habits, such as never turning right; the reason why he never leaves the house (a vicious attack in the past by a gang of local youths). The second narrative follows the story of two characters outside the house who are loosely based on the children of Harper Lee's novel and simply referred to here as Girl (JoAnne Haines) and Boy (Rob Ewans). They too are siblings locked in an uneasy alliance, with the boy, resentful, forced to look after his younger sister over the course of a long summer holiday. Like Boo and Benny, they have lost their mother, not to death but to a second

169

marriage. Together they inhabit the playground outside Boo's house and goad each other with stories about the spectre-like figure within: how he once stabbed his brother with a pair of scissors, and how he comes out at night to prowl and to prey on domestic animals.

The twin stories echo and encircle one another: themes of sibling rivalry, dependency, and parental absence play out during one claustrophobic summer month. A 'murder mystery' plot underpins the story: a girl, 'Kelly Spanner', has gone missing. Like Boo, she is a spectre, a focus for communal fear. The children convince themselves that Boo has her in the house and venture ever nearer to find her. Inside, Boo also thinks about the missing girl. He keeps a scrapbook filled with images of Kelly, news reports, and sightings. He watches the children outside the house. Eventually this precipitates Girl's meeting with Boo, first outside the house and eventually inside. From this moment the story darkens. A series of misunderstandings, compounded by worsening fears for the missing girl, leads towards tragedy. Girl finds Boo's scrapbook full of details about the Kelly Spanner case. In shock, thinking that she has found the murderer, she runs from the house. Boo is convinced that Girl is in danger, and decides to follow her, to try to 'look after her'; but he is caught by a neighbour looking through the children's window and is accused of paedophilia. Boo runs first back to the house but hardly has he uttered his story to Benny than shouts are heard and an egg is thrown at the window. Boo runs again, this time onto a road, hounded by teenagers shouting 'Paedo'. His last words are 'Who's looking after the kids?' before running into the path of an oncoming vehicle. The play ends with a short collective address to the audience by Boy, Girl, and Benny. They take turns to confess and sometimes to evade responsibility for their part in these events.

Boo is a play. It is also, by turns, a life event, a ghost story, a murder mystery, a shadowing of life through art, an adaptation, an inversion, an incubus, a communing, and an inquiry about what makes a scapegoat. Psychoanalysis, Adam Phillips suggests, 'as a form of moral enquiry [...] asks what, if any, alternatives there are to scapegoating; and what our lives would be like if there were' (Phillips 2006: xv). That 'what, if any' shifts the emphasis of psychoanalysis away from 'cure' to interpretation. French historian Henri Stiker (1999) views scapegoating as integral to an understanding of disability as cultural mechanism: as a harnessing of violence of 'all against all' into something sublimated towards the individual. In the same way that Zizek distinguishes between subjective violence, which can be seen, and objective – or symbolic – violence, rooted in language, scapegoating deflects and

conceals the 'real' underlying violence (Zizek 2008). As Stiker argues, it is precisely in the desire for *mimesis* that the scapegoat is created (1999: 30). Scapegoats, like performances, are made possible only by substitution of the original. Theatre, home of mimesis, *par excellence*, is also the place in which anxieties about imitation are exemplified. As Rebecca Schneider argues, suspicion of mimesis is an innate part of the theatre-making process and relates to a 'fear of indiscreet origins – of emphasis gone amok, lost, or appropriated without "proper" identification', thus making '[o]riginality [...] a cultural product fraught with anxiety' (2001: 97). Mockingbirds, so called because they copy other birds, suggest that mimicry is bound up with mockery, that the impersonation of human others, on stage, invokes discomfort – as well as pleasure – which upsets 'natural' order. This is not so much a moral question as one of repetition, invoking psychoanalysis once more:

> The compulsion to repeat, through representation and reproduction, is not only the root of mimetic behaviour and of the twice performed of performance, it is also inherent within [...] the heart of the psychoanalytic tradition. (Read 2001: 162)

If mimesis is central to an understanding of *Boo*, then the uncanny is the spectral presence that haunts it. The uncanny is felt as an ambiguous thread, knitting together – or unravelling – the theoretical enquiries contained in this chapter: enquiries about authorship, actor presence, and spectatorship. These readings overlap and complicate each other in revealing ways: adaptation as Freudian 'retranscription', in which memory is present, not as a reliable single entity but as a shifting chimera; Lacan's 'return to Freud' as adaptation, a challenge to the status of the foundational texts; autistic presence (of the lead actor) as aesthetic adaptation, inversion of the 'original', and challenge to the equation between 'psychological depth' (naturalism) and social truth.

Psychoanalysis leads to an overriding sense of the complexity of the theatre transaction: that what we see is 'only what we thought we saw [...] [T]he "real play" [is] "split", multiple and non-unified: a cacophony of voices, impulses and perceptions, each crying for attention' (Kubiak 2001: 37). In *Boo*, the action takes place in the domestic sphere of the protagonist, immediately invoking Freud's family drama. It is no accident – or perhaps it is a kind of *slip* – that at the centre of the stage is a couch and that the play lasts not much longer than the 50 minutes of the 'classic' analytic hour. As Alan Read has noted wittily, the real transaction of this hour is 'fee association' rather than 'free association',

and this is no different in the purchase of *Boo* as a theatrical product (2001: 149). In both instances, insights must be paid for and their value assigned, with little hope that these can be scientifically verified.

The uncanny or *unheimlich* (unhomely) evades straightforward definition. In Freudian terms, the uncanny is what one refers to when 'everything that was meant to remain secret and hidden has come out into the open' (Freud: 132). Nicholas Royle's (2003) much longer response to Freud's text, seeks to locate psychoanalysis, as well as literature, as *branches* of the uncanny – that is, as fields that have become 'strange to themselves'. The uncanny is suggestive of many things: solitude, darkness, death (and the death drive), compulsion, co-incidence, doubles (*doppelgängers*), nostalgia, repetition, *déjà vu*, anxiety, disembodied voices or incomplete bodies, eerie sensation, ghostly apparitions, and lifeless objects coming to life. All these features appear in *Boo*. The return of something once familiar, now repressed, involves two related processes: the revivifying of childhood complexes and the re-emergence of unsurmounted primitive beliefs – as Freud believed, children exhibit the residues of ancient animistic impulse. Thus the uncanny persists as feelings that are 'foreign to oneself': both of and not of the self, things that can never be fully repressed. The uncanny resides, as Stanley Cavell put it, in the 'surrealism of the habitual' (1988: 154): what is familiar is never fixed and what is strange is always close to home. Like Boo Radley, who prefers – or is forcibly encouraged – to remain at home, the 'uncanny reminds us not just that there is no place like home but, in another sense, there is no other place' (Haughton in Freud 2003: xlix).

The uncanny is an insightful mode of framing aesthetics and disability. For Freud, the uncanny is not an either/or distinction between aesthetics and psychology but a means by which oppositions of all kinds are suspended – the uncanny is likely to be felt in instances where the imaginary and the real blur, where 'proper' distinctions of all kinds can no longer be definitively made. The uncanny is a place in which 'normal' navigational tools no longer work, where the 'we' or the 'I' that speaks is no longer sure of its footing. *Boo*, a familiar story made strange, is uprooted, inverted, and made to inhabit a different reality. A leather sofa denotes 'living room', and three rectangular screens allow multimedia images to be projected. The screens convey a series of images, framed by a dotted line: the inside of Boo's scrapbook. At various intervals they include external scenography (the house), internalised character (collages included in Boo's scrapbook), impressionistic flashback (images of Boo being hounded by a gang), and even a pre-recorded sign language interpreter (Anthony Evans) who literally *doubles* the main

character. Moving between the internal and external walls of the house, the performance plays with ideas of inside and outside, of seen and hidden, of theatre and anti-theatre, and asks us to consider who in society has the right to walk freely and visibly and appear on stage. What happens when someone who has remained unseen for so long suddenly becomes visible? When might this be 'good' and what are the dangers or unforeseen consequences?

Unheimlich, like disabilty, is a word that contains its own opposite. In a similar way, *Boo*'s stage is a place that denotes home but feels anything but cosy. Devoid of a maternal presence, the place is inhabited by orphans. Parents are either dead or at work; and the characters share, by the end, nostalgia for something that they have never known:

> And everyone knew each other/ and never locked their doors./ It was like a village. A village. Not an estate./ And there was a maypole. And everyone used to dance round it./ No. They didn't do that. Nobody ever did that. Except in stories./ But it was different. It used to be different. Back then. When she was little. (Kenny 2009)

The 'she' referred to is Girl's mother. Like Boo's mother, she is an absent present. The play is shot through with grief. In this it reflects not just the grief of the characters but that of the author, Mike Kenny, whose mother died early in the writing period. She came to haunt the text as much as the Estate of Harper Lee, concerned as to how 'their' 'original' might be re-animated. Kenny's text became a way of working out a personal loss. As I will show, he was able to enact this through the voice of Jonathan Ide, a figure able to ventriloquise Kenny's grief.

Harold Bloom argues that the uncanny was the 'only major contribution the twentieth century has made to the aesthetics of the Sublime' (quoted in Royle: 14). The sublime is the ultimate Freudian aesthetic since it evokes anxiety: that which cannot be contained in 'normal' beauty or proportion, which evokes dread and awe. For Bloom, the uncanny work is great simply *because* 'the authentically daemonic or uncanny always achieves canonical status' (1994: 458). He argues that the canonical evokes 'a certain strangeness, a mode of originality that either cannot be assimilated, or so assimilates us that we cease to see it as strange [...] When you read a canonical work for the first time you encounter a stranger, an uncanny startlement rather than a fulfillment of expectations' (ibid.: 3). This chapter returns to 'quality' through a slightly distorted lens. I suggest that, along with *Small Metal Objects*, *Boo* represents a startling addition to the canon of uncanny performance. Both works

convey the radical undecidability of learning disabled identity and invoke strange 'side affects': namely, what have 'I' just seen? Is 'it' real? Which bits were 'proper' and which bits did not, somehow, 'belong'? The uncanny, by placing what does and does not belong in doubt, is another way of asking those questions about theatre.

What, then, is the uncanny proposition of this chapter? A three-fold one. First, that an autistic actor at the centre of the play commands a strange, unsettling presence. He is the lack, or 'void', which in Lacanian terms evades representation. One may be drawn toward this lack but at the same time deeply troubled by it – Ide's presence is incomplete. Second, that various projections 'write onto' Ide, not least that of the author, Kenny, imagining not just Ide as Boo but Boo/Ide as himself: his own 'imagined autism'; also his grief and solitude. Third, that out of this psycho-creative process spring dramaturgical affects, which, in the case of *Boo*, form a complex and shifting *mise en scène*, both theatrical and anti-theatrical: filmed projections, phantom characters, different registers of acting. I argue that to understand *Boo* it is vital to ask what is seen and hidden in the dramaturgy, what is both of the theatre (*heimlich*) and of something else (*unheimlich*). What follows is divided into two sections: Ide's affect and side affects. In the first section, I analyse the play's dramaturgical elements, or, as I refer to them, in light of the lead actor, *Ide's affects*. In the second section, I provide an analysis of these affects on a public audience: the side affects of the drama. The line that separates Ide's affects and side affects is necessarily a reflective surface, indicative of the complex relationship between artistic intention and spectator reception. The two affects contain and replicate one another; Ide's is, coincidentally, an anagram of side. Each word is the uncanny double of the other.

Ide's affect

There are at least four 'presences' to consider in relation to the on-stage version of Jonathan Ide. There is Ide 'himself': lean, tall, angular, shuffling across the stage, fingers fluttering. There is Kenny's Boo, the character created with the actor. Kenny researched the Aspergic condition, often described as 'high-functioning' autism, to create a claustrophobic world. Boo lives with his brother Benny in a maisonette:

> Boo: It means little house. It's not a house. And it's not little. Benny calls it half a house. Mrs. Rogers calls it a flat. Because round here is the flats. It's not. It's a maisonette, but nobody calls it that. (Kenny 2009)

In his frequent asides to the audience – virtually the only speech in the play directed beyond the fourth wall – Boo's deadpan punning is constant. The combination of Ide's idiosyncratic direct address and the black comedy of Boo's literalness convey a deep, often comic alienation. This is the third presence: that of autism itself. Autism, which has been defined as a developmental disorder creating a deficit in language and sociability and an obsession with order,[1] has much in common with 'presence' as a classificatory acting term. Both call into question the notion of the distinct or fundamental entity. Is presence, like autism, an objective substance? Do some people have 'It', that mysterious but palpable quality that makes us want to watch them above others; or conversely, that quantity of asociality that sets them radically apart. Ide, paradoxically, has both. Autism and actor presence have been defined either as 'core conditions' or, in the case of the former, a spectrum onto which some women and (possibly all) men fit, to a greater or lesser extent. The cause of 'it' has been either (erroneously) assigned to parenting or else a 'cure' identified (presence can be 'taught' in acting class just as some autistic children acquire language through training). Autism acts, then, as a set of performative behaviours and a series of metaphors.

The fourth presence is that of the fictional creation, the spectre-like Arthur 'Boo' Radley, a figure who, at the end of the novel, is revealed as a person in ghostly form, 'sickly with hands that had never seen the sun, so that they stood out garishly against the dull cream wall'; his hair, 'dead and thin'; his mouth 'shallow'; his 'grey eyes so colourless' the child thinks him blind (Lee 1960: 294). Every move he makes is 'uncertain as if he were not sure his hands and feet could make proper contact with the things he touched' (ibid.: 303). His presence cannot be taken for granted: 'Having been so accustomed to his absence, I found it incredible that he had been sitting beside me all this time, present. He had not made a sound' (ibid.). There is something about Boo, even when present, that is defined by absence, and this is heightened in Lee's novel when Scout says, a few moment later, as she watches him close the door: 'I never saw him again', evoking the possibility that this 'Grey Ghost' never existed (ibid.).

In what follows I deliberately conflate theories of autistic and actor presence. Far from wishing to convey the idea of an 'essential' presence, in existence *prior* to character, I argue for a more nuanced approach, viewing both presence and autism as unstable categories, which are, in Derrida's terms, reduced if they are sought in the 'impossible presence' of the absent original. In fact, Derrida's suggested response to this

'impossible' project mirrors the choice facing learning disabled artists: that they can either give in to nostalgia for the lost authentic, or they can accept the futility of the task and embrace the disruption of uncertainty.[2] Presence and autism are *both* real *and* symbolic. As the central pillar of the dramaturgy, Ide's performance places the terms autism, presence, mimesis and intention in doubt and in a way that generates new potential for both theatre and disability.

Autistic presence

MH: What is autism?

JI: It's a kind of thing where ... where ... you don't know how to say what it is.

(Diaries 29 February 2009)

Autistic presence, sometimes referred to as a developmental disorder or 'delay', is manifest in Ide's performance in two ways: first, as a literal delay in the delivery of text; and second, as a narrative trope that conveys his character in 'classic' autistic terms, through his character's refusal to move outside tightly prescribed routines. Presence originates in the Latin *praesentia*, or presentiment, meaning premonition or foreboding. It can also refer to 'sensing a presence', that of a supernatural element. I have already established the sense in which *Boo* was 'haunted' by the original text, and the fact that the character of Boo haunts Lee's story. Yet Ide's performance takes this notion to another level. In one early rehearsal, the director called out an emotion. Individually, actors were asked to respond first with a sound and then a gesture. The director then asked the actor to extend the gesture, hold it still, to hang onto 'it'. Then the actor, after what seemed like an uncomfortable pause, was asked to speak. Ide, the first to try this, was offered the emotion 'thrilled'. It took him about ten seconds to 'find' something to present. He seemed to be trying to 'find' the emotion and then to place himself in an approximation of it. The result was as if Ide was 'quoting' an emotion, as opposed to embodying it. During the same rehearsal, a large screen behind the stage was wired to a camera. It enabled those watching to view the on-stage action, twice. Reality and screened representation were not simultaneous. There was a one- or two-second delay in the feed, so that if, say, you waved your arm, you could see the action a fraction later on screen (almost like a literal manifestation of Schechner's 'twice behaved behaviour'). This delay related to the performance on stage. Even spontaneous moments by Ide involved a delay: between thought and action, between gesture and

sound, between script and delivery.³ This gave the performance a particular aesthetic quality – defined by gaps, pauses, sometimes uncomfortable delays – which, I argue, continued into public performance.

As Stuart Murray argues, the clinical definition of autism in the *Diagnostic and Statistical Manual of Mental Disorders* (*DSM-IV*) as 'an impairment in social interaction and communication, language delay and repetitive behaviour' (2008: 27) vies not just with social constructionist models of disability but a plethora of cultural narratives and public metaphors. In short, autism must always *stand for* something. It is often an abstracted idea rather than an engagement with those so defined: emotional detachment one minute, male psychology the next; nervous parental foreboding; or magical *savant* powers. It has even been called 'advocacy disorder', the condition whereby middle-class parents fight for their child's right to a 'special' education (see Hacking 2006). Moreover, autism is what Murray refers to as 'perceptual difference' (2008: 105). This works on at least two levels: medical perspectives/autobiographical accounts, which 'look out' – stressing the unusual way in which people with autism perceive the world – and the wider cultural accounts, which 'look in'. In the latter culturally dominant discourse, 'the invitation to look at autism has never been greater' (ibid.: 105). In a sense, autism is the neurological 'find' of the twentieth century, the disorder that spawned an entire 'spectrum' (oppositional defiance disorder, attention deficit hyperactivity disorder, obsessive compulsive disorder, to name a few). The phrase 'on the spectrum' is at least as common now in everyday speech as psychoanalytic terms such as 'projecting' or 'identifying'. However, there remains the perverse sense that, despite knowing virtually nothing *about* autism (what causes it or how treatment might best be offered), it is somehow something 'known'. It has achieved celebrity disorder status, a condition that leads to certain core expectations: 'classic' symptoms such as obsessive rituals, hand-flapping, echolalia (the mechanical repetition of words or sounds), inability to share eye contact, and the capacity to store huge, computer-sized amounts of memorised information. That last 'savant' capacity, as portrayed by Dustin Hoffman's character in *Rain Man* (1998), has come to stand for autism at a level of public imagining, somewhat unbalancing the fact that such extraordinary processing skills make up only a small percentage of the diagnosed population. Hoffman's representation was so strong (or so strongly met a need) that it became a foundational origin. A character in *Snow Cake* (2006) refers to the autistic Linda (Sigourney Weaver) as being 'just like the person in *that* film'. This suggests that

autism *only* exists at the level of representation, at one remove from 'itself': a concurrency of reality and cultural fantasy.

To an extent, therefore, Ide plays not just a version of himself or of Boo, but a version of Hoffman in *'that* film', meaning that autistic presence *already exists*, as representation. And for this reason its 'return', in the form of Ide, is a deeply uncanny sensation, evidencing the fact that '[s]omething comes back because in some sense it was not properly there in the first place' (Royle 2003: 85). Because autism does not 'automatically signal its presence' through a 'continual visual signification of disability' (Murray 2008: 104), many people with autism lead concealed lives. What makes Ide's performance radical is his autism, a radicalism of a highly paradoxical kind. His autism is predicated on its contingent, slippery identity; even identity is too fixed a term – rather, its *being there*. This goes against the grain of two hegemonic cultural forces: the fixedness of disability as a social category and the 'perceived impossibility of personal development' in autistic lives (Murray 2008: 106). In theatre, or narrative mimesis more generally, this hegemony is underpinned by the perpetual absence of an autistic protagonist – that is, someone capable of desire or change. Ide's performance is highly ambiguous. He both evades and replays the passive role. He pursues, as the character, a drive but there are times when his anti-intentional force undercuts the 'actions' of the protagonist.

The autistic character, almost universally in mainstream cinema, whilst often central to the plot, is rarely anything other than a vehicle for the nondisabled protagonist to change: to become more caring (*Rain Man*) or overcome past trauma (*Snow Cake*). In thrillers such as *Mercury Rising* (1998), the autism functions as vulnerable witness trope: autism is that which traps or conceals the secret. On a psychoanalytic level, the person with autism is repressed *ad absurdum*: it is not simply that the interiority cannot be accessed but that there is nothing else *but* the interior. Only when the skills of the autistic character are of use do they actively appear to drive the story forwards, as in *Mercury Rising*, when Simon's savant abilities enable him to crack the code. Of equal relevance in such films is the framing of nondisabled performances. In the immortal words of Robert Downey Jnr in *Tropic Thunder* (2008), going 'full retard' is typically an opportunity to praise the acting technique of the 'star turn'. The sheer *amount* of acting evidenced by Weaver and Hoffman is evidence of a 'special' talent and almost validates their entire *oeuvre*. Yet as Murray points out, the same response is not afforded to those child actors who inhabit similar roles: it is as though their minimal, sometimes catatonic, performances have sprung from the direction

to 'act less' or else not at all. For Murray, such a dichotomy evidences the 'presence/absence continuity that is central to filmic representation of autism' (2008: 128). It is as though autism is both 'everything and nothing, with the gulf in between allowing for every kind of portrayal imaginable' (ibid.). Murray also cites the preponderance for autism in such narratives to oscillate between passivity and extreme behavioural disruption. When Adam Sandler's (Aspergic) Barry in *Punch Drunk Love* (2002) smashes a plate glass window at a party, the effect is akin to the car crash at the beginning of the film: a sudden violence, devoid of meaning or narrative signposting, a deeply irruptive force. Autism is thus the performance of either no preference or a violently determined one.

'It': the strange presence of Jonathan Ide

Ide performs at a different register to his fellow actors, a presence that could be defined either as 'absence' or 'meta-presence'. He is long and spare like a lead singer in an Indie rock band. Ide's performance is hyper-real, in the sense that it strains the boundaries that have been set by the rest of the dramaturgy. Everything else on stage is 'real'. Disbelief is suspended: this is Boo's living room; this is his brother. But with Ide, something else is always going on, some kind of meta-commentary on his own acting. He makes the other performances – which are broadly naturalistic – seem artificial. He breaks the fabric of artifice. He appears to be playing 'himself', acting and not acting in the same gesture. In a fictive re-imaging of jazz musician Art Pepper, Geoff Dyer observes: 'In San Quentin, the grey prison fatigues make him feel like an actor performing scenes from the life of Art Pepper' (1996: 170).[4] So too, Ide: *he is like an actor performing scenes from the life of Jonathan Ide.*

The Stage acknowledges Ide's portrayal as 'a performance of tremendous emotional honesty, balancing his character's curiosity with deep anxiety, [his] moments of reactive wit [...] delivered with laconic charm', which contributed to making the work 'a landmark production' (Berry 2009). Likewise, Tola Ositelu notes that Ide's 'turn as the man-child' adds a 'richness to performance that would be 'very difficult to affect' without him (Ositelu 2009). Ide, as Boo, is framed aesthetically 'outside' the other characters. On one level, the play is not about representing 'something' – autism, prejudice, community, disability – but about representation itself: or rather its impossibility. If the business of the actor is to knowingly represent someone, then Ide places this in doubt. He troubles the 'intentional' in performance in a way that might be characterised as 'fractured intentionality': his intention seems to shift, sometimes abruptly, rather like an actor in rehearsal playing

with different motivations through a single scene; it is as if an invisible director is calling out at varying intervals, 'Now try bored ... stand-up ... Distracted ... good, now ... laughing'. The spectator is compelled to care about Ide – and the character he plays – by force of his vulnerability. Early in the process, however, I noted the following:

> I feel worried about the work – will it stand up? Will John learn his lines? Will he pull it off without that constant support? There is no easy way to say it: this is all a risk. I recall something Phelim McDermott said about directing. As a word of advice he said, 'Always give yourself a big problem.'
>
> John is a big problem.
>
> I can't decide now if he is compelling, fascinating, enigmatic or boring. This has always been a question but now, nearing performance, it is intensified. Is what you once saw as beautiful authenticity, now incompetent acting? Is the absence of technique – rather than his strange absent presence – now the thing that defines him? As Mike says early on, 'He's got a lot to do with not much experience behind him to do it.'
>
> Tim and Rio had done a style run the day before. They talked about how much John came alive when they were doing this. He didn't get the styles, but what he did, almost as a by-product, was great. ('All the right notes but not necessarily in the right order'.)
>
> By pretending to be something else he became more like himself.
>
> By faking it, he became the real thing.
>
> *To be natural is such a difficult pose to keep up.*
>
> (Diaries 28 February 2009)

Ide, then, did not always appear to be 'up to' the task in hand; yet this only added to his vulnerability, to the sense of virtuosity attained against the odds.

Vulnerability features large in Joseph Roach's definition of the charisma located in celebrities. 'It', that 'easily perceived but hard to define quality possessed by abnormally interesting people' (2004: 555), is a deeply suggestive term, not least because 'it' is the neuter pronoun, typically referring to non-human, non-gender specific, or lifeless entities. 'It' is also death, as in the phrases 'he bought it' and 'that could have been it'. 'It' is both highly desirable and disturbing, which may account for the self-destructive behaviour of many who acquire celebrity status. In children's games, those chosen to be 'It' are 'simultaneously elected and ostracized' (ibid.: 561); and 'It' also alludes to the freakish or monstrous.

Roach goes beyond the notions of presence as magical essence to portray it as something *both* ineffable *and* rooted in performance traditions. In short, '"It" is the ability to command the recursive co-presence of mutually exclusive characteristics' (566) – to hold seeming oppositions of innocence and experience, or strength and vulnerability, in a single performance. Roach gives the example of Marlon Brando, who was praised by a New York Times reviewer for his role in *Last Tango in Paris*, a performance that gave insight into the 'desperate vulnerability that underlies the male drive toward sexual domination' (A.O. Scott, quoted in Roach 2004: 560). Taking this point to its logical conclusion, Roach cites Tony Barr, the programming director of CBS drama in the 1980s, who averred that 'strength without vulnerability lacks dramatic interest, while vulnerability without strength is just disgusting' (ibid.). In the following analysis I indicate how Ide's performance treads a fine line between strength and vulnerability.

Does Ide have 'It'? One answer to this is that Ide dominates the stage; he pulls focus. The others do, but Ide *is*. He is cool, in the way that rock stars are cool or perhaps more like jazz players. He possesses the deep strangeness of someone like Thelonious Monk. Geoff Dyer writes about Monk as a man with more than a passing resemblance to a person with autism (1996: 33–57). He can only communicate with one other person – Nellie, his wife – and she assumes the mantle of carer for the genius who cannot function without constant support. He cannot speak, at times, unless via the piano. On *Thelonious Himself* (1957) perhaps the finest track is a nine-minute solo improvisation called 'Functional', a loping, lazy blues stomp, the emotion in which stems from the player's reticence, his obliqueness. There is no sentimentality, even in the tracks dedicated to his lovers. He is *functional*: life lived is material for the function that is music. Ide, likewise, delivers the lines *functionally*. There is nothing that could be described as the expression of emotion; yet his vulnerability is extended outwards and attains an oblique kind of virtuosity. His art is like that of Monk: an art of obliqueness.

For Diderot, the essential paradox of the actor is that he is void as a person: a nothing whose absence allows him to inhabit someone (anyone) else. Roach makes a profound leap with this idea:

> The great actor's personal absence, a kind of affectively disabling autism, paradoxically enables his creation of the illusion of absolute presence. [As Diderot believes] '[i]t's because he's nothing that he's everything to perfection, since his particular form never stands in the way of the alien forms he has to assume'. (Roach 2004: 561)

Ide thus embodies the metaphor of the actor as autist. It is not so much his *difference* from the ideal of the actor as his *literal embodiment* of the ideal that surprises. Ide's radical alterity suddenly becomes radical proximity. This echoes Margrit Shildrick's argument, that the normative ideal (corporeal and psychic wholeness) is based on denial of our *always* vulnerable bodies and psyches (Shildrick 2002). From a Lacanian perspective, the infant is a vulnerable being before she is a sexual one: she is beset by the terrors of castration and mutilation. In order to construct a workable identity, the child must disavow these realities. In his account of the 'mirror stage' – which, incidentally, he recounts as a drama – Lacan argues that the self is formed precisely through the disavowal of early trauma, and that the self that emerges is a 'totality' that assumes the 'armour of an alienating identity' (Lacan 1977: 4). As Shildrick phrases it:

> The stability and distinction of normative embodiment relies then, from the first, on a re/suppression of the disintegration which belongs to the subject as embodied, and, indeed, precedes the subject as such. The originary lack must be made good by a lifelong desire to recognize oneself, and to be recognized as a unified and stable self. (Shildrick 2002: 80)

Lacan's Imaginary, then, in one sense, *is* disability: the fragmented body, or un-integrated self, which *resists* rigid containment. From this viewpoint, several logical conclusions may be drawn. First, identity is defined by vulnerability; second, this vulnerability must remain repressed or unacknowledged in order for the 'autonomous' self to defend (the illusion of) wholeness; and third, those persons 'marked' by vulnerability present a profound challenge to the status quo. Shildrick, whose study of vulnerability is entwined with that of the 'monster', argues, 'What makes the other monstrous is not so much its morphological difference and unfamiliarity, as the disturbing threat of its return' (2002: 81). Monsters, then, represent an *internal* threat, which stirs the long-repressed origins of human fears. Freud's uncanny is another name for this fear: fear that resides in a disturbance to what is *already known*, an 'anxiety-provoking double that haunts the margins of self-presence' (ibid.).

In rehearsal and post-show discussions, Ide often made little rational sense. Like Bruno S on set in *Kaspar Hauser*, he would enter into flights of fancy regarding particular details. For example, during one rehearsal he became adamant that the location of 'Bridlington' in Kenny's text

should be changed to 'Scarborough', because he had once been 'ill' in Bridlington. The following exchange with Wheeler ensued:

Hargrave: Jon, is it important what Tim thinks?
Ide: No, not really.
Wheeler: Is it important what anyone thinks?
Ide: Yes, the audience of course.
Wheeler: Well, as there is no audience here, I'm sort of them. Is it
 important what I think?
Ide: Yes, of course.
Wheeler: That sort of completely contradicts what you said a moment
 ago ... (*Laughter*).
Ide: (*Laughs*)
 (Diaries 23 January 2009)

In both instances, Wheeler, like Herzog with Bruno, took Ide seriously. Bridlington was changed to Scarborough and actor and director accepted that both their roles were 'important'. In Shildrick's view, monstrosity and vulnerability are two sides of the same coin, a little like Carlson's dynamic pairs, discussed in the first chapter: they evoke a tension between the 'ideal' human – 'fully present to himself, self-sufficient and rational' (Shildrick 2002: 5) – and the excluded other, who embodies division, non-rationality, and dependency. Moreover, the capacity to bear the vulnerability of the other is, at root, the capacity to bear that exact same feature in oneself.

How, then, is the monstrous/vulnerability pair embodied in Ide's performance? Partly, the answer is that Ide is *playing* a monster. He evokes, albeit loosely, the same character from the original story. At times he plays with this, as in the opening scene in which he moves behind the screen, arms raised, claws clenched, like Nosferatu, ready to attack his brother. Even his monster is vulnerable, failed, any sense of threat disappearing as he emerges, shuffling on stage. He does not play to the image or to the comedy of the moment; there is no 'intention' behind the act. Ide prepares for the following monologue, shuffling his paper, placing it under the couch, squaring up to the audience on stage. He says:

Boo: I've got a secret I'm going to tell you.
Don't tell anybody.
Because then it won't be a secret.
Will it be a secret if I tell you?
I don't know.

Maybe not.
Benny buys me sweets.
That's not the secret.

(Kenny 2009)

He runs the words together, asking the question and answering it in the same breath. As with Laherty in *Small Metal Objects*, the strangeness arises from the gap between the intention of the text – revelation of a hidden motive – and the deadpan delivery, which 'fails' this intention. Yet it does not fail to evoke sympathy. As Kenny noted during rehearsal, 'John brings a searching quality to the work, as if he is looking for the line, and this speaks for the wider struggle of the character' (30 January 2009). Ide's performance invokes a sensation that he is searching for the line itself, but not the *meaning* of the line. The line becomes something abstract.

Ide interrupts the journey from authorial intent to reception; as if in the midst of an alluring static, the meaning is withheld. It is difficult to capture his intonation on paper. There is something soothing about it. Not childlike exactly but the voice you might put on for a child to make them feel safe. His voice is incapable of denoting harm – a soft Yorkshire accent, low key, not variant in register, but compelling, lulling. The 'secret' is that Boo saves the sweets and gives them to the children. Shortly after this, he tells us:

But I had to go to the dentist
I didn't like going to the dentist.
He said he wanted to look in my mouth.
I didn't mind him looking in my mouth so I opened it.
But he didn't just look in it.
He stuck these things in it.
Metal things.
They clicked and tasted like …
I haven't got a word that says what they tasted like because I've never tasted anything like it. They tasted like hurt.
So I screamed.

(Kenny 2009)

The scream, when it comes, is not a scream. Ide says 'Ahhh' loudly, a little like Alan Partridge delivering his catchphrase. It is as if the emotion has been cut and pasted into the performance.

The key difference between the original Boo and Ide's copy is that the copy speaks. The ideology of the dramaturgy, too, is very different

from Palmer and Hayhow's insistence on the primacy of the body as the conveyer of the authentic. It contrasts markedly with *Hypothermia* also: In *Boo*, *all* the characters speak and convey meaning primarily through that speech. The play endlessly undermines a unitary aesthetic, and does so primarily through talking. With regard to Girl's remark to Boo, 'You're just like a kid, but you're not a kid are you?', Kenny explained that the line had originated with Haines during an improvisation, but that as soon as it became scripted, it lost its 'Haines-like' quality and felt false. Kenny noted, humorously to Haines, 'It is your line. I just wrote it, so pop it back in your mouth and make it sound like yours again' (Diaries 28 February 2009). This play of ownership between speech acts chimes with Zizek's point about speech more generally in film. The introduction of sound into cinema fundamentally altered the form: it ceased to possess 'innocent vulgar vitality' and entered the 'realm of double sense, hidden meaning, repressed desire [...] In other words: film was Chaplinesque, it (became) Hitchcockian' (2001: 2). Zizek perceives a deeper meaning in Chaplin's aversion to sound; that his dislike alluded to the 'disruptive power of the voice, of the fact that the voice functions as a foreign body, as a kind of parasite introducing a radical split: the advent of the Word throws the human animal off balance and makes him a ridiculous, impotent figure [...] striving desperately for lost balance' (ibid.: 3). It is not that Boo returns, it is that he returns, *talking*.

I argue that *Boo* does two things, which separately, are relatively uncontroversial. First, the play refocuses Boo as sacrificial victim, 'an untouchable [...] entity [...] an object in the psychoanalytic sense' (Zizek 2001: 65). Second, it ensures that the spectator is 'transposed into his own perspective, brought face to face with the uncanny scene in which it is not simply a subject but the thing itself which starts to talk' (ibid.). It is the juxtaposition of these two structural devices that makes the play subversive. Not only is the 'victim' seen, he is heard, from his 'own' point of view: the scapegoat is the narrator. And, as I demonstrate later in this chapter, the words that Kenny 'pops back' into Ide's mouth have a further uncanny purpose: of speaking Kenny's grief.

In the constant oscillation between character and persona, actor and role, intention and chaos, Ide exhibits a definitive challenge to normative notions of both self and actor. He disrupts not just the binary between strength and vulnerability or between innocence and experience, but Roach's paradigm of the 'It' person as someone who is capable of *reconciling* such oppositions. Ide does not contain or master such oppositions; rather, they seem to leak, or occasionally to burst, out of him. There is no 'balance point' with Ide, only a seemingly ever-present

possibility that he will do something unplanned, irreparable even. This quality, whilst not exactly 'It' in Roach's sense, is nonetheless crucial to an understanding of *Boo*, a work that always seemed at the point of overflowing its frame. The title of Heusen and Burke's jazz standard 'But Beautiful' feels apt here: the lyrics of this song hint at the paradox of Ide's performance: 'Love is funny, or it's sad/Or it's quiet, or it's mad/ It's a good thing or it's bad/But beautiful'. They evoke the risk of the performance: 'Beautiful to take a chance/And if you fall, you fall/And I'm thinking/I wouldn't mind at all'. There are times when it is hard to determine if Ide is 'tearful or gay' and when a 'problem' is 'play'. If Ide fails to mediate the dialectic of 'It', this failure is still beautiful.

Authorial presence

As Royle points out, Freud's essay on the uncanny 'keeps mum' about the death drive (2003: 88), meaning that he does not mention it directly, but it is subliminally present throughout. *Boo* 'keeps mum' in the sense that it keeps mum present, alive, if only in language:

> After my mum died. My mum died. She died. Yeah. My mum died. My mum died. My mum died. My mum died. My mum died. Yeah. Forgot what I was going to say. (*He walks around the flat in the same direction he always does. Then he looks out of the window.*) (Kenny 2009)

Kenny explains that he wrote these words exactly as he himself felt them. Alone, grieving, unable to move forwards with the script, Kenny was voicing his own state of mind. Writer and protagonist are intimately connected, then, not just in a practical sense – because Kenny had to deliver a script that suited Ide's temperament and presence – but in a deeper psychological way. Ide, as Boo, is also performing in Kenny's own words that deeply internalised 'autistic' persona that is the writer working on the play. Ide is playing Boo but also Kenny; and Kenny is playing Boo, inhabiting him via Ide. At some unconscious level, perhaps this is what Kenny means when he says that 'this play feels more inhabited' than previous plays he has written for the company (Kenny 2008).

I argue that Kenny and Ide shared a form of *telepathic* authorship. If telepathy is the ability to perceive what someone else is thinking or feeling, then, as Nicholas Royle argues, literature is the uncanniest of forms. Royle critiques not the 'omniscient narrator' or 'point of view' but rather the meta-critical language of theory that names these terms. Substituting 'point of view' with 'telepathy' performs several functions. First, it

deconstructs the assumed unity of 'author', 'narrator', and 'character', and refocuses them as indiscreet, overlapping entities. Second, it recasts authorship as a generator not of omniscience but *inter-subjectivity*.[5] Third, what is at stake is not just 'character' but the autonomy of the 'I' that speaks or the 'one'. 'Telepathy' is a way of speaking about authorship that allows for ambiguity, for strange collaborations. Royle explains:

> As soon as there is the explicit configuration of someone speaking as someone else, of an author speaking for a narrator, or of a narrator speaking as (or for) a character, there is literature and there is essentially something secret going on. (2003: 266)

The secret he refers to is an open one, the 'just is' of literature, that which Derrida refers to as 'being-two-to-speak': the 'I' that is author and character. In *Boo* I suggest that Ide and Kenny created a kind of 'third person' narrator/character: an amalgam of the two speaking as one.

The emergent 'voice' contained in the play is grief-stricken and struggling to come to terms with what has happened. Kenny says:

> Jon drew something out of me that no one has. The first time I met Jon I thought I'm going to have to step up to the mark here. His very being throws down the gauntlet that is not going to make it easy for you. I was lucky that I'd had this experience with Mark [an autistic boy previously cared for by Kenny] where I didn't step up to the mark or whatever the cliché is. I felt like I'd let him down, I couldn't do the caring [...] With this play it is the thing beneath the thing. I didn't know what to do with it. All I'm required to do is to write a play but with this [...] I felt it had to be authentic. (Kenny 2009)

In this context 'authentic' takes on a different meaning from that put forward by Palmer and Hayhow in Chapter 3. When Kenny produced the first draft, he felt it was clearly 'a play about caring' or 'who looks after whom' (email to Wheeler 10 October 2008). Yet it was more than this: a play about the *failure* to care. If kindness is being able to bear the vulnerability of the other, then this play shows up the cracks in that process. As he says:

> One thing that is concealed, or maybe it is both concealed and revealed, is around the character of Benny, those negative feelings about being a carer. It's quite difficult because sometimes you're not allowed to have them. Sometimes with Disability Arts stuff I get just

a bit fucked off with having an open door policy all the time. Just occasionally I want to be the one being looked after! Sometimes, I think, I give you a great part and you mess me about! Benny's character is actually concealing a lot of my negative shit, my shadow stuff. (Kenny 2009)

The work is uncanny in the sense that all works are uncanny: they carry the mark or the signature of the author, the 'style' that Deleuze calls 'the foreign language within language' (1998: 113). *Boo* allows that membrane that separates one thing (fiction) from another (reality) to be porous, fragile. Kenny's repetition of the sense that this work is 'different', or 'more inhabited', or closer to the 'real world', is an indicator of the depth of identification between author and protagonist. This was not a one-way process. At the start of one rehearsal Ide performed an impromptu dance routine and sang, 'I wanna be like Mike/Oo-ah-ah/I wanna be like Mike'. Kenny wrote *Boo* for Ide so that someone could speak his grief, and Ide wanted to be like Kenny, his 'author'. In the strangest way, it was the perfect transaction.

Boo is the one character who shares with the author the mobile concurrency of being here, there, and dramaturgically everywhere. *Tele* – absence or distance – and *pathos* – suffering – are bound up in this process: identities are not fixed and knowable but mixed and shared. Ide's performance is 'strangest' perhaps because of authorial telepathy (this two thinking and feeling as one). For this reason the play stands in contrast to Petra Kuppers' description of a stage adaptation of *The Curious Incident of the Dog in the Nighttime* (Kuppers 2008). Here, Kuppers critiques Haddon's novel as an inauthentic, nondisabled view of autism, which the dance company seeks to rectify, to authenticate by nonverbal means. This critique might be directed at *Boo* but it would risk validating something that, as I have argued, is deeply problematic: the assumed unity of the subject. In *Boo*, by contrast, there is no sense that such a unity exists, rather that identity in itself is strange and uncertain.

Boo is dominated by an absent woman, and marked by mourning, solitude, and the kind of compulsive repetition that Freud argued was linked explicitly to the death drive. During the second development week – for which Kenny delivered not a complete play but 'two separate unfinished fragments of a play' (e-mail to Wheeler 10 October 2008) – the author was most concerned with the ending:

You won't be getting waves of love from the audience. What they're getting is a distorting mirror through which they will look at themselves. A distorted Greatest Hits. My problem or my challenge is to

take the story so far and then take it further and resolve the story of these people. I've got ideas, but given the fact that it's you, what are your feelings? Up to where we've got to with *Boo*. You're walking in the skin of these people. Where might this story go? I'm telling the same story twice: a mirror. I've gone mirror mad. (Diaries 28 November 2008)

At this stage, there were two plays that ran independently of each other. Discussions about endings with the cast echoed Kenny's feeling that he was 'performing a very delicate operation' (e-mail to Wheeler 10 October 2008). He was dealing with the weight of the 'world's favourite novel' (ibid.) but also was concerned not to 'freak the actors'. He said: 'I'm maybe just seeking reassurance that I'm not leading Mind the Gap to a place you don't want to go' (ibid.). Kenny was particularly concerned that the world he was creating, whilst not exactly full of paedophiles or violence, is a 'world where these things exist' (ibid.). Kenny's concern was particularly acute in relation to Ide because he was the one who was on one level being asked to represent the monster at large. As he later reflected, 'I would have gone much further. I wanted the world to be more horrible. I wanted to rub the audiences' noses in it' (Kenny 2009). If there is a niggling flaw in the play, for Kenny, it is that he did not realise the full potential – the horror – of the material because he was concerned to protect the actors.

Boo has been brought back to life in order to die. Boo haunts the original book and Ide, as Boo, haunts the stage in this inverted version. He is like a ghost on stage, usually present at the side, watching the children, occasionally echoing their lines. Mid-point in the process, it was mooted that the play was happening not in 'real time' but in Boo's head. This would mean that Boo was either already dead or longing for death. What this 'reading' unlocks is an invitation to see the play as a process of mourning. As Richard Schechner points out:

> The ancient Greeks always sent a messenger on stage to report the violent acts performed out of the sight of the spectators. Actually, of course, these acts were never performed – they existed as reports only [...] The fictive violence of the stage refers not to the past or to elsewhere but to the future – to threats, to what will happen if the aesthetic-ritual project crashes. (1993: 259)

Points of intersection between the play, tragic structures, and disability are uncanny: the structure of tragedy as a re-working of the archetypal family drama; violence as a repression of 'primal' feelings;

the word 'tragedy' derived from the ancient ritual of scapegoating; the medical – sometimes called 'tragic' – model of disability that turns impaired people into 'dustbins for disavowal'; and the play itself written in the midst of the author's grieving process. In the conventional terms of tragedy, Boo dies because of a flaw: 'doomed to fall short of the goal' because he is 'stuck in a state of incompleteness or immaturity' (Booker 2005: 329). This has implications for any learning disabled protagonist, who may always be defined by society as immature and incomplete: like Icarus, a tragic figure who is 'in every sense the boy who cannot grow up' (ibid.: 330). As Girl says to Boo: 'You act like a kid but you're not a kid are you?'

The play calls authorial intention into question. A central purpose of adaptation is on one level to make the work one's own, at least to be anything but a slavish copy. Yet if delineating between 'origin' and 'copy' is, as I have argued, inherently problematic, *Boo* unveils another paradoxical layer of complexity. In making 'it' his own, Kenny was forced to inhabit someone else: Ide, who in turn became a focal point for his grief. Kenny's and Wheeler's avowed intention(s) at the start were as follows: to avoid a simplistic sympathy for Boo; to employ 'limited' direction techniques – that is, to 'set up structures in which people played'; and to explore a darker side to the notion of 'a child in a man's body' (April 2008). As Kenny developed the script, the intentions were modified: initially to tell two stories rather than one; then to collapse those stories back into one. At some point the play became a work about caring, or the absence of that care. As Edward Said notes, 'a beginning intention is really nothing more than the created *inclusiveness* within which the work develops' (1985: 12). The work that *Boo* became bears the traces of a proliferation of voices enmeshed in a strange mimetic dance. As rehearsals progressed, there occurred a growing sense of shared identifications, of coincidences, of life and art blurring. This is true of rehearsal processes, and of the psychoanalytic processes, 'the transitional space for collaborative exchange' (Phillips 2007: 118). The mimetic desire that humans have channelled into scapegoating springs from the same place that makes kindness, generosity, and humour possible. The *Boo* rehearsals were a time of copy and exchange.

Theatrical and un-theatrical presences

Ide's presence is not 'complete' in aesthetic terms until it is mediated by the dramaturgy, made sense of in the wider dramatic engine. Thus for Patrice Pavis, there is no 'intrinsic' actor presence; rather there occurs a 'collision between the social *event* of theatre and the fiction of the

character and the *fabula*' (1998: 286). Likewise, in Stanislavskian drama-turgy, presence is index-linked to the character's through line: his goal, without which his activities will be unclear; or, in other words, there is no 'proper' presence outside the intention of the character. Crucially, however, despite being authored as an 'unbroken line', Ide bends and possibly breaks that line. Moreover, he does not attain the position of Brecht's actor-mechanic, operating between social self and dramatic role from the safety of the dialectic: there is too much uncertainty at play for this. I argue that whilst the rest of the cast represent 'theatre' (unified character, mimesis), Ide embodies 'performance' (dislocated character and fractured mimesis) – the dramaturgy is thus the holding form for a symbolic system in a state of continual flux. In what follows I explore the meaning and implications of this interpretation.

Boo's dramaturgy plays with boundaries: with screens, doorways, maps, and routes, often troubling the relationship between on and off stage or between different stage presences. As Wheeler explains:

> For me the screens [used in the production] allowed us to move quickly between metaphoric landscapes. As if all locations were being summoned up by Boo, they were in his head. I liked the economy of stage transformation from *inside to outside* with no moving parts. At one moment in the maisonette, the next in the playground or in Boo's head exploring google maps. From a directorial perspective I was interested in how I could use filmic foreground, mid-ground and background techniques on stage. Allowing for scenes to overlap or for one scene to be seen though another. This has something to do with wanting more complexity in our work by overlapping percep-tions. (Wheeler 2012)

The screens work both as a dramaturgical device and as a way of unlock-ing the generative capacity of Ide's presence. I have already demon-strated how writer and lead actor were joined in a bond of projective identification; 'projection' also describes the visual dramaturgy. As noted in Chapter 2, Melville's *Bartleby* is an exemplar of autistic pres-ence. Rather than representing 'something', Stuart Murray proposes that 'the idea of difference [Bartleby] embodies travels throughout the story, disrupting as it goes' (Murray 2008: 58). In *Boo*, Ide's 'strangeness' disrupts the dramaturgy as it goes. Wheeler found an uncanny drama-turgical frame that allows, seeks out even, the disquiet that autistic pres-ence evokes. The uncanny breaks with the unifying frame of the proper and orderly. It *accepts* the strange as *part of* hearth and home. Under

Wheeler's direction the play was able to contain the mourning Kenny and the unpredictable Ide; and not just contain but allow something aesthetically rich and strange to develop, a 'cut and paste' aesthetic, echoing Boo's scrapbook, which seemed not only to complement Ide but to grow from him. This quality is reflected in Ide's acting, which at times leapt between different aesthetic registers. He echoed the lines of other characters at times, watching not just them but his own translator on the screen.

In fact, it is difficult to delineate between Ide and the dramaturgy writ large, so infused do the two elements seem, as if the dramaturgy *is* Ide. When Boo drops the 'real' sweets into the projected image of a bin, they drop to the 'real' stage floor with a dull thud. There is something rough and improper about this, yet in its way it perfectly sums up the roughness of the aesthetic: inherently palimpsestuous, it pierces the membrane between the real and the projected. It sometimes feels like a 'demo' version, with the slightly 'unproduced' feel of vocal tracks that have been laid down before being polished. The other characters continually project onto Boo. The children speak of the house: 'It looks empty. It looks it but it's not', alluding to the absence that Ide evokes. So too, the *actual* projection works to show what Boo sees as he wanders past houses at night: 'It's night time/And you have the lights on. And you look at the window. You can't see through. You just see yourself. It's like a mirror. But if you're outside, you can see in.' The dramaturgy is a hall of projecting mirrors, all of which cohere around the central projection that is Boo himself.

Of these projections, perhaps the most startling is that of the British Sign Language (BSL) sign interpreter, Tony Evans. As soon as the play was blocked, Evans was filmed, cut, and pasted onto the screens. He became another uncanny presence, a fifth performer, present, but not quite. He watches from the wings, interpreting the action, another self, dressed in black like one of Wim Wender's angels, yet frequently out of sync. Sometimes he glitches or fades a little like the teleport system in *Star Trek*. Sometimes he interprets what has just happened a few moments before. Sometimes he pre-figures the story – by accident – explaining to a hearing-impaired audience what is about to unfold. There is one moment – the speech about the death of the mother – where he acts out the feeling of being sad. His performance, coming after Ide says 'My mum died', provides an aesthetic and emotional twist. The spectator sees, then hears, then – like a shadow play – sees an interpretation of what has been said. In his own diary, Ide makes the slip that Evans is there 'doing the version for death people to understand'.

Sometimes, when the timing was perfect, Evans would disappear from the screen at the exact moment Boo had finished his speech, enacting the loss of mum precisely. The signer represents the writer at one remove from his protagonist, who is helping him to grieve. And he represents the spectator also – interpreting the protagonist, signifying him, identifying with him. Yet perhaps the signer also represents autism, or at least, a metaphorical allusion to it: a perceptual difference or delay. Film is an uncanny phenomenon, as Tony Gunning observes, one that seems to 'undermine the unique identity of objects or people, endlessly reproducing the appearances of objects, creating a parallel world of phantasmatic doubles alongside the concrete world of the senses' (1995: 43). Equally, film once seemed to possess magical powers, making 'things appear and disappear [...] conjure ghosts [...] mutilate and reconstitute bodies' (Stern 1997: 357). Film, as utilised in *Boo*, fulfils this role rather well. Objects appear and disappear, almost like a scrapbook collage of uncanny phenomena.

Theatre is founded on the exhibition of real people as mimetic objects. If fine art is defined by Greenberg's 'ineluctable flatness of its support', then theatre's essential form is corporeal.[6] Place into this arena the vulnerable or even palpably anti-social human, and the stakes are raised even higher. If theatre is an inherently libidinous and amoral place, how much more troubling it is if someone appears on stage who appears not to have mastered their own intentions. Traditional theatrical mimesis depends on identification with the protagonist of the drama, one who wilfully pursues a goal. This figure, in Freudian terms, enables the audience to enter into a symbolic neurosis, to 'live out' that struggle for the duration of the play. Mimesis is curtailed if the protagonist displays no will, or sits outside the machinery of unifying narrative. As Elin Diamond notes, Plato identified both 'good' and 'bad' mimesis: the former, narration; the latter, impersonation. Those who undertook the latter risked contamination by impersonating 'inferior' others:

> Then those we are educating ought not – since they are men – to play the parts of women, young, or old [...] nor may they play the roles of either female or male slaves nor perform any slavish act [...] neither should they impersonate a coward nor any other kind of bad man whose behaviour is repugnant to [our] standards. (Quoted in Diamond 1997: vi)

Ide's performance, and the dramaturgy itself, interrogates not just the notion of minor characters, but who should 'impersonate' such

a character. Or perhaps, more radically, it troubles the relationship between the something that 'is' and the something made like it. Plato warned of the danger of impersonation: the fear that imitation would become a doubling or splitting of self, thus undermining both the authenticity of the original and the stability of the Republic.

If theatre features 'representation of the observed and the actual, intelligible configurations of character, narrative coherence, meaningful patterns of action' (Barish 1981: 464), then Ide represents an opposing force. Taking the main hallmarks of 'performative' – as opposed to theatrical – performance from Josette Feral, Ide engages in narrative 'rather ironically with a certain remove, as if he were quoting, in order to reveal its inner workings'; he 'rejects [not just narrativity and representation but] the symbolic organisation dominating theatre and exposes the conditions of theatricality as they are'; he evokes 'discontinuity and slippage'; and he refuses to offer the audience what they expect of 'a proper protagonist' (see Feral 1982: 175–179). Ide is in a constant process of undoing the dramaturgy. His perfect double would be Bartleby, who, facing eviction from the office, has the screens – which had kept him secluded – folded and removed, leaving him 'the motionless occupant of a naked room' (1982: 52). Ide consistently undoes the frame and silently invites the entire edifice to collapse. Thus he is the perfect manifestation of Feral's performative persona, 'whose aim is to undo competencies which are primarily theatrical' (ibid.: 179).

Yet this undoing is Ide's value and the tension he brings is inscribed deeply in the dramaturgy. Evans' oddly alive projection plays with this mimetic problem. He is the split-self framed as both aesthetic conceit and disability access. In one striking moment, at the exact mid-point in the play, when the four characters arrive on stage for the only time together, Evans splits again. He appears twice, this time on both screens. At the end of the piece he appears 'with' the cast to take a bow. During rehearsals someone mentioned that autism was 'like performing for an empty auditorium'. In this case, the comedy of Evans' bow arises from precisely that: he is not there. When he took the bow, he was performing it for a single camera. The double signifies death because it makes the individual doubtful of her continued identity. It makes someone the co-owner of the other's knowledge. It exudes comedy, yet also something more uncomfortable: the notion that Evans is buried alive in the show. Evans is trapped, still alive, but only able to communicate through what is, to many, an unknowable and silent language. There is nothing to *prove* that he is still alive; he is there, not there, popping up, coming back, but unable to move beyond the strange confinement of

the screen. When Derrida responded to Freud's *'es spukt'* ('it spooks, "it ghosts", it comes back'), he suggested that the stranger be welcomed:

A stranger who is already found within (*das Heimliche-Unheimliche*) more intimate with one than oneself, the absolute proximity of a stranger whose power is singular and anonymous (*es spukt*) an unnameable and neutral power, that is, undecidable, neither active nor passive, an an-identity that *without doing anything* invisibly occupies places belonging finally neither to us nor to it. (Derrida 1994: 173)

This definition could stand for Ide, or for his character, or for his double, Evans. Ide is not impassive but he is not quite active either. His is a neutral performance, one of radical undecidability; Evans, 'without doing anything', or indeed being there, comes to occupy a central place in the dramaturgy. My own 'fascination' with the ethereal Evans, however, was not always shared. As Jo Verrent pointed out, from a hearing-impaired perspective, 'for 80 percent of the time, the interpretation ran ahead of or significantly behind the performance, making it irritating and nonsensical. So full marks for effort there, and for the commitment to providing sign language interpretation, but a fail in relation to providing access' (Verrent 2009). This is an important finding and another parallax: a sight of the same performance from two perspectives that cannot be reconciled, only respected as different. Yet there is so much in that 'only': culture, history, life narrative, class, aesthetic preference, perceptual or cognitive difference. The two perspectives do not invalidate each other; on the contrary, they highlight once more the purpose of a poetics: to uncover and further investigate contested beliefs. On one level, it is a perfect example of the effect/affect dynamic in action: an instrumental purpose that failed its projected outcome but met another unforeseen one.

I have argued that Ide radically challenges the normative conceptions of character or narrative, and thus becomes a powerful anti-theatrical force. This becomes a generative act, which, rather than 'destroying' the mimetic representations enacted by the rest of the cast, brings them into sharper focus. Just as Brecht's dramaturgy did not so much suppress as *revivify* mimesis by use of the dialectic image, so Ide re-orientates the axis of dramatic coherence/incoherence. I am writing after Feral (1982) and also Ridout (2006), who both argue that the dichotomy between theatre (competent, normative, mimetic, false) and performance (undoing competencies, anti-mimesis, real) is reductive to the extent that all

theatre *contains* performance, as it were, behind the scenes. Furthermore, Fried's disavowal of theatre as a 'degenerate art form' reveals performance's conflicted love for theatre. All theatrical performance arises as an uncanny play between that which must be seen (character, plot, scenography: the Symbolic) and that which must remain hidden (desires, flows: Lacan's Imaginary realm in which objects elude representation). *Boo* exhibits these elements in a highly original way. It neither refuses mimesis nor embraces it fully. *Boo* gives the audience exactly what Feral argues performance gives theatre: an exploration of its 'under-side [...] a glimpse of its inside, its reverse side, its hidden face' (1982: 176). If mimesis is felt most vividly in theatre when it is most at risk of collapse, then it is felt deeply in *Boo*, in which this collapse is a perpetual feature. The rest of the cast 'do', Ide just 'is'. This places Ide at the margins of the theatrical: 'Theatricality cannot be, it must be *for* someone. In other words, it is *for the Other*' (ibid.: 178). What Ide puts in delicious doubt is who or what his performance is for. The dramaturgy accepts Ide *as he is*, or *how he appears*, and this is what makes the work a radical statement. *Boo* allows what is hidden (non-theatricality, autism, *unheimlich*) to be seen. On *Boo*'s publicity leaflet Ide's hands cup his face; then as the centre-fold opens, he reveals himself, the face open-mouthed as if trying to voice something. By opening and closing the booklet at speed the image is crudely animated; it flickers to life. Ide's live performance embodies this flickering interplay. Here, not here. Seen, hidden. Boo!

Side affects

Audiences that saw *Boo* were invited, implicitly, to make a judgement about the actors: must they either be seen or, like the archetypal Boo Radley, be kept hidden? Like Boo's 'coming out' in the play, the visibility of the actor playing him might have unintended, unsettling consequences. Early in the devising process, Wheeler noted:

> I'm interested in [...] how we re-frame the character of Boo for a contemporary audience. I'm also interested in how we implicate the audience in our version. Mike says he is struggling with how to connect the wider idea of community to this tight-knit set of characters. Strikes me that the audience will be 'the community' and I want to make sure that we commune on a very deep level. (Wheeler 2008b)

This section analyses the 'communing' that took place: the consequences, both ethical and aesthetic, for these actors to tell this story

on stage in front of a general public; how they are 'on stage' and how might this be subtly different from seeing or meeting them 'off stage'. Defining his role as a psychoanalyst, Adam Phillips said: '[T]he so-called patient does the difficult thing – talks of things that trouble him – and the so-called psychoanalyst takes the fallout. Both the patient and the analyst are recipients of these side effects, of all the things said and implied and unintended and alluded to' (Phillips 2006: xi). I am concerned here with the 'side affects' of the theatre experience. Alongside what happens in the play itself, the subject of what follows is the side affects of the actors post-show, or backstage. Similarly, I am concerned with the nondisabled spectators' view of what these performers did *not* do, or did in a way that was different from actors who embody normative theatrical conventions.

This section draws on conversations with a small group of spectators whose insights are particularly revealing. The official audience data, gleaned from questionnaires throughout the tour, is extremely positive overall; the comments focus on the strength of the performances, the design concept and the writing: 'Beautifully written and funny, and heart wrenching'; '[S]o thought provoking, afterwards we discussed for an hour or so all the challenges and reflections we had had during the performance'; '[T]he themes of misinterpretation and the detrimental nature of the lack of community [were] fantastic!'. It is important to note that, as Verrent's dislike for the 'faulty' BSL interpretation demonstrated, there is no singular audience. In the remainder of this chapter, there is little reflection on the views of learning disabled spectators; there is vital work to be done in this area. Rather, the responses that follow are gleaned from in-depth interviews with undergraduates who saw the show at Live Theatre in Newcastle on 30 March 2009. The majority were impressed by the piece. Of their responses, I have deliberately chosen to discuss a selection of them – five in total (three undergraduates and two members of academic staff) – which offer insight into an anxiety that some nondisabled spectators felt. Such anxiety is revealing in two ways. First, it raises the spectre of 'normative' cultural values. Second, it reveals problematic assumptions about the nature of theatre and who has access to it. Siebers has argued that 'able-bodied people focus in face-to-face encounters more on their own anxiety than on the feelings of the person with the disability' (2008: 43). My intention in what follows is to look this anxiety in the face. These audience responses reflect complex dynamics. For the most part it is not visual *difference* that is the focus of the unrest but rather its *lack*.

Reading the signs

Audience reception of *Boo* oscillates between stable and unstable signi-
fiers, between what does and does not settle into dramatic illusion.
Taking Michael Quinn's 'Celebrity and the Semiotics of Acting' (1990)
as a starting point, I argue that the presence of disability functions, not
exactly like celebrity, but rather as a similarly *disruptive signifier*, one that
complicates the transmission between text and character or between
character and spectator. Quinn suggests three core components of act-
ing: the person of the performer; the immaterial dramatic character that
exists in the mind of the spectator; and a third intermediary position –
the stage figure *created* by the production, which acts as signifier. The
first represents an *expressive* function, of the performer's own subject,
which is closely bound up in her celebrity (or disability); the second
is *conative*, furnishing the character from 'the personal store house of
experience that constitutes each viewer's competence' (Quinn: 155); the
third is *referential*, the stage figure who ties the person to the character.
In the 'normal' realm of 'post-romantic western theatre' (ibid.), what
constitutes 'good art' is mostly acting of the referential kind: that is,
the type that achieves a suitable aesthetic distance between character
and actor and unifies the sign, tethers it to the world of the play. Quinn
proposes that celebrity subverts this 'ideal'; disability, I argue, does
the same.

One spectator explains:

> Some didn't enjoy [*Boo*] because they felt that the actors were per-
> forming themselves – they could see the backstage area and thought
> that there wasn't really any skill involved – that it wasn't acting.

There is clearly disappointment felt by this person – or the others they
allude to – when they 'see' the actors behind the set. The idea that
'no skill is involved' is reminiscent of a joke in Stoppard's *Shakespeare
in Love*, when one character, a respected Elizabethan actor, resists the
concept of a woman playing her own gender with the line, 'Where's
the art in that?'

Another interviewee says:

> I thought 'Girl' was a good actress, but seeing her in the bar after I
> realised she wasn't acting so to speak.

The perceived proximity between actor and character creates a resist-
ance reinforced by the visibility of the actors off stage. Quinn theorises

the effects of sign slippage. First, celebrity (or disability) *resists* theatrical signification by creating a surplus of personal (expressive) value. Second, this surplus *splits* the sign rather like a version of Brecht's *Verfremdungseffekt*, linking the person to the spectator without the need for referential character information. In the case of a celebrity, information – or gossip – about celebrity is brought to the audience prior to the performance and functions as a way to 'fund perceptions' (1990: 156). In the case of disability, cultural meanings or prejudices fill this perceptive gap. Third, the effects of such semiotic shifts are both structural and psychological. The 'star' replaces the expressive person with something allied but different: a semiotic hybrid who tends to dominate the entire work. This means that the dramatic role is always in thrall to celebrity. Similarly, I suggest that learning disability displaces semiotic fixedness and points to how 'cultural values are inscribed in our acting conventions' (160).

But what *can* be seen exactly? In rehearsals no attempt had been made to 'hide' the actors behind the set. At Live Theatre, which has a very small backstage area, it was not possible to conceal all the actors all of the time. But what do they *do* backstage that an audience could see? Very little: Ewans sips some water. He turns to Haines. She smiles. They carry the energy of the characters with them off stage. They are not 'neutral' but neither do they draw attention to themselves. The audience response to this 'state', quoted above, places these actors in a kind of double negative: they are not acting but neither are they 'not not acting'; not themselves but 'not not themselves' either.[7]

As Haines, who played Girl, eloquently points out:

> You probably can't tell I've got a learning disability. I just act like a young kid [...] that's how Boo describes having a disability. To be honest I don't know how you tell someone is or isn't. It's in the face, maybe.

Yet her presence seems to provoke unease in another spectator:

> I was very struck by the visibility of the back stage and I remember too feeling somehow disappointed by that. Girl at one point came off stage from a quite tense scene and then seemed (to me) to flop down, grinning in an off-hand kind of way and there was from there a different quality to what we'd just seen. And yes, I suppose it did raise for me instinctive questions about the 'authenticity' of the performance.

Key to this response was her belief that all this was intentional:

> I thought the director clearly wanted us to be aware of that distinc-
> tion between front/back regions [...] my responses were continually
> being complicated and frustrated and that was a good thing.

What this response has in common with others is the confusion of
positive and negative values: on the one hand, irritation; on the other,
a desire to see the 'good' in this irritation. The 'quality' of the acting
is always double-edged. Those who witness it struggle with their own
sightings. A character walks off stage and is seen 'grinning in an off-
hand way'. The spell is broken and disaffection sets in. 'Am I meant
to see this?' they ask. 'Is it rehearsed?' 'If so, how do I feel about this?'
'Does it enhance or discredit the aesthetic?' Perhaps the spectators
are also struggling with the nature of critique itself. By saying 'nega-
tive' things, they might risk causing offence, so they double back on
themselves, as in the phrase, 'my responses were continually being [...]
frustrated, and that was a good thing'. From Ewans these comments
provoke wry amusement:

> People don't like it when someone without a disability plays a disa-
> bled part. But then when someone who has got a disability plays
> someone with a disability it's like [*he laughs*] we're just not acting
> [...] [*laughs again*] [...] You've got nowhere to go. It's crazy. You shoot
> yourself in the foot. (Ewans 2009)

It is as though the 'surplus' sign of disability overshadows other signs
at the actor's disposal. Ewans is judged twice: for something he does
and something he is. A precise parallel exists between the surplus of
disability and that of celebrity. A major point of difference, however,
is the *stability* of these signifiers. In contrast to the 'news about the
actor' that 'fund(s) perception' (Quinn 1990: 156), the presence of dis-
ability becomes a quest for something that is *unknown*. The audience
may have had an idea about, or personal experience of, learning disabil-
ity, yet they knew nothing about Ewans, only that all the actors were
in some way disabled. The spectators have been *searching for* the sign,
the thing like celebrity that might *stand in* for the expressive function
of the person of the actor. As a mirror opposite that of celebrity, Ewans'
disability is an unstable signifier: what troubles is not its presence, but
its ambiguity, the fact that the spectator is unsure what the disability
is and how much of 'it' there is. Celebrity, by contrast, represents an

absolute presence of *dasein* (the thing in itself), and is, as Quinn puts it, 'impervious to the gaps that might deconstruct it' (1990: 156). In many cases, visually marked impairments lead to the same kind of 'total' signification. Learning disability in this case, with no visual signifier, *is* the gap: that which disrupts the fixedness of any sign.[8] Disability becomes a 'substitute for the "someone" we know apart from the play' (155): it is the thing that, like celebrity, prevents total identification with the referential figure of the actor in the drama.

Ironically, as Quinn points out, celebrity and role often merge when character and star appear to have been cast into a role that suits their presence and temperament. If this does not happen, the work is read as either poor casting or a deliberate technical challenge. Dustin Hoffman did it twice: when he passed for a woman (*Tootsie*) and a man with autism (*Rain Man*). His process is parodied in *Tropic Thunder* (2008), where the actors debate the pros and cons of 'going full retard'. The only person on stage in *Boo* who is significantly *different* from his off-stage persona is Clay. This begs the question: why is it socially acceptable for a star to be both close to *and* far from their *expressive* persona, but not so for a learning disabled actor? For one spectator, the pervasive sense was that *Boo* was not different *enough*: 'I expected to see something that only a learning disabled person could perform effectively – however, at this time I don't actually know what that is!' The formal 'three act [...] structure' did not significantly demonstrate 'the *use* of a learning disabled cast as different'. In a sense this echoes Kenny's point that the work ended up being formally 'quite conventional' (2009).

Why should this matter? The expectation is not simply that learning disabled actors might be employed but that they will produce something *authentically* disabled. The student suggested that the company should produce 'something like *Hamlet, Blue Orange* or *Blasted* rather than a piece [that had] a learning disabled protagonist'. He said: 'I would not have enjoyed *The Pitmen Painters* any less if it had been performed by learning disabled actors [...] but with *Boo* [...] it was just too much about his problem.' This demonstrates conflicting issues: the need to see something authentic (strange), contrasted with the desire to implant the disabled actor into an existing canon, one that might be re-vivified by their presence. What is *not* desired is the learning disabled protagonist. This echoes the uncanny: *Boo* brings autism not just close to home but close to convention. There is nothing 'radical' about the form of the work: what is radical is the presence of difference in what is *already known*.

Clearly, the analysis of such a response cannot be reduced to surplus signs or unstable signifiers. This invites a return to Bert O. States' point (explored in Chapter 2) that in the experience of theatrical anomalies, 'one feels the shudder of its refusal to settle into the illusion' (1985: 37). But what exactly is released by this shudder? Ridout argues for something altogether non-mystical: namely the sense that this is a *labouring being* 'at the service of' dominant forces' (2006: 125). The potential for exploitation invokes guilt or shame. What *Boo's* spectator is seeking to erase here is not the actor's difference but his sameness. It is no accident that he refers to the actors 'being used' or 'using' repeatedly, as in the phrases 'I expected to see these actors being *used* in a professional environment' or 'Ide seemed to be *using* his impairment'. To quote Ridout, who discusses such stage anomalies as children or animals, 'there is nothing strange about them, except the strangeness we impose upon them in order not to see them looking back, in order not to experience, as affect, the shame of our violent shared history' (ibid.: 128). Perhaps what the spectator found difficult to engage with was his own discomfort at whether or not such actors were indeed 'being used'. But 'used' to what end? Precisely in the service of a theatrical form that would normally operate without the surplus of signs.

One final point about celebrities is that they may at times refuse to 'tone down' their performance to fit into the overall vision. Quinn argues that, in psychoanalytic terms, 'the absolute status of the star provides the spectator with a ground, a stable construction' that permits Lacan's 'handing back of truth to the Other' (1990: 158). Ide's disability complicated this sign identification: he became, in contrast to Lacan's 'subject who is supposed to know' (ibid.), rather the one who is not sure what he knows. Competence and intentionality are enmeshed in the matrix of the star turn, as they are with learning disability. Brando's star turn in *Apocalypse Now* (1979) is famous for its incompetence, for the kind of fragmented intentionality that appears on the screen and establishes the instability of the character, Kurtz. The level of scaffolding that Brando required (cue cards, endless takes) is a cliché of both celebrity excess *and* learning disability. As a surplus sign, Ide disrupted the identification with the character but did not, seemingly, substitute his disability for the spectator to 'project the self onto and into' (ibid.: 158) in the way that celebrity might. In strict Lacanian terms, the spectator is only able to project because unconsciously they feel a lack. This is Roach's point about 'It', that charisma fulfils a need, an absence. Yet there is no sense from the spectators that they were able to project onto Ide. Arguably, this is what makes the adaptation so radical: it invites you

to identify with the monster. Ide, in formal terms, replicates Brando's disruption of the visual and symbolic field. He does so without the crucial commodity that is the star's authority: he is a nobody to Brando's somebody.

Looking at the evidence

The invitation to look at disabled bodies is underpinned by a history of the stare, the look that interrogates, seeks to quantify, that confers the power of a centre (starer) upon social periphery ('staree'). As noted in the analysis of *Small Metal Objects* in Chapter 2, staring casts disability in the way that the 'male gaze' casts women, as objects to be desired and controlled; it constructs an image and *fixes* the identity of the other. Yet on a psychoanalytic level, staring makes us who we are: sustained visual regard by an attentive other is necessary to form the human personality. For Lacan, the mirror stage is the period in the infant's development that consolidates the self as subject: by recognising her 'self', the child moves out of the realm of the fluid imaginary and into a fixed unity, an illusion of wholeness. The act of looking is, thus, innately ambiguous. As Phillips postulates, the appearance of a potential staree constitutes a 'radical besiegement of the subject', meaning that one stares but always feels a concurrent anxiety about it (1993: 42). The unusual or unexpected body – 'that we expect neither to see, to know or to be' (ibid.: 39) – is a threat to the mastery of the superego whose power resides in a perpetual denial of vulnerability. In a psychic sense, disability, and the threat to order that it generates, is society's best-kept secret.

Boo's dramaturgy plays with staring, glimpsing, and looking, and invites self-reflexive spectatorship. Boo tells of walking the streets at night: 'There was a woman, old I think. She closed the curtains. She looked straight at me. But she didn't see me. I don't think she saw me.' On a psychic level, what does the audience see? When Ide looks out at the audience, he is inconsistent. It is not as simple as saying there is 'no look' or 'no subjectivity', rather that both are unstable. Ide's look oscillates between the invitation of a stand-up comedian and a strange grey area between acknowledgement and blankness. In Lacanian terms, when Boo stares back, it is neither neutral nor entirely subjective. This creates a strange dislocatedness. In psychoanalytic terms, the Other looking back, *unbidden*, is disturbing because it confronts the spectator with the Other's desire – meaning, they cease to be a sign/object and become a desiring subject. This may be the primary challenge of the play. The Boo who was hidden comes out: he does not just talk back, *he looks back*; and he does so in a way that has no staged precedent.

The following piece of text, spoken by Boo, takes on a more complex reading in this light:

> I'll show you something. If it's night time. And you have the lights on. And you look at the window. You can't see through. You just see yourself. It's like a mirror. But if you're outside, you can see in. (Kenny 2009)

This works as commentary not just on Boo, the character, but on the audience. Sometimes they can see through, sometimes into Boo and perhaps sometimes into themselves.[9]

The post-show discussion, a regular feature of the tour, was an opportunity for the actors to answer questions and reveal themselves to the audience. On the occasion of the Live Theatre performance, two factors played a part in spectatorship. The first was the pre-show talk – involving myself, Wheeler, and Kenny – which sought to 'place' the company's work in context. The second was the presence in the post-show audience of some quite strident disability advocates whose contribution tended to force the agenda of disability rights and to 'shout down' views that did not accord with their own. One student remarked: 'I wasn't able to think of the work as just the work. I had to think about the event as a whole. I wished I'd been able to just see the work.' A member of staff who saw the show on another night felt disappointed that the actors could not be more specific or engaged in a discussion of the devising process. In his own words: '[M]aybe I have a romantic notion of the actor as being deeply involved in every aspect of the production.' He was disappointed that the actors' usual response was 'it was the director's idea'.

The post-show discussion was itself double-edged. The actors were seen, but their responses were either well-rehearsed or in the case of Ide, wildly improvised. There was little analysis of the meaning of the show. The actors demonstrated a performative eloquence that was not matched by discursive articulacy – this may be one definition of what it means to have a learning disability. Perhaps the actors did not feel confident in expressing their ownership of the work or in detailing the actual process of creativity involved. The romance of the 'totally involved' devisor as expressed above is often invoked in theatre involving learning disabled artists. This has to do both with the non-hierarchical drives of devising *per se*[10] and the context of disability politics.[11] The perception of the nondisabled director as undemocratic or even coercive was discussed in Chapter 1; but this *disappointment* with the actor, post-show, belies

the very real collaboration witnessed in the rehearsal room. Clearly, the directors framed the creative work but the scenes were whittled at, shaped in a context of mutual respect and a desire to tell a story that was deeply influenced by the lived experience of the cast members. As Ewans commented, he and Haines 'were like Boy and Girl because we were involved from day one of planning'. Ironically, one spectator was 'confused' that 'the roles had been written with these specific actors in mind'. She wanted, in her words, 'to believe that they had been acting'.

Developing Hanna Segal's ideas about aesthetics, psychoanalyst Darian Leader suggests something initially surprising but perfectly logical: that audiences do not so much identify with the protagonist as with the *creator* of the story (2008: 87). Freud terms this fleeting type of connection as 'hysterical identification'. The spectator is not emotionally tied to the creator of the work as they are to someone they have loved and lost; rather, the artist becomes the interlocutor with whom they can share a grief – they enter into a 'dialogue of mournings', a little like the process whereby a community hires a professional mourner to release blocked emotion. Segal's ideas offer another way to consider the perception of learning disability on stage, where the spectator might experience a 'hysterical identification' with the person or persons perceived to be 'the creators'. It is possible that this fleeting allegiance might also be complicated by more difficult feelings: hostility might come to bear on the creators, either because they are perceived as controlling or because the spectator cannot bear their *actual* hostility towards the vulnerable actor. Emma Gee, Mind the Gap's Director of Outreach at the time of *Boo*, has suggested that short selections of filmed rehearsal might usefully be presented in future post-shows in order to 'demonstrate the process more accurately' (2009–2010). This is a measure of how deep the need for additional context might be, yet it does seem to place the nondisabled artist in a position of defending a rehearsal *process* as well as an aesthetic product, almost as if they carry a 'burden of proof' that extends back into the inception and process of the show. Equally, as Wheeler argues, it attests to the importance of ensuring that 'questions are framed or re-framed for learning disabled people' (2010b). This is a fundamental challenge, not just for practitioners, but for academics. Just as *Boo* is haunted by its source text, this book is haunted by the fact that those upon whom it impacts might not be able, in its current form, to access it.

Learning disability, like celebrity, subverts the authority of the author as primary maker of meaning. By overstepping the sign, each actor attains an ambiguous status, as someone who threatens the

pre-arranged contract. In *Boo*, Wheeler 'used' individual acting talent to considerable effect. The point is, an actor like Ide only ever seemed to enter into a *partial* contract: he had the power as 'both sign object and producer, to subvert the efforts of other artists to authenticate themselves through fictions of absolute authority' (Quinn 1990: 15). One nondisabled audience member made the point that Ide's inarticulacy in the post-show discussion re-enforced the major achievement that was his eloquence in performance; another made the further suggestion that 'there were times [post-show] when I wasn't sure he wanted to be there'. At the end of Boo's speech about the death of his mother, when he says, 'I forgot what I was going to say', a spectator leaned over to ask a member of the company's staff, 'Did he forget his lines, really?' Ide's fractured intentionality had potent side affects. Were the spectator uninformed about the company and its processes, she might worry about the ethics of Ide's presence on stage; she might wonder if it was exploitative, even cruel; she might question whether he had given informed consent for his actions, or even fear personal consequences: a certain lack of control might lead to chaos ... and this Boo character may be a murderer ... he holds a large pair of scissors ... and if he does not fully grasp the distance between character and self then who knows where we might.[12] Nicholas Ridout argues that the 'oscillation' one sees in a person experiencing stage fright is tantamount to a 'semiotic shudder': 'they [the actor] are somebody being not quite where they ought to be, and flickering there' (Ridout 2006: 60). Stage fright is such a suggestive parallel because it is something that must be kept hidden from an audience at all costs. When the spectator looks at Ide, they do see someone flickering and perhaps, unconsciously, they get a fright.

Heading them off at the pass

The actors were critiqued as being both too near to their expressive sign *and* too far: that is, for being disabled, trying to play nondisabled. Ellis mentions this in her thoughts on *Boo*'s imminent tour:

> I wonder if it annoys or worries the audience that learning disabled performers play non-disabled characters. Alan is more visibly learning-disabled than Jonny yet he plays the non-disabled character. I like this but wonder if the audience suspend their disbelief in this. I personally think that the excellent casting of JoAnne and Rob means that their realistic sibling relationship overrides their learning disability. In this sense it's a good advert for the agency – the actors

on our books are so good they can play learning disabled and non-learning disabled parts! (Ellis 2009)

In fact, it was something that *did* worry one nondisabled audience member:

> Because the piece was performed entirely by learning-disabled actors this lessened the intended impact of Boo as a marginalised character. Although it is at odds with *Mind the Gap's* mission I feel that the use of non learning-disabled performers in the three other roles [might] have actually enhanced the piece and enhanced its point. Ultimately, I felt like I was watching an example of a specialist theatre group at work [...] rather than a cast portraying the dilemma of a marginalised character. Perhaps, the whole piece [might] have been more effective if it had been produced by someone else.

The company were interviewed individually and asked if it was important to them to be regarded as 'an actor' or a 'learning disabled actor'. Without hesitation they each replied, 'an actor', not least because they would most likely, in Clay's words, 'get more lines'! Ewans also raised the point that one would not think to employ a disabled plumber, simply a plumber.

These actors offer neither the full 'weight' of psychological subtlety, nor the 'knowing' irony of postmodern practice. Tantalisingly, they offer something new, unchartered, and imprecise: a *dis*-precision, a performance aesthetic that draws an audience to examine its own cherished beliefs about what an actor actually is. The presence of four disabled actors on stage sends a message that might enhance the emotional impact of the play. One reviewer commented: 'There were four Boo Radleys on stage. As actors with learning disabilities, each actor will have spent a lifetime experiencing the marginalisation, discrimination and fear that Boo feels' (Verrent 2009). The difficulty in 'telling' the disability creates a tension, rather like that which might accompany an all-Black cast in Othello. The disability of all the performers seems to be placed in question. Three of the people on stage are playing nondisabled characters, and so the 'fact' of their disability seems to dissolve, to become something rather more mysterious.

Identity was a rich area for discussion amongst the company. As Ewans says: 'What I really liked was ... I hate the word but ... to play someone "able-bodied", because the last two parts I've been disabled. This was a different kind of role.' These are perhaps unfathomable

problems of representation. Ewans' disability risks typecasting him as a performer but the pleasure he takes in 'diversifying' tends to convey his disability negatively: something to be escaped, transcended. Think of Robert Downey Jr's controversial parody of a method actor 'blacked up' as a GI in *Tropic Thunder* (2008); undergoing an identity crisis, he tries to hold onto himself with the words, 'I'm the dude, playing the dude, disguised as another dude'. Robert Ewans – the disabled dude disguised as another dude playing the Boy dude – is one representative of the struggle for disabled access to theatre. Seen through this lens, his is a comedy of uncertainty and subterfuge. One spectator put it thus: 'Many people thought Robert Ewans was the best actor because he was the best at not coming across as disabled.' This is the meta-textual question of the show: to what extent could the three actors (Ewans, Clay, Haines) *pass* as nondisabled? Many in the audience did not 'realise' that they were disabled. For others, the 'problem' was that because they *were* disabled, Boo was not 'outcast enough'. *Boo* involved the 'coming out' of socially invisible persons, not as themselves, but *as actors*. Clearly, for some audience members this coming out process was an unsatisfactory one. *Boo* disrupted not just the actor signifier or the dynamics of watching: it affected the 'closet' narrative of hidden identities. *Boo* did more than acting work: it did identity work. Perhaps this is the core side affect of the piece: the extent to which it destablised identity formation.

Erving Goffman defined passing as a strategy for coping with 'spoiled identities', the act of disguise being necessary to escape stigma. As Siebers argues, passing is more complex than Goffman allows, mainly because the secrets about identity concern more than visual concealment. Siebers argues that 'closeting' involves things not merely concealed but difficult to disclose, the inability to disclose being 'one of the constitutive markers of oppression' (2008: 97). He argues that the metaphor of the closet disrupts the structural binary that casts passing as action between knowing and unknowing subjects:

> The closet often holds secrets that either cannot be told or are being kept secret by those who do not want to know the truth about the closeted person. Some people keep secrets; other people are secrets. Some people hide in the closet, but others are locked in the closet. (2008: 98)

This offers a striking parallel with *Boo*, both in fictional terms (Boo is the open secret *par excellence*, locked in the closet not just by his parents but by a whole community), and in terms of learning disability as an

identity that must be kept hidden.[13] Passing and closeting are compli-
cated by learning disability because they invoke the degree of agency
necessary for sustained social disguise. What *Boo* requires of the three
'supporting' actors is that they pass as an act of aesthetic labour. They
are asked to pass for something they are 'not' and in so doing a concep-
tual gap is revealed.

On one level, their passing is quite straightforward. Ewans and Haines
get to be the oppressors; Clay becomes the conflicted carer. Yet argu-
ably what makes the piece subversive is that the three actors exhibit
no visual signifier of impairment that would require disguise. As Joseph
Grigely asserts, 'I look into a mirror at myself, search for my deafness,
yet fail to find it. For some reason we have been conditioned to presume
difference to be a visual phenomenon, the body as the locus' (2000:
27–28). If able-bodied is defined by invisibility, then it follows that
disability must be marked. Thus disabled persons who are *unmarked*
present a particular type of problem: they do not act/look the way they
should. Thus the hidden quality of the disability that Haines, Ewans,
and Clay 'have' is another message *concealed* inside the play: that learn-
ing disability has a deconstructing theoretical power, simultaneously
concealing and revealing its own subject. Siebers argues that *physically*
disabled bodies when placed inside ableist spaces expose – in their 'lack
of fit' – the shape of the normative body, which has hitherto remained
'neutral', invisible (2008: 105). Transposing this operation, I argue that
when a learning disabled actor 'moves into' a nondisabled role, the fit
exposes what a role is: namely a cultural construct that inducts people
into the social fabric and thus one that can be challenged. In this case
there was no 'lack' of fit. What was strange was the absence of lack, the
ease of fit.

In the dark

Ridout redirects attention from the edges of the performance project to
the centre of bourgeois commerce and views the link between spectator
and actor as a game of psychological cat and mouse: 'the theatrical set
up, where [...] the encounter with the other person, in the dark [...] is
also an encounter with the self, and thus the occasion for all sorts of
anxieties that one might begin to discuss under the headings such as
narcissism, embarrassment or shame' (Ridout 2006: 10). Perhaps this
makes theatre disability's shadow: a place for nondisabled people to
experience their own anxiety rather than the 'reality' of the other per-
son. Looking, gazing, glancing, staring, glimpsing are all sightings that
happen internally as well as outwardly. If theatre does not exactly make

people ill, it might make them queasy. Theatre is *inherently* bound up with anxiety and failure. It is what Barish has called 'ontological queasiness', the idea that modern theatre, based in buildings and tightly circumscribed in rules and conventions creates a challenge to our deepest feelings about ourselves – after all this feigning, the spectator may ask: 'Then what is it, exactly, that makes me real?' Yet the ambiguity of the spectator's experience is the generative value that Thomson perceives in staring. It is precisely the starer's *lack* of control that allows new creative possibilities to emerge (see Thomson 2009: 21). The starer is no longer master of all he surveys, but is, briefly, undone. Unexpected bodies (or actors) that provoke the stare expose gaps in mastery. This point relates back to Feral's analysis, discussed earlier in the chapter, of performance's tendency to undo the competencies of theatre. In this sense learning disability undoes not just performer competence but spectator competence too. Its 'unexpected' quality forces the spectator into dialogue with their own mastery. Yet, if the spectator can abandon what they already 'know', this will generate openness to new knowledge, which in turn will undo the prescribed boundaries of self.

Sartre's primal scene involves peeping through the keyhole at the Other making love. His fear in this moment is not seeing the act itself but being found out. This psychic description thus defines the act of staring as that which makes us most human, yet most ashamed. It is this fundamental triangulation of staring that makes it so powerful – as Lacan would later point out, there is always another Other (the Big Other) who watches the person watching. One never watches alone; there is always someone else who *knows*. This complicates and enriches the way audience reception might be understood. Just as the actors' identity oscillates, so 'the audience' are not so much a 'single' entity but a shifting psychic territory, of which each member is accompanied by invisible Others who mark out the boundaries of what can 'properly' be seen. The act of triangulation (the other watching the spectator watching the actor) begs the question: what does the space between them consist of? What is in it? Is it a mass of unconscious desires or is it blank? Judging by some of the spectator responses to *Boo*, at least some of the space is filled with faces from history, those projections discussed in Chapter 4, which are projecting still: authorship, fakery, and authenticity tied up in the faces of fools, freaks, ferals, and outsiders

Be more like yourself, be more like your character, be in a different play, be in the same play but please write it yourself; make something more authentic, something more like you, be more proper, less proper, confound me, make it easy for me, go quicker, be more wild, stay domesticated, wake up, stay

dead, be phenomenological, stay semiotised. The audience response spills out beyond the stage to incorporate the backstage glimpse, the post-show look, the late bar sighting: spectators gaze with the watchfulness of detectives towards actors defined by syndromes, conditions, and impairments invisible or camouflaged. It is as if the spectator is looking for clues, slips, the revealing of a con. One side affect of this is the way the show continually opens up to reveal its own insides: its processes, its mechanisms. Far from being a closed aesthetic artefact, *Boo* seems to invite deconstruction, opening out to reveal further mysteries within. It cannot be contained. Ethnographer Dean MacCannell extended Goffman's notion of a society increasingly separated into front and back regions, the latter 'closed to audiences and outsiders, [allowing] conceal-ment of props and activities that might discredit the performance out in front', to conclude that 'sustaining a firm sense of social reality requires some *mystification*' (MacCannell 1989: 93). Seeing Haines or Ewans back stage seems to have interrupted that mystification. Ironically, without it some people thought that the wool had been pulled over their eyes, that what they were encouraged to believe in as real acting was in fact a façade: a fake of a fake. Or, if you allow the *Tropic Thunder* allusion once more, the dude playing the dude was not really playing the dude. He was just the dude in disguise. That glimpse of 'the dude' through a small fissure into the back region called the performance into question, and in some way discredited it.

Conclusion

Many contemporary theatre companies – Forced Entertainment, for example – base their work on a conceit: that the 'self' is an artificial construction to be mediated through the additional artifice inherent in performance. Such 'shifts in registers' or 'oscillations' are a well-established aspect of contemporary dramaturgy.[14] But with regard to *Boo*, some spectators seemed to want to *prove* the inauthenticity of what they saw. They could not believe that the actors had 'done it' and even if they did do it, they did not do it knowingly. Theatre, like psychoa-nalysis, 'is not for those who prefer their calculations rational, or their investments – emotional and financial – guaranteed [...] the effects can-not be known in advance' (Phillips 2006: xii). 'We can jump', as Phillips suggests, 'but we can't jump to conclusions. All we can do is [...] see where the side effects take us' (ibid.: xiii). The side *affects*, in this case, have revealed theatre's repressed, its shadow. Disability's presence is like the lifting of the veil that reveals the mechanisms of fraud in Oz. The

subject becomes the conventions of theatre itself, the nature of acting, the rules of the on-stage/off-stage transaction. The teller and his strange mechanism fascinate more than the tale. Normative theatre values are inverted. This is what disability, as evidenced throughout this book, does to performance: in the ambiguous relationship between person and persona in *On the Verge*; in the leaky boundaries between the real and the represented in *Small Metal Objects*; in *Hypothermia's* heightened naturalism; and in the competing definitions of quality embedded in *Pinocchio*. Disability undercuts, doubles, hijacks, or slips a veil around a performance so that one's expectations are turned upside down: the familiar made strange; the strange familiar; the commonplace uncanny.

The conclusion of this study of the uncanny is that *Boo* disassembles and reconfigures the notion of 'authentic' or 'proper' learning disability. Kenny's disclosure that he had to 'step up to the mark' with Ide, meaning, in one way, that he had to 'be authentic', is made stranger by the process he employed to do this: he went deeper inside, tried to find Ide *in himself*. He *welcomed the stranger*. This is made stranger still, as 'stepping up to the mark' included acknowledging an earlier trauma, the 'Mark' whom Kenny had 'failed' yet who had left his mark. The play then is not just about 'looking after' in the caring sense, but in the sense of looking back, or living a second time with after-knowledge: of shaping a mimetic world out of the past. The play *Boo* is a series of doubles, shattering any linear notion of primary author → adapter → product.

As Judith Butler did *not* say:

> The parodic replication and resignification of *able-bodied* constructs within *disabled* frames not only brings into relief the utterly constructed status of the so-called original, but it shows that *able-mindedness* only constitutes itself as original through a convincing act of repetition. The more that 'act' is expropriated, the more the *ableist* claim to originality is exposed as illusory. (Butler 1991: 23, my own substitutions in italics)

In all adaptations, what is at stake is the status of an authentic original that attains power from its implied naturalness by being the subject of a copy. At the birth of psychoanalysis, there was a less than clear-cut distinction between scientific and lay diagnosis, and an early distinction was made between malingerers and genuine sufferers. Alan Read portrays this as a distinction between 'authentic' and 'mimetic' patients: between those who really have the symptoms and those who simulate them. Intriguingly, he signals the most recent manifestation of this

issue as 'the surveillance and monitoring of people with disabilities so as to expose the performance of their injuries and infirmities' (2001: 154). This suggests, *pace* Carlson, that disability is inherently unstable: that it requires continual monitoring of both quantity (how much) and quality (of what kind). Intellectual disability invites a recurrence of the 'volatile interpretive space' of the freak show, in which the advertising of 'biggest' or 'smallest' or 'most authentic' was not invoked in order to prove the fact but rather to 'provoke profitable conjecture' (Tromp 2008: 8). Equally, as Read notes, both psychoanalysis and performance trouble the distinction between the real and the fake. They invoke a symbolic realm that does not fit into either category and is, in Mikkel Borch-Jacobsen's term, 'surreal':

> Bertha, playing her role (her second personality) on the stage of hysteria, was also watching from the wings, as spectator of her own theatricality. The paradox of the trace (of hysteria) is nothing other than the 'paradox of acting', as Diderot put it, which is why Bertha concluded that 'the whole business has been simulated'. (Borch-Jacobson 1996: 89)

Is there something 'inherently' performative – thus mimetic – about disability that will always tend toward the inauthentic? Or perhaps, in line with Ackerman and Puchner's definition of modernism, disability will always be 'based on an authenticity that can ultimately only uncover its own artifice' (2006: 4). The 'surreality' of the learning disabled person has been remarked upon as a 'natural' quality, involving a preference for illogical diversions in thought or away from linearity (Hayhow and Palmer). 'Surreal', in Borch-Jacobsen's framework, is not 'natural', however, but mimetic: the repetition of acts, which in their turn become deceptively true. The complexity of mimesis' relationship to identity is analysed by Elin Diamond in her discussion of the comparative aesthetics of Afro-American artist Zora Neale Hurston and Bertolt Brecht. For both artists, the relationship to the 'primitive' stereotype was a dialectic and strategic one. For Hurston, who argued that Black Americans had had their 'nature' defined for them, the purpose was to demonstrate that such an identity was *both* inherent *and* detachable: 'a characteristic that could and should be "acted out"' (Diamond 2006: 113). Integral to the Negro sense of identity was 'mimicry' and 'modification', Hurston arguing that 'permeating the Negro's entire self is drama' (quoted in ibid.: 2006: 129). I am not arguing for a reductive comparison between Hurston's aesthetics and contemporary theatre

and learning disability. I do, however, argue that the deployment of mimetic strategies in both traditions, and the complex negotiation of subjugated and dominant identities *through performance*, is highly relevant. Throughout the process of making *Boo*, a complex array of competing authenticities were at play, with varying degrees of mimetic value: the Estate of the distant Harper Lee, which haunted the adaptation rather like a litigious female Boo; Kenny's adaptation, which ceased to be a second and became an original; Jonathan Ide's Boo, which was the paradoxical presence that dominated the work and challenged traditional mechanisms of 'character, conflict and narrative telos' (Diamond 2006: 115). Ide outgrew Boo, creating something that transcended the fulfilment of a role. Like the archetypal fool, he called into question what a role is, and in doing so caused side affects, which permeated the entire dramaturgy.

If the canon is always, as Bloom suggests, uncanny, then is *Boo* canonical? Or is it inferior, derivative, a travesty? Zizek describes this kind of debate about adaptation as a 'pseudo problem', preferring to read different interpretations as 'complementary versions of the same myth which interpret each other' (2001: 131). In a sense, this *was* the work of adaptation, a stripping down of the book in order to construct an interpretive parallel. In this case, the adaptation brought clarity to the original and revealed a kind of interpretive secret: the secret was dad. The loss of the mother deflected away from the primary absence: it concealed the loss of the father. This is the greatest absence of the play *Boo*; one loss concealed another. In the summer of 2008, when the work was tentatively being discussed, Kenny remarked, 'I'm missing the parent'. He was referring to the absence of the Atticus character; yet, two months later, his own mother was dead. This uncanny premonition would define the play that *Boo* became, but in another sense it spoke for the loss that he had *already* suffered. This is, potentially, the primary meaning of the play: that there *are* no fathers like Atticus Finch. The 'first' myth was a nostalgic return to a place that never existed, a world of perfect balance. Characters like Finch had not just balance, they had *character*. The 'second' makes 'character' problematic, not least because Ide preferred to remain outside such convention. Benny, the brother/carer is not the surrogate mother; he is the substitution for the father. The secret was close to home.

This is the sixth adaptation of a canonical work that Mind the Gap has produced, and begs the question: why such repetition? One answer is that the adaptations are a critique of the *paternal* canon: Steinbeck (*Of Mice and Men*), Shaw (*Pygmalion*), Stevenson (*Dr. Jekyll and Mr. Hyde*),

Rostand (*Cyrano*), Cervantes (*Don Quixote*). Even *To Kill a Mockingbird* has spawned a theory that it was in fact written by a man, Truman Capote. The absence, in *Boo*, of the father is a kind of authorial self-sacrifice: a recognition that all second versions either honour or destroy the mythic 'God the Father'. Coming back to Janet Wolff's point, raised in Chapter 3, *Boo* does not reject the canon outright but rather engages with it. It examines *Mockingbird*'s 'mythic structure' and suggests ways in which the novel conceals certain injustices behind the revelation of others. By substituting Boo for Tom Robinson as sacrificial victim, the play reveals another layer within the first myth. This second myth is far more ambiguous, not simply because there is no balance – no 'eye for an eye' – but because there exists the latent possibility that Boo 'invites' it. Unlike Tom Robinson, Boo never actually proclaims his innocence. Zizek, in his reading of René Girard's work on sacrifice, argues that the ancient practice of scapegoating is to some extent always based on the manipulation of naïve believers, that there is always someone *who knows* that the victim is innocent and is able to persuade the community to carry out his wishes. Such a process relies on the victim protesting his innocence: since 'the more he is innocent, the greater the weight of his sacrifice' (Zizek 2001: 85). Yet, the second Boo never quite fulfils his role; he does not enter into the tragic pact. His is either a total absence of self-knowledge – as in the penultimate scene where he 'enters into' the role of paedophile – or a knowing surrender to his fate, in the hope that he might eventually be needed. Ide's performance played this ambiguity, a knowingness inside the absence, the secret within the secret.

Phillips suggests that psychoanalytic sessions are never finished, only abandoned (2006: 22). Criticism is a way of putting off the act of ending, of *refusing* to abandon the work, of continuing to care about it and keep it alive, which is also the act of parenting: an act of love, absent from the play. Criticism is also, as Edward Said reminds us, a way of beginning: beginning to talk about work in a new way. This, as I have argued, is one of the urgent tasks facing the poetics of theatre and learning disability: to find a language that can begin to reflect a practice emerging from a critical silence. J. Hillis Miller spoke of the purpose of 'uncanny criticism' as that which embraces uncertainty or hesitation, which is a 'labyrinthine attempt to escape from the logic of words' into 'regions which are alogical, absurd', from which the critic attempts to rationalise and put in 'an image, a narrative, a myth' (quoted in Said 1985: xvii). This chapter is a way of furthering the urgent claim of criticism; that is,

constant re-experiencing of beginning and beginning-again whose force is neither to give rise to authority nor to promote orthodoxy but to stimulate self-conscious and situated activity, activity with aims non-coercive and communal. (Said 1985: xx)

This claim is one I make not for myself but for *Boo* as an authoring process. Self-consciousness is shorthand for the attempt to understand why scapegoats are with us and why communality might be a way of warding them off, or at least keeping them inside us: strangers to ourselves. *Boo* is an alternative to scapegoating because the double makes the subject 'co-author of the other's knowledge' (Haughton, quoted in Freud 2003: 150). This is an apposite description of *Boo*: there is a single author; and there are many.

Conclusion: A Proper Actor

> The awkward paradox is that we become truly our-
> selves only by copying others. (Peter Nicholls, quoted
> in Phillips 2006: 201)

Amateur professionals

The following is a conversation with Alan Clay – who played Benny in
Boo – that took part during rehearsals:

Clay: I'm not just a learning disabled actor, I'm a proper actor.
Hargrave: What's a proper actor do that's different?
Clay: A proper actor does stuff like Shakespeare and stuff. Hard,
 complicated stuff. More than a few lines. A disabled actor
 gets only a few lines.
Hargrave: Like what?
Clay: A simple line.

The notion of 'a proper actor' has insinuated itself through this book.
Two dominant strands have been the perceived inability of the learning
disabled performer to be the sole, autonomous author of work, and the
expectation that such a performer may require extra support to embody
a role. A third theme, the meaning and use of authenticity as an operat-
ing value, has collided with a fourth: the various ways in which the real
and the counterfeit seem forever in contention, complicating or camou-
flaging the notion of the 'proper'. A 'proper actor' has also taken on a
different nuance after the psychoanalytic turn of the preceding chapter:
if our best intentions are always a cover story for the strangeness inside
ourselves – our uncanny or 'improper' intuitions – then a proper actor

217

is always going to be a kind of spectre haunting the rehearsal room: a fake in search of an authentic original.

I conclude by reflecting on the politics of the amateur/professional binary. Like other binaries discussed – man/child; authentic/fake; art/ politics; disabled/nondisabled; normal/freak; author/actor – amateur and professional are '(1) never fully equal, and [are] (2) always in each other's pockets' (Garber 2001: 5). Their power as definitional categories is attained by force of their mutuality: from the sense that they only exist in close proximity and that such proximity is consistently disavowed. Or put another way, the amateur/professional pair is the parallax gap that haunts the poetics of theatre and learning disability. I want to look at this parallax from several perspectives, to uncover the value of its double binds.

As Marjorie Garber notes, the amateur was 'idealised as playing for love – love of the game, love of country, love of school. The professional, by contrast played for advancement and for money' (2001: 5). Many of our cultural definitions of professional are tied up with the term performance, a '*pro*' being 'distinct from amateur and mainly distinguished by superior and dependable performance; a seasoned [...] expert, an *old pro* or *real pro*' (Garber 2001: 19). Such terms are in stark contrast to one dictionary definition of *disabled* as 'someone incapable of performing or functioning' (*Encarta World*). The problem of delineating unambiguously between passionate amateurs and jobbing professionals is compounded by the theatre itself, in which professionalism is often suspect. In the context of his own company, Clay is an 'old pro': dependable and seasoned. Yet Clay – like Colborne, Teuben, or Laherty – inhabits an interstitial realm, between categories. He is both *of* the same economy and once *removed*: whilst he may play for a paying audience, he himself remains able to claim pay for his labour only in strict limits (due to complex disability entitlements), and is equally unable – on the evidence of the cultural imaginary explored in Chapter 4 – to be the spontaneous creative genius of the aesthetic realm. Clay cannot 'own' fully, in aesthetic or financial terms. Skelton has described the payments issue as 'my single most difficult job', leading the company into an 'imperfect and uncomfortable place' (2012). As mentioned in Chapter 3, behind the rhetoric of 'Valuing People' lies not just a shifting bureaucracy but an ideological system that perpetuates the notion of learning disabled persons as inherently unproductive. In the case of payment, the parallax is very clear: there is simply no neutral equivalence to be found between Clay and a trained nondisabled performer such as Russell in *Small Metal Objects*. Whilst, for the duration of the performance both may display

talents of roughly equal measure, and be valued for these, the economic disparities off stage render their differences foundational. Without a level playing field, there can be only parallaxes.

Shifting perspective slightly, the amateur/professional divide can be viewed through Freud's 'narcissism of minor differences': that is, the contiguity that breeds hostility and mistrust among social groups who reside close together, whether geographically or psychologically or professionally. Such narcissism is keenly felt in theatre where the 'natural' may be as highly prized as the seasoned expert. As Nicholas Ridout argues:

> What is lacking in the performances of the amateurs is precisely that which the professional would routinely seek to deny, namely 'professionalism'. That is to say the only difference between amateurs and professionals is work. If amateurs were paid to do it they would have done enough of it to do it better, or rather to do it professionally. The actor is not the spontaneous creative genius of the [...] aesthetic realm, but a labourer in the same economy as everyone else. (2006: 28)

The hostility is felt due to the close affinity between professional and amateur, rather than in any major difference. In a different context, Garber has noted the identity crisis that autodidacts sometimes evoke in professional scholars, in that 'the self taught man can mimic the scholar', causing the scholar to sense 'his own vulnerability and his own fussy limits' (Garber 2001: 88). The point is pertinent to theatre in the sense that both are the uncanny double of the other: the amateur envies the professional her status, while the professional needs to distance herself from those who are performing her function, potentially as effectively. Professionalism by definition cannot be self-taught, and depends on the institutional transmission of tradition. Perceivable in Clay's desire to be considered a proper actor is an envy of the professional. Envy – the desire to be the equal of another – underpins the ambition to perform, an ambition that need not be the preserve of nondisabled actors alone. Garber's description of envy is relevant here:

> A belief develops in a class of persons, based on perceived (or conceived) inferiority: another class of persons, already more socially or politically powerful and more highly esteemed, is thought to possess the real thing, of which one's own version is 'inferior', smaller, bogus, merely titillating, insignificant. (Garber 2001: 68–69)

This is precisely what Clay alludes to in his desire for properness and leads to the conclusion that, whilst it may be rooted in a very particular kind of injustice, such envy is in fact a productive driving force. Thus, far from, in Richard Hayhow's words, 'aping the mainstream' (2008b), Clay is enviously seeking – with 'wish, desire, longing and enthusiasm' (Oxford English Dictionary definition) – to emulate the achievements of others.

Sara Jane Bailes posits the term 'amateurism' – in relation to Forced Entertainment – not in opposition to professional but rather as a contrasting aesthetic strategy that borrows amateur affects in order to create works that challenge virtuosity as the operating ideal. This is a tactical device that might usefully be 'borrowed' by learning disabled artists. The problem of course lies in Forced Entertainment's under-achieving *intention*. Arguably, Clay, by the fact of his disability, is *already* under-achieving mastery *unintentionally*. Amateurism is not, in his case, the 'tactical "wedge" that prizes apart theatre's apparatus' (Bailes 2011: 93) but his way of being in the world, which cannot be altered. In this sense then, one might delineate between professional amateurs (Forced Entertainment) and amateur professionals (Mind the Gap). The former remain tactically in control of their affects whereas the latter oscillate between intentional and unintentional under-achievement. In practice, the affects of such techniques are much the same. As Bailes notes, the response of Forced Entertainment audiences that are unfamiliar with the company is often to question which 'bits' were intentional or accidental, which were real or staged. The correlation between these two vastly different companies results in an intellectual short circuit, another parallax in which the 'same thing' is seen from radically different perspectives. For art theorist John Roberts, whose subject is the reduction of skill in contemporary art, amateurs are 'those who try and fail the test of professional cultural assimilation' (2007: 156) and are thus 'redeemed from the disdain of academic judgement and the stigma of failing to achieve critical self consciousness' (ibid.: 158). That is an exact depiction of the situation facing contemporary learning disabled performers prior to the undertaking of this research; it is also a precise description of the kinds of amateur affects sought by the avant-garde for much of the twentieth century. In the work of both Mind the Gap and Forced Entertainment, theatrical affects stem from a deep eccentricity that fails, purposefully or otherwise, to see what is 'artistically appropriate'; and this 'produces a kind of mistranslation or mis-seeing of what is culturally approved' (Roberts 2007: 157). Throughout this book, some of the most startling affects have stemmed precisely from such acts of

mistranslation or mis-seeing, which is, after all, another way of describing the poetry inherent in camouflage.

Garber's definition of an 'amateur professional' is 'someone who is learning, or poaching, or practicing without a license' (2001: 19), a transgressive identity marked in brilliant figures like amateur sleuth Sherlock Holmes. Aaron Cross, protagonist of *The Bourne Legacy* (2012), is a secret agent, revealed to have been born with a low IQ, which is raised exponentially by 'the programme'. Without a constant supply of 'chems', Cross, whose 'real' identity is Kenneth Kitsom, faces regression of physical and mental ability. The entire second act of the film is predicated on the maintenance of Cross's second (nondisabled) identity. This is made possible only via genetic modification; to keep his 'normative' superhero self intact he must 'viral off' the chems. The film may be the first example of a learning disabled secret agent. Cross's story is set against a narrative of increasing complexity, as competing government departments reveal secrets within secrets. The film acts as a web-like metaphor for the questions of value, categorisation, disavowal, and identity shifting analysed thus far. Cross is that most professional of amateurs: the rogue agent. Cross, like Bourne, is not 'born' but constructed. Disavowed by his own government, he is without a licence, yet symbolically and actually a powerful practitioner: an identity whose revelation threatens the normative rules. It is of course almost a cliché to suggest that the very notion of national security is based on the disavowal of foundational violence, carried out regularly by persons who do not officially exist. If the double agent is the creation of the state, the disabled actor, too, is constituted via a double agency – both real and symbolic, she fulfils a cultural function.

During the writing of this book, one actor, Edmund Davies (Master of Ceremonies at the Moth Ball), was suddenly 'unmasked' as 'nondisabled'. After many years of living as a learning disabled person and accessing the Special Education system, he found himself re-described. In the theatres of disability it may be that the Department of Social Security will function as the final arbiter of authenticity. It is possible that learning disability has been unintentionally 'cured' through theatrical training. Is this 'good' or 'bad'? It is usual, if still shocking for many nondisabled people, to consider that they themselves, whether gradually or suddenly, will eventually become disabled. It is more unusual to think of the reverse: a disabled person changing into a nondisabled one, either by cure or corrective definition. A professional disabled person, who had worked for TV and radio, representing disabled characters, Davies has since become an amateur nondisabled person.

Clay's desire to be a 'proper actor', rooted in an ambition to get main – as opposed to supporting – parts, can and should be valued. For Clay, however, being the amateur denotes continual under-achievement. Whilst there is no denying the powerful affects of learning disability's occasional amateurishness, such affects may be unwanted. If the amateur is neither the proper character nor the proper actor playing the character, then he is a proper anomaly. In essence, this is the route taken by Palmer and Hayhow in their pursuit of authenticity:

> The skills we advocate developing [...] are very different to those prized in conventional actor training methods and are governed by the attributes of the individual rather than the perceived demands of the profession. (2008: 57)

Yet the 'we' that speaks here has presumably benefitted from training methods, enabling them to make discernments about the kind of aesthetics they want to explore. Therefore, when the authors speak of 'imposing alien theatrical models on the (disabled) actor' (2008: 59), the question has to be asked: alien to whom, and by whose authority? The deeper question is why social and aesthetic categories are constructed that place artists in an either/or position. The kind of training in conceptual and performance art that might render 'failure' a valued aesthetic choice is not one that is currently available to learning disabled artists. Equally, post-dramatic artists may have benefitted from relatively mainstream actor training. Training is rarely uniform or singular; just as Colborne's formal projection improved 'on the job' (during *On the Verge*), so most working actors accrue training over the course of a lifetime, rather than via a neat, specific, temporally unified package.

Colborne is an example of the bifurcation between genius and talent. If genius, derived from the cultural fantasy of origins, is bearer of the real thing (authenticity), then talent is 'merely' the cultural second, a facsimile that proceeds by interpreting and reinvesting genius's original capital. But Colborne complicates this dynamic. In his talent – propped up, dependent – he reveals a genius for seeming. His genius is, on the surface, free-standing and unsupported, but it is scaffolded by a network of aesthetic and social systems. This he has in common with every other working artist. If tradition is simply a way of articulating something that has come to be commonplace, then Colborne re-creates tradition: he reveals that the one-person monologue is in fact an oxymoron. His genius has – like all contemporary genius – quotation marks around

it. As Garber argues, the term 'genius' is a way of 'certifying the real-ness, the authenticity, the originality of the geniuses of the past' (2001: 84–85). The Kantian notion of genius as 'innate mental disposition' or *ingenium*, through which 'nature gives the rule to art' (ibid.: 82) is bound up in the notion of the inspired singular producer: he who serves as the standard by which others will be judged or by which copies will be made. Aesthetics is founded on the replication of ideal, original pro-ducers, who are long dead.

The amateur/professional binary was well articulated by Brecht, who found in the 'simple' acting of the amateurs much to recommend. By 'simple' he was referring not so much to ineptitude but rather to pov-erty, and lack of surplus energy and resources:

> A little more money, and the room shown on stage would be a room; a little more speech training, and the actors' speech would be that of 'educated people'; a little public acclaim, and the performance would gain in forcefulness; more money for eating and leisure and the actors would cease to be tired. (1964:149)

Brecht shifted attention away from the 'innate' qualities of the untrained towards the material facts that separate proper from amateur. This is another primary finding: that the artworks themselves are the product of specialised labour. This labour is not specific to learning dis-ability but to a set of highly evolved collaborative artistic practices. Yet on a most basic level, as Bailes points out, 'theatre making offers one of the most sophisticated and creative ways that humans seek to render imagining tangible' (2011: 31). Thus, the majority of works discussed in the preceding chapters are politically charged in that that they render tangible a world in which disabled and nondisabled collaborate in the shared desire to break free of categories that bind. As I have evidenced, these works complicate Kirby's simple/complex dynamic. By stripping back, by doing less, Simon Laherty, in *Small Metal Objects*, does more. In the way that Jez Colborne reveals more by revealing everything, Laherty turns inwards, revealing himself by resisting action; he switches off, the actor as meditating guru. Colborne does 'more' and so does Jon Tipton (Pinocchio); but Laherty and Peter Wandke (Uncle Joe in *Pinocchio*) do less. Were we to utilise Kirby's continuum from acting to non-acting, most performances in these shows would fall under the heading of 'simple acting'. Kirby's line between simple and complex is most problematic when applied to Colborne. *On the Verge* may represent 'simple' acting at a very complex register. Colborne's text often seems

at one remove from his body, as if we are witnessing an actor graft-
ing the performance onto himself piece by piece. Colborne achieves a
double agency of making the simple appear complex and – when he
gets behind the keyboard – making the complex appear simple. The
complexity of this process offers a new perspective on the virtuosic. As
States defines it, 'Virtuosity in the theater, as in athletics, is not simply
skill but skill displayed against the odds which, when mastered, become
beautiful passages' (States 1985: 119). Delineating between complete
mastery and failed virtuosity is meaningless in the face of such unique
performances.

The tensions underlying professionalisation are better understood
as rooted in historical anxieties. The feralisation of learning disabil-
ity, discussed in Chapter 4, emphasised the role of rehabilitation.
'Idiocy' could be cured or moderated by rote learning and 'mastery
of the will' (Mitchell and Snyder 2006: 115). Seen in this context,
training Alan Clay to improve his speech – to make it more proper –
might be viewed negatively as a normalising process. Yet as Emma
Gee remarked, 'Alan has a tendency to run words together [...] that
makes the distinguishing of words difficult. He drops into vocal
habits [...] a slur to his voice that can create an odd sounding drawl'
(Gee 2009–10). This is a highly complex question, which cannot be
reduced to a rights discourse or advocating for access. On the surface
there are 'objective', qualitative standards: an actor needs to be heard;
yet underlying this is the complexity that unconventional speech
patterns are culturally contingent. Just as 'received pronunciation' in
British media gave way to a mix of regional accents, so it might be
that 'audiences are increasingly exposed to complex speech patterns'
(Wheeler 2010b). Equally, Gee makes the point that a writer might
'adjust the text to ensure it suits Clay's vocal needs, for example
shortening sentences or working with plosive sounds to keep the
enunciation crisp' (Gee 2009–10). Furthermore, the complexity of
learning disability as a category and a set of social processes means
that foundational impairments are often accompanied by a set of
secondary or assumed impairments. To quote Gee, '[W]e hit upon the
double barrier that learning disabled people face: assumptions about
ability go untested and habitual tropes are reinforced in an attempt
to be "enabling"' (ibid.). The fact remains that following continual
training opportunities, Clay was hired on three touring productions
outside Mind the Gap. In the Shakespearean sense, Clay's professional
training represents the essence of laboratory: a *labour* of *oratory*; the
making of eloquent speech.[1]

Towards a craft-based poetics

The club footed Hephaestus, proud of his work [...] is the most digni-
fied person we can become. (Sennett 2008: 296)
My disability is what I am regardless of being an actor [...] My worst
fear is that I will be stereotyped as the actor with something wrong.
(Ewans 2009)

This fact of making something tangible and eloquent unites many dif-
ferent theorists – Baugh, Read, Rancière – in seeing the value of art in its
irreducibility to the social realm. Art's 'foreignness of form', according
to Adorno, is precisely what allows it to have an impact, to change, if
not material conditions, then consciousness itself. Yet, this book has
sought to embed the aesthetic with a clear materiality: its rootedness
in human contingencies. As Rancière notes, poetics suggests a com-
pound of *poesis*, a way of making, and *aesthesis*, an economy of affects
(2007: 112). I have proposed, then, a poetics of the theatres of learning
disability: by foregrounding the acts of making and the acts of perform-
ing, I hope to have demonstrated that theatre has the potential to radi-
cally alter normative perceptions of learning disabled persons. These
(mis)perceptions include: perceived failure of attention (as opposed to
a dynamic of attentive and inattentive states); a static and inept social
identity; a culturally unproductive and overly dependent way of being
that makes such persons burdensome and only of secondary cultural
value; and that their value lies in informing an 'us' about 'their' (and
thus 'our') authentic self.

The book has also faced up to some of the most fundamental aes-
thetic questions of the last hundred years, namely the following: What
does it mean to *be* an artist, whether bourgeois or counter-cultural?
What constitutes autonomous, subjective authorship? What is the role
of skill or deskilling in the preparation of art? Who or what constitutes
the 'original' that others (amateur, self-taught, surrogate) must copy?
The answers in each chapter have been as various as the artworks, yet
one in particular seems to encompass all others: this is the fact that the
process known as artistic authorship resists categorisation as innate skill
and is, rather, as John Roberts argues, a process of 'collective intellect
and shared labour' (2007: 156). It is the fundamental interconnected-
ness of theatre that makes it a laboratory, imperfect yet aspirant, for the
creation of less prescribed social identities.

Where some have made the case either for a return to beauty (Scarry
2006) or at least a re-validation of the aesthetic (Woolf 2008), sociologist

Richard Sennett has called for a return to craft, both as an act of mind-engaged labour and a value for improving social relations. For Sennett, craftsmanship 'names an enduring, basic human impulse, the desire to do a job well for its own sake':

> Craftsmanship cuts a far wider swath than skilled manual labour; it serves the computer programmer, the doctor, and the artist; parenting improves when it is practised, as does citizenship. In all these domains, craftsmanship focuses on objective standards, on the thing itself. (Sennett 2008: 9)

Sennett also emphasises the socio-economic barriers to becoming a 'good' craftsperson: 'schools may fail to provide the tools to do good work, and workplaces may not truly value the aspiration for quality' (ibid.). The parallels with theatre and learning disability are clear. I have argued that rather than focusing on the 'authentic self' of the performer, more value might be placed on the 'objective standards' of the artwork produced. So, too, it is essential to open a dialogue about what constitutes 'good' work. If work is found wanting, it is not simply a case of ignoring or dismissing it but rather of asking what barriers – social and aesthetic – have produced this lack and what provision might be made. This is not to suggest the redeployment of a simplistic aesthetic hierarchy, but rather a careful analysis of the properties, both moral and aesthetic, of the work itself. This approach offers a more dynamic relationship between the performer and the rest of her society than models of advocacy or therapy. Rather than situate success or failure in the individual, the challenge for society becomes: how might this work be viewed from different perspectives, and how best can it be nourished and supported? As Sennett makes the case:

> The capacity to work well is shared fairly equally among human beings [...] no lack of intelligence among ordinary human beings threatens [this]. [...] Rather than lack of mental resource, the craftsman is more likely to be threatened by emotional mismanagement of the drive to do good work; society can collude in that mismanagement or seek to rectify it. (Sennett 2008: 285)

In this sense, the amateur/professional binary moves into the background, and another more specific set of opposites emerges. I want to conclude by drawing together some of the strands that have been implicit throughout. That I identify two antithetical models may

sound counter-intuitive at this stage. I do so, not to solidify them in binary opposition, or to out the 'right' from the 'wrong', but instead to present them as doubles that haunt each other. As Marjorie Garber has suggested, 'if at the beginning of any discipline's self-definition, it undertakes to distinguish itself from another, "false" version of itself, that difference is always going to come back to haunt it' (2001: 57). As with the amateur/professional, the following models should be regarded as deeply entwined, their mutuality underscored by their disavowal.

As I summarise it, the 'authentic' theatre of disability, evinced by Palmer and Hayhow, proposes that theatre should:

- Be surreal, because all learning disabled people have innately surreal imaginations and operate on a different understanding of the world to nondisabled people.
- Privilege non-verbal virtuosity. (It is only through the body that the truly authentic voice of the learning disabled person be heard.)
- Work in montage or juxtaposition, not narrative.
- Convey feeling more than intellect.
- Facilitate the growth and presentation of self rather than train the actor as a representational agent: value self-expression (truth) rather than expression arrived at through pre-existing vocational frameworks (commodity).
- Take as its subject whatever arises from the rehearsal process, rather than that which arrives via pre-existing narratives (all that is not devised directly through the disabled person is inauthentic).
- Be rooted in cultural resistance, not cultural rapprochement.
- Evoke an immutable essence of disability that can be judged as present or absent in the work.
- Be the result of – and keep the essence of – spontaneous eruptions of creativity rather than choreographed units of action.

This 'authentic' model represents a desire to replace other models, such as the social model of disability, which reduces the aesthetic dimension to a by-product of political justice. In doing so it reduces the disabled artist to a representation of cultural authenticity – an absolute Other – who can only create certain types of work. I argue that this model, whilst useful in uncovering many important issues, is not adequate to provide a framework for analysis, largely because the diversity of the practice among different companies demands a more supple, responsive theorising. This book advances a new poetics, one that treats disabled identity as a more complex creative construction and privileges the

appraisal of artworks *as work*, rather than an existential process. Rather than dwell on the quest for authenticity, it seeks out other criteria that value the lifelong pursuit of a vocation.

The poetics of the theatres of learning disability might therefore be listed as follows:

• Be rooted in complex embodiment that values cognitive diversity as a form of human variation.
• Operate in full awareness of ableist projections and historical genealogies.
• Be pragmatic in the pursuit of quality; that is, the measure of the artwork's soundness, its fitness for purpose.
• Privilege concrete experience of individual artists rather than abstracted beliefs about learning disability.
• Move between the formal aesthetic worlds of surreal or real, abstract or figurative.
• Develop the actor's own skill base.
• Work with the full range of aesthetic forms in order to tell the stories that most matter.
• View the actor as a craftsperson, a labourer in the theatre economy, albeit one currently disenfranchised from most existing training systems.
• Take its stimulus from anywhere it can find it.
• Be rooted in the collaboration between disabled and nondisabled artists, who have in common their cultural labour.
• Be able to work within and against dominant cultural norms in order to influence mainstream practices.
• View disability as a culturally determined and therefore infinitely mutable state of being, part of a continuum of abilities, prized or subjugated at different historical moments.
• Be crafted through the range of preparatory practices open to theatre makers, resulting in a diversity of aesthetic practices from the semi-improvisatory to the tightly prescribed.
• Recognise the authentic in artworks rather than individuals.

Recognition of a performer as a theatre labourer provides a necessary corrective to a socially harmful perception of learning disabled citizens as economically or culturally unproductive. Philosophically, it corrects a view of the intellectually impaired as 'less than' full human beings. It also corrects the imperative to produce a 'proper' kind of theatre. Craft is open to the full range of aesthetic forms. The value of craft lies precisely

in its diversity, allowing the actor to carry their training from one pro-
ject to the next. It does not depend on a single or pure theatre form;
rather, it resides in and among all forms, allowing the actor to carry
their training from one project to the next, developing, expanding, and
allowing for contradictions and reversals. Craft is the bedrock of a job of
work, whether amateur or professional: what the work is regardless
of its 'authenticity'.

There are echoes here of Schechner's demarcation between 'tradi-
tion seeking' and 'forward looking' avant-garde(s) (1993: 10–18). The
'tradition seeking' avant-garde, like the 'authentic theatre of disability',
seeks a singular and universalising truth; the former in cultures other
than a dominant Western one, the latter in the potential of a pure,
'essential' disabled culture. Both are Artaudian projects, searching for
theatres rooted in ritualistic, extra-theatrical practices, placing great
emphasis on 'the actors' psycho-physical abilities' and on 'textual
montage' (Schechner 1993: 12). A poetics has more in common with a
'forward looking' avant-garde, which appropriates both existing popu-
lar forms and emergent social practices; innovation is sought in the
hybridisation of 'experimental' and 'mainstream' forms rather than in
a recreation of an authentic past or purity. Perhaps the clearest demar-
cation between these 'types' is to be found in Roberts' account of the
distinction between the amateur and the self-taught artist. Whereas
the latter's identity (directly akin to the outsider artists identified in
Chapter 4) resists all existent cultural forms, the former engages in a
working relationship with the technical aspects of advanced or profes-
sional practice. The consequence of the latter's absolute resistance, for
Roberts, is 'a fetishization of retarded craft that is ultimately opposed to
the self-development of the non-professional or occasional artist and to
the development of collective intellect' (2007: 159). Here, retardation
implies a delay or blockage in skill acquisition, rather than a descrip-
tion of cognitive agency; yet it does beg the question of the relationship
between the two. I argue that divergent or delayed craft can be recog-
nised, celebrated even, without being fetishised, and certainly without
threat to collective creation; but only if the open *possibility* of skill
development is also maintained. The amateur becomes, then, in Roberts'
words, 'a new kind of artist lying in waiting' (ibid.), one who erodes the
distinction between artists and non-artists: in that sense, the 'third actor'
identified in Chapter 5, whose presence complicates the stability of the
symmetrical, and places identity in doubt.

What matters are difference and the possibility of diverse definitions.
The theatres of disability are best served by a rich eclecticism. In an era

in which it is increasingly difficult to define where the conservative ends and the radical begins (or rather which avant-garde is most 'in advance', and in advance of what exactly), it is beholden on us – all of us – to try to find ways of thinking and acting that nurture talent by whatever means necessary. Ability, any ability, can only be stifled by lack of nurture.

In Greek myth, according to Sennett, the 'club footed Hephaestus, proud of his work [...] is the most dignified person we can become' (2008: 296). He is recognised for his craft, not his difference: what he does, not what he is.

Envoi: The Bartleby Parallax

In response to a culture of diversity, which is, in effect, the culture of sameness, Bartleby prefers indifference. His presence is the *punctum indifferens* of the fool; his difference is close to Derrida's notion of *differance*, a deliberate hybrid of 'to differ' and 'to defer'. *Difference* is, like Bartleby, always double: words only have meaning in relation to other words, so meaning is perpetually deferred. Difference between words engenders binary opposition, which perpetuates hierarchies.

If an email is sent from an iPhone without a title, a warning flashes up: 'empty subject'. This is precisely what Bartleby confronts the reader/narrator with: the pain of the empty subject. The tragedy of Bartleby is that he is unable or unwilling to say what he wants. His desires are negations; they are only ever deferrals of something unnamed. Bartleby resists signification because he desires nothing. Pinocchio, on the other hand, does desire: to be a real boy, a 'proper' actor. The actors discussed in these pages are both different and, occasionally, indifferent. There is no singular 'actor with learning disabilities', only a plurality of voices and sensitivities.

What happens when a dominant figure in literature – Boo Radley, Bartleby – is unmasked as disabled? It reveals that the canon is not a monolithic, static entity but rather a process of unmasking and remaking.

Bartleby persists. If recent critics have mourned the former reduction of Bartleby to a signifier of capitalist alienation, then those same critics may have under-estimated the political significance of the 'new' strange or autistic Bartleby. As Zizek argues, in revolutionary terms, the 'difficulty of imagining the New is the difficulty of imagining Bartleby in power' (2006: 382); and what is stage presence if not a particular form of power? That a sense of the absurd underpins the concept of, say, Jez

Colborne playing Jason Bourne – *The Colborne Identity!* – evidences such difficulty.

The Bartleby parallax is this: a gap, not between hegemony and its negation, but the opening up of a space between *both* and something much more radical. One cannot say that Bartleby – or Steve in *Small Metal Objects* – demonstrates passive resistance since it is not clear what he is resistant to. Bartleby's negation is pure since it is stripped of qualitative difference: the negation is not a 'something' but a void. Bartleby constitutes resistance of a *differant* kind: he is not merely saying 'no' to the job (therefore to himself as a productive citizen) but to all (existing) forms of resistance. His is both a separating out and a deferral.

Theatre, if it is applied as a mark of resistance, might reflect on what form such resistance takes. The increasing difficulty of acting in a way that escapes, let alone resists, neoliberal design, forces a crisis in all forms of representation. Bartleby does nothing, and this nothing *is* the radical act. Zizek is surely right to note the holophrastic quality of the term: 'I prefer not to' is rather like a simple phrase or word uttered early in language development that speaks for a much more complex set of meanings (in the way that 'ball' might mean 'I want to play with the ball').[1] Here, intriguingly, resistance is a form of developmental delay. It is not a refusal of the game or even a confounding of the rules; it is another game entirely, with few or no rules.

It is a feature of Bartleby's enduring power that he replicates. The most emphatic statement of this tendency is to be found in Enrique Vila-Matas's 'novel of footnotes', *Bartleby & Co* (2000). Here, the 'hunchback' narrator analyses the Bartleby Syndrome: writers who have ceased to write. 'Only from the negative impulse, from the labyrinth of the No, can the literature of the future appear' (2000: 3). What if one was to apply such an exacting standard to the theatres of the future? I am not suggesting that theatre should immediately cease, but rather that one might imagine the implication of such a future, of what creative avenues would be afforded by a total or even partial negation. 'We should view the actor as a craftsperson, a labourer in the theatrical economy!' I prefer not to. 'We should make work rooted in complex embodiment which values diversity in full awareness of the ableist society's projections!' I prefer not to. 'We should move between the formal aesthetic worlds of surreal or real, abstract or figurative!' I prefer not to. Just as the book contains important lessons, it also contains its own negation: its lessons outside the curriculum. Bartleby, and the various manifestations of 'the no', are reminders that there is always an outsider, beyond the limits even of that which is formally excluded. Indeed, that which

negates the status quo is always a product of that self same system. Bartleby's power, at least symbolically, stems from his refusal to embody anything specific.

Tim Wheeler spoke of a rehearsal in which one actor persistently refused to co-operate. Her refusal manifested in the tendency to step away from the ensemble, rather like the archetypal protagonist, to perform other tasks in a corner of the space, and eventually to sit and do nothing. Wheeler's response was to sit with the protagonist, to try to see things from her perspective. Eventually the rest of the ensemble stopped what they were doing and joined them. The protagonist, ensemble, and director were now one body: staring at the empty space, wondering what might happen next. This is the most exacting manifestation of the Bartleby parallax: a minimal shift in perspective that opens up a definitively new space. It is not a case of authentic versus craft or professional versus amateur, but rather of both sets of determined content versus the void. The empty space viewed by the ensemble is the abstract 'normality' made concrete. Far from being a determined content, 'normal' is the point of universal emptiness. That is why the Arts Council's recent 'Creative Case' is ultimately a self-undoing project: by arguing *for* diversity one is *accepting* that there is a non-diverse centre from which to deviate. Such a space does not exist. In the same way, by accepting the absolute binary between disabled and nondisabled, one perpetuates an unquestioning assumption that disability is, *a priori*, ontological difference.

Diversity is uniformity's best-kept secret.

The UK education system allows the process of 'disapplication' from the formal curriculum for some children with special educational needs. The study of disability makes neologists of us all: to append 'dis' to a given term creates instant portmanteau words like *distoriography, disprecision, dismodern*. Such words acquire a particular agency in certain contexts, upsetting binary hierarchies, cripping or queering them. Yet they also mask and conceal – like the uncanny, they contain their own opposite. The danger is that a term like 'nondisabled', in its political apprehending of the 'dis', risks hiding the very thing that should be outed: the empty universal of ability; the fact that there *is* no 'disability', only different capabilities contained in a plethora of human potential. 'Dis' was first applied to 'ability' in the years following the World War One as a way of describing incapacity to work (following injury); it has since taken on the mantle of ontological distinction.

The very notion of 'applied theatre', with its emphasis on tangible effects (educational outcomes; reduction of behaviours deemed

challenging; improvements in health), has swiftly evoked a correspond-
ing anxiety: a concern for affects (intangible feelings and impulses;
beauty). As Franc Chamberlain has noted, the term 'applied theatre' is
indivisible from 'good intentions' and the existence of particular shared
ideological values: this is what separates the attacks of 9/11 from a Boal
workshop. Both apply performance (acts; symbols; communal events)
in the interests of social transformation with widely different inten-
tions.[2] 'Disapplied theatre' – a term first mooted by Wheeler – implies,
rather, that intentions are precisely unknown, and that values cannot
be shared without careful deliberation. Perhaps Wheeler's descriptor
was a reaction to the sudden predominance of an essentially academic
term encroaching on a longstanding practice. On the other hand, 'dis-
applied theatre' might entail the creation of a new space outside both
effect *and* affect. *Disaffection* – a lack of satisfaction – contains both
indifference and different affects. By making 'no' the starting point,
the theatres of the future may continue to ask, 'What is theatre, where
can it be performed and by whom?' but from a radically different
(Bartlebyan) perspective. These are aesthetic questions as much as they
are moral ones.

Zizek reports an internet rumour of a 'lost' *Bartleby* movie starring
Anthony Perkins (the actor who played Norman Bates in *Psycho*), and
makes a connection with the final scene of Hitchcock's film, imagining
Bartleby/Bates/Perkins saying, 'I couldn't even hurt a fly'. This is what
makes Bartleby's presence so unbearable, so radical. It is not violence as
such but rather the persistent underlying potential of rupture to order:
his insistent vulnerability.[3]

Appendix: Easy Read Summary

This is written by Ruth Townsley and Matt Hargrave

About this easy read summary

This booklet is about an academic book written by Matt Hargrave.

Matt is a lecturer in performing arts at Northumbria University in Newcastle upon Tyne. He has worked with people with learning disabilities, as actors and artists, for many years. He worked very closely with staff and actors at Mind the Gap theatre company in Bradford to do the work for his book.

Matt's book is about theatre by actors with learning disabilities. He has written about the work of actors at Mind the Gap, as well as the work of other actors and theatre companies. It has taken Matt six years to do the work for his book. It is about the length of a novel and takes several days to read. It has lots of interesting ideas, but most of these ideas are very complicated.

This easy read summary will tell you about some of the main ideas Matt has written about. A researcher and writer called Ruth Townsley has written the summary, with help from Matt. Mind the Gap theatre company asked Ruth and Matt to write the summary so that some actors with learning disabilities can find out more about Matt's ideas.

Ruth and Matt have tried to write this summary so it is easy to understand for some people with learning disabilities who can read. However, they know that it won't be right for everyone who reads it. You might need extra help to read and understand the words and ideas. Or you might want to know more about Matt's ideas and may find this booklet too easy. Staff at Mind the Gap will be able to help you with this.

The summary tells you about some of the most important ideas from the book. It can't tell you about all of Matt's ideas and thoughts as this would make the booklet too long. So it just covers the main parts of the book, from Chapter 1 to Chapter 6, plus the Conclusion.

Matt knows that some people might not like his ideas, or may not agree with them. He thinks that this is OK and may be a good thing. It might help us to talk and think about things that have not been discussed before.

Mind the Gap are hoping to do more work to make Matt's research and writing easier to understand. This booklet is just the start.

Chapter 1: Why the Social Model of Disability Does not Work for Theatre

Learning disability means different things to different people. And it has been called different things at different times in history. Sometimes it means having difficulty with thinking and remembering. Sometimes it means that other people, and society in general, don't help you enough.

The social model of disability says that all disabled people have a right to be part of society, but there are barriers that stop this. These barriers are known as discrimination. For example, not all information is easy to understand. This can be a barrier for many people with learning disabilities. The social model says that society needs to change, not disabled people.

The social model is the opposite of the medical model of disability. The medical model of disability sees disability and discrimination as people's own problems. The medical model says that people should change, or get help, so they fit into society more easily.

The part of the social model that is about making and performing theatre is called disability arts. For the last 25 years, disability arts has been the most important way of thinking about theatre by actors with learning disabilities.

Disability arts has questioned why so few disabled people are characters in film, TV, and theatre, or are actors themselves. It expects all theatre by disabled actors to promote the social model of disability and tell people that society needs to change. It wants disabled actors to use their disability, and the discrimination they face, as a central part of the theatre they make and perform. It also thinks that disabled actors should have as much control as possible over how disability theatre is made and performed.

Matt says that there are lots of reasons why these things are important. Disability arts has done lots of good things to make a difference to the lives of disabled people. However, the making and performing of theatre by actors with learning disabilities does not always fit the disability arts model. For example, most theatre companies working with actors with learning disabilities are jointly run with nondisabled people. And not all actors with learning disabilities want to do performances that are about discrimination and impairment. But this doesn't mean their work is less interesting, or less important.

Matt thinks that we need to find other ways of thinking and talking about theatre and learning disability. Thinking and talking about different types of theatre is called poetics. At the moment, the main ways of thinking and talking about theatre by actors with learning disabilities come from the medical model or the social model of disability. Audiences and critics look at the ways that theatre by actors with learning disabilities is made and performed and say things like:

- 'The actors don't seem like proper actors – they don't speak clearly and they forget what to do. This is a problem.' (medical model)
- 'The actors haven't made up the play themselves – nondisabled people have written the script and are running the theatre company. This is a problem.' (social model)
- 'We can't always understand theatre by actors with learning disabilities. We don't want to criticise the actors, or the theatre companies, as we might hurt their feelings. This is a problem, but we don't want to talk about it as it's a bit tricky to say what we mean.' (medical model and social model)

Matt says that we need to find new and different ways of thinking and talking about theatre and learning disabilities. We need a new poetics that supports actors and theatre companies as artists in their own right. They have the right to have their work discussed as deeply and critically as all actors and theatre companies do.

Chapter 2: Why Learning Disability Is Valuable and Beautiful in Theatre

This chapter is about performances by two different theatre companies. **Small Metal Objects**, by Back to Back from Australia, toured in the UK in 2007. **Hypothermia**, by Dark Horse theatre from Huddersfield, toured in 2010.

Small Metal Objects involves four actors: two who are learning disabled and two who are nondisabled. Sonia Teuben is an actor with learning disabilities who plays a man, Gary. Simon Laherty, who has autism, plays Steve, Gary's friend. A nondisabled actor, James Russell, plays Alan. And his friend, Carolyn is played by the nondisabled Genevieve Picot.

Both Gary and Steve are drug dealers. Alan phones them as he wants to buy drugs from them. They meet up, but Steve changes his mind about the deal and makes a mysterious decision not to move. Gary

won't leave his friend, so the deal is called off. Alan doesn't like this, so he phones his friend Carolyn for help. Carolyn tries to persuade Steve to get the drugs. She offers him sex. But Steve does not move. Alan and Carolyn give up and go away. Gary and Steve are left behind to talk about what has just happened.

The action takes place in a busy and real public place. **Small Metal Objects** has toured train stations, shopping centres, parks, and other urban spaces throughout the world. Matt saw it on Stratford East railway station in London. The audience sits on a bank of raked seating and each person has a small set of headphones on which to hear what the actors are saying. The actors have small microphones and speak as they would do normally.

Hypothermia involves five actors, of whom one (Ben Langford, who plays Oskar) has a learning disability. The character, Oskar, does not speak. It seems that he cannot make choices by himself, although this changes at the end of the play. Unlike **Small Metal Objects**, the play is designed to take place in a standard theatre, with a raised stage and hidden off-stage area.

The action is set in Nazi Germany during the Second World War. Oskar is a young man with learning disabilities who is in a long-stay hospital. The hospital is run by Dr Erich (played by Bradley Cole). He has an assistant called Lisa (played by Fay Billing). Lisa used to be a patient at the hospital before she got a job there. Many of the hospital's patients are being sent to a mysterious place called the Hadamar Institute. We soon find out that people never come back from Hadamar because they are killed there. Dr Erich has a visit from his old friend, Dr Katscher (Johnny Vivash). Dr Katscher tells Dr Erich to send seven people to Hadamar to be killed. Two of these are Oskar and Lisa. Dr Erich doesn't want to send anyone, but Dr Katscher makes him. Dr Katscher says he has to decide whether to send Lisa or Oskar. In the end Oskar makes his own decision to go to Hadamar, so that Lisa can live. At the end of the play there are pictures which show that all the characters have died, in different ways.

In Chapter 2, Matt writes about **Small Metal Objects** and **Hypothermia** in lots of detail. He talks about how the work was made and how it is performed. He also writes about the performances of the actors and what he thinks about them. These are some of the things he says:

- In **Small Metal Objects**, the audience has to work hard to understand what is going on and what things mean. It is not always clear who is acting and who is not, who is a man and who is a woman,

who is nondisabled and who has learning disabilities. Sometimes things might go a bit wrong. For example a member of the public might talk to one of the actors, not realising they are performing. It can be difficult to keep an eye on the actors and to hear what they are saying. **Small Metal Objects** gives the audience lots of things to think about while they are watching the play, and afterwards. This makes the audience more active. They pay more attention to the play and want to ask more questions.

- In **Hypothermia**, things seem easier to understand. It is clear who the actors are and which actor is disabled. It is also clear which character has learning disabilities. Things are less likely to go wrong or stop at the wrong time. The words are easy to hear and you never lose sight of the actors as they are on a small stage right in front of the audience. **Hypothermia** might be easier to watch, but it gives the audience less to think about during and after the performance. This makes the audience more passive. They pay less attention to the play and have fewer questions about what the actors are saying and doing.

- Matt thinks there are lots of reasons for the differences between the two plays. One reason is that they were made differently and are performed in very different places. This means they each have a different form. For **Small Metal Objects** the form means that things can go wrong very easily. This makes the work more risky. The form also makes the play seem complicated, so the audience has to work harder to understand it. For **Hypothermia**, the form means that things probably won't stop or go wrong. This makes the work less risky and easier to understand.

- Matt says that some forms of theatre are not better than others. It is not that one form is right and another form is wrong. But he does think that theatre is at its best when audience members are active rather than passive. This does not mean that members of the audience have to get out of their seats (though they might if they want to!) It's just a good thing when theatre makes us ask questions about how we live our lives and how this relates to characters on stage.

- Matt says that both these shows, like all types of theatre by actors with learning disabilities, can help people to think about each other in different, new, and changing ways. In particular, theatre by actors with learning disabilities shows that what we think about each other is constantly changing and is not fixed.

- Matt also says that performance by actors with learning disabilities is art in its own right. By that he means that actors with learning

disabilities do things that are important and valuable, whatever roles they play on stage. Their performances show that learning disability is not a problem, but simply another form of human experience that can be explored through theatre. Theatre helps to show learning disability as a form of human variation.

Chapter 3: Why It Is very Important to Talk about Quality in Theatre

This chapter is about the making and performing of **Pinocchio**, by York Theatre Royal, in 2007. **Pinocchio** was a joint project between three nondisabled actors from York Theatre Royal, and four actors with learning disabilities from the Shysters (Coventry) and Full Body & The Voice (Huddersfield). The nondisabled actors were Vicki Hackett, Laura Sanchez, and Robin Simpson. The learning disabled actors were Jon Tipton, Lisa Carney, Ben Langford, and Peter Wandtke.

Pinocchio used music, dance, mime, and theatre to tell the story of a wooden puppet who becomes a real boy. A nondisabled actor (Vicki Hackett) was the narrator and spoke most of the words. There are two scenes, out of eight in all, where the other actors had lines. In these scenes, the actors had speaking parts as puppets. For the rest of the play, the actors used dance, mime, and gesture to tell the story of **Pinocchio**.

In this chapter, Matt writes a lot about the process of making **Pinocchio**. He explains that actors and staff from the Shysters and Full Body & The Voice were used to having lots of time to make theatre. Their productions tended not to use words and were usually based on the ideas and experiences of the actors with learning disabilities involved. The two theatre companies felt it was very important for all of their actors to be fully involved in making and performing the productions.

When the Shysters and Full Body & the Voice started working together with the York Theatre Royal, things were very different. They only had four weeks to put the play together and to rehearse it. The director from the York Royal Theatre seemed to be in charge. He decided that **Pinocchio** needed to make sense and be clear to hear. This meant that the rehearsals focused on making something that was good enough for a mainstream audience in a big, city theatre.

When **Pinocchio** was performed, lots of people liked it. But some people, including Matt, thought that **Pinocchio** didn't work very well. On the one hand, it didn't allow the actors with learning disabilities

to have much of a voice, or to do theatre in their own way. But on the other hand, it wasn't really good enough for a mainstream, paying audience. Matt argues that in trying to be 'good quality' theatre, **Pinocchio** ignored the things that would have been really interesting to watch. It also covered up the support that the actors needed to help them do their jobs well. This doesn't mean that the play was bad, or not important. But it does mean that we should talk about what didn't seem to work and why this was.

At the end of this chapter, Matt asks: what is 'good quality' theatre? He argues that there are no right answers to this question. He says that all types of theatre by actors with learning disability should be valued enough to be talked about in a critical way. Every show is different. Every actor is different. Every theatre company is different. There is no right or wrong way to 'do' theatre by actors with learning disabilities, although some people think that there is. Just because actors have learning disabilities should not mean that their work cannot be talked about and criticised, like other types of theatre.

Matt says there are three main reasons why it is very important to talk about quality in theatre by actors with learning disabilities:

- There are lots of different ways of talking and thinking about quality. What makes good theatre for one person won't be good theatre for someone else. If we don't talk about the different viewpoints that people have, then ideas about quality won't change and develop. Quality might only ever get talked about in ways that feel comfortable, or familiar to people. It will mean that people with the most power or control will continue to say which art is the best art. These powerful people are not usually persons with a learning disability.
- Many actors with learning disabilities and their theatre companies work very hard to make and perform quality shows. When audiences see quality theatre like this, it can help them to think about actors with learning disabilities in different ways. It can also help them to re-think their views about what makes good theatre.
- Some people think that good theatre just happens, as if by magic. They think that some actors are born to act and don't have to do much practice to make good shows. This isn't true. It takes specialist skills and lots of hard work, by a team of people, to make quality theatre. Talking about theatre by actors with learning disabilities can help to show how quality is something that has to be worked at. It can help to explain what makes good theatre.

Chapter 4: How Ideas and Words from History Help Us Understand What Being a Performer with Learning Disabilities Means Today

In this chapter Matt talks about how people with learning disabilities have been seen and understood in art and theatre at different points in history. He argues that it is important to look back at these old ideas about performers with learning disabilities. They can help us to understand more about what it means to be a learning disabled performer today.

Matt looks carefully at four ways that people with learning disabilities have been understood in the past. He says that at different times in history, and even to this day, artists and actors with learning disabilities have been seen as outsiders, as feral human beings, as freaks and as fools. These words and ways of thinking about people can seem rude and hurtful. It can be upsetting to see them written down. But Matt says that it is important to look at these words again, to consider what they meant in the past and what they mean now.

The idea of being an **outsider** is one way that people have understood and talked about artists with learning disabilities. Outsider art describes work that does not fit most people's ideas about what art should look like. It also describes art that has been made by people with no formal training. Very often, outsider artists may have lived in places that are not part of mainstream society. One example of an outsider artist is Judith Scott, who died in 2005. Judith had Down's Syndrome and spent 35 years in long-stay hospitals. When she came out of hospital at the age of 42, she had some art classes and started to make sculptures of her own. Her sculptures used fabric, wool, paper, and other soft materials. Judith wrapped the materials around something solid, like a piece of wood or a metal fan, to create a new object. Judith did not speak, and no-one really knows why she made these sculptures. For this reason some people thought this meant she was not an artist. But lots of people thought the sculptures were beautiful and interesting and that Judith was therefore a talented artist. Her work has been displayed in many art galleries around the world.

Another way that people with learning disabilities have been understood in the past is as **feral** human beings. This means they were seen as primitive, child-like people, with no history of their own. Matt gives the example of a man called Kaspar Hauser, who appeared in Germany in 1828. Kaspar could not walk or talk. He was not able to explain his past or where he had come from. He seemed to have no knowledge of how society worked, or how to act as a human being. Even now, people

with learning disabilities are often talked about in terms of their IQ and the level of their learning disability. Using words like mild, moderate, severe, and profound, can take away people's individual qualities and feelings. This can make them seem like they are not fully developed human beings and that they can't take responsibility for their actions or make their own decisions.

The **freak** shows of Victorian England give another example of the ways that people with learning disabilities have been seen and understood. Matt says that a freak is someone who has something unusual about their body or mind that people can make money from. Freak shows are usually staged performances designed to amuse and frighten an audience. They involve paying close attention to something that is unusual about someone. The word 'freak' is often used in a bad way and we tend to think of freak shows as places where people are bullied, or made fun of. Matt says this is only partly true. History tells us that in freak shows from the past, it was often unclear who was in charge. Often the show went wrong or things fell apart. The performers talked back to the audience or refused to do what they were told. Sometimes it was unclear if the freak was real or fake.

Finally, Matt looks at the idea of the **fool** in theatre and performance throughout history. The fool has been part of different types of theatre for centuries and has almost always been played by a man. At different points in time, the idea of the fool has meant different things. In Greek and Roman times, rich people employed a fool to make fun of them at home and in public. This was supposed to bring them good luck. In medieval England, the fool was a court jester. The jester would entertain people by doing silly or funny things. But often these things, like juggling or doing tricks, were crafts which involved specialist skills and a lot of practice. In Tudor and Elizabethan times, the fool often had a very complicated part to perform in plays. Sometimes he was part of the play, sometimes he was outside of it, playing the role of a narrator, or speaking directly to the audience. Shakespeare often used the role of the fool to help the audience understand the play more easily. The fool spoke the truth when other characters did not. He put things plainly even if it made other characters feel uncomfortable.

Matt says that when audiences watch actors with learning disabilities now, they use ideas from the past to think about what they see in the present. Most audience members don't realise that they are doing this, or may not want to admit it. Matt says it's important to talk carefully about what is happening to our thoughts and reactions when we watch learning disabled performers. Being aware of words and ideas we are

using from the past can help us to understand what it means to be a performer with learning disabilities in the present.

Matt also suggests that actors with learning disabilities might want to experiment themselves with some of these ideas from history. Matt says it might be dangerous, but not necessarily a bad thing, to act out the role of the outsider, the feral human, the freak, or the fool. In fact, Matt thinks that by doing risky things, theatre by actors with learning disabilities will upset audiences and critics. This will force them to talk about things they don't really want to. This may be uncomfortable for everyone. But in the end, it may help us to understand each other, and the world, in more rewarding ways.

Chapter 5: What A One-Person Show Can Teach Us about Being a Learning Disabled Performer

This chapter is all about a production called **On the Verge**, by Mind the Gap theatre company, which toured in 2005. **On the Verge** is a solo performance by musician and actor Jez Colborne. Matt believes it is the only one-person show ever to feature a learning disabled performer.

On the Verge was a joint project between Jez Colborne (performer), Tim Wheeler (director), Mike Kenny (writer), and Jonathan Bentley (film-maker). It is about a road trip along the famous Route 66 in America. Jez, Tim, Mike, and Jonathan made this journey by motorbike and car. Jez talked to people along the way and together the team collected lots of ideas, words, and film footage.

In **On the Verge** Jez talks about the trip, the things he saw, and the people he met. He sits at a tall table, on a tall bar stool with a coat stand in the background. The audience listens to his stories, whilst watching film footage of the trip itself. Sometimes Jez tells jokes, or acts out conversations with some of the people he met. Every now and then, he also turns to his keyboard to sing songs about the trip or about his experiences as a disabled man. Jez has Williams Syndrome and he talks about his disability freely and confidently as part of the performance.

In this chapter, Matt looks very deeply at how **On the Verge** was made and how Jez performs it. Matt says that **On the Verge** was very much a joint project. When Jez is on stage, it looks like **On the Verge** is all his own words and ideas. He is playing the part of a solo artist and performer with learning disabilities. But Matt points out that Tim, Mike, and Jonathan were involved in creating **On the Verge** too. And the reality is that they also helped to create the role that Jez plays as a solo performer.

Matt says that when Jez is performing on stage he seems to do things that are genuinely new and different. For example, he pays a lot of attention to certain things like unzipping his jacket, or putting sugar in his coffee. These things make Jez look like he is thinking very hard about the acting he is doing. They can sometimes make his performance seem like it has tiny spaces between different words and gestures. Matt thinks this makes Jez looks like he is acting the part of 'being Jez Colborne'. And that this is a genuinely new thing to be doing as a learning disabled performer.

Matt points out that a huge amount of detailed and specialist work went into making **On the Verge**. This work didn't stop once the play started to be performed. Matt noticed that Jez continued to make small changes and improvements to his performance throughout the tour. Matt also noticed that Jez's learning disability seemed less obvious at different points during touring. Sometimes Jez looked like a nondisabled actor playing the role of an actor with learning disabilities.

Theatre can help people to think about each other in different, new, and changing ways. Theatre by actors with learning disabilities gives a chance for audience members to consider how they think about disabled people. In particular, theatre by actors with learning disabilities shows that what we think about each other is constantly changing and is not fixed.

Matt thinks that Jez's performance in **On the Verge** raises questions about what an actor is, who can be an actor, and how work by learning disabled actors can be talked about. Matt also thinks that **On the Verge** shows how this sort of theatre is a craft. It takes specialist work and skills learnt over time to produce a quality show, like **On the Verge**.

Chapter 6: What Makes Some Kinds of Learning Disability both Familiar and Strange?

This chapter is about Mind the Gap's production of **Boo**, which toured in 2009. The four actors who worked on **Boo** were Jonathan Ide (who played Boo), Alan Clay (who played Boo's brother Benny), and JoAnne Haines and Rob Ewans (who played a sister and brother – Girl and Boy).

Boo is a young man with Asperger's syndrome. He lives with his older brother Benny on a modern housing estate in Northern England. Boo never leaves the house and he has particular routines and obsessions. One of his obsessions is keeping a scrapbook about a local girl called Kelly Spanner who has gone missing.

Girl and Boy play outside Boo's house and sometimes they see him through the windows. He sees them too. They are scared of Boo and make up stories about him. They convince themselves that he has taken Kelly Spanner and that she is inside his house.

One day, Boo and Girl meet. She goes inside his house and sees the scrapbook about the missing girl, Kelly Spanner. Girl thinks that Boo must have killed Kelly and runs from the house. Boo is worried about Girl and runs after her to 'look after her'. But a neighbour sees him looking into the window of Girl's house and accuses him of being a child molester. Boo runs home, but the local people start shouting at him and throwing things at his house. He runs out onto the road and is killed by a car.

The actor Jonathan Ide has Asperger's syndrome, like Boo the character he plays. In this chapter, Matt writes about Jonathan's performance in a lot of detail. He also writes about what other people have said about Jonathan's acting and about the play **Boo** more generally. These are the main things that Matt says in Chapter 6:

- As Boo, Jonathan has a strong and powerful presence on the stage. This makes the audience want to look at him and listen to him.
- When Jonathan plays Boo he sometimes makes mistakes, or forgets his lines. But it's not always obvious whether this is part of the play, or not.
- Because he has Asperger's syndrome himself, it sometimes looks like Jonathan is not just acting the part of Boo, but also playing himself. By both acting, and not acting, his performance as Boo seems very real.
- Because of this, Jonathan's performance can make the acting of the other actors in **Boo** seem less realistic. As they are playing nondisabled characters, they have to do more acting work. They are pretending to be people they are not. This makes their characters seem less realistic than Jonathan's character, Boo.
- Mike Kenny wrote Boo. Mike was very sensitive to how Jonathan felt and thought about things. This is important to say because some people thought the play would have been better if it had been written by the actors themselves. Matt thinks it is more complicated than this. He thinks that what made **Boo** good was that disabled and nondisabled people (like Mike and Jonathan) were working together. They were artists, and they shared ideas and feelings. This made them more equal, not less equal. At times they worked together so well, it was like they were the same person.
- Audiences get confused and worried by watching Jonathan and the other actors in **Boo**. They enjoy the show, but they are not sure who

is disabled and who is not. They worry that the actors might make mistakes and that the play might fall apart. People like to categorise things and put labels on other people to help them understand the world. When they can't do this, they feel uncertain and confused. These feelings can cause a sort of tension that can make audiences feel uncomfortable.

• Matt thinks that this tension can help audiences to think more deeply about the play they are watching and what they feel about the performances of the actors. He thinks it can also help them to think about how they watch a play and what this means to them. This can bring about new ideas and ways of looking at the world. And Matt thinks this tension is directly related to the fact that the audience is watching theatre by actors with learning disabilities.

• Matt thinks that all these things are to do with something quite difficult to accept or to explain. This is that we all share, whether we are disabled or nondisabled, something called vulnerability. This means that we need support. It also means that we are often afraid of things: we all fear losing things, or not being able to talk to other people, or being alone. If we could accept these things in ourselves, then we could get better at not blaming or ignoring others. People like Boo, for example. This is what makes some kinds of learning disability both familiar and strange. This is because it involves everyone – not just people with learning disabilities.

Conclusion: Why We Need a Poetics of the Theatres of Learning Disabilities

This is the last chapter of the book. Here, Matt talks again about some of the main ideas from the previous chapters. He says that the book has looked at how different types of theatre by actors with learning disabilities are made and performed. Talking about how theatre is made and performed is called **poetics**.

Matt says that theatre by actors with learning disabilities can seem both familiar and strange, both clear and confusing, both stable and unstable, both safe and scary, both structured and messy. These things are known as contradictions. They can make performances by actors with learning disabilities seem difficult to understand and to talk about. However, Matt argues that this is exactly what makes them new, different, and exciting.

The making and performing of theatre by actors with learning disabilities causes a range of reactions and responses from audiences and critics. It raises questions about the ownership of the work, the identity

of the actors as disabled people, the support the work needed during planning, rehearsal, and on stage, and the power held by nondisabled co-workers. Audiences enjoy watching actors with learning disabilities, but they also experience feelings of confusion, doubt, fear, irritation, and uncertainty.

These responses and reactions come about because people are thinking about theatre by actors with learning disabilities in ways that feel comfortable and familiar to them. They are using the knowledge and understanding they already have about how to react to theatre. However, as many types of theatre by actors with learning disabilities are new and different, these reactions and responses don't always explain these performances properly or help audiences and critics to fully understand them. This causes tension and makes audiences and critics feel uncomfortable.

Matt believes that if we talk about these responses and reactions, and the tension they create, they may lead to new ways of understanding theatre and looking at the world. Talking about this tension might help to open up a new and different sort of communication between theatre companies and their audiences and critics. It might mean that learning disability is seen not as a problem, or a difficulty, but as another form of human experience that can be represented and explored through theatre. It might also give audiences and critics the words and understanding to be able to treat actors with learning disabilities as artists in their own right. And this will mean that performances by actors with learning disabilities should have the same right to critical review as all types of theatre.

Thinking and talking about how artworks, like theatre, are made and performed is known as poetics. As a new form of theatre, we need to find a new poetics for theatre by actors with learning disabilities. In this book, Matt has looked carefully and deeply at the work of a few learning disabled actors and their theatre companies. He has tried to explain their work by using different ways of thinking about learning disability and theatre. In this way, the book has argued for the importance of a new poetics of the theatres of learning disability. It has also shown how this might look and work in practice.

Matt says that new ways of understanding performances by actors with learning disabilities might include:

- Valuing learning disability as a form of human variation.
- Understanding that society does not value human variation and instead tends to see learning disability as a problem or a difficulty.
- Thinking carefully and deeply about what makes quality theatre.

- Valuing the performances of actors as individuals, rather than thinking general things about actors with learning disabilities that are not always true.
- Valuing different forms and types of theatre.
- Supporting people to develop the specialist skills they need to be actors and understanding them as craftspeople, with jobs to do.
- Working together with a range of artists and co-workers, disabled and nondisabled alike.
- Understanding disability as something that changes and develops, rather than something that is fixed.
- Understanding that what is true, real and valuable about a piece of theatre is jointly created by everyone who has worked on it. It is not just the product of those who are performing it.

Rob Ewans, an actor from Mind the Gap, sums up these ideas when he says he wants to be recognised for what he does, not what he is:

'My disability is what I am regardless of being an actor. My worst fear is that I will be stereotyped as the actor with something wrong.'

More information

- Do you want to know more about the ideas in this easy read summary?
- Or perhaps you'd like to share your own ideas about theatre by actors with learning disabilities?

We hope that this easy read summary will lead to other ways of making the ideas from Matt's book easier to understand. There may also be some workshops and live discussions.

- Do you have any other thoughts about how we could make Matt's ideas easier to understand for more people with learning disabilities?

If you have any questions, thoughts, or need more help, please get in touch:

Write to us: Mind the Gap Studios, Silk Warehouse, Patent Street, Bradford, BD9 4SA

Call: 01274 487390

Fax: 01274 493973

Email: arts@mind-the-gap.org.uk

Notes

Prologue: Of Moths and Methods

1. The phrase belongs to James Clifford, quoted in Geertz (2000: 110).
2. See Kittay, E. (1999).
3. For a discussion of the tensions in academic research and learning disability, see Stalker (2012).

1 The End of Disability Arts: Theatre, Disability, and the Social Model

1. In the social model, therefore, it is 'incorrect' to use the term 'people with disabilities'; rather one should say, 'disabled people'. Yet, Goodley and Moore are forced to adapt their own preferred terminology in favour of 'people with learning difficulties': 'in recognition of the preference of the international self-advocacy movement'. Yet, by referring to 'members of performing arts groups *labelled* as having learning difficulties' (Goodley and Moore 2002: 211, my emphasis), they enter a double bind.
2. In 2012, Texas courts began using John Steinbeck's character description of Lennie from *Of Mice and Men* as a definition of learning disability to justify the execution of a man with a low IQ. This evidences the unstable, arbitrary, and disturbing qualities of learning disability as a category in contemporary times. (See www.telegraph.co.uk/culture/books/booknews/9462677/John-Steinbecks-writing-shouldnt-be-used-in-death-row-cases-says-son.html).
3. The immovable identification with disability as collective political identity leaves no scope for discussion of individual pain, suffering, or bodily complexity. Any attempt that 'X' made to reference individual struggle or trauma would not fit the affirmation model. As Shakespeare notes, with autism in particular, the biological basis can actually be liberating for people and families since in 'previous generations, parents were blamed for having emotionally deprived their children' (2006: 72).
4. See Annie Delin's article in Pointon and Davies (ed.) (1997: 176–178).
5. An argument *for* dramatherapy in the context of learning disability can be found in both Cattanach (1996) and Chesner (1995). Susan Hogan's more general work on the history of art therapy (2001) is insightful in its analysis of the spiritual element of such therapies, in the UK context.
6. Helen Nicholson in 'Applied Theatre/Drama: an e-debate in 2004' in *Research in Drama Education, The Journal of Applied Theatre and Performance* 11:1, 2006: 90.
7. This is, of course, a generalisation. There are a few clear instances that demonstrate a more nuanced perspective: see for example, Dave Calvert's excellent 'Loaded Pistols: the interplay of social intervention and anti-aesthetic

tradition in learning disabled performance' *Research in Drama Education: The Journal of Applied Theatre and Performance*, 2010:15 (4), pp. 513–528.

2 Pure Products Go Crazy: The Aesthetic Value of Learning Disability

1. See Bailes (2011) for a comprehensive analysis of performance's relationship to 'success'.
2. See Turner and Behrndt (2008: 26–22).
3. The phrase is taken from Carlos Williams Carlos's poem 'To Elsie', and the line that begins it: 'All the pure products of America go crazy'. Anthropologist James Clifford uses the poem as a platform on which to base his argument about the crisis in ethnography and the decline of the 'pure', 'authentic' ethnographic subject in an age of complex cultural cross-fertilisation: 'This feeling of lost authenticity, of "modernity" ruining some essence or sources is not a new one.' He alludes also to a 'violence, curiosity, pity, and desire in the poet's gaze. Elsie provokes very mixed emotions. Once again, a female, possibly coloured body serves as a site of attraction, repulsion, symbolic appropriation' (Clifford, J. (1988) *The Predicament of Culture* (Harvard) referenced http://writing.upenn.edu/~afilreis/88/clifford.html).
4. See Bauman (1989: x) for a brief discussion of the problem of 'absolute' evil.

3 On Quality: Disability and Aesthetic Judgements

1. See Verrent's blog (www.joverrent.com September 2012).
2. See Frederic Jameson's review of Zizek (www.lrb.co.uk/v28/n17/fredric -jameson/first-impressions).
3. The films are all currently available: see the *Push Me* collection at thespace. org, (accessed 23 September 2014).
4. Co-director Richard Hayhow has subsequently made the point that my reading of the piece might have changed radically if I had viewed the later performances: '[F]or me York was too big a venue for the production – the kind of skills needed to 'play' that space are connected with a high degree of artifice. When *Pinocchio* was performed in a much smaller venue in Coventry it had a completely different feel to it. I'm not sure your argument about the barrier would have as much force there' (Correspondence, July 2008). This begs the question of whether the main stage was the appropriate venue.
5. See: http://en.wikipedia.org/wiki/Jumping_the_shark, accessed 25 October 2012.
6. It is notable how many open points of access there were into the development process, heavily subsidised by the Arts Council. *Pinocchio*, in hindsight, seems part of the internal analysis of diversity and quality within the national funding structures. The title of these events suggests a break with the past: *See Me Now* (2005); *Act Different* (2007). These are invitations, but also commands, as if a fundamental shift has occurred in practice that needs to be registered in a forthright and direct manner.

4 Genealogies: The Cultural Faces of Learning Disability

1. See Peiry (2006: 33).
2. The phrase belongs to anthropologist Dean MacCannell (1989: 4).
3. See hidden-worlds.com/judithscott/ accessed 20 July 2012.
4. Indeed, the notary is describing the very essence of an academic tract: a unique body of research that quantifies with expert precision that which it appropriates.
5. In Stephen King's *Dreamcatcher*, Duddits, an adult with Down's Syndrome, 'was always a sword with two edges [...] Duddits the saviour [...] Duddits the killer (King 2001: 689). Duddits' 'gifted' mind plays as conduit for a horrific supernatural being. He is at once the 'mindhold' for the ET – creating the risk in the first place – and the 'stronghold', a virtual place where other characters can hide from the creature. Duddits is a dark angel, capable of immense good but awful harm. He is not just the conduit for the supernatural: he *is* the supernatural. As one character says, 'We've been odd [...] ever since we knew him' (689). The story is also evidence of the way in which the character with a learning disability is usually the conduit – in this case quite literally – for the story, but never the central protagonist. As with Raymond (Dustin Hoffman) in *Rain Man*, his is the narrative vehicle through which the nondisabled characters change or grow: 'Duddits was how we defined ourselves. He was our finest hour' (King 2001: 103).
6. It is documented fact, not included in the film, that Hauser, like the fictional Bartleby, worked as a copying clerk in a law office (see Newton 2002: 161).
7. Durbach describes a tendency in disability studies to reify figures of the past so that 'the wondrous monsters of antiquity, who became the fascinating freaks of the nineteenth century, transformed into the disabled people of the later twentieth century' (2009: 16). Conversely, Durbach argues that freakery and disability 'were radically different ways of dealing with difference that should not be collapsed' (ibid.).
8. An excellent example of the persistent ambivalence of the freak show can be found in Matt Fraser's cabaret show, *From Freak to Clique*: 'Disabled performers years ago/Had just one outlet, the freak show/We've come so far from beginning so low .../In these post modern times we're all in the know/You celebrate the liberal zeitgeist of this show/My emancipated stage craft makes you glow/Not a disabled performer but a disabled pro'. Fraser teasingly suggests that contemporary performance has not eradicated the freak show but, perhaps, created a surrogate for it. The 'liberal zeitgeist' may reflect not just the emancipatory glow of his stage craft, but a desire to have the freak reincorporated into a more acceptable form. See http://www.vam.ac.uk/content/videos/m/video-mat-fraser-from-freak-to-clique, (accessed 21 September 2012).
9. For a summary of Goffman's ideas on stigma and their relationship to performance, see Chemers (2008). The freak show, in addition to Goffman's low-key alleviation strategies, actually heightens existing stigmas and fabricates new ones. Rather than concealing stigma, performance can be a flagrant demonstration, which arguably gives the stigmatised person more agency than in more usual day-to-day encounters. The freak, aided by props, costume, lighting, and script, may gain the upper hand. As Chemers argues, the process 'feeds rather than challenges the systems of discrimination' (2008:

17) but 'it does manage to renegotiate the terms' of societal engagement (ibid.). Furthermore, Chemers argues persuasively that 'an analysis of the freak [...] separates the actor from the role' (ibid.) and crucially reveals 'the mechanisms by which the terms of stigma may be manipulated to the gain of the stigmatised individual or group' (ibid.).

10. Ironically, the word 'trickster' carries the more modern connotation of *Shyster* – the name of the theatre company studied in Chapter 3 – meaning the con artist who disrupts the pre-existing rules of professional engagement.

5 Nobody's Perfect: Disability Identity as Masquerade

1. An example of this is that a performer with Down's Syndrome might be expected, given the script of her everyday life (which includes expectation of reduced memory recall), to *forget* her theatrical script. If she *does* forget elements of this *theatrical* script, then the everyday *performative* script is reinforced. Such is the representational tightrope walked by the learning disabled actor.

2. It is interesting to compare Dylan's performance in Sam Peckinpah's *Pat Garrett and Billy the Kid* to Colborne's in *On the Verge*. Dylan's performance is remarkably odd here – autistic and 'shut down' somehow – very different from Colborne's upbeat communication. Dylan is tantalisingly 'impaired', which makes the performance strange and unsettling. The point is reinforced in Todd Haynes's film *I'm Not There* (2007), a subversive 'biopic' of Dylan in which six different actors – as diverse as Cate Blanchett and the late Heath Ledger – play Dylan (or perhaps 'Dylan') in different episodes of his life. The film is interesting for another related reason. It is fascinating to see female Blanchett 'pass' for Dylan during his *Blonde on Blonde* phase, echoing yet another 'pass': that of the intellectually impaired Australian actress Sonia Teuben who passes for both a man and a 'nondisabled' in *Small Metal Objects* (2007). Performances by both these Australians are 'uncanny'.

3. This does beg the question of exactly 'who' is on stage. Both the metaphor of the ghostwriter and Phelan's discussion of performance consciousness relate to Nicholas Royle's analysis of a wide variety of cultural phenomena in *The Uncanny* (2003). See Chapter 6 for an in-depth discussion of the uncanny.

4. Camouflage destabilises perception by upsetting the notion of symmetry and thus stable or binary distinction. For an invaluable discussion of the subject, see Schwartz (1996: 176–209).

5. The British comedian Ricky Gervais became embroiled in very public debates about 'cripping up' and about the ethics of using the word 'mong' to denote learning disability. For Gervais in disability drag, see the Channel 4 sitcom *Derek* (2012); alternatively, read comedian Stewart Lee's infinitely funnier review: (http://www.guardian.co.uk/commentisfree/2011/nov/13/stewart-lee-comedy-offensive-gervais).

6. The term 'nemesis' is deliberately provocative and ironic. After Lloyd Newson's comment, mentioned briefly at the start of Chapter 3 – that performance work involving impaired performers of insufficient technical ability risked 'demeaning the art form' – it is not too far an intellectual leap to see someone like Colborne as the enemy who will bring about the downfall of normative values about virtuosity.

7. Schwarzenegger is an example of a celebrity persona who has pushed his masculinity to the point of parody. In support of Halberstam's theory that masculinity only becomes visible in hyperbole, psychoanalyst Darian Leader argues that to play a woman (in the film, *Junior*) was the only logical turn in his career: 'the more the attributes of manliness are exaggerated, the more feminine the result [...] Schwarzenegger is the ultimate self-made man in this sense: his body has been built up, making him a symbol and camp caricature of capitalism' (1996: 29).

8. It is not my intention to ignore contemporary critiques of Camp that seek to reclaim it back from Sontag as a distinctly political Queer identity; there seems little reason why critiques of the dominant aesthetic cannot exist in parallel to each other, a 'Dis-Camp' or a 'Camp Syndrome' sharing elements with, but remaining distinct from, 'Queer Camp'.

9. For a discussion of 'Voyage and Return' narrative, see Booker (2005).

10. See Lewiecki-Wilson (2003) for an excellent summation of the issues surrounding facilitated speech with people with complex impairments.

11. The term 'mutation' of course carries many negative connotations, particularly in relation to the medical treatment of disabled people. In medical terms, as scientific historian Armand Marie Leroi points out,

> mutations are deficiencies in particular genes. Mutations arise from errors made by the machinery that copies or repairs DNA [...] Mutations alter the *meaning* of genes [...] they are collectively a Rosetta Stone that enables us to translate the hidden meaning of genes. Who, then, are mutants? There can only be one answer, and it is consistent with our everyday experience of the normal and the pathological. We are all mutants. But some of us are more mutant than others. (2005: 14–18)

The term 'mutation of interest' is used non-scientifically by Roland Barthes to describe the process that takes place when a detail in a photograph so totally overwhelms his reading of it that he cannot see anything else (2000: 49).

6 The Uncanny Return of Boo Radley: Disability, Dramaturgy, and Reception

1. See Hacking (2006).

2. For an excellent summary of Derrida's ideas on presence, see '"Just Be Yourself": *Logocentrism* and *differance* in performance theory' in Auslander (1997: 28–38).

3. Dyer uses a similar 'device' in his novel *Paris Trance* (1998: London: Abacus). A couple share a flat with a large mirror that has the uncanny quality of delaying its own image. In one scene, the couple makes love in front of it, and witnesses their climax *after* it happens: 'Everything they saw lagged fractionally behind what they felt' (1998: 113–114).

4. Dyer uses fiction and extended metaphor to explore the personal and aesthetic qualities of eight musicians. It is an act of 'imaginative criticism' that blurs the boundaries between fiction and aesthetic analysis. In regard to Art Pepper, he is also 'writing over' Pepper's own startlingly confessional autobiography, *Straight Life*. Dyer's blurring of real and performed identity

re-enforces the peculiar tone of Pepper's own book: it is as if Pepper is voic-
ing his own life through an actor (Jimmy Cagney or Frank Sinatra), so that
what appears to be 'straight talking' is actually pathological elaboration.
Pepper may only be able to access himself via the self-made mythic repre-
sentation of his life.

5. As both Freud and particularly Lacan convey, the 'subject' is not master of
her own house: she is both agent of meaning and subject to it. And as Helen
Cixous has observed, 'character' locks the artist into a 'treadmill of reproduc-
tion' (1974: 387) and closes down the 'open, unpredictable, piercing part of
the subject' with its infinite potential to rise up' (ibid.: 384).

6. This is possibly at the root of much anti-theatrical sentiment. Morally, as
Jonas Barish notes, anti-theatricality is bound up with anti-semitism – both
'Jews and itinerant entertainers' were historically viewed as 'predators'
(1981: 485). This leads some critics to argue that the 'otherness' of the actor
corresponds with that of the mountebank or prostitute, 'that their very
existence is a provocation, a projection of a false mimesis' (Ackerman and
Puchner 2006: 2). Aesthetically, the destructions of theatricality on the mod-
ernist stage have included the erosion of the human form through puppets
or machines; the removal of the proscenium as essential architecture; and
framing of performers that negates unmediated or authentic presence.

7. See Schechner (1985: 110) for a discussion of the 'not'/'not not' dynamic in
play and performance.

8. Another excellent example of this is the phenomenon of Susan Boyle, the
celebrity singer who may or may not have a learning disability, whose noto-
riety treads a fine line between seen and hidden, a kind of manufactured
presence that tries to account for her talent but also her strangeness.

9. One of Kenny's inspirations for *Boo* was the film *Red Road* (2006), which tells
the story of a CCTV operator, who, grieving after the death of her husband,
becomes obsessed with a man she sees on camera, and follows him. The
film, and perhaps *Boo*, is almost a textbook in Lacanian theory. Both works
foreground the sense that there is always an Other watching, and one can
never be sure what it sees. The female protagonist in *Red Road* almost *becomes*
this Big Other; we see everything from her point of view, as we often do with
Boo. The very absence of a neutral, objective point of view is what makes *Red
Road* so disturbing: buildings, parks, urban spaces 'look' at the protagonist,
without eyes; there is no point at which to locate the look – no subjectivity –
and therefore she cannot tell who she 'is' for them.

10. See Heddon and Milling (2006: 223) for conclusions regarding levels of
democratic decision-making in devised theatre.

11. See Charlton (2000).

12. For a discussion of 'intentionality' in a different performance context, see
the review of Rita Marcalo's *Involuntary Dances* (2009) by Jo Verrent: http://
www.disabilityartsonline.org/?location_id=1110.

13. The disclosure that Arthur Miller's son had a learning disability and was
institutionalised from a young age was a reminder of the relationship
between learning disability and the closet. That there is no mention of the
disabled son in his – on the surface, revealing – autobiography, *Timebends*
(1978), can only heighten the parallel.

14. See Turner and Behrndt (2008: 188–190).

Conclusion: A Proper Actor

1. The etymology of the word is to be found in Read (2008: 2).

Envoi: The Bartleby Parallax

1. See Zizek (2006: 384).
2. See Chamberlain's comments (94) in 'Applied Theatre/Drama: an e-debate in 2004', in *Research in Drama Education*, Vol 1:1, February 2006: 90–95.
3. See Zizek (2006: 384).

Sources and Bibliography

Sources

Interviews/correspondence

The following artists participated in research. Their comments are taken from transcripts of interviews or e-mail correspondence undertaken between April 2006 and December 2012. In the text, the references are abbreviated using the following system:

Jonathan Bentley, Filmmaker, *On the Verge*
Interview: Halifax 10.4.2006 Ref: Bentley (2006)
Alan Clay, Acting Company, *Mind the Gap*
Interview: Bradford 10.9 2009 Ref: Clay (2009)
Jez Colborne, Performer, *On the Verge* and *Sirens*
Interview: Bradford 12.4.2007 Ref: Colborne (2007a)
Comment on text: 14–21.7.2007 Ref: Colborne (2007b)
Edmund Davies, Acting Company, *Mind the Gap*
Interview: Bradford 11.9 2009 Ref: Davies (2009)
Rhiannon Ellis, Assistant Director, *Boo*
Correspondence: 3.3.2009 Ref: Ellis (2009)
Robert Ewans, Performer, *Boo*
Interview: Bradford 11.9.2009 Ref: Ewans (2009)
Bridget Foreman, Dramaturg, *Pinocchio*
Interview: York 27.10.2007 Ref: Foreman (2007)
Emma Gee, Former Director of Outreach, *Mind the Gap*
Correspondence: 8.8.2009–5.6.2010 Ref: Gee (2009–10)
Bruce, Artistic Director, *Back to Back*
Interview: London 8.11.2007 Ref: Gladwin (2007)
JoAnne Haines, Performer, *Boo*
Interview: Bradford 11.9.2009 Ref: Haines (2009)
Richard Hayhow, Former Artistic Director, *The Shysters*
Interview: York *27.10.2007* Ref: Hayhow (2007)
Interview: York 16.7.2008 Ref: Hayhow (2008a)
Correspondence: 18.7.2008 Ref: Hayhow (2008b)
Jonathan Ide, Performer, *Boo*
Interview: Bradford 11.9.2009 Ref: Ide (2009)
Mike Kenny, Writer, *On the Verge, Boo*
Interview: York 10.4.2006 Ref: Kenny (2006)
E-mail correspondence: 26.1.2007 Ref: Kenny (2007)
Interview: Bradford 8.11.2008 Ref: Kenny (2008)
Interview Newcastle Upon Tyne: 30.3.2009 Ref: Kenny (2009)
Simon Laherty, Performer, *Small Metal Objects*
Interview: London 9.11.2007 Ref: Laherty (2007)

257

Undergraduate students and staff, *Northumbria University*
Interviews and discussion: 7.5.2009 Ref: NU (2009)
Jon Palmer, Former Artistic Director, *Full Body and the Voice*
Interview: Huddersfield 23.11.2007 Ref: Palmer (2007)
Jim Russell, Performer, *Small Metal Objects*
Interview: London 9.11.2007 Ref: Russell (2007)
Julia Skelton, Administrative Director, *Mind the Gap*
Interview: Bradford 12.4.2007 Ref: Skelton (2007)
Telephone interview: 9.11.2009 Ref: Skelton (2009)
Telephone interview: 5.12.2012 Ref: Skelton (2012)
Sonia Teuben, Performer, *Small Metal Objects*
Interview: London 9.11.2007 Ref: Teuben (2007)
Jo Verrent, Director, *ADA Inc*
Interview: Harden 9.11.2009 Ref: Verrent (2009)
Correspondence: 2.10.2012 Ref: Verrent (2012)
Tim Wheeler, Artistic Director, *Mind the Gap*
Interview: Bradford 12.4.2007 Ref: Wheeler (2007a)
Phone Interview: 13.11.2007 Ref: Wheeler (2007b)
Comment on text: 14–21.7.2007 Ref: Wheeler (2007c)
Interview: Bradford 8.11.2008 Ref: Wheeler (2008)
E-mail correspondence: 12.12.2008 Ref: Wheeler (2008b)
Interview: Bradford 10.9.2009 Ref: Wheeler (2009)
Interview: Harden 9.11.2009 Ref: Wheeler (2009b)
E-mail correspondence: 20.4.2010 Ref: Wheeler (2010)
E-mail correspondence: 1.6.2010 Ref: Wheeler (2010b)
Email correspondence: 7.12.2012 Ref: Wheeler (2012)

Performance viewings

Boo (2009)

14.2.2009 Bradford: Mind the Gap Studios*
24.2.2009 Sheffield: University Workshop Theatre
30.3.2009 Newcastle Upon Tyne: Live Theatre
Note: *The Bradford performance was video recorded

Hypothermia (2010)

19.2.2010 Scarborough: Stephen Joseph Theatre

On the Verge (2005)

6.10.2005 Leeds: The Carriageworks
12.3.2006 Bradford: National Museum of Film and Photography
15.6.2006 London: Jackson's Lane*
23.7.2007 Hong Kong: The Fringe Club
24.7.2007 Hong Kong: The Fringe Club
24.7.2007 Hong Kong: The Fringe Club
Note: * The Jackson's Lane performance was video recorded

Pinocchio (2007)

19.10.2007 York: Theatre Royal, Matinee and Evening

Small Metal Objects (2005)

8.11.2007 London: Stratford East Station
9.11.2007 London: Stratford East Station
A recorded film version of a live Australian performance was also used in the research process, kindly sent to me by Alice Nash.

Text

Brooks, V. (2010) *Hypothermia*, London: Joseph Weinberger
Gladwin, B. (2005) *Small Metal Objects*, unpublished play script
Kenny, M. (2006) *On the Verge*, unpublished play script *
Kenny, M. (2009) *Boo*, unpublished play script
Note: * refers to the updated edition 24.6.2006. (All direct quotations from the play refer to this version of the text.)

Symposia

21.10.2005 *See Me Now*, York Theatre Royal (Ref: Symp. 2005)
5.3.2006 *Beam Festival*, Bradford, National Museum of Film and Photography
9.3.2006 *Jumping the Shark: Creative Practice in Theatre and Learning Disability –
Where Now?*, Coventry University (Ref: Symp. 2006)
5.7.2007 *Act Different* symposium, Lawrence Batley Theatre, Huddersfield (Ref: Symp.2007)
6.10.2007 *RiDE (Research in Drama Education)* symposium, *Disability: Creative Tensions in Applied Theatre* at Central School of Speech and Drama, London (Ref: RiDE symp. 2007)

Reports/correspondence

Brown, I. (2005) Letter in Response to Audience Complaint, West Yorkshire Playhouse, regarding *Of Mice and Men* (Ref: Brown 2005)
Caswell, D. (2004) 'Quality Revised Paper', Disability Strategy Project Team, Arts Council England, accessed on line as media upload, 22.9.2012
Creative Case (2012) 'What is the Creative Case for Diversity?' Arts Council England 2012, (www.creativecase.org.uk, accessed 22.10.2012) (Ref: Creative Case 2012)
Hewitt, P (2005) 'Changing Places: Reflections of an Arts Council Chief Executive', www.artscouncil.org.uk/media/uploads/documents, accessed 9.8.2012
McMaster, B. (2008) 'Supporting Excellence in the Arts, From Measurement to Judgement', Department for Culture, Media and Sport, www.artscouncil.org.uk/publication_archive, accessed 9.8.2012

Websites and show reviews

Berry, K. (2005) Review of *On the Verge* www.thestage.co.uk/reviews/review.php/6538/on-the-verge (accessed 2.5.2009)
Berry, K. (2009) Review of *Boo* http://www.thestage.co.uk/reviews/review.php/23699/boo (accessed 9.2.2013)
Boys, C. (2007) Review of Pinocchio in www.britishtheatreguide.2007 (accessed 8.9.2008)
Darke, P. (2003) 'Now I know why Disability Arts is drowning in the River Lethe' in www.outside-centre.com (accessed 23.7.2012)

Darke, P. (2004) 'An interview with Paul Darke' in www.outside-centre.com (accessed 23.7.2012)

Gosling, J. (2006) 'What is Disability Arts?/what it isn't' in http://www.ju90. co.uk/blog/what.htm (accessed 2.8.2012)

Hickling, A. (2007) Review of Pinocchio in http://www.guardian.co.uk/stage/2007 (accessed 28.9 2012)

Javin, V. (2010) Review of *Hypothermia*: 'Enduring Debate about Human Values' in www.examiner.co.uk (accessed 7.10.2011)

Loxton, H. (2007) Review of *Small Metal Objects* in www.britishtheatreguide (accessed 2.8.2009)

Ositelu, T. (2009) Review of *Boo* http://www.offwestend.com/index.php/plays/ view/2860 (accessed 9.2.2013)

Price, J. (2007) 'Pinocchio at the York Theatre Royal' in theyorker.co.uk (accessed 12.9.2008)

Robinson, A. (2011) Review of *Of Mice and Men* in http://www.leedsguide.co.uk/ (accessed 2.2.2012)

Sutherland, A. (2005) 'What is Disability Arts?' in www.disabilityartsonline.org. uk (accessed 2.8.2012)

Verrent, J. (2009) Review of *Boo* in www.disabilityartsonline.org.uk (accessed 3.7.2012)

http://www.mind-the-gap.org.uk (accessed 7.7.2012)

http://backtobacktheatre.com (accessed 7.7.2012)

http://www.fullbody.org.uk (accessed 7.7.2012)

www.bild.org.uk accessed (15.7.2012)

www.disabilityartsonline.org.uk (accessed 2.8.2012)

http://thespace.org/items/e00007gc (accessed 27.7.2012)

http://www.susanaustin.co.uk (accessed 27.7.2012)

www.parallellinesjournal.com (accessed 11 7 2012)

www.darkhorsetheatre.co.uk (accessed 29.08.2012)

www.joverrent.com (accessed 1.11.2012)

Bibliography

Abbs, P. (1987) *Living Powers*, London: Falmer

Ackerman, A. & Puchner, M. (2006) *Against Theatre: Creative Destructions of the Modernist Stage*, Palgrave: Basingstoke

Adams, R. (2001) *Sideshow USA: Freaks and the American Cultural Imagination*, Chicago & London: Chicago University Press

Artaud, A. (1997) *The Theatre and Its Double*, London: John Calder

Atkinson, D., Jackson M. & Walmsley, J. (1997) *Exploring the History of Learning Disability*, Kidderminster: BILD

Auslander, P. (1997) *From Acting to Performance, Essays in Modernism and Postmodernism*, London: Routledge

Auslander, P. (1999) *Liveness: Performance in a Mediatized Society*, London: Routledge

Babbage, F. (2004) *Augusto Boal*, London: Routledge

Babbage, F. (2005) 'Putting Yourself on the Line: Ethical Choices in Research and Writing' at PALATINE: University of Sheffield, Whose Theatre (History) is it

Anyway? A forum on the ethics of radical theatre practice, Available on line: http://www.palatine.ac.uk/events/viewdoc/163/
Babbage, F. (2010) 'Augusto Boal and the Theatre of the Oppressed', in Hodge, A. (Ed.) *Actor Training* (2nd Edition), London: Routledge, 305–325
Bailes, S. J. (2011) *Performance, Theatre and the Poetics of Failure*, Abingdon: Routledge
Baugh, B. (1988) 'Authenticity Revisited', in *The Journal of Aesthetics and Art Criticism*, 46: 4, 477–487
Bauman, Z. (1989) *Modernity and the Holocaust*, Cambridge: Polity
Bauman, Z. (2005) *Liquid Life*, Cambridge: Polity
Barish, J. (1981) *The Antitheatrical Prejudice*, Los Angeles: University of California Press
Barnes, C. (2008) 'Generating Change? Disability, Culture and Art', Paper available one line http://disability-studies.leeds.ac.uk/files/library/Barnes-Generating-Change.pdf accessed 5.3.2013
Barthes, R. (2000) *Camera Lucida*, London: Vintage
Bayliss. P. & Dodwell, C. (2002) 'Building Relationships Through Drama: The Action Track Project', in *Research in Drama Education*, 7: 1, 43–60
Becker, H. S. (1982) *Art Worlds*, London: University of California Press
Becker, H. S. (2007) *Telling About Society*, Chicago: Chicago University Press
Bell, C. (2007) '"Performance" and Other Analogies', in Bial, H. (Ed.) *The Performance Studies Reader*, London: Routledge, 98–107
Benjamin, A. (2001) *Making an Entrance: Theory and Practice for the Disabled and Nondisabled Dancer*, London: Routledge
Bennett, D. (1998) (Ed.) *Multicultural States: Rethinking Difference and Identity*, London: Routledge
Bennett, A. & Royle, N. (2009) *An Introduction to Literature, Criticism and Theory, Fourth Edition*, Harlow: Pearson Longman
Bhahba, H. K. (1994) *The Location of Culture*, London: Routledge
Bial, H. (Ed.) *The Performance Studies Reader*, London: Routledge
Bishop, C. (2004) 'Antagonism and Relational Aesthetics', in *October Magazine*, MIT: Fall, 51–79
Bishop C. (2006) 'The Social Turn: Collaboration and its Discontents', in *Artforum*, February 2006
Bishop, C. (2012) *Artificial Hells, Participatory Art and the Politics of Spectatorship*, London: Verso
Blackmur, R. P. (1935) 'A Critic's Job of Work', in Adams, H. (Ed.) *Critical Theory Since Plato* (1992) Fort Worth Texas: Harcourt Brace
Bloom, H. (1994) *The Western Canon*, London: Macmillan
Boal, A. (2006) *The Aesthetics of the Oppressed*, Abingdon UK: Routledge
Bogdan, R. (1997) *Freak Show: Presenting Human Oddities for Amusement and Profit*, Chicago: University of Chicago Press
Booker, C. (2005) *The Seven Basic Plots: Why We Tell Stories*, London: Continuum
Borch-Jacobson, M. (1996) *Remembering Anna O*, (trans Olson, K.), London: Routledge
Bourriaud, N. (1998) *Relational Aesthetics*, Dijon: Les Presses du Reel
Brecht, B. (1964) *Brecht on Theatre, the Development of an Aesthetic*, London: Methuen
Brettell, C. (1993) *When they read what we write: the politics of ethnography*, London: Bergin and Garvey

Brigham, L. (2000) *Crossing Boundaries: Change and Continuity in the History of Learning Disability*, BILD: Kidderminster

Brighton, A. (2006) 'Consumed by the Political: The Ruination of the Arts Council', in *Critical Quarterly*, 48: 1, 1–13

Burns, E. (1972) *Theatricality: A Study of Convention in the Theatre and in Social Life*, London: Longman

Butler, J. (1991) 'Imitation and Gender Insubordination', in Fuss, D. (Ed.) *Inside/Out: Lesbian Theories, Gay Theories*, London: Routledge

Butler, J. (1993) *Bodies that Matter: On the Discursive Limits of 'Sex'*, London: Routledge

Calvert, D. (2010) 'Loaded Pistols: The Interplay of Social Intervention and Anti-aesthetic Tradition in Learning Disabled Performance', *Research in Drama Education: The Journal of Applied Theatre and Performance*, 15: 4, 513–528

Campbell, P. & Kear, A. (Ed.) (2001) *Psychoanalysis and Performance*, London: Routledge

Carlson, L. (2005) 'Docile Bodies, Docile Minds: Foucauldian Reflections on Mental Retardation', in Shelley, T. (Ed.) *Foucault and the Government of Disability*, Michigan: University of Michigan Press

Carlson, L. (2010) *The Faces of Intellectual Disability: Philosophical Reflections*, Indiana University Press

Cattanach, A. (1996) (Ed.) *Drama for People with Special Needs*, London: A&C Black

Cavell, S. (1988) *In Quest of the Ordinary: Lines of Skepticism and Romanticism*, Chicago: Chicago University Press

Chaim, B. D. (1984) *Distance in Theatre: The Aesthetics of Audience Response*, Ann Arbor: UMI Research Press

Chesner, A. (1995) *Dramatherapy for People with Learning Disabilities: A World of Difference*, London: Jessica Kingsley

Carr, L. & Watson, D. (2007) *Art Disability Culture Magazine*, July: Issue 198

Charlton, J. I. (2000) *Nothing About Us Without Us: Disability, Oppression and Empowerment*, Berkeley: University of California Press

Chemers, M. (2008) *Staging Stigma, A Critical Examination of the American Freak*, London: Palgrave

Cixous, H. (1974) 'The Character of "Character"', trans. Keith Cohen, *New Literary History* 5: 2, 383–402

Coffey, A. (1999) *The Ethnographic Self*, London: Sage

Conquergood, D. (2007) 'Performance Studies: Interventions and Radical Research', in Bial, H. (Ed.) *The Performance Studies Reader*, London: Routledge, 369–381

Conrad, P. (1999) *Modern Times, Modern Places, Life and Art in the Twentieth Century*, London: Thames and Hudson

Conroy, C. (2003) 'Casting the Outsider', Paper presented at *Finding the Spotlight Conference*, LIPA Liverpool, May 2003

Conroy, C. (2009) 'Disability: Creative Tensions Between Drama, Theatre, and Disability Arts', in *Research in Drama Education: The Journal of Applied Theatre and Performance*, 14:1, 1–14

Corker, M. & French, S. (1999) *Disability Discourse*, London: OUP

Corker, M. & Shakespeare, T. (2002) *Disability/Postmodernity*, London: Continuum

Couser, T. (1997) *Recovering Bodies: Illness, Disability and Life Writing*, Wisconsin: University of Wisconsin Press

Crutchfield, S. & Epstein, M. (2000) *Points of Contact: Disability, Art & Culture*, Ann Arbor: University of Michigan Press

Davidson, M. (2008) *Concerto for the Left Hand: Disability and the Defamiliar Body*, Ann Arbor: University of Michigan Press

Davies, A. (1987) *Other Theatres: The Development of Alternative and Experimental Theatre in Britain*, London: Methuen

Davis, L. (2011) 'The Disability Paradox: Ghettoisation of the Visual', available online at: http://www.parallellinesjournal.com/article-the-disability-paradox. html

Davis, L. (2002) *Bending Over Backwards: Disability, Dismodernism and Other Difficult Positions*, New York: New York University Press

Darke, P. (2003) 'Now I Know Why Disability Art is Drowning in the River Lethe', in Riddell, S. & Watson N. (Eds.) *Disability, Culture and Identity*, Harlow: Pearson Prentice Hall, 131–142

Darke, P. (2000) 'Understanding Cinematic Representations of Disabilty', in Shakespeare, T (Ed.) *The Disability Reader*, London: Continuum

Deleuze, G (1998) *Essays Critical and Clinical* (trans. Smith, D.W. and Greco, M.), London: Verso

Derrida, J. (1994) *Spectres of Marx: The State of the Debt, the Work of Mourning, and the New International*, (trans. Kamuf, P.), London: Routledge

Diamond, E. (1992) 'The Violence of "We"', in Reinelt, J.G. and Roach, J. R. (Eds.) *Critical Theory and Performance*, Ann Arbor: University of Michigan Press, 390–398.

Diamond, E. (1997) *Unmaking Mimesis*, London: Routledge

Diamond, E. (2006) 'Deploying/Destroying the Primitivist Body in Hurston and Brecht', in Ackerman, A. & Puchner, M. (Eds.) *Against Theatre: Creative Destructions of the Modernist Stage*, Basingstoke: Palgrave

Durbach, N. (2009) *The Spectacle of Deformity, Freak Shows and Modern British Culture*, Berkley: University of California Press

Dyer, G. (1996) *But Beautiful, A Book About Jazz*, London: Vintage

Eagleton, T. (1990) *The Ideology of the Aesthetic*, Blackwell: Oxford

Eagleton, T. (2003) *After Theory*, London: Penguin

Eagleton, T. (2003) *Sweet Violence, The Idea of the Tragic*, London: Blackwell

Elkins, J. (1996) *The Object Stares Back, on the Nature of Seeing*, New York: Simon and Schuster

Empson, W. (1951) (2nd Edition) *Seven Types of Ambiguity*, London: Chatto & Windus

Emunah, R. (1994) *Acting for Real: Dramatherapy, Process, Technique and Performance*, London: Bruner & Mazel

Fahey, T. & King, K. (2002) *Peering Behind the Curtain: Disability, Illness and the Extraordinary Body in Contemporary Theatre*, London: Routledge

Feral, J. (1982) 'Performance and Theatricality', in *Modern Drama*, 25, 170–181

Ferris, J. (2005) 'Aesthetic Distance and the Fiction of Disability', in Sandhal, C. & Auslander, P. (Eds.) *Bodies in Commotion*, Ann Arbor: University of Michigan Press, 56–68

Fielder, L. (1993) *Freaks: Myths and Images of the Secret Self*, London: Anchor

Finklestein, V. (1981) 'Disability and the Helper/helped Relationship: A Historical View', in Brechin, A., Liddiard, A. & Swain, J. (Eds.) *Handicap in a Social World*, Seven Oaks: Hodder & Stoughton

Foucault, M. (1971) *Madness and Civilization*, London: Routledge
Foucault, M. (1978) 'Stucturalism and Post-structuralism', in Rabinow, B. (Ed.) *Michel Foucault: Aesthetics, Method, and Epistemology*, New York: New Press
Foucault, M. (1979) *Discipline and Punish: The Birth of the Prison*, New York: Vintage
Foucault, M. (1984) *The Foucault Reader*, London: Penguin
Freud, S. (2003) *The Uncanny*, Trans. D. McLintock, introduction by Haughton, H., London: Penguin
Fryer, N. (2010) 'From Reproduction to Creativity and the Aesthetic: Towards an Ontological Approach to the Assessment of Devised Performance', in *Research in Drama Education: The Journal of Applied Theatre and Performance*, 15: 4, 547–562
Fuchs, E. (2004) 'EF's Visit to a Small Planet: Some Questions to Ask a Play', in *Theater*, 59:34, 5–9
Garber (1992) *Vested Interests, Cross-Dressing and Cultural Anxiety*, New York: Routledge
Garber, M. (2001) *Academic Instincts*, Woodstock Oxfordshire, Princeton University Press
Garner, S.B. (1994) *Bodied Spaces: Phenomenology and Performance in Contemporary Drama*, Ithaca: Cornell University Press
Gee, M. & Hargrave, M. (2011) 'A Proper Actor? The Politics of Training for Learning Disabled Actors', in *Theatre, Dance and Performer Training*, 2: 1, 34–53
Geertz, C. (1983) *Local Knowledge: Further Essays in Interpretive Anthropology*, NewYork: Basic Books
Geertz, C. (1998) *Works and Lives: The Anthropologist as Author*, Cambridge: Polity Press
Geertz, C. (2000) *Available Light: Anthropological Reflections on Philosophical Topics*, Woodstock Oxfordshire: Princeton University Press
George, D. (1996) 'Performance Epistemology', in *Performance Research*, 1:1
Goffman, E. (1992) *The Presentation of Self in Everyday Life (New Edition)*, London: Penguin
Goodall, J, (2008) *Stage Presence*, London: Routledge
Goodley, D. & Moore, M. (2002) *Disability Arts Against Exclusion: People with Learning Difficulties and Their Performing Arts*, Kidderminster: BILD
Goulish, M. (2000) *39 Microlectures: In Proximity of Performance*, London: Routledge
Grace, A. (2009) 'Dancing with Lassitude: A Dramaturgy from Limbo', in *Research in Drama Education, The Journal of Applied Theatre and Performance* Special Edition: On Disability 14:1, 15–29
Grigely, J. (2000) 'Postcards to Sophie Calle', in Siebers (E+.) *The Body Aesthetic: From Fine Art to Body Modification*, Ann Arbor: University of Michigan Press, 17–40
Grosz, E. (1996) 'Intolerable Ambiguity: Freaks as/at the Limit', in Thomson, R. G. (Ed.) *Freakery: Cultural Spectacles of the Extraordinary Body*, New York: New York University Press
Gunning, T. (1995) 'Phantom Images and Modern Manifestations: Spirit Photography, Magic Theatre, Trick Films, and Photography's Uncanny', in Petro, P. (Ed.) *Fugitive Images: From Photography to Video*, Bloomington: Indiana University Press, 42–71

Hacking, I. (1999) *The Social Construction of What?*, Cambridge Mass.: Harvard University Press

Hacking, I. (2006) 'What is Tom Saying to Maureen', available on line: http://www.lrb.co.uk/v28/n09/ian-hacking/what-is-tom-saying-to-maureen accessed 12.11.2012

Hahn, H. (1998) 'The Politics of Physical Difference: Disability and Discrimination', in *Journal of Social Issues*, 44, 39–47

Halberstam, J. (1998) *Female Masculinity*, London: Duke University Press

Haraway, D. (1991) *Simians, Cyborgs, and Women: The Reinvention of Nature*, London: Routledge

Hargrave, M. (2009) 'Pure Products Go Crazy', in *Research in Drama Education, The Journal of Applied Theatre and Performance* Special Edition: On Disability, 14: 1, 37–54

Hargrave (2010) 'Side Effects: An Analysis of the Public Reception of Theatre Involving Learning Disabled Actors', in *Research in Drama Education, the Journal of Applied and Social Theatre*, Special Edition, On Aesthetics of Applied Drama, 15.4

Harvie, J. (2005) *Staging the UK*, Manchester: Manchester University Press

Haseman, B. & Winston, J, (2010) '"Why be interested?" Aesthetics, Applied Theatre and Drama Education', *Research in Drama Education, The Journal of Applied Theatre and Performance*, 15: 4, 465–475

Hauerwas, S. (1986) *Suffering Presence*, Notre Dame, Ind., University of Notre Dame Press

Heddon, D. & Milling, J. (2006) *Devising Performance, A Critical History*, Basingstoke: Palgrave MacMillan

Hevey, D. (1992) *The Creatures that Time Forgot: Photography and Disability Imagery*, London: Routledge

Hevey, D. (1991) 'From Self-Love to the Picket Line: Strategies for Change in Disability Representation', in Lees, S. (Ed.) *Disability Arts & Culture Papers: Transcripts of a Disability Arts and Culture Seminar* November 20th 1991 available on line http://disability-studies.leeds.ac.uk/files/library/Lees-arts-and-culture.pdf accessed 6.3.2013

Hellier-Tinoco, R. (2005) 'Becoming-in-the-world-with-others: Interact Theatre Workshop', in *Research in Drama Education*, 10: 2, 159–173

Hodge, A. (Ed.) (2010) *Twentieth Century Actor Training*, 2nd Edition, London: Routledge

Hogan, S. (2001) *Healing Arts: A History of Art Therapy*, London: Jessica Kingsley

Humphrey, J. (2000) 'Researching Disability, or Some Problems with the Social Model in Practice', in *Disability and Society*, 15: 1, 63–85

Hutcheon, L. (2006) *A Theory of Adaptation*, Abingdon, Oxon: Routledge

Hyde, L. (2008) *Trickster Makes This World: How Disruptive Imagination Creates Culture*, London: Cannongate

Jacobson, H. (2007) *Kolooki Nights*, London: Vintage.

Jackson, A. (2007) *Theatre, Education and The Making of Meaning: Art or Instrument?* Manchester: Manchester University Press

Jackson, S. (2011) *Social Works: Performing Art, Supporting Publics*, London: Routledge

Jameson, F. (2006) 'First Impressions: a review of Zizek's The Parallax View', in *London Review Of Books*, 28: 17, September 2006

Jennings, S. (1990) *Waiting in the Wings; Dramatherapy with Families, Groups and Individuals*, London: Jessica Kingsley
Jennings, S. (2009) *Dramatherapy and Social Theatre*, London: Routledge
Jones, S. (2004) 'New Theatre for New Times: Decentralisation, Innovation and Pluralism 1975–2000', in Kershaw, B. (Ed.) *The Cambridge History of the British Theatre, Volume 3, Since 1895*, Cambridge: Cambridge University Press, 448–470
Karafistan, R. (2004) 'Being a Shyster: Revisioning the Actor with Learning Difficulties', in *New Theatre Quarterly*, 20: 3, 265–279
Kershaw, B. (2004) (ed.) *The Cambridge History of the British Theatre, Volume 3, Since 1895*, Cambridge: Cambridge University Press
Kershaw, B. (1999) 'Discouraging Democracy: British Theatres and Economics, 1979–1999', in *Theatre Journal* 51:3, 367–383
Kershaw, B. (1999) *The Radical in Performance: From Brecht to Baudrillard*, London: Routledge
Kershaw, B. (1992) *The Politics of Performance: Radical Theatre as Cultural Intervention*, London: Routledge
Kester, G. (2004) *Conversation Pieces: Community, Art and Communication in Modern Art*, Berkley: University of California Press
King, S. (2001) *Dreamcatcher*, London: Hodder & Stoughton
Kirby (2002) 'On Acting and not Acting', in Zarilli, P. (Ed.) *Acting Re:considered*, London: Routledge, pp. 40–53.
Kittay, E. (1999) *Love's Labor: Essays on Women, Equality and Dependency*, London: Routledge
Kot, J. (1999) *Distance Manipulation: The Russian Modernist Search for a New Drama*, Evanston: Northwestern University Press
Kubiak, A. (2001) 'As If: Blocking the Cartesian Stage', in Campbell, P. & Kear, A. (Eds.) *Psychoanalysis and Performance*, London: Routledge
Kuppers, O. (2008) 'Dancing Autism: The Curious Incident of the Dog in the Nighttime and Bedlam', in Henerson, B. and Ostrander, R. (Eds.) *Understanding Performance and Disability Studies*, London: Routledge
Kuppers, P. (2003) *Disability and Performance: Bodies on the Edge*, London: Routledge
Kuppers, P. (2001) 'Deconstructing Images: Performing Disability', in *Contemporary Theatre Review*, 11: 3–4, 20–35
Kureishi, H. (2002) *Dreaming and Scheming: Reflections on Writing and Politics*, London: Faber & Faber
Kirby, M. (2002) 'On Acting and Not Acting', in Zarilli, P. (Ed.) *Acting Reconsidered (2nd Edition)*, London: Routledge, 40–53
Kleist, H. (undated) 'On the Marionette Theatre' (trans. Idris Parry) www.southerncrossreview.org/9/kleist.htm, accessed 12.10.2012.
Lacan, J. (1977) *Ecrits, A Selection*, New York
Lassiter, L. (2005) *The Chicago Guide to Collaborative Ethnography*, Chicago: University of Chicago Press
Leader, D. (1996) *Why Do Women Write More Letters than they Post?*, London: Faber
Leader, D. (2002) *Stealing the Mona Lisa, What At Stops us From Seeing*, London: Faber & Faber
Leader, D. (2008) *The New Black: Mourning, Melancholia and Depression*, London: Penguin

Lee, H. (1960) *To Kill a Mockingbird* (2004 edition*)*, London: Vintage

Leeds, S. (1991) 'Disability Arts and Culture Papers', available on line http:// disability-studies.leeds.ac.uk/files/library/Lees-arts-and-culture.pdf accessed 6.3.2013

Leighton, F. (2009) 'Accountability: The Eethics of Devising a Practice-as-research Performance with Learning-disabled Performers', in *Research in Drama Education, The Journal of Applied Theatre and Performance* Special Edition: On Disability, 14: 1, 97–113

Leroi, A. M. (2005) *Mutants: On the Form, Varieties and Errors of the Human Body*, London: Harper Collins

Lewiecki-Wilson, C. (2003) 'Rethinking Rhetoric through Mental Disabilities', in *Rhetoric Review*, 22: 2, 156–167

MacCannell, D. (1989) *The Tourist, a New Theory of the Leisure Class*, New York: Schocken

MacCannell, D. (1992) *Empty Meeting Grounds: The Tourist Papers*, London: Routledge

MacGregor, J. M. (1989) *The Discovery of the Art of the Insane*, Princeton, N.J: Princeton University Press

MacGregor, J. M. (1999) *Metamorphosis – The Fiber Art of Judith Scott: The Outsider Artist and the Experience of Downs Syndrome*, Oakland: The Creative Growth Centre

MacLagan, D. (1991) 'Outsiders or Insiders', in Hiller, S. (Ed.) *The Myth of Primitivism – Perspectives on Art*, London: Routledge, 32–49

MacLagan, D. (2009) *Outsider Art: From Margin to Market Place*, London: Reaktion

Masefield, P. (2006) *Strength, Broadsides from Disability on the Arts*, Stoke: Trentham

Melville, H. (1853) *Bartleby the Scrivener: A Story Of Wall Street*, New York: Melville House, 2010 reprint

McAuley, G. (1998) 'Towards an Ethnography of Rehearsal', in *New Theatre Quarterly*, 14, 53

McDonnell, B. (2005) 'The Politics of Historiography – Towards an Ethics of Representation', in *Research in Drama Education*, 10: 2, 127–138

McKenzie, J. (2001) *Perform or Else: From Discipline to Performance*, London: Routledge

Mclean, A. & Leibing A. (2007) *The Shadow Side of Fieldwork, Exploring the Blurred Boundaries Between Ethnography and Life*, Oxford: Blackwell

McRuer, R. (2004) 'Composing Bodies; or, De-Composition: Queer Theory, Disabilty Studies, and Alternative Corporealites', in *jac* 24: 1 available at jaconlinejournal.com/archives/vol24.1/mcruer-composing.pdf

McRuer R. (2006) *Crip Theory: Cultural Signs of Queerness and Disability*, New York University Press

McRuer, R. & Mollow A. (ed.) (2012) *Sex and Disability*, London: Duke University Press

Michalko, R. (2002) 'Estranged Familiarity', in Corker, M. & Shakespeare, T. (Eds.) *Disability/Postmodernity: Embodying Disability Theory*, London: Continuum

Mitchell, W. J. T. (2005) *What Do Pictures Want?* London: University of Chicago Press

Mitchell, D. & Snyder, S. (2005) 'Exploitations of Embodiment: Born Freak and the Academic Bally Plank', in Disability Studies Quarterly 25: 3, available on line at www.dsq-sds.-archives.org, accessed July 2010

Mitchell, D. & Snyder, S. (2006) *Cultural Locations of Disability*, London: University of Chicago Press

Morrison, E. & Finkelstein, V. (1991) 'Culture as Struggle: Access to Power', in Leeds, S. *Disability Arts and Culture Papers'* Transcripts of a Disability Arts and Culture Seminar 20 November 1991 available on line http://disability-studies.leeds.ac.uk/files/library/Lees-arts-and-culture.pdf accessed 6.3.2013

Mouffe, C. (2000) *The Democratic Paradox*, London: Verso

Murray, S. (2008) *Representing Autism: Culture, Narrative Fascination*, Liverpool, University of Liverpool Press

Narayan, U. (1997) *Dislocating Cultures*, London: Routledge

Newton, M. (2002) *Savage Girls and Wild Boys, A History of Feral Children*, London: Faber

Nicholson, H. (2005) *Applied Drama: The Gift of Theatre*, Basingstoke: Palgrave Macmillan

Orwell, G. (1951) *Shooting an Elephant and Other Essays*, London: Secker & Warburg

Otto, B. (2007) *Fools are Everywhere, Court Jester Around the World*, Chicago & London: Chicago University Press

Pachmanova, P. & Woolf, J. (2006) 'Strategies of Correction and Interrogation' in *Mobile Fidelities: Conversations on Feminism, History and Visuality, n.paradoxa* online 19: May 6006, 86–98

Palmer, J. & Hayhow, R. (2008) *Learning Disability and Contemporary Theatre: Devised Theatre, Physical Theatre, Radical Theatre*, Huddersfield: Full Body and the Voice

Pavis, P. (1998) *Dictionary of the Theatre: Terms, Concepts and Analysis*, Buffalo: University of Toronto Press

Pavis, P. (2003) *Analyzing Performance: Theatre, Dance and Film*, Ann Arbor: University of Michigan Press

Perring, G. (1999) 'Making a Difference; A Cultural Exploration of the Relationship of Non-Disabled Artists to Learning Disability', MA Thesis, University of East London

Perring, G. (2005) 'The Facilitation of Learning Disabled Arts: A Cultural Perspective', in Sandhal, C. & Auslander, P. (Eds.) *Bodies in Commotion*, Ann Arbor: University of Michigan Press, 175–189

Peterson, M. (1997) *Straight White Male: Performance Art Monologues*, Jackson: University of Mississippi Press

Phelan, P. (1996) *Unmarked: The Politics of Performance*, London: Routledge

Phelan, P. & Lane J. (Ed.) (1998) *The Ends of Performance*, New York: New York University Press

Phelan, P. (2005) 'Reconsidering Identity Politics, Essentialism and Dismodernism, An Afterword', in Sandhal, C. & Auslander, P. (Eds.) *Bodies in Commotion*, Ann Arbor: University of Michigan Press, 319–325

Phillips, A. (1993) *On Kissing, Ticking and Being Bored: Psychoanalytic Essays on the Unexamined Life*, Cambridge: Harvard University Press

Phillips, A. (1995) *Terrors and Experts*, London: Faber and Faber

Phillips, A. (2006) *Side Effects*, London: Penguin

Phillips. A. (2007) *Winnicott*, London: Penguin

Peiry, L. (2006) *Art Brut: The Origins of Outsider Art*, Paris: Flammarian

Pointon, A. & Davies C. (eds.) (1997) *Framed: Interrogating Disability in the Media*, London: British Film Institute

Prentki, T. (2012) *The Fool in European Theatre, Stages of Folly*, Baskingstoke: Palgrave

Price, D. & Barron, L. (1999) 'Developing independence: The experience of the Lawnmowers Theatre Company', in *Disability and Society*, 14: 6, 819–829

Quarmby, K. (2011) *Scapegoat: Why We are Failing Disabled People*, London: Portabello

Quinn, M. L. (1990) 'Celebrity and the Semiotics of Acting', in *New Theatre Quarterly*, 6: 22, 154–161

Ramon, S. (Ed.) (1991) *Beyond Community Care: Normalisation and Integration Work*, Basingstoke: Mind/MacMillan Education

Ranciere, J. (2002) 'The Aesthetic Revolution and its Outcomes: Emplotments of Autonomy and Heteronomy', in *New Left Review*, 14, March-April 2002, 133–151

Ranciere, J. (2004) *The Politics of Aesthetics*, (trans. Rockhill G.) London: Continuum

Ranciere, J. (2007) *The Future of the Image*, (trans. Elliot, G) London: Verso

Read, A. (1995) *Theatre and Everyday Life: An Ethics of Performance*, London: Routledge

Read, A. (2001) 'The Placebo of Performance: Psychoanalysis in its Place', in Campbell, P. & Kear, A. (Ed.) *Psychoanalysis and Performance*, London: Routledge

Read, A. (2008) *Theatre, Intimacy & Engagement: The Last Human Venue*, London: Palgrave

Reed, N. C. (2004) 'The Specter of Wall Street: "Bartleby the Scrivener" and the Language of Commodities', in *American Literature*, 76, 2

Reeve, D. (2004) 'Psycho-emotional Dimensions of Disability and the Social Model', in Barnes, C. and Mercer, G. (Eds.) *Implementng the Social Model of Disability: Theory and research*, Leeds: The Disability Press, 83–100

Reinders, J. S. (2002) 'The Good Life for Citizens with Intellectual Disability', in *Journal of Intellectual Disability Research*, 1: 46, 5

Roach, J. (1996), *Cities of the Dead: Circum-Atlantic Performance*, New York: Columbia University Press

Rousseau, J. J. (1979) *Emile, or On Education*, (trans. Bloom, A.) New York: Basic

Roach, J. (2004) 'It', in *Theatre Journal*, 56: 4, 555–568

Rhodes, C. (1994) *Primitivism and Modern Art*, London: Thames and Hudson

Ridout, N. (2006) *Stage Fright, Animals and Other Theatrical Problems*, Cambridge: Cambridge University Press

Riviere, J. (1929) 'Womanliness as a Masquerade', in Tripp (Ed.) *Gender, A Reader*, Basingstoke: Palgrave, 130–138

Roberts, J. (2007) *The Intangibles of Form: Skill and Deskilling in Art After the Readymade*, London: Verso

Roulstone, A. (2010) 'RiDE Themed Edition – On Disability: Creative Tensions in Applied Theatre: An Extended Review', in *Research in Drama Education: the Journal of Applied Theatre and Performance*, 15: 3,431–439

Royle, N. (2003) *The Uncanny*, Manchester: Manchester University Press

Said, E. (1985) *Beginnings: Intention and Method*, London: Granta

Sandahl, C. (2003) 'Queering the Crip or Cripping the Queer? Intersections of Queer and Crip Identities in Solo Autobiographical Performance', in *GLQ*, 9: 1–2, 25–56, Duke University Press

Sandhal, C. & Auslander, P. (2005) *Bodies in Commotion*, Ann Arbor: University of Michigan Press

Scarry, E. (2006) *On Beauty and Being Just*, London: Duckworth & Co

Scharff, J. (1977) *Foundations of Object Relations in Family Therapy*, New York: Jason Aronson Inc

Schechner, R. (1985) *Between Theatre and Anthropology*, Philadelphia: University of Pennsylvania Press

Schechner, R. (1993) *The Future Of Ritual*, London: Routledge

Schechner, R. (2003) *Performance Theory* (2nd Edition), London: Routledge

Schinina, G. (2004) 'Here We Are: Social Theatre and Some Open Questions about Its Development', in *The Drama Review*, 48: 3 (T183), 17–31

Schjeldahl, P. (1998) 'Notes on Beauty', in Beckley, B. & Shapiro, D. (Eds.) *Uncontrollable Beauty: Toward a New Aesthetic*, New York: Allworth, 53–61

Schneider, R. (2001) 'Hello Dolly Well Hello Dolly: The Double and Its Theatre', in Campbell, P. & Kear, A. (Eds.) *Psychoanalysis and Performance*, London: Routledge

Schwartz, H. (1996) *The Culture of the Copy*, New York: Zone

Sedgwick, E. K. (1993) *Tendencies*, Durham: Duke University Press

Sennett, R. (1992) *The Fall of Public Man*, New York & London: Norton

Sennett, R. (2008) *The Craftsman*, London: Penguin

Shakespeare, T. (2006) *Disability Rights and Wrongs*, London: Routledge

Shakespeare, T. & Corker, M. (2002) *Disability/Post-modernity: Embodying Disability Theory*, London: Continuum

Shakespeare, T. (1997) 'Cultural Representations of Disabled People: Dustbins for Disavowal?', in Barton, L. & Oliver M. (Eds.) *Disability; Past Present and Future*, Leeds: The Disability Press

Shank, T. (1996) *Contemporary British Theatre (Updated edition)*, London: Methuen

Shklovsky, V. (1965) 'Art as Technique', in Lemon, L. T. & Reis, M. J. (Ed.) *Russian Formalist Criticism: Four Essays*, Lincoln: University of Nebraska Press, 3–24

Sheldon, A., Traustadóttir, R., Beresford, P., Boxall K., & Oliver M. (2007) 'Disability Rights and Wrongs?', in *Disability & Society*, 22: 2, 209–234

Shellard, D. (1999) *British Theatre Since the War*, New Haven: Yale University Press

Shildrick, M. (2002) *Embodying the Monster, Encounters with the Vulnerable Self*, London: Sage

Shildrick, M. (2009) *Dangerous Discourses of Disability, Subjectivity and Sexuality*, Basingstoke: Palgrave

Shildrick, M. (2012) 'Critical Disability Studies: Rethinking the Conventions for the Age of Ostmodernity', in Watson, N., Roulstone, A. & Thomas, C. (Eds.) *Routledge Handbook of Disability Studies*, London: Routledge

Showalter, E. (1997) *Hysteries: Hysterical Epidemics and Modern Culture*, New York: Columbia University Press

Siebers, T. (2008) *Disability Theory*, Michigan: University of Michigan Press

Siebers, T. (2010) *Disability Aesthetics*, Michigan: University of Michigan Press

Sierz, A. (1997), 'British Theatre in the 1990s: A Brief Political Economy', in *Media, Culture and Society*, 19, 461–469

Silver, A. (2002) 'The Crooked Timber of Humanity: Disability, Ideology and the Aesthetic', in Shakespeare, T. & Corker, M. (Eds.) *Disability/Post-modernity: Embodying Disability Theory*, London: Continuum

Simmer, B. (2002) 'Theatre and therapy: Robert Wilson', in Schneider, R. & Cody G. (Eds.), *Re: Direction (2nd Edition)*, London: Routledge, 147–157

Smit, C. R. (2008) 'A Collaborative Aesthetic: Levinas' Idea of Responsibility and the Photography of Charles Eisenmann in the Late Nineteenth Century Freak Performer', in Tromp, M. (Ed.) *Victorian Freaks, The Social Context of Freakery in Britain*, Columbus: Ohio State University Press

Smith, O. (2005) 'Shifting Apollo's Frame, Challenging the Body Aesthetic in Theater Dance', in Sandhal, C. & Auslander, P, (Eds.) *Bodies in Commotion*, Ann Arbor: University of Michigan Press

Snyder, S. & Mitchell, D. (Eds.) (2006) *Cultural Locations of Disability (2nd Edition)*, Chicago: University of Chicago Press

Sontag, S. (1999) 'Notes on "Camp"', in Cleto, F. (Ed.) *Camp: Queer Aesthetics and the Performing Subject*, Edinburgh: Edinburgh University Press, 53–66

Southworth, J. (2003) *Fools and Jester at the English Court*, Stroud: Sutton

Spivak (1988) 'Can the Subaltern Speak?', in Nelson, C. & Grossberg, L. (Eds.) *Marxism and Interpretation of Culture*, Urbana: University of Illinois Press, 271–313

Stalker, K. (2012) 'Theorizing the Position of People with Learning Difficulties within Disability Studies: Progress and Pitfalls', in Watson, N., Roulstone, A. & Thomas, C. (Eds.) *Routledge Handbook of Disability Studies*, London: Routledge

States, B. (1985) *Great Reckonings in Small Rooms*, Berkeley: University of California Press

States, B. (2002) 'The Actor's Presence: Three Phenomenal Modes', in Zarrilli, P. (Ed.) *Acting Reconsidered (2nd Edition)*, London: Routledge, 23–40

Steene, M. (2007) 'Outsiders?', in *Pallant House Gallery Magazine*: 12, www.pallant.org.uk

Steiner, G. (1978) *On Difficulty and Other Essays*, Oxford: Oxford University Press

Stern, L. (1997) 'I Think Sebastian, Therefore I ... Somersault: Film and the Uncanny', in *Paradoxa*, 3: 3–4, 348–366

Stern, R. (2008) 'Our Bear Women, Ourselves: Affiliating with Rebecca Stern', in Tromp M., (Ed.) *Victorian Freaks, The Social Context of Freakery in Britain*, Columbus: Ohio State University Press

Stiker, H. (1999) *A History of Disability*, Ann Arbour: University of Michigan Press

Sutherland, A. (1997) 'Disability Arts, Disability Politics', in Pointon, A. & Davies, C. (Eds.) *Framed: Interrogating Disability in the Media*, London: British Film Institute

Swain, J. & French, S. (2000) *Toward an Affirmation Model of Disability*, Newcastle: Carfax

Thomas, C. (2007) *Sociologies of Disability and Illness*, Basingstoke: Palgrave

Thompson, J. & Schechner, R. (2004) 'Why "Social Theatre"', in *The Drama Review* 48: 3 (T183), 11–16

Thompson, J. (2009) *Performance Affects, Applied Theatre and the End of Effect*, Basingstoke: Palgrave Macmillan

Thompsett, A. R. (1996) 'Changing Perspectives', in Campbell, P. (Ed.) *Analysing Performance: A Critical Reader*, Manchester: Manchester University Press, 244–267

Tomlin, L. (2004) 'English Theatre in the 1990s and Beyond', in Kershaw, B. (Ed.) *The Cambridge History of the British Theatre, Volume 3, Since 1895*, Cambridge: Cambridge University Press, 498–512

Tomlinson, R. (1982) *Disability, Theatre and Education*, Bloomington: Indiana University Press

Thomson, R. G. (1996) *Freakery: Cultural Spectacles of the Extraordinary Body*, New York: NYU Press

Thomson, R. G. (1997) *Extraordinary Bodies: Figuring Physical Disability in American Literature and Culture*, New York: New York University Press

Thomson, R. G. (2005) 'Dares to Stares: Disabled Women Performance Artists and the Dynamics of Staring', in Sandhal, C. & Auslander, P. (Eds.) *Bodies in Commotion*, Ann Arbor: University of Michigan Press, 30–42

Thomson, R. G. (2009) *Staring: How We Look*, Oxford: Oxford University Press

Tremain, S. (2005) *Foucault and the Government of Disability*, Ann Arbour: University of Michigan Press

Tromp, M. (ed.) (2008) *Victorian Freaks, The Social Context of Freakery in Britain*, Columbus: Ohio State University Press

Turner, B. S. (2006) *Vulnerability and Human Rights*, University Park: Pennsylvania State University Press

Turner, C. & Behrndt, S. (2008) *Dramaturgy and Performance*, Basingstoke: Palgrave Macmillan

Turner, V. & Turner, E. (2007), 'Performing Ethnography', in Bial (Ed.) *The Performance Studies Reader*, London: Routledge

Van Maanen, J. (1988) *Tales of the Field, On Writing Ethnography*, Chicago: University of Chicago Press

Vasey, S. (1991) 'Disability Arts and Culture: An Introduction to Key Issues and Questions', in Leeds, S. (Ed.) *Disability Arts and Culture Papers*, Transcripts of a Disability Arts and Culture Seminar, 20 November 1991 available on line http://disability-studies.leeds.ac.uk/files/library/Lees-arts-and-culture.pdf accessed 6.3.2013

Vila-Matas, E. (2004) *Bartleby & Co.*, (trans. Dunne, J.) London: Vintage

Welsford, E. (1935) *The Fool: His Literary and Social History*, London: Faber & Faber

Willeford, W. (1969) *The Fool and his Sceptre, A Study of Clowns and Jesters and their Audience*, London, Edward Arnold

Willett, J. (1984) *The Theatre of Bertolt Brecht*, London: Methuen

Winston, J. (2006) 'Beauty, Goodness and Education: The Arts Beyond Utility', in *The Journal of Moral Education*, 35: 3, 285–294

Winston, J. (2011) *Beauty and Education*, London: Routledge

Wolff, J. (2008) *The Aesthetics of Uncertainty*, New York: Columbia University Press

Zizek, S. (1997) 'Multiculturalism, Or, the Cultural Logic of Multinational Capitalism', in *New Left Review* September/October 1997, 28–51

Zizek, S. (2001) *Enjoy Your Symptom!*, London: Routledge

Zizek, S. (2006) *The Parallax View*, MIT, Cambridge, Mass

Zizek, S. (2005) 'Against Human Rights', in *New Left Review* 34, July/August 2005, 115–131

Zizek, S. (2008) *Violence: Six Sideways Reflections*, London: Profile

Index

273

CPSIA information can be obtained
at www.ICGtesting.com
Printed in the USA
LVOW04*1521190216

475861LV00015B/146/P